TOPICS IN
AMERICAN ART
SINCE 1945

TOPICS IN AMERICAN ART
SINCE 1945

Lawrence Alloway

W·W·NORTON & COMPANY·INC·
NEW YORK

Copyright © 1975 by W. W. Norton & Company, Inc.

FIRST EDITION

Library of Congress Cataloging in Publication Data
Alloway, Lawrence, 1926–
 Topics in American art since 1945.
 Includes bibliographical references and index.
 1. Art, American. 2. Art, Modern—20th century—
United States. I. Title.
N6512.A5663 1975 709'.73 74–34361
ISBN 0–393–04401–7
ISBN 0–393–09237–2 (pbk.)

Published simultaneously in Canada
by George J. McLeod Limited, Toronto

PRINTED IN THE UNITED STATES OF AMERICA

1 2 3 4 5 6 7 8 9 0

To *Sylvia*

CONTENTS

8 *Contents*

LIST OF ILLUSTRATIONS

INTRODUCTION

The subject of art criticism is new art or at least recent art. It is usually the first written response. The early readings of works of art by critics may or may not be confirmed in time, but, after all, the intentions of artists are subject to changing interpretations too. Nonetheless, the closeness in time of the critical text and the making of the work of art gives art criticism its special flavor. To a considerable extent the genre remains what it was when Denis Diderot invented it, the record of spontaneous response and fast judgment to the presence of new work. However, there is a difference now, caused by a speed-up in the application of analytical methods to the crowded present.

Art history is the model that has lead critics toward specific topics or more closely defined problems. On the other hand, there is a risk of the influence of art history abridging the freedom of the critic. This happens when a deterministic view of the succession of history is imposed prematurely on the current scene and the recent past. Such historical foreshortening is a way of suppressing the numerical density and stylistic diversity of the present by means of pre-emptive formulas. Appreciative writing, dealing with congenial bits of the general culture, which used to be the art critic's highest aim, is rare now. The article, a piece of prose with a specific target, has replaced the broad consensual themes essential to the essayist. I should add that I am not an art historian, and what I write is art criticism with footnotes.

This book consists of a selection of reviews and articles written in the sixties and early seventies. If a piece seemed reprintable, after the shock of rereading, because it made a point that still seemed interesting, I have let it stand. This is not because I am infatuated with my words once they are in print, but because I want to preserve their historical identity. Art criticism is occasional, written in response to particular events such as exhibitions and anniversaries. Tampering with the words could only reduce what evidential value a text might have, entangling the directness of early response with second thoughts and hindsight. I have reprinted, therefore, but not rewritten, except for small changes for the sake of consistency, often initiated by the copy editor. Footnote density, for example, in what follows fluctuates according to the sources of the different articles.

The state of information on any topic varies with time. When I wrote "The American Sublime" in 1963, for instance, proposing a connection between Edmund Burke's definition of the sublime and the painting of Newman, Still, and Rothko, the subject was at one state, and it is at another state now, more than ten years later. To try and align these two levels would blur what was initially said and would conversely restrict what I might have to say now. I have written a good deal of art criticism, so in cases where I was doubtful and the temptation to edit was strong I was able to simply drop the piece. This selection does not include pieces on European artists or theoretical essays dealing less with artists and their works than with the impact on aesthetics of the expanded communication system of the twentieth century (this is another book). As it stands, *Topics* presents a chronological profile of aspects of American art from Abstract Expressionism to the early seventies. (A note on the title: topics has a double meaning which seems appropriate. On one hand, it is the subject or theme of a discourse, its argument and its evidence. On the other hand, the word also refers to tacit ideas, the commonplaces that are shared by both artists and their public. In this sense the essays here may represent more than my personal opinion.) The year "1945" in the title is not exact, but an approximate marker.

The concentration on American art is close to my heart. Even when I lived in England my main interest was in American art (though nothing that I wrote in England is reprinted here). It is also a fact that for the greater part of my writing life I have worked for American magazines. In the fifties I wrote about British art for *Art News* and then for *Art International,* which though technically a Swiss publication has an American editor and publisher, James Fitzsimmons. In 1962 I became curator of the Solomon R. Guggenheim Museum and three of my catalogues are reprinted here. In 1966 I returned to magazine writing, for *Arts* until 1970 and since 1971 for *Artforum.* In addition I have written for *The Nation* since 1968. All this gave me a chance to see at close quarters the art that I had admired at a distance. As I list these activities I realize the extent to which I have depended on my editors. I have certainly not made up all the subjects on which I have written. Samuel Edwards, when he was at *Arts Magazine,* proposed subjects I had never thought of. Robert Hatch, at *The Nation,* has kept my focus wider than it would have been, drawing both oversights and repetitions to my attention. John Coplans at *Artforum* has brought up topics that he thought would suit me and has suggested approaches that have firmed up vague impulses. All these people have influenced the contents of this book. To Linda Nochlin and to H. Stafford Bryant, Jr., my editor at W. W. Norton & Company, I am indebted for making this book possible.

ACKNOWLEDGMENTS

The selections in this volume have been previously published in various publications, including *Art International:* "Melpomene and Graffiti: Adolph Gottlieb's Early Work"; *Artforum:* "The Biomorphic '40s," "Agnes Martin," "Robert Smithson's Development"; *Art News:* "Gesture into Form: The Later Paintings of Norman Bluhm"; *Arts Magazine:* "Jackson Pollock's Black Paintings," "Marilyn as Subject Matter," "Roy Lichtenstein's Period Style," "Hi-way Culture (with Notes on D'Arcangelo," "Art as Likeness," part of "Allan Kaprow: Two Views," "Arakawa: An Interview"; *Auction:* "Pop Art: The Words," "The Expanding and Disappearing Work of Art"; *The Nation:* "Jackson Pollock's 'Psychoanalytic Drawings,' " "Willem de Kooning," "Sol LeWitt," "Jasper Johns' Map," "George Segal," part of "Allan Kaprow: Two Views," the discussion of Kenneth Noland in "The Uses and Limits of Art Criticism," "Radio City Music Hall"; *Studio International:* "The Public Sculpture Problem." "The Reuben Gallery," "Barnett Newman: The Stations of the Cross and the Subjects of the Artist," and "Systemic Painting" are from the catalogues of exhibitions that I arranged at the Solomon A. Guggenheim Museum in 1965 and 1966. "Serial Forms" is from the catalogue of the exhibit "American Sculpture of the 60s," arranged by Maurice Tuchman at the Los Angeles County Museum in 1967, and "Leon Polk Smith" is from the catalogue of an exhibition arranged by Gerald Nordland at the San Francisco Museum of Art in 1968. "Rauschenberg's Graphics" is the catalogue text of an exhibition arranged by Stephen Prokopoff for the Institute of Contemporary Art, University of Pennsylvania, in 1970. "Artists and Photographs" was published on the occasion of an exhibition of this name at Multiples, Inc., in the same year. "Photo-Realism" was written for the catalogue of an exhibition of selected works from the Ludwig Collection and others, shown by the Arts Council of Great Britain in 1973. "Notes on Op Art" was first printed in *The New Art,* edited by Gregory Battcock (1966), and the introduction to "Stolen" is from a book published jointly by Multiples Inc., Colorcraft Lithographers, and the Dwan Gallery in 1970.

I wish to thank editors and publishers of the various publications for their permission to use the writings included here.

Credit is due to the following photographers: Nancy Astor, plate 16; Oliver Baker, plates 3, 5, 9, 12, 18, 19, 23; Rudolph Burkhardt, plates 29, 31, 36, 38, 40, 50, 51; Geoffrey Clements, plates 33, 39, 48; Hickey and Robinson, plate 64; O. E. Nelson, plates 21, 28; Howard Smagula, plate 55; Eric Pollitzer, plates 21, 28, 30, 34, 35, 37, 53, 56, 59; Soichi Sunami, plate 10; John Weber Gallery, plate 63.

ABSTRACT EXPRESSIONISM

Differentiation, not reduction, is the aim of these articles. It was my hope to propose internal differences and distinctions within the general grouping of artists called Abstract Expressionist. In one case the use of biomorphic form is taken as the stylistic common denominator of a subgroup of Abstract Expressionists at a certain moment of history. In the case of Gottlieb my intention was to isolate one period of his work that I both admire on its own merits and consider representative of much New York art of the forties in its evocation of myth. In "The American Sublime" I have taken another subgroup within Abstract Expressionism, one I feel to be of singular importance, and have attempted to define a connection between its intentions and the traditional aesthetic of the sublime. An extension of this line of thought, of course, runs through the piece on Newman's *Stations of the Cross*.

THE BIOMORPHIC

'40s[*]

Bio: "a combining form denoting relation to, or connection with, life, vital
phenomena, or living organisms."

Morphology: "the features, collectively, comprised in the form and structure
of an organism or any of its parts."

The movements of 20th-century art, to the extent that they began with
artists' acts of self-identification, in opposition either to another group of
artists or against a public made grandiose and threatening as the Philis-
tines, tend to stay monolithic. Efforts are made to unify these discrete
movements, like different shaped beads on a string of "the classical
spirit" or "the expressionist temperament," but obviously this delivers
very little, except an illusion of mastery to the users of cliché. More is
needed than a revival of the exhausted classical/romantic antithesis,
which leaves the movements to be united sequentially undisturbed.
Modern art tends to be written about by the artists and their friends
in the first case, and by generalizers and popularizers after that, with the
result that the mosaic of movements has remained largely unaffected, to
the detriment of unorganized artists and traditions. For example, there
is a line of biomorphic art (which combines various forms in evocative
organic wholes), that, to the extent that it is discussed in the usual frame-
work, could only be viewed as a part of Surrealism. What failed to fit
would come under such headings as Precursors of, or The Inheritance
of, Surrealism, or, maybe, just plain Independents (as if the artists were
eccentrics, or nuts, off the main-line).

Biomorphism, so far as Surrealism goes, is a painterly equivalent of
the transcriptual puzzles and combinations of objects of Magritte and
Dali. However, the main painters of biomorphism have been merely

SOURCE: From *Artforum,* IV/1 (September, 1965), 18–22.

* This essay incorporates brief passages from two other pieces by the author:
the introduction to *William Baziotes, A Memorial Exhibition,* The Solomon R.
Guggenheim Museum, New York, 1965, and "Gorky," *Artforum,* Vol. 1, No. 9,
March 1963.

affiliated to Surrealism, or Shanghai-ed into it, as is the case with Arp and Miró; Masson alone, for much of his career, was an official Surrealist. Biomorphism, with its invention of analogies of human forms in nature and other organisms, has wide connections, for example, with Art Nouveau (in which the human body shares a promiscuous linear flow with all created objects) and with Redon, whose ambiguous imagery is born of reverie.

In New York in the mid-40s biomorphism was of the greatest importance and one of its sources was certainly Surrealism. However, we must also account for the position of an artist like Baziotes whose *Moon World,* 1951, is very close to the bland sack of Brancusi's marble seal, *Le Miracle,* 1936. Another example of the pervasiveness of biomorphism apart from the influence of Surrealism, is the late work of Kandinsky. After 1934 there is a persistent use of waving tendrils and squirming free forms, but dried out when compared with the juiciness of Miró, or the ripeness of Arp. These irregular radiating or flattened forms, however parched, are fully characteristic of biomorphism's inventory of organic form. In the visual arts it is a cultural reflex to regard nature as landscape. However, in biomorphic art, nature can also be a single organic form, or a group of such forms (like Baziotes' *Moon World*). Or they can be presented in swarms, tangling with one another. Barnett Newman, writing about Stamos, indicates the importance of nature to him, as to other biomorphic artists: "His ideograph captures the moment of totemic affinity with the rock and the mushroom, the crayfish and the seaweed. He redefines the pastoral experience as one of participation with the inner life of the natural phenomenon.[1]

In addition to the flat, more-or-less placid, and (as it were) one-cell biomorphs, another aspect of organic imagery is important. This is linear-based (as opposed to painterly and planar) biomorphism, with the canvas or paper swarming like the jungle which exists below the ordinary scale of human vision. (Hence the importance of microscopy, either as a direct visual influence, or, more usually, as conceptual backing to justify an artist's working assumption of "endless worlds," extensions of consciousness beyond the proportionate contour of classical and Renaissance art.)

Proliferating biomorphism is the analogue of manic activity in the artist, whose muscular activity issues in the marks which we interpret as a self-discovering subject. The graphic preliminaries of the artist suggest forms out of which conflations of human, floral, animal, and insect-like forms can be developed. Crowded and manic biomorphism is directly linked to automatism, which was cultivated by the Surrealists as a means of direct access to the Unconscious mind. The ideal of direct action was most clearly recognized in drawing, except for phases of Masson's and

1. *Theodoros Stamos.* Exhibition Catalogue, Betty Parsons Gallery, New York, March 1947.

Ernst's painting. In New York in the '40s automatism was pressed as a cause by Matta, who influenced Motherwell and Baziotes. Pollock, too, expressed interest in its procedures. Referring to "European moderns" Pollock said: "I am particularly impressed with their concept of the source of art being the unconscious." [2] There is an unbroken link between automatic processes in art (working at speed, encouraging accidents) and belief, often of a rather nonchalant and expedient sort, in the unconscious.

The unconscious, in its turn, is linked to mythology which, after a lively influence on 20th-century culture, reached a climax in the '40s, and nowhere more than in New York. The appeal of myth must have had something to do with the fact that it offered a control mechanism by which all data, all experiences, could be handled. It was not myth as a body of precise allusions as, say, in 17th-century poetry, but myth as a kind of "manna." Myths, absorbed more or less automatically in our education, updated by Freud and Jung, revealed ubiquitous patterns that tied in the personal psyche with the greatest events, new or old. Revealing of this aspect is "A Special Issue on Myth," published by the magazine *Chimera* is 1946.[3] Here is a partial name-list from its 88 pages: Alcestis, John Buchan, Columbus, Dante, Earwicker, Faustus, Gluck, Hitler, and so on to Veblen and John Wesley; subjects discussed include witches and warlocks, Hegel's spirit, the Siegfried cycle, and Walpole's *Castle of Otranto*. This should be enough to show that in the '40s, mythology was seriously regarded as a key to the psycho-social order we share with world culture. (Adolph Gottlieb remembers that he had a copy which he kept for about ten years.) Mythology, used like this, turned the whole world into an intimate and organic spectacle. Thus, an artist with an interest in mythology could discover its enduring and fastastic patterns in his art and, at the same time, project his personal patterns out into the world. The pleasure taken in pre-history, as subject and title, in Rothko and Stamos, for example, is indicative of this quest for unplumbed humanity, with the remote in time as a metaphor of psychological depth.

At a moment when abstract artists were turning from existing geometric styles, mythology gave to evocative and suggestive, but not precisely decodable, signs, the appropriate atmosphere and ideal context. Of the biomorphists, Baziotes, Gottlieb, Pollock, and Rothko used myth-conferring titles, and so did Gorky in the sense of binding his paintings to personal desire and memory. There is a psycho-sexual content in biomorphic art, which abounds in visceral lyricism full of body allusions. Gorky, in this respect comparable to Baziotes and Rothko, creates a kind of polymorphous fabulism. Particular cases of resemblance are not

2. Quoted from *Arts and Architecture,* February, 1944, in: "New York School, The First Generation," Los Angeles County Museum, 1965.

3. *Chimera,* New York vol. 4, no. 3, Spring 1946.

interesting: the point is the identity of everything with its simultaneous phases of seeding, sprouting, growing, loving, fighting, decaying, rebirth. The impression is of a natural and personal abundance, in opposition to geometric art (urban or platonic) or figurative art (bound to particular cases). The desire for a nuanced and subjective imagery was manifested in paintings that did not subordinate the artist's use of paint to a tidy and cleaned up end-state. On the contrary, rich meanings were located within the creative act itself, so that the process-record itself is sensitized. Biomorphic art depends in part (1) on the depiction of beings and places, but also (2) on the enactment of the work itself. The artist's gestures are image-making and keep their identity as physical improvisation beyond the point of completion. Gorky's and Pollock's linearism, Rothko's liquidity, Baziotes' scumbled haze of color, were all technical devices fused with permissive meanings.

Thus biomorphic art emerged in New York as the result of a cluster of ideas about nature, automatism, mythology, and the unconscious. These elements fed one another to make a loop out of which this evocative art developed. It made possible, too, the continuation of aspects of biomorphism familiar in European art (especially Miró and Klee) although native artists like Arthur G. Dove, with his uterine landscapes, may have helped predispose American artists to the ambiguous mode. If it was the conjunction of these varied elements that was fruitful in New York for biomorphism, considerable latitude in its forms is to be expected. This, in fact, is the case, and assuming that a tradition is validated more by how far it can be stretched than by how narrowly it can be administered, it is a sign of biomorphic art's historical appropriateness that so much could be made of it. One aspect of its diversity is seen in Still's biomorphism which is at the border of his abstract art, and hence ambiguously interpretable as abstract. His paintings of circa 1938 to circa 1946 are rocky and troll-like; a stickily dragged paint creates a Northern melodrama of thrones and presences, like Mount Rushmore as the statue of the Commander.

A checklist of American biomorphists in the '40s would be unmanageable if it were comprehensive, but it is possible to indicate the central groupings. Pollock, in drawings of the late '30s made what are virtually straight biomorphic exercises. These chain-reactions of repetitive and transforming imagery, are presumably the type of drawing that he discussed with his Jungian analyst in 1939. Pollock's paintings were not stylistically kin with these fluent drawings, however: his biomorphic paintings of 1943–46 set the human or totemic passages in a late Cubist framework. These works are a turbulent extension of Picasso's so-called *Surrealist* "Three Dancers," 1925, in the direction of more direct passion and fuller human traces. It was not until 1951 that he revived the iconography of these periods, ambiguously human, fully biomorphic, in the black paintings, without any Cubist bracing. Gorky's

1. Arshile Gorky: *Study for Dark Green Painting* (1946). Crayon on paper, 19″ × 24″. Estate of the artist.

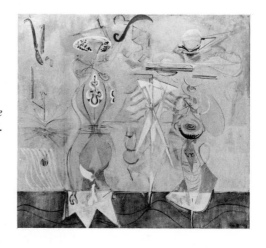

2. Mark Rothko: *Slow Swirl at the Edge of the Sea* (1946). Oil on canvas, 72″ × 80″. Formerly San Francisco Museum of Art.

3. Theodoros Stamos: *Archaic Sentinel* (1947). Oil on panel, 38″ × 30″.

early metamorphic scenes also derive from Cubism; in the '30s he made what Alfred Barr called Curvilinear Cubism, as undulant as cartoons of well-stacked girls or rippling biceps. In a way, Gorky's development parallels André Masson's, who, from being a Cubist, and friend of Gris, expanded Cubist subject-matter, and then relinquished its forms entirely for organic and improvisatory work. However, Gorky's sexy Cubism was only a preliminary for the full biomorphism of the three *Garden in Sochi* paintings (1940–41), with their conspicuous adaptation of Miró, leading into the linear twists and folds, washed with transparent color and flecks of clear hue (like a parted orifice) of *The Pirate 1*, 1942. Gorky influenced de Kooning, but biomorphism in de Kooning (circa 1945–48, 1949–50), no matter how many breasts and slits jerk and ripple, in forms like ghosts made out of sheets in old-fashioned cartoons, is implicitly urban. His mannequins piled in a warehouse are a rationalized version of the pastoral bacchanals of Gorky.

Four artists were particularly occupied with the evocation of the primal, using pre-history and marine biology. Rothko, between circa 1945 and 1947, paints an imagined ocean floor in which linear organisms wriggle as his wrist moves, creating animate forms transparent to their misty backgrounds. A 1945 painting was entitled *Birth of Cephalopods*, which are a class of Mollusca "characterized by a distinct head with 'arms' of tentacles attached to it; comprising Cuttlefishes, the Nautilus, etc., and numerous fossil species" (OED). Alien but beguiling, disembodied but sexual forms drift, hover, and coalesce. Stamos stated the theme clearly in 1946 (after hesitant moves in the preceding year). *Omen* and *Nautical Warrior*, both of 1946, present marine forms animated in ways to imply combat, encounter, self-awareness and contact. Biological low life is the analogue of human feeling and order. Gottlieb's pictographs, begun in 1941, have a biomorphic potential as when the artist speaks of using "hand, nose, arms" as details in painting, "often separating them from their associations as anatomy." [4] Beyond this, however, is the frequent appearance in paintings of 1946–47 of fleshy marine forms, as in *Return of the Mariner*, 1946. Baziotes evolved in 1947 (after a period in 1942 when he was occupied by the promises of automatism) a biomorphic style that was the base of all his subsequent work. He used, in that year, rudimentary human contours which assimilated references to a dwarf, Cyclops, an armless and legless

4. Quoted from "Limited Edition," 1945 in: *New York School. The First Generation*, Los Angeles County Museum, 1965. *The Tiger's Eye*, 2, 1947 (a magazine that Barnett Newman was an associate editor of) included an anthology of poetic writing and painting on the theme of "The Sea" (pp. 65–100). It included a Milton Avery beach scene, two fully biomorphic Stamos paintings of circa 1946, and Baziotes' patterned cubist "Florida Seascape" 1945. Elsewhere in the magazine Stamos wrote (in "The Ides of Art"): "I am concerned with the Ancestral Image which is a journey through the *shells and webbed entanglements* of the phenomenon" (my emphasis).

4. Jackson Pollock: *Banners of Spring* (1946). Oil on canvas, 33″×43″. Collection of E. J. Power, London.

5. Willem de Kooning: *Pink Angels* (1947). Oil on canvas, 52″×40″. Collection of Mr. and Mrs. Frederick R. Wiseman, Beverly Hills, California.

6. William Baziotes: *Dwarf* (1947). Oil on canvas, 42″×36″.

veteran of World War I, a heavy female contour. These elements were not opposed, but subsumed to unified images. Other interests of Baziotes were "lizards and prehistoric animals," [5] not to mention the zoo and the aquarium.

To conclude: a description of biomorphic art cannot be restricted to a Surrealist ambience, although this was certainly a stimulus. It is important to stress that several of the American artists contacted earlier, original traditions which Surrealism had adapted and rigidified. Thus, Baziotes went around "behind" Surrealism to a form of reverie more like Redon's than, say, Dali's: in Baziotes flora and fauna lyrically oscillate but within a formal canon of unperturbed refinement. When he wrote "it is the mysterious I love in painting. It is the stillness and the silence," [6] he raised unmistakably the symbolist canon of inert and strange beauties. Gorky, too, can be connected behind André Breton, who helped with his titles, to a broader style, the tradition of the Grotesque. Vitruvius, who objected to this capricious ornamental style, described it well by writing against it: "How can a tender shoot carry a human figure, and how can bastard forms composed of flowers and human bodies grow out of roots and tendrils?" [7] Several aspects of biomorphic imagery can be considered as an incorporation into easel painting of the monstrous fusions and calligraphic energy of the Grotesque. Other connections could be made back to traditional iconographies of herbal, bacchanal and paradise, which combine pastoral scene with erotic act. However, enough has been said to show that biomorphism is a continuation of extensive traditions of fantasy, as well as the product of a particular historical situation in New York in the '40s.

5. For these quotations, and others, see: *William Baziotes, A Memorial Exhibition*, The Solomon R. Guggenheim Museum, New York, 1965.

6. Baziotes. *Ibid.*

7. Quoted by Wolfgang Kayser: *The Grotesque in Art and Literature*, Indiana University Press, 1963.

MELPOMENE
AND GRAFFITI
Adolph Gottlieb's Early Work

American painting of the 40s, when first seen as a unit called Abstract Expressionism or Action Painting, was celebrated for its confluence of major talents, and rightly. It has been less frequently remarked that there is one group of artists, working in various styles, who developed in the early 1940s, and another group that does not come on strong until later in the decade. The distinction is worth making, as a step towards replacing the clap-of-thunder theory of New York Painting with a complex and graduated set of real relationships. De Kooning, Gorky, and Pollock are the possessors of strong styles early, and so is Adolph Gottlieb; others, such as Baziotes, Hofmann, Kline, Motherwell, Newman and Rothko do not develop fully characteristic styles until the later 40s. (I omit Still from either group until his dating has been cleared up.) Rothko's watercolors or Motherwell's collages are not of fundamental consequence compared to their later work; Gottlieb's Pictographs, however, though different from his later work, are no less purposeful and developed. The Pictographs of the 40s, along with some later work, are on view at the Guggenheim Museum and his later work is at the Whitney Museum of American Art.

Gottlieb remembers [1] how Rothko and himself, discussing the impasse of American painting in 1941, were considering alternatives. What to do instead of subway scenes with *Pittura Metafisica* hints, like Rothko, or still lifes on the beach, derived from object pictures like Pierre Roy's, as in Gottlieb's case. They decided that a change of subject matter was needed and they concurred on their *next* subject: classical mythology. Rothko began his Aeschylus watercolors and Gottlieb painted *The Eyes*

SOURCE: From *Art International*, XII/4 (April 20, 1968), 21–24.

1. Adolph Gottlieb. Dialogue with the author. Whitney Museum of American Art, February 13, 1968.

of Oedipus, his first pictograph. This way of arriving at a new subject may seem arbitrary, but, in fact, was not. Mythology was being approached, by one route or another, by various American artists, including Gorky and Pollock. The personal experience of psychoanalysis or its cultural influence, a mythologizing phase of literary criticism, and late Surrealism, all contributed to a revival of the value of myth.

Diane Waldman, in the catalogue of the earlier half of the present exhibition, writes: "It is interesting to speculate that the introduction of primitive forms at this time was required (like Dubuffet's) primarily for pictorial reasons (automatism) rather than for the interest in myth as such." [2] Mrs. Waldman's phrasing implies a separation where I can't see one. She is right to insist as she does later in the catalogue, that the myths are decontextualized and deracinated, but this is what gave them their new meaning. It does not give them no meaning, which is what the phrase "primarily pictorial" implies. Open-ended mythological subject matter, combined with a repertory of biomorphic forms, solved a problem that Gottlieb shared with other artists of his generation in New York. How to retain flatness in painting, without resorting to the existing forms of abstract art; or, to put it another way, how to convey the presence of momentous content without using an imagery of spatial illusion? Pictographs, a simulated language system, were used by Gottlieb to appropriate the plane of the picture without losing the appearance of two dimensions. (Incidentally, despite the European origin of Maurice Dénis and other theorists of painting's essential flatness, all the later developments of the idea occur in the U.S.) In 1942 Gottlieb used the word *Pictograph* as a title and also *Pictographic Symbol,* making clear the significative intention of his closed surfaces.

The "literary" versus "pictorial" antithesis which accompanied the American revival of flat-painting esthetics, has blurred the nature of the achievement of the 1903–13 generation of painters in New York. They asserted subject matter while operating within a tradition more sensitive than anywhere else to consistency of convention. Gottlieb, for example, undoubtedly generates the atmosphere of meaning but, in fact, his sets of Pictographs are not transcribable. What he is doing is asserting the human by declaring his art, or Art, to be a symbolizing activity, but the basis of the combinations of signs is his own free associations or painterly improvisation. Gottlieb told me that when he happened to learn of pre-existing meanings attached to any of his pictographs, they became unusable. The signs needed to be evocative, but unassigned. On the other hand, in retrospect, we can see that the Pictographs belong to a definite area of human experience. The forms that recur are sexy, apparitional, tribal, decidedly part of the heritage of Freud and Frazer who set everybody loose in an underworld of common, mysterious symbols.

2. Whitney Museum of Art and the Solomon R. Guggenheim Museum. *Adolph Gottlieb* by Robert Doty and Diane Waldman, 1968.

The main early quotation from Gottlieb reprinted in the Guggenheim-Whitney catalogue is the statement of 1943 to the *New York Times,* signed jointly with Rothko. Six years ago Gottlieb remembered the composition of the letter, thus: Barnett Newman did the introduction and Gottlieb drafted four of the succeeding propositions.[3] The proposition that stressed art's "timeless and tragic" subject matter was Rothko's. It is curious that this statement, probably the first document of the period to become a cliché through overquotation, is presented once again, in preference to other texts fully authored by Gottlieb and not well known at all. In 1944 Gottlieb wrote: "I disinterred some relics from the secret crypt of Melpomene to unite them through the pictograph, which has its own internal logic. Like those early painters, who placed their images on the grounds of rectangular compartments, I juxtaposed my pictographic images, each self-contained within the painter's rectangle, to be ultimately fused within the mind of the beholder." [4] Here are several clues to the Pictographs: archaism, in which cultural artifacts are emblems of the unconscious; a reference to mythology, so explicit that Gottlieb must have looked it up, or come across a reference to the Muse of Tragedy at just the right moment. In addition, there is the notion of the work's "logic" completed by the spectator's perception. The assumption is that the relics with which the painter works are not specialized formal items, but subjects of a common humanity. Thus, the evocative imagery did not have to mean the same, point by point, to Gottlieb and the spectator for it to work. Myth, as the term was used in the 40s, was not a network of one-to-one references, but an oceanic sharing of the imagery of birth and death, desire and terror. On this basis, the spectator's area of legitimate interpretation was somewhat expanded.

The combination of art as human evidence and art as formal structure is expressed admirably in a statement of Gottlieb's in 1951. "I am like a man with a large family and must have many rooms. The children of my imagination occupy the various compartments of my painting, each independent and occupying its own space. One can say that my paintings are like a house, in which each occupant has a room of his own." [5] Artists' statements of the past twenty-five years contain numerous when-I'm-in-my-art type statements, and Gottlieb's is surely a classic for the completeness with which he uses the topics of art as making (the house image) and art as sexual creativity (my "children").

The Pictograph Period enabled Gottlieb to stay as flat as he wanted but, at the same time, for his signs to range between the hieratic and the rawly human. What Gottlieb did, it seems, was to pick up a latent

3. In conversation with the author, 1962.
4. Caption, in Sidney Janis. *Abstract Art and Surrealist Art in America.* New York, 1944.
5. Adolph Gottlieb. *Arts and Architecture.* 68. 9. Los Angeles, 1951.

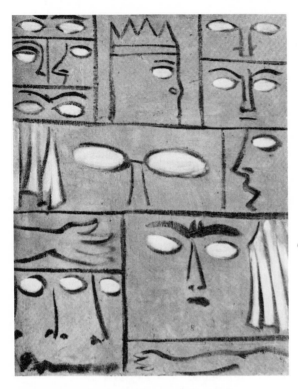

7. Adolph Gottlieb: *Eyes of Oedipus* (1941). Oil on canvas, 32″×25″. Estate of the artist.

8. Adolph Gottlieb: *Return of the Mariner* (1946). Oil on canvas, 20″×24″.

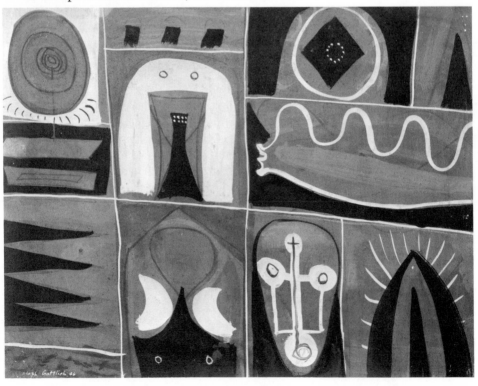

possibility in painting as it existed by the end of the 30s and extend it brilliantly. Paul Klee has been both brought on and put down so often as an influence on the art of the 40s, that it is hard to see his influence objectively at present. The basic point is that Klee's work combined painterly and graphic forms, spatial fusion and sequential ordering, in forms that opened up painting mainly in the direction of mysterious writing (including some interpretation of gesture). It was a third term, because his art was neither abstract nor descriptive. It is Klee's role, as a mixer of sign conventions, that gave him his importance in the 40s, to Gottlieb among others. The Pictographs come with a grid, the uniform divisions of which reduce recessive space and distribute forms equally all over the picture surface. More definitely present than Klee, in terms of physical reminiscences, is Miró; his influence is clear in bright Miró-esque paintings and drawings of the mid-40s incidentally.

The term Pictograph is appropriate for Gottlieb's work, inasmuch as his signs usually stand for objects (eyes, arm, crown, teeth, fish, head). Barnett Newman, on a couple of occasions, opted for the term ideograph in relation to American painting of the 40s, out of a comparable sense of the usefulness of sign systems as an alternative to abstract art and realism.[6] The term Ideograph means signs for ideas and qualities not directly depictable. However, Gottlieb's emphasis on specific objects, of which his paintings of the 40s almost always grittily consist, is a distinction worth preserving. Newman's sense of the ideograph lead into his immediately subsequent formulation of the Sublime. Gottlieb, on the contrary, did not produce "objectless" paintings stylistically relatable to the American Sublime until 1957, when the *Burst* series began.

Eyes of Oedipus, where it all started, has a single ground, milk chocolate in color, crossed by a spare armature bearing laconic and repetitive signs. The eye or eye-and-nose form and hand of the first work persist in *Pictograph* of the following year, but diversified in grouping. *Expectation of Evil* repeats some of the earlier motifs, including the fish with a barbed mouth, but Gottlieb alternates linear signs with details in tonal modelling. *Pendant Image,* one of a dozen that belong to the Guggenheim Museum owing to the Baroness Hilla Rebay, continues Gottlieb's invention of heads in terms of anatomical and biomorphic details, but also, in its wide flowing contours, resembles graffiti. The theme of eyes is stressed in both *Mutable Objects* and *Home of the Magician,* as a single dominant in the former, numerous and scattered in the latter. The eye is a popular multivalent sign: it combines hostility (being watched) and curiosity (identifying with the image);

6. Betty Parsons Gallery, New York. *The Ideographic Picture.* Introduction. Barnett Newman, 1947.

male (investigative) and female (by vaginal analogy). Any of these accessible but amorphous meanings abound in Gottlieb's use of the eye image. If *Home of the Magician* rests, basically, on humor, *Equinoctical Rite* has no ironies about its mythic tone which is derived in part from primitive art, as in the columns of eyes and magic fish. Though his paint, in this case, is nuanced, the marks take on animal or vegetal life with the unquenchable vitality of graffiti. (Note the head with feet in the top row and the Modigliani mushrooms, second down on the right, as typical of Gottlieb's biomorphic cast.) The pictographs of 1949–51 tend to be either rich and textured as in *T,* or hard and bright. In the latter the human drama of the earlier pictographs relaxes, as in *Man Looking at Woman* or *Bent Arrow,* to become an unaffective extension of the clean, hard Miró-esque references of the mid-40s. In retrospect it becomes clear that these years are the end of a period; otherwise extremes of ripeness and crispness could not alternate with such aplomb.

Gottlieb's development has three main phases: the Pictographs, 1941–51; what I propose to call, for the present, his middle period, 1951–57; and his later work, relatable to the Sublime, possibly, from 1957 to date. This rough scheme is not meant to wipe out earlier periods or ancillary groups of work (such as the interesting pastels of 1943, for example, which are omitted from the exhibition), but to indicate a main line. Gottlieb was quoted by Milton Esterow in the *New York Times* as denying that his exhibitions amounted to a retrospective; however, the Guggenheim is showing 1941–56 and the Whitney 1951–66. About forty Pictographs were shown (that is, four for each year he was working in the style), but they were not an adequate sample of the decade. It is a pity, given the scale of the enterprise, that the Gottlieb build-up should have fallen short at this critical point. On the other hand, the period that got doubled up at both museums (1951–56) is his weakest. This is the time when Gottlieb, legitimately bored with ten year's concentration and restraint, opened up flamboyantly into big scale and luxurious color, as in the *Unstill Lifes* and *Imaginary Landscapes.* This period includes, too, the overlapping grids in which layered scaffolding rips up the surface and minces the space created, with excessive animation (as in *Labyrinth III, Trajectory,* and *Blue at Noon*).

For a work to be a Pictograph the imagery must be significant and the whole must be compartmented; from 1949 on these qualities become respectively lighter and looser, until in works like *Archer* and *Tournament* (both 1951) we are in the presence of pseudo-Pictographs. These are large works partaking of the textures and colors of the middle period, examples of a hedonistic texture and monumentality of form which pulverizes the small scale and momentous content of the main 1941–50 paintings.

THE AMERICAN
SUBLIME

In an exhibition catalogue of 1947 *The Ideographic Picture* [1] Barnett Newman declared that art must make "contact with mystery—of life, of men, of nature, of the hard, black chaos that is death, or the greyer, softer chaos that is tragedy." At the time he wrote, art in New York was bound up with myth and primitivism and undoubtedly these themes, manifesting themselves as an interest in archaic writing and primitive sign systems, can be connected with the exhibition. However, Newman stressed the ideological character of signs, rather than their spatial or linear properties. As he put it: "here is a group of artists who are not abstract painters, although working in what is known as the abstract style." This exhibition included work by Newman (*Gea, Euclidean Abyss*), Mark Rothko (*Tiresias, Versal Memory*), and Clyfford Still (*Quicksilver, Figure*). The use of signs in painting was a way of getting free of systems of representation that destroyed the picture plane, but without adopting non-figurative art. In 1947 Newman abandoned his discrete signs and developed a planar style which depended on the whole format of the picture equally. Still appears to have alternated between various possibilities, but one of these styles was certainly a non-linear, strongly planar image, which may be seen as early as 1944. It is stated decisively in, among other works, 1947–48 *W,* a large black painting which was loaned to Rothko soon after it was painted. [2] Rothko thinned his iconography, which in the '40s had moved from classical fragments to submarine biology, and made his first 'empty' pictures in 1949–50. [3] The excess of subject matter which characterized the myth-rakers and ideographers (other paintings in the show were called, characteristically, *The Fury, Astral Figure, Dark Symbol, The Sacrifice*) subsided, leaving

SOURCE: From *Living Arts,* 2 (1963), 11–22.

1. *The Ideographic Picture*. Betty Parsons Gallery 1947.
2. Reproduced as no. 32 in *Paintings by Clyfford Still*. Albright-Knox Art Gallery, Buffalo, 1959.
3. Lawrence Alloway: "Notes on Rothko." *Art International* VI 5–6 1962.

only a deposit of myth on the simpler forms that emerged. A process of purification and magnification had begun.

The bare plane of the canvas was promoted, not to act as the carrier of solid or linear signs but to be a chief structural feature of the painting. Flatness, emptiness, magnitude followed the abandonment of sign-painting and painting-writing. What was retained, however, was a belief in art's power to connect with the human condition, even in the absence of signs to point to it. The artist's decisions, the picture's substantial presence, a format of primal character, a lack of formal variation, resulted in an art that was both pure and expressive. The myth-rakers' influence persisted, though in an underground mode: although the signs vanished the fund of common humanity they had revealed was not denied. The new phase, which transcended the study of signs, can be approached by a comparison with the aesthetics of the sublime.

In 1948 Newman wrote *The Sublime Is Now,*[4] a text of central relevance to his own work and to that of artists with whom he was then connected, Still and Rothko. "The question that now arises is how, if we are living in a time without a legend or mythos that can be called sublime, if we refuse to admit any exaltation in pure relations, if we refuse to live in the abstract, how can we be creating a sublime art?" His answer is that "we are making it out of ourselves, out of our own feelings." He defines the new sublime by a series of rejections. The Greek ideal of beauty has led to "a fetish of quality," instead of to a "relation to the Absolute." "A concern with 'beauty' " is identified by Newman with "a concern with what is 'known.' "[5] The exaltation that he was after could not be found in Greek "perfect form," but was more like "Gothic or Baroque in which the Sublime consists of a desire to destroy form." He rejected the possibility of a sublime art remaining within "the reality of sensation (the objective world . . .)." Thus, the sublime was separated from dependence on the classical, the abstract, or the sensational. On the same occasion Robert Motherwell defined the sublime as something "silent and ordered," in which the artist "transcends his personal anguish." It is opposed to expressionism and to "the beauty and perfection of the School of Paris." The sublime was to be reached, to quote Newman again, by "freeing ourselves of the impediments of memory, association, nostalgia, legend, myth." Rothko rejected "memory, history, or geometry" and Still announced "no outworn myths or contemporary alibis."[6] Though neither of the artists mentioned the sublime as a quality, what they wrote and painted at the time does not

4. "The Ides of Art: Six Opinions on *What Is Sublime in Art?*" Subsequent quotations from Newman are from this source, unless otherwise specified. Robert Motherwell was among the other contributors with "A Tour of the Sublime," which is quoted below. *The Tiger's Eye.* December 15, 1948.

5. *Modern Artists in America,* first series, eds. R. Motherwell, A. Reinhardt, 1951.

6. Mark Rothko: *The Tiger's Eye,* 9, 1949; Clyfford Still: *15 Americans,* Museum of Modern Art, 1952.

deny its relevance. Still's demand that the measure of an artist's great-
ness is "the depth of his insight and his courage in realising his own
vision" [7] is close to what Newman means by the sublime. It is also close
to Longinus' statement that "sublimity is the echo of a noble mind." [8]
J. Benjamin Townsend, in the most informative article on Still, quotes
the artist as saying: "I fight in myself any tendency to accept a fixed,
sensuously appealing, recognizable style"; "I am always trying to
paint my way out of and beyond a facile, doctrinaire idiom." [9]

Newman expressly states that the sublime he is talking about is op-
posed to traditional art. "I believe that here in America, some of us, free
from the weight of European culture, are finding the answer by com-
pletely denying that art has any concern with the problem of beauty and
where to find it." Nevertheless, his version of the sublime can be con-
nected with the 18th-century definition of it, which was also originally
conceived as antithetical to the problem of beauty. (It is not my inten-
tion to make a section of American painting dependent on a phase of
European aesthetics, but to point to an analogy which is useful in char-
acterizing aspects of the work of Newman, Still, and Rothko.) Edmund
Burke [10] separated the sublime both from the pleasures of "the most
learned voluptuary" and from the well-being of the healthy body. Instead
he linked the sublime to "the passions which belong to self-preservation,"
evoking "an idea of pain and danger" reminiscent of the old problem of
taking pleasure in tragedy. (The pairing of art and danger reappears in
statements of Still's, such as "These pictures could be swords slipped
through the belly" or "let no man under-value the implication of this
work or its power for life; or for death, if it is misused." [11]) Burke's in-
tention of taking art away from trivial and sensual causes and basing it
instead on momentous and powerful ones is analogous to Newman's.
Qualities which Burke considered as arousing the sense of the sublime
include "greatness of dimensions," "Vacuity, Darkness, Solitude, and
Silence," and "Infinity." Here is a precedent, not only for the Ameri-
can distrust of Greek form, but also for liking "a rudeness of the
work" (represented by Burke as preferable to "dexterity") which is
opposed to the idea of art as contrivance. This is comparable to New-
man's and Motherwell's rejection of the School of Paris. The links be-
tween Burke's and Newman's sublime are not stylistic. They result
from the desire to put art into relation with "the strongest emotion
which the mind is capable of feeling," to quote Burke. In Newman
this appears as the statement: "we are reasserting man's natural de-

7. Clyfford Still: *15 Americans,* op. cit.
8. Longinus: *On the Sublime* IX 2.
9. J. Benjamin Townsend: "An Interview with Clyfford Still." *Gallery Notes*
XXIV 2. Albright-Knox Art Gallery, Buffalo, 1961.
10. Edmund Burke: *A Philosophical Enquiry into the Origin of Our Ideas of
the Sublime and Beautiful.* 1757. I viii, I xviii, I xi, II ii, II vi, II viii, II xii.
11. Clyfford Still: Statement (typescript). Betty Parsons Gallery 1950; "Paint-
ings by Clyfford Still." Albright-Knox Art Gallery, Buffalo, 1959.

sire for the exalted, for a concern with our relationship to the absolute
emotions." Although Newman does not think particularly highly of
Burke, he does allow that at least Burke "insisted on a separation of
beauty and sublimity," thus clearing the way for the sublime as a
transcendence of notions of beauty.

Still, Newman, and Rothko all paint big pictures. According to Burke
the sublime is caused by an astonishment in which "the mind is so en-
tirely filled with its object, that it cannot entertain any other, nor by
consequence reason on that object which employs it." This idea of an
art of powerful domination of the spectator indicates something of the
effect of the big picture in American art. Burke's description of the
effect of reading sublime passages in poets and orators, "that glorifying
and sense of inward greatness," is relevant here. The importance of the
link between 18th- and 20th-century ideas of sublimity lies in this (sub-
lime as powerful domination, sublime as absolute emotion, sublime as
exaltation) rather than in particular correspondences, though these also
exist. Burke, for example, refers to the sublime as being produced by
"sad and fuscous colors, as black, or brown, or deep purple," [12] and
Newman, in 1945, wrote of "the revived use of the color brown . . .
from the rich tones of orange to the lowest octave of dark browns." [13]

There is another level at which the sublime connects with American
art, but this is of reduced seriousness. This involves us with what
Benjamin T. Spencer has called the Topographical Fallacy, which as-
sumes that the New World's grandeur in scenery would issue in sublimity
of poetic vision and loftiness of style.[14] Connections between an experi-
ence of place and pictorial space have a long history in American
aesthetics. Based on Romantic ideas about organic national qualities in
art, it was believed by promoters of a native style in America in the
19th century, that "the sweep of the prairies, the majesty of the Rockies,"
and the "thunder of Niagara" could not but "issue in sublimity of poetic
vision and loftiness of style." [15] The Continental landscape as the sub-
lime, though embedded in 19th-century thought, persists covertly in
20th-century art criticism. For example, Still has been reported to feel
"that his fluid, often flame-like vertical shapes have been influenced by
the flatness of the Dakota plains"; [16] or "the only possible tie between his
image and the spectator's visual associations is the long, horizonless,
'egocentric' (*sic*) plains of the Midwest and West where Still grew
up." [17] Dore Ashton quoted Baudelaire on George Catlin's "vast savan-

12. Burke, *op. cit.* 11 xiv.
13. Barnett S. Newman: "La Pintura de Tamayo y Gottlieb." *La Revista Belga*
4, 1945.
14. Benjamin T. Spencer: *The Quest for National Identity,* 1957.
15. *Ibid.*
16. *Magazine of Art,* March 1948.
17. *Art News Annual,* 1960.

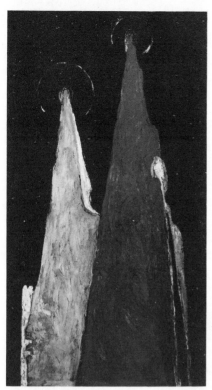

9. Clyfford Still: Untitled (1946). Oil on canvas, 57″ × 33″. Betty Parsons Gallery, New York.

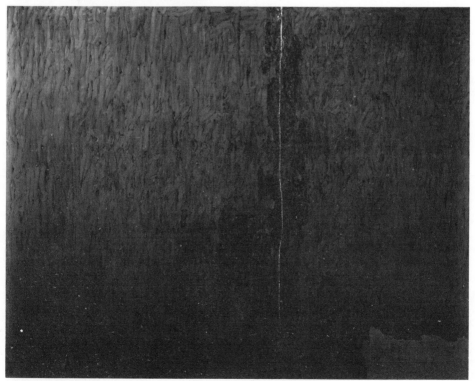

10. Clyfford Still: *Painting* (1951–52). Oil on canvas, 94″ × 82″. Collection, The Museum of Modern Art, New York. Blanchette Rockefeller Fund.

nahs, deserted rivers," and applied it to Still.[18] That the landscape meanings projected onto these big pictures should so consistently use images of the Continental sublime is significant. It does not imply a real link between the land and the art, but, rather, indicates the aesthetic of sublimity being described and half-recognized by its conventional landscape forms.[19] The frequent connection of Rothko's paintings with sunsets of terrific grandeur also records cultural reflexes which continue to identify the sublime with the big country.

Statements made by Rothko in the '40s, though he later regretted them as reductions of silence and freedom, provide background information relevant to his later work. In 1943, for example, he wrote: "only that subject matter is crucial which is tragic and timeless." [20] Two years later he referred to "tragic experience" as "the only source book of art." [21] In 1947 he declared: "both the sense of community and of security depend on the familiar. Free of them, transcendental experience becomes possible." [22] In his early work Rothko referred directly to classical tragedy: for example, the Oresteia trilogy of Aeschylus provided the theme for *The Omen of the Eagle*.[23] Obviously, specific references are neither possible nor wanted in his later work, but the momentous sense of a transcendent experience persists, in a purified way. The pictures of Rothko often have an atmosphere fully in accord with his early declarations about the tragic basis of art. He has spoken of himself as the most violent of all American painters.[24] His "tragedy" is the analogue of Newman's "absolute emotion" and of Still's "total responsibility" for "an unqualified act." [25] The radical simplicity of the art of these three artists is geared to a rigour and autonomy which aim at an imagery of psychic greatness. It is felt, by those who can feel it, through a series of repudiations which makes possible an art of density and silence. This silence is not the cessation of activity, but a

18. *New York Times,* November 15, 1959.

19. Robert Rosenblum was the first writer (after Newman) to revive the term sublime and apply it to American art. He made no use of Newman's article, however, and vitiated his argument, by restricting himself to landscape parallels ("The Abstract Sublime," *Art News* 59 10. 1961). He compared Ward and Still. Turner and Rothko, Turner and Pollock. Earlier ("British Painting vs. Paris." *Partisan Review,* XXIV 1 1957) Rosenblum had more convincingly compared Turner's *Evening Star* with Rothko, and concluded that the star contributed "to nature's infinity" as expressed in the painting, and was therefore crucial to the Romantic spirit of the work. In this way it was unlike Rothko, he pointed out.

20. In a letter to the *New York Times,* June 13, 1943. The letter was signed by Rothko and Adolph Gottlieb. Barnett Newman (who did not sign) and Gottlieb wrote most of the letter, but Gottlieb remembers the "tragic and timeless" bit as Rothko's.

21. Mark Rothko: Personal Statement. Ed. David Porter, 1945.

22. Mark Rothko: "The Romantics Were Prompted": *Possibilities,* 1, 1947–48.

23. Sidney Janis: *Abstract and Surrealist Art in America,* 1944.

24. In conversation, 1958.

25. Clyfford Still: *15 Americans, op. cit.*

web of mysteriously felt potential acts. The artists' negations issue in a declaration of commanding power.

The American sublime, in the form suggested here, involves certain ideas which can be summarized under the headings of artist, physiognomy, and content. First, the artist is defined in idealistic terms, regarded as a hero, with connections to the prophet, the sage and the seer. He is the antithesis of Picasso, whose art is fundamentally diaristic. There is no sense of occasion in the sublime artist, but neither is there a sense of impersonality. To return art to a central role in society is a purpose of these artists. Their work, the succession of their works, the undeviating spirit in which they are created, become a moral model for human action. The work of art does not depict a moral episode, but is itself the product of an intense moral act. Morality, in such a context, means the seriousness and continuity of the creative act. Secondly, the physiognomy of the picture is, typically, a compound of maximum area with minimum diversity. Still, Newman and Rothko painted enormous canvases which were not divisible into smaller areas, but in which the whole work was a single unit. Rothko's frayed rectangles, Still's tattered planes, Newman's wall-like masses combine the huge and the simple. Thirdly, the content of the painting is partly the result of the artist's morality and partly the result of the work's appearance to the spectator as an imperious but mysterious artifact. The subject is non-verbal but deeply human. The artist is not concerned with diversification or elaboration; his concern is the monumentalizing of his own emotion, creating canvases whose vastness, simplicity and clarity are the statement of a personal subject. Uniqueness is born from monotony, drama from privacy. Nothing is more different than two black Stills, two Indian-red Newmans, or two mulberry Rothkos. These works have a minimum of formal characterization, such as oppositions of line against colour, or large and small forms contrasted, and so on. The picture is not a sum of controlled parts, but a single unit which swallows formal differentiations in its creation of a primary statement.

It is through the artist that the sublime is reached. That is to say, the sublime is not an existing category or state which bestows on the artist, if he wins access to it, ready-made aesthetic rewards. The sublime is not the known, but the unknown. On the other hand, it is clear what is not sublime: beauty, mass taste, habit are not. The artist's capacity is the measure of sublimity. It is not the artist's job, however, to decipher celestial riddles. Mystery is shifted from the unseen to the world of work, to the reality of the artist's achievement. A sublime painting is mysterious, but not because it is the image of a higher, hidden reality. It is mysterious because it is a non-utilitarian object, the product of a creative will, and so shaped that it resists the usual terms in which we analyse and discuss works of art. It is absolute, because it is the evidence

of decision and performance; revelation is the property of the original work of art, because we have not seen it before.

Burke suggested [26] that "uniformity" is a cause of the sublime. "If the figures of the parts should be changed, the imagination at every change finds a check; you are presented at every alteration with the termination of one idea, and the beginning of another; by which means it becomes impossible to continue that uninterrupted progression which alone can stamp on bounded objects the character of infinity." Burke's "artificial infinity" is a possible description of the effect of Newman's huge expanses of colour, taller or longer than a man's reach. The big picture that is unified in colour, in which drawing is reduced to modifications rather than interruptions of a single field of colour, gives a sense of grandeur. The spectator's proximity to such a work calls forth the feeling of awe. On another level Newman's titles are clearly clues to the sublime. He has said that "I think it would be very well if we could title pictures by identifying the subject matter so that the audience could be helped." [27] Some of his titles are: *Covenant, Tundra, Dionysus, Prometheus Bound, Eve.*

Elaine de Kooning [28] listed some of the imagery that has been used to describe Rothko's painting: "doorways to hell," "walls of light," "light falling through a fish pond," "lagoons inhabited by vanishing palaces." All these fancy quotations are responses to the spectrum from glow to refulgence which Rothko's colour-washes create. At the same time, they imply by their figurativeness, the subjects which haunt even empty canvases. Light does not fall on objects or areas but is generated by the entire picture. The light source is within the picture, not visibly located, but diffused throughout the whole area. An influence on Rothko is late Bonnard, but there is a fundamental difference between Bonnard's handling of light (which derives from Impressionism) and Rothko's exalted light. The light of Impressionism and its derivatives (except for Monet's late work) was associated with sensations of the terrestrial good life, whereas Rothko's light dismisses the colourful world. In sublime aesthetics, incidentally, colour was associated with beauty, light with sublimity.[29]

Light as a metaphor for illumination (in the sense of revelation) has a different character, and one that is more relevant to Rothko. Neo-Platonic and mediaeval mystics regarded light as the radiant energy of the Creator, and this is closer to Rothko's subject than Impressionism is. Rothko's characteristic effect of light combined with obscurity is an-

26. Burke, *op. cit.* II ix.
27. *Modern Artists in America, op. cit.*
28. Elaine de Kooning: "Two Americans in Action: Kline and Rothko." *Art News Annual,* 1958.
29. Burke, *op. cit.* II vii/viii.

ticipated by Burke when he observes that "extreme light . . . obliterates all objects, so as in its effects exactly to resemble darkness." [30] Rothko's paintings, though filmy and soft-edged, are dense, united by tonal or colour continuities. The avoidance of complementary colours and of black and white contrasts gives his paintings their other-worldly look. The paintings combine the fugitiveness of an after-image with an architectural stability, based on North-South, East-West axes.

Light, as the medium in which we perceive objects, is often regarded atmospherically as a veil. The continual overlays of thin washes in Rothko, which produce his glimmering and flaring lights, are like veils. Veil imagery is traditional in revelatory art. The only way that mysteries can be presented in art, as Pico della Mirandola, for one, argued, is by veils or symbols. The rhetoric of veils and secreted mystery is implicit in Rothko, and is one source of that feeling which his work has of carrying a momentous but illusive subject. It is the peril of veil- and symbol-users that the veil or symbol becomes substantial and beautiful in its own right, thus interposing its form before that of the mystery it is supposed to serve. In Rothko the veils have solidified and become the substance of the mystery. His is an art in which traditional forms of mystery and sublimity have been retained (obliquely, and even subliminally). Radiance and solemnity have an iconography, and Rothko, as a result of his desire for an art of calm and violence ("tranquillity tinged with Terror," to quote Burke) has repossessed certain past themes of art on his own terms.

Modern art has been treated by several generations as a breathless succession of "new" movements, each one hedonistically freed from the past. The past has been primitively identified as merely the goal of appeals to authority, both by "modern" and anti-modern artists and critics. An anthology of such statements would reveal extraordinary monotony. However, history is not simply the authority of a gallery of father-symbols. The past is not a static source of unchanging law, but one half of a dialogue with the present. History is the record of human acts and ideas, displayed in more diverse and complex forms than in any other branch of knowledge. The past is always interpreted according to present knowledge and topical interests; it changes as quickly as our apprehension of the present changes. The records of history are highly responsive to new experience.

By comparing a concept of the sublime formulated in the 20th century with its 18th-century form, therefore, I am not necessarily accommodating the art of the present (in what I take to be its greatest manifestation) with the past. Nor am I enlivening the 18th century by attempting to make it appear topical. Common to both usages is the concept of the

30. Burke, *op. cit.* II xiv.

11. Barnett Newman: *Day Before One* (1951). Oil on canvas, 132″×50″. Oeffentliche Kunstsammlung, Basel.

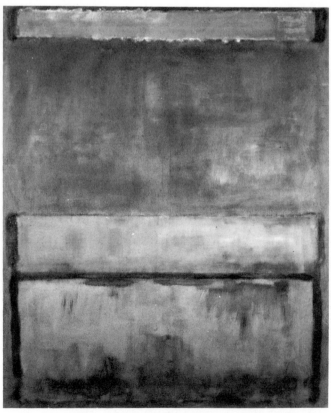

12. Mark Rothko: *No. 9* (1958). Oil on canvas, 99″×82″. Collection of Mr. and Mrs. Donald Blinken, New York.

sublime as part of an expansive, or transcendent, move, with the intention of showing that art could not be contained by an existing, objective canon. The existence of numerous verbal parallels suggests, also, the persistence of the 18th-century form of idea, even as it is being transformed by Newman for use in, and as a response to, a different situation. It is as part of the endless feedback between history and the present that I see the comparison of the 18th century's and our ideas of the sublime.

BARNETT NEWMAN
The Stations of the Cross
and the Subjects of the Artist

Newman did not begin these paintings with The Stations in mind. The first two paintings were done early in 1958 in Brooklyn Heights, where he lived from 1956 to 1958. There was some question in his mind of titling them so that they might constitute a pair, such as Adam and Eve, but he decided against this. Then, as he has said, "I knew I would do more" and in 1960 he painted two, the same size, also in pure black on raw canvas, with comparable phasing of the vertical bands. All four have a solid black left edge and a modulated band, rather more than two-thirds across the canvas, to the right. In the first, plumes of dry brush marks expand around a narrow band; in the second a narrow band is outlined in black and set off-center in a wider grey band; in the third a narrow solid and a narrow plumed band adjoin; and in the fourth a narrow band, freely contoured, is set in a flowing black band. It was after the fourth that he realized the number and meaning of the work on which he was engaged. In December 1961 he exhibited what is still the first painting of the Stations as a single work under the title of *Station.* The work was subsequently reproduced as *The Series, 1,*[1] but there can be no doubt that the Stations theme was now a definite project in Newman's mind.

The discovery of a subject that proposed fixed limits did not mean that Newman could now work easily by filling in a given schema. In 1962 he produced two more paintings, the *Fifth* and *Sixth,* in 1964 three paintings, in 1965 three, and the two final paintings were begun

SOURCE: From Barnett Newman, *The Stations of the Cross: Lema Sabachtani* (New York, 1966), pp. 11–16, the catalogue of an exhibition at the Solomon R. Guggenheim Museum.

1. Cleve Gray. "The Art in America Show," *Art in America, New York,* vol. 49, no. 4, 1961, p. 94.

in 1965 and finished early in 1966. Thus Newman's Stations were ar-
rived at through a process of self-recognition. This fact alone is sufficient
to separate them from commissioned works on the subject in which the
number of Stations and the incidents appropriate to each Station are
clearly known in advance. Newman worked, first, without pre-knowledge
of group or cycle; then, as a result of developing possibilities within the
work itself, he accepted a definition that partially determined the future
course of the series. It became a project, a speculative extension into
the future, demanding paintings for its realization. This method of learn-
ing from the initial stage of work is parallel to the kind of responsiveness
that Jackson Pollock revealed in single paintings. He would make a
mark and then develop or oppose it by other marks until he reached a
point at which he had exhausted the work's cues to him to act further.
Newman has demonstrated the possibility of such awareness operating
not in terms of visual judgment and touch within one painting, but as a
source of structure for a series. A comparable extension of improvisation
beyond the formal limits of the single work occurred in Newman's
lithographs *18 Cantos* which "really started as three, grew to seven, then
eleven, then fourteen, and finished as eighteen." [2]

The production of a series by Newman is an unexpected develop-
ment in his work. Unlike other artists of his generation, given to
numbering their paintings and to production in runs, he has consistently
defined his work by separate titles, a verbal statement of the autonomy
of each work. Newman has observed: "I think it would be very well
if we could title pictures by identifying the subject matter so that the
audience could be helped. I think that the question of titles is purely a
social phenomenon. The story is more or less the same when you can
identify them." [3] Without relegating any of the painting's function to
language he indicates a relation of usefulness between verbal and visual
elements.

The fact that Newman has now painted a series does not, in fact,
dissolve the compactness and solidity on which his earlier work seems
predicated. His art has never been the continuous record of the artist's
life, in which each work records a unique phase of an artist's sensibility.
Under the terms of serial painting the continuity of sequels tends to
override the determinate form of each single work. One problem of
working in serial form is knowing when to stop. The inventiveness,
energy, and, perhaps patience of the artist become the decisive factors.
Motherwell's *Elegies for the Spanish Republic,* for example, are open-
ended; they constitute a series that does not seem to be bound by any
known limits. The proliferation of the series involves us in the person-

2. Barnett Newman. Preface, *18 Cantos. A Volume of Lithographs.* West
Islip, New York, 1964.
3. Robert Motherwell, Ad Reinhardt, eds. *Modern Artists in America.* New
York, 1951, p. 15.

ality of the artist. Newman, on the other hand, in *The Stations of the Cross,* is working with a subject which is personal but regulated by number. Although one cannot link his individual works with particular Stations of the Via Dolorosa, the number fourteen is both an absolute limit and a symbol; more or less than this number would make it impossible to recognize any connections with the declared iconography. Thus Newman's series embodies an order inseparable from the meaning of the work.

The subject of the Stations of the Cross is a late development in Christian iconography. It was not until the seventeenth century that it developed in its modern form, as an expansion of a briefer early theme. From the fifteenth century there are numerous representations of the Way of the Cross, in the form of Seven Falls (a holy number extrapolated from the fullest account of the events in *St. Luke*). These were: Christ carrying the Cross, The First Fall, Christ meets Mary, the Second Fall, Veronica hands Him the face-cloth, The Third Fall, Entombment. In this form Christ, who carries the Cross alone in *St. John,* is aided by Simon and accompanied by a procession, including the grieving women (from *St. Luke*). This theme, with accompanying devotional exercises, spread in Germany, but not elsewhere, in the sixteenth century. Codified in devotional manuals it was doubled in length in the seventeenth century. Pope Innocent XI granted the Franciscans the right to erect Stations in their churches in 1686, and in 1731 Clement XII fixed the number at fourteen. The customary sequence of the Stations is now: Christ condemned to death, Christ carrying the Cross, the First Fall, Christ meets Mary, Simon helps to carry the Cross, Veronica hands Him the face-cloth, the Second Fall, He comforts the women, the Third Fall, He is stripped of His garments, the Crucifixion, the death of Christ, the Deposition, the Entombment.

It may be objected that paintings in which one cannot recognize, for example, Christ condemned to death or Christ carrying the Cross are not Stations of the Cross at all. However, apart from the number symbolism there are other grounds for supporting Newman's title. As Newman said, "the artist's intention is what gives a specific thing form." [4] It is also possible to parallel the paintings with Christ's journey on the basis of an analogy between the events of the subject matter and the event of painting the series. The order of the paintings is the chronological order of their execution. Thus the subject matter is not only a *source* to Newman but, in addition, a parallel with aspects of his own life, so that the original event and the paintings are related like type and antetype in the Testaments. This is an expansion (though on a more ambitious scale than anything earlier) of an idea central to Newman's thought. He has always insisted on the non-functional origins of speech and, hence,

4. Ibid., p. 18.

of art. "The God Image, not pottery, was the first manual act." "What is the explanation of the seemingly insane drive of man to be painter and poet if it is not an act of defiance against man's fall and an assertion that he return to the Adam of the Garden of Eden?" [5] The mythic has always been natural to Newman, not only as the subject matter of paintings but assimilated as analogy, as metaphor, in the creative act itself.

Although obviously Newman's Stations are a radical departure from existing Stations by other artists, there is a fundamental connection between them and traditional iconography. Pilgrims tracing the presumed Via Sacra at the original site, the devout who visited chapels spaced as at Jerusalem (for example the early fifteenth-century series of chapels at the Dominican friary, Cordova) or who followed the sequential displays in Franciscan churches were all engaged in a participative experience. Even the Stations in a church constituted an analogic pilgrimage. The worshipper reduced the historical distance between himself and Christ, or to put it another way, Christ's suffering is eternal. As the Stations are outside the Liturgy they were free to be experienced in terms of spectator participation (as in the dramatic and pathetic paintings of Domenico Tiepolo painted for San Polo, Venice in 1748–49). On the Via Sacra itself, in spatial simulations of Jerusalem, or in condensed sequence, the succession of Stations encouraged identification and parallelism with Christ. The spectator's time and Christ's time coincided. In Newman's Stations what had been the experience of the spectator has become the experience of the artist. Thus the lack of a full panoply of iconographic cues should not allow us to think that Newman's paintings are any fourteen.

Newman has emphasized that he regards the Stations as phases of a continuous agony and not as a series of separate episodes, in which he is basically at one with traditional iconography (although he did not research it beforehand). One consequence of this view is that it would be a serious misreading of the work to consider it in formal terms as a theme and variations. Theme-and-variation readings are applicable neither to the subject matter nor to the restriction of means to black or white paint on raw canvas, because such a form assumes a first statement (giving the theme) accompanied by modifications. In fact, there is no such key to the Stations of the Cross, which have to be experienced as a unit of fourteen continuous parts.

Newman has proposed a modification of traditional iconography beyond that of his reductive imagery.[6] He has added the last words of

5. Barnett Newman. "The First Man Was an Artist." *The Tiger's Eye*, Westport, Conn., vol. 1, no. 1, October 1947, pp. 57–60.

6. One other modification of the form of the Stations is Newman's addition of a fifteenth painting to the group. *Be, II* is a different size and color (solid white field flanked by an orange and a black band). It functions less as a focus, conspicuous because of its differences, than as a supplement; it is a shift and affirmation. It was exhibited earlier under the title *Resurrection* (Allan Stone Gallery

Christ on the Cross, his last words as a man, to the Stations: Lama Sabachtani (to use the King James version, though Newman prefers James Moffatt's version, Lema Sabachthani).[7] To add "My God, my God, why hast thou forsaken me" (or, as Moffatt has it, "My God, my God, why forsake me") is to emphasize the unity of the Passion and, as it were, to replace duration by spreading the climax of the Passion over its earlier phases. Indeed so strong is Newman's sense of the unity of the fourteen paintings that he regards the group as a cry. Christ's question is, as it were, the irreducible human content of the Passion, the human cry which has been muffled by official forms of later Church art. In the four years' gap between the *Fourth* and *Fifth* Stations there is a picture which must be linked with this concept of the series as a cry. This is a big painting *Shining Forth* (*To George*), which is painted in black on raw canvas. A slim band on the left, a wide one in the center, and two frayed tracks of black parted to define a narrow open band on the right, echo elements from the Stations. The painting, as the title declares, is commemorative of the artist's brother who died in February 1961. Thus, a personal experience of death occurred soon after Newman had decided what his theme was to be, a confirmation of the universality of Christ's death.

In 1948, an early date for such a statement, Newman published a text on the sublime, a key document for his own intentions and of central relevance to post-war New York painting. He identified his own work with the sublime which, as an esthetic concept, condenses "man's natural desire for the exalted." [8] Rudolf Otto, in *The Idea of the Holy,* proposes the sublime as "the most effective means of representing the numinous." [9] Influenced by sublime esthetics, as well as by religious tradition, he instances "magnitude," "darkness," "silence," and "emptiness" as sublime. These terms apply, with some precision, to aspects of Newman's work, whereas traditional formal analysis (dealing in the balancing of discrete and contrasted units) does not. In the past this iconographic theme of the Stations has not been the occasion of the works that are usually considered to be the high points of Christian art. Newman's series is not being implicitly backed by a tradition of art and iconography which will feed his own paintings. On the contrary, though the Stations have been important devotionally, the processional requirement usually consigned them to the aisles or columns of churches; serviceable function

1962). It is a link between the human cry and a state of being, between Christ as a man and Christ as God.

7. *The Bible. A New Translation* (by James Moffatt), New York, Harper Brothers, 1935.

8. "The Ides of Art—Six Opinions on *What Is Sublime in Art." The Tiger's Eye,* Westport, Conn., vol. 5, no. 6, December 15, 1948. "The Sublime Is Now," pp. 51–53.

9. Rudolf Otto. *The Idea of the Holy,* Oxford, Oxford University Press, 1923, chapter VII.

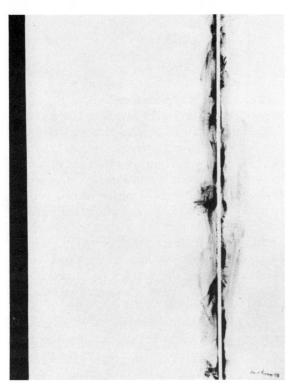

13. Barnett Newman: *First Station of the Cross* (1958). Acrylic on canvas, 78″ × 66″. Estate of the artist.

14. Barnett Newman: *Second Station of the Cross* (1958). Acrylic on canvas, 78″ × 66″. Estate of the artist.

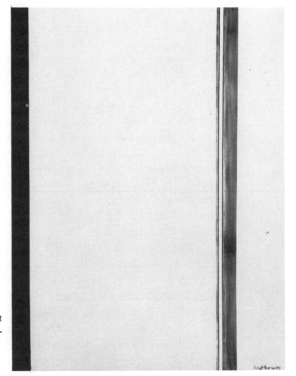

rather than star position (like an altarpiece) was the point. Though Newman is concerned with the Passion of Christ he has taken it in one of its least familiar and least historically prestigious forms.

The celebration of primitive art in the earlier twentieth century assumed a break between modern art and Christian-Hebraic-Classical culture. The affinity of the modern artist and primitive art was used to criticize the complexities and ambivalence of our own tradition in comparison to the primitivist's view of primitive art and culture. Common to Newman and to Northwest Indian or Pre-Columbian artists, about whom he has written, is a concern with the mythic and with cosmogonies. Thus his appreciation of primitive art is part of the same impulse that led him to use Hebraic and Classical titles for his paintings and, now, a Christian theme. Newman can use the Stations of the Cross as a metaphysical occasion, without sacrificing the intimacy and elaboration of our own tradition or the vividness and impact of other tribes' beliefs. In fact, Newman's viewpoint is sufficiently wide, his independence sufficiently rigorous, for him to consider transformations of Renaissance art as well as parallelisms with primitive art. In fact, the form that his continuities take are often more radical than slogans of revolution and change.

Newman, reflecting on the human figure as a subject, observed: "In the art of the Western world, it has always stayed an object, a grand heroic one, to be sure, or one of beauty, yet no matter how glorified, an object nonetheless." [10] Then, a few years later, he used sculpture as an occasion to argue that the hero having become an unusable image, the gestures he once made, as in the Renaissance, must now be made without the support of the body, as an object. "By insisting on the heroic gesture, and on the gesture only, the artist has made the heroic style the property of each one of us, transforming, in the process, this style from an art that is public to one that is personal." [11] Gesture becomes the artist's act, not that of his subject, and in this form is accessible without the particularities of musculature and drapery. Thus, when Newman paints the Stations of the Cross in terms of his gesture, he is taking possession of the traditional theme on his own terms, but these terms include his homage to the original content. His concern with religious and mythical content never delivers an idol but a presence. The presence is one that the artist shares with any evoked hero or god because it is in his work that the presence is constructed and revealed.

The Stations of the Cross is an iconographic theme that requires a serial embodiment in space. (Matisse's Stations in La Chapelle du Rosaire, Vence are exceptional in that the episodes are drawn on one

10. Barnett Newman. Introduction, *Adolph Gottlieb*. Wakefield Gallery, New York, 1944.
11. Barnett Newman. Introduction. *Herbert Ferber*. Betty Parsons Gallery, New York, 1947.

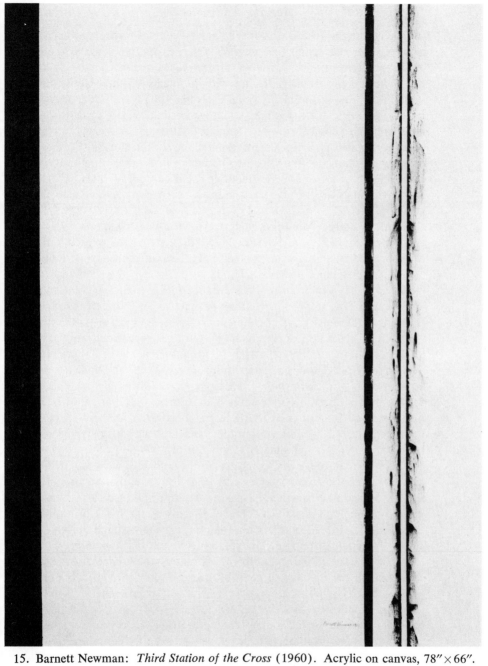

15. Barnett Newman: *Third Station of the Cross* (1960). Acrylic on canvas, 78″ × 66″. Estate of the artist.

surface across the East wall, with the movement of the spectator reduced to a left-right-left reading of numbered scenes.) The spatial structure of the Stations recalls Newman's project for a synagogue in 1963 in which he was necessarily dealing with problems of three-dimensional symbolism. The action of the ritual determines the form of the architecture, so that the worship of the congregation becomes a structure, and not merely an activity within a container. Although Newman's Stations have no obligatory arrangement (something of the flexibility of easel painting is retained), they need to be adajcent, so that repetitions and cross-references can perform identifying and expressive roles. Flexible as the paintings are, their spatial unity, as a group, is essential to their meaning.

Newman's large paintings, such as *Vir Heroicus Sublimis* 1950–51 and *Cathedra* 1951, are relevant here. In a statement written for an early one-man exhibition he stated: "There is a tendency to look at large pictures from a distance. The large pictures in this exhibition are intended to be seen from a short distance."[12] Large, one-color paintings, viewed close up, produce effects of space as magnitude (as external coordinates diminish), of engulfment by color; in short a participative space. This reduction of optimum spectator distance from the work of art is comparable to the reduction of formal elements in his paintings, avoiding diversification and elaboration to preserve the wholistic character of each work. Newman's sense of space explains his great feeling for the Indian Burial Mounds in the mid-West seen in 1949, after he had manifested an interest in working large. It is not that these shapes in the earth initiated his interest, but they coincided with his personal sense of space, simplicity, and the human monument.

The recurrent image in the Stations is of two bands, variously defined, that modulate the field of raw canvas. The canvas is blond in color and slightly flecked and Newman has successfully precipitated the untouched ground into color. It is given color relationally by the black or the white that it carries. In the three white paintings (nine through eleven) the canvas is very different in appearance from the black paintings. The fact that he used oil paint and three different synthetic media reveals his awareness of the function of color in the series, not only in its relational aspects but as a physical property. Different blacks occur from one painting to another and, sometimes, within one painting. Thus the series as a whole, for all its impression of austerity, constitutes a highly nuanced system. Another difference can be seen by comparing a bare black painting, such as the *Fifth Station,* with more extensively covered paintings, such as the *Seventh* or *Thirteenth Station.* The standard size of the series dilates and contracts, rises and falls, according to the proportion and emphasis of the bands. Thus the organization is not

12. Barnett Newman. Typescript written on the occasion of his 1951 exhibition at Betty Parsons Gallery.

restricted to internal divisions of planes and contrasts of forms. All the formal changes, involving as they do areas that cross the total surface, are wholistic in character. It is this largeness and unity in his work, perhaps, that has encouraged notions about the "hypothetical extendability of his areas and bands of color." [13] The Sublime in art may be majestic and vast but this is not the same as continuous and amorphous. Such an idea would link Newman and Mondrian with whose geometry Newman's art demonstrates, in fact, no kinship. Mondrian regarded his lines as bits of a universal grid that ran on beyond the work of art, an image, which, though not literally true, expresses his belief in painting as symbolic of universal order. Though Newman's art raises major issues, of the Passion and Death as in the Stations, for example, he does not do so as the basis of absolutes. Man is the center of Newman's world-picture and it is from man that art originates. Art is, therefore, centrifugal to man and not, as in Mondrian, our glimpse of absolute truth existing separately from us.

13. Walter Hopps. Introduction, U.S. Pavilion catalogue. VIII Biennale, São Paulo, Brazil, 1965.

JACKSON POLLOCK'S
BLACK PAINTINGS

Jackson Pollock's first black painting seems to be *32, 1950*. It is one of a group of classical paintings done that year. The others are *1* (known as *Lavender Mist*), *28, 30* (known as *Autumn Rhythm*), *31* (known as *One*), and a mural in William Rubin's collection. In these works the turbulence of the first drip-paintings is subdued to a coiling equilibrium and the long, narrow formats of the brighter early drips is solidified into large but proportionately traditional rectangles. The disciplined but infinitely varied morphology of *32* established an all-over suspended surface of flowing and branching forms. During the next two years Pollock pursued the use of black with, it seems to me, both a sense of being carried along by the momentum of inventiveness and, at the same time, by an emerging critical spirit which entirely changed the meaning of the later works.

These paintings are frequently described as black and white but this is wrong. In the 1940s there were several artists of Pollock's generation who used black and white, notably de Kooning with his paintings in enamel of 1946–48, Motherwell with his *At Five in the Afternoon,* 1949, the sketch which got escalated into the *Elegies for the Spanish Republic,* and Franz Kline who by 1949 was doing the drawings on which his 1950 black-and-white paintings are based. De Kooning was first, but his works were fairly small; Kline and Motherwell were later, but their paintings were larger. Common to all of them, however, is the fact that they used black *and* white (or, maybe, black and ochre), but never black singly in paintings. Pollock at the time was alone in making one-color black paintings; this is a crucial difference and one that is lost when his work is called "black and white." Only Barnett Newman, in paintings of 1958 and later, seems to have understood the difference between black-and-white paintings and black paintings on raw canvas.

The importance of this distinction can be seen by considering the way

SOURCE: From *Arts Magazine,* XLIII/7 (May, 1969), 40–43.

in which the black paintings of Pollock were executed. Pollock poured black Duco, thinned with turpentine, onto raw canvas, not onto a dead-white canvas. The tools were either sticks or old brushes hardened solid or, according to Lee Krasner Pollock, basting syringes. The paint, though subject to exceptional control, was not applied by touch; the paint impressions that we see were formed by the fall and flow of liquid, in the grip of gravity, onto a surface that was not hard and firm, like a primed canvas, but soft and receptive as sized but unprimed duck. Thus the black, even when applied in a continuous stream, does not produce a strongly directional visual reading. It burrs at the edges as it leaks out into the canvas. The effect is somewhat like photographic enlargements of an etched line, in which the irregularities of the edges turn the contours into sensually fraying thresholds. The black line tends to dilate as a mark rather than to converge upon enclosed areas. Thus what looks like drawing is, in fact, a restrained but pervasive way of painting; the black paintings are concerned with the fusion of color and surface, of paint and field.

This effect has been noticed in the more abstract black paintings, such as *26, 1951,* where the painting is clearly seen to expand laterally into the untouched field of the canvas. It has been harder to recognize this property in many of the other paintings of 1951 owing to the presence of figurative elements. Indeed the iconography of heads, lovers, warriors, has a neoclassic abundance, but, also, a neoclassic inconsequentialness which dissolves the reality of rape or combat. According to Michael Fried, "by 1951 Pollock returned to traditional drawing with a vengeance." [1] He allows that Pollock even here, is less "tactile" than de Kooning, but concludes that Pollock is dealing himself out of the mainstream of (Greenbergian) "modernism." Fried's point is that in the preceding drip paintings, line "is no longer *contour,* no longer the edge of anything." However, a close look at the black paintings shows why Fried is wrong: as a rule, Pollock's iconography is not conveyed by volume-inducing lines. The lines not only have a non-directional property, as they stain out onto the canvas, but the sign-system in use is not one based on the perception of solids and their translation into a two-dimensional system.

The functions of drawing are not restricted to Renaissance-type iconicity of flat signs and volumetric originals. Calligraphy is also a form of drawing, a sign-system with non-solid but referential elements. It should be remembered that the iconography of figures that Pollock used is not an invention of his own, though it seems to have a great source of release and entertainment to him, but consists of clichés. It is an amalgam of Freud and Jung, mythology and Surrealism. He is painting, therefore, absolutely conventional figures, erotic or aggressive or appari-

1. Michael Fried. *Morris Louis,* New York, n.d. p. 20.

tional, so that their delineation could be calligraphic without any sense of losing their spatial existence. Their spatial existence is ideographic not volumetric, so that Fried's notion of a return to contour and edge (implying sculptural solidity) is irrelevant. As signs, as clichés, and as marks, Pollock's black paintings oppose their three-dimensional potential as images.

To see the character of the 1951 period more clearly we might compare two paintings of heads, one from this year and one from 1952 when Pollock's way of using black had changed substantially. The early painting, *10,* has a folkloric reputation as a "self-portrait by Jackson," but there seems to be no more reason to think so than in the case of *Portrait and a Dream,* 1953, the head in which has been described by the artist's widow as "probably a self-portrait." What is noticeable about this image is precisely its lack of subjective echoes; it is clearly a head, but the head seems to arrive without especial drama through the accretion of paint marks. That is to say, the cluster of marks produces an image, not so much as a gesture of self-expression but as a proof of the naturalness of image-making. We project configurations into random objects without difficulty and Pollock seems to be producing his image in a visualisation of this projective process. A head can be made out of anything and here the means is an island of paint marks. Any oval, with some internal emphasis, will turn into a head; this is a kind of primal image-making that Dubuffet, for example, was also interested in. The island-form, however, is not one that we read in terms of solids and voids, projections and recessions, but in terms of flow and of puddling, that is to say, non-volumetrically.

This holds true, too, for most of the paintings of 1951. Consider the four paintings visible in an installation shot of the Betty Parsons Gallery in 1951 when the black paintings were shown. One of the paintings, *3,* is open and fluent, but the other three are dense and impacted with neoclassic (and Mexican mural) iconographic devices. However, even when the forms overlap, as in *22,* the fact that a single matt black is the only substance used reasserts the basically flat structure of the painting. The semi-symmetrical form of *18* is also a part of that search for a primal iconography, a condensed sign-language. The brute fact of symmetry evoked by flowering forms such as these inevitably evokes organism recognition patterns in the viewer. That Pollock was concerned with art as potent signs is proved by earlier drawings in which he quoted rudimentary human figures from rock and cave paintings. Here in the black paintings this interest culminates in a deeply human play with conventions. It is important not to treat the black paintings as if they were really abstract, but at the same time we must try and define the particular use of signs and conventions which underlies his iconography. Its overtly Renaissance look is a screen. It is true, as everybody has pointed out, that the figures are revivals of his

earlier pre-drip paintings, but given, now, a far more complex significative function.

If we compare *10* with *7, 1952,* various differences become immediately apparent. For one thing the sustained fusion of black with the canvas is constantly disturbed. Areas of the painting have been done by hand, thus interrupting the disembodied effect of thin poured paint with physical pressure points, where the brush hit the canvas (which is spattered with studio debris). Also the canvas has been painted on at least two ways up, and the phases of work are left visible as a dichotomy rather than as options. All this introduces, in a way that is unknown in heads of the preceding years (*24, 1951,* is another example), planes that have the abrupt effect of ridges within the head. There is no question here of basic head-or-body schemata emerging from clusters of marks; this head is being painted as a solid body in space. There is no intrinsic objection to this kind of drawing, obviously, but it is true that the kind of drawing Fried located in the work of 1951 can be found in *some* works of 1952. It matters where the division is made: I see the originality of the drip paintings, 1947–50, as extended unexpectedly, brilliantly, and successfully by Pollock through the first year of the black paintings, whereas Fried makes a 1950 cut-off point which I regard as brutally premature.

There is no doubt that the later work of Pollock does not support the long runs of sustained energy and internal development that characterize his mature work. The later work is strained and discontinuous by comparison, which is not to write it off. *7* is typical, in its mingling, not to say grinding together, of pouring and pressure methods of applying paint, of various other later black paintings. Some of the results have high intensity, as in this image, with its sense of expressionist anguish, like a battered hellenistic head. To look back from this tattered image to *10* of the previous year is to move back into a totally coherent style of painting which is fully compatible with the drip paintings of the four preceding years.

There is some reason to indicate the exhibiting history of Pollock's black paintings. They were unveiled at Betty Parsons in 1951 and in the following year some black paintings of 1952 were shown at Janis. In 1955 Janis showed *Echo, 1951,* and in 1958 four 1950–52 paintings belonging to the Pollock Estate. The estate went to Marlborough Fine Art (via David Gibbs) and, between 1961–64, Marlborough toured the estate, including several important black paintings, in Europe and New York. In 1963 Ben Heller could write: "As yet the world has not fully appreciated these canvases," [2] although by then the Stedelijk Museum, Amsterdam, had acquired the biggest of all the black pictures, *32, 1950.*

2. Ben Heller. Introduction. *Black and White.* The Jewish Museum, New York, 1963, unpaginated.

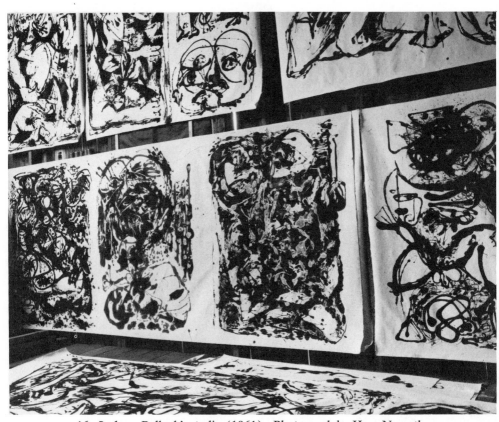

16. Jackson Pollock's studio (1961). Photograph by Hans Namuth.

It is curious, therefore, to find William Lieberman still commenting on "the neglect of the paintings in black and white." [3]

Lieberman records that it was not until the Museum of Modern Art's Pollock retrospective in 1967 that he really dug the black period, though he points out that the Museum had "featured four of the black and white paintings as a group in its exhibition 'New Images of Man.' " Lieberman directed the admirable 1967 show, but I suspect him of doing something that people who work at the Museum of Modern Art habitually do. There is a museum-oriented view of art in which staff members always cite a museum show when another would do as well and if an artist is to be reproduced, the example will always be drawn from the museum's collection (present or future). Instead of building the pictures up the repetition tends to exhaust paintings by over-exposure. Pollock's *1, 1950,* for instance, and de Kooning's *Woman 1* have just about been sun-flowered by over-reproduction and I hope that the history of the black paintings will not get too firmly affixed, unearned, to the museum's exhibition schedule.

3. William Lieberman. Introduction. *Jackson Pollock: Black and White.* Marlborough-Gerson, New York, 1969.

JACKSON POLLOCK'S "PSYCHOANALYTIC DRAWINGS"

Until recently the psychoanalysis of art was restricted to dead artists. In the hands of Freud, retrospective analysis was an extension of the 19th-century idea of art as a means of contact with great minds. For all the distressing symptoms that he detected in Leonardo, Freud's view of artists was essentially old-fashioned and ennobling. Subsequent psychoanalysts possessed neither Freud's tact nor his sense of the continuum of culture, with the result that crude post-mortems on absent heads flourished. One victim, Vincent van Gogh, was analyzed at different times in terms of syphilitic dementia and schizophrenia, of "affective epilepsy" and "epileptic psychosis," aggravated respectively by Oedipal conflict and addiction. No wonder Artaud was driven to proclaim "the good mental health of Van Gogh who, during his whole life in this world we live in, burnt only one hand in addition to cutting off his left ear." Later psychoanalysts have shown themselves to be more sophisticated in terms of art and more sensitive to the human pain of illness. (Martha Wolfenstein, "Goya's Dining Room," *The Psychoanalytic Review*, XXXV [1966].) Validation, however, remains illusory.

In the United States, though not in Europe, we have a situation in which attendance on a psychologist, of one school or another, is common, not to say statistically normal. With such an input of patients, artists must be showing up regularly and, as it happens, the general level of art appreciation has risen, including that of doctors. We ought, therefore, to have the beginning of a literature on the psychoanalysis of live artists, or artists personally known to the analysts who write about them. One sign of this are the so-called "Psychoanalytic Drawings" by Jackson Pollock. (C. L. Wysuph, *Jackson Pollock: Psychoanalytic Drawings* [Horizon Press, 1970].)

SOURCE: From *The Nation* (November 2, 1970), 444–445.

The drawings are from a single source, a doctor whom Pollock consulted for eighteen months in 1939–40. The propriety of this event, a doctor selling a patient's work, is not clear, but it is thirty years since the sessions and fourteen since the artist's death [Pollock died in 1956]. It certainly constitutes a financial gain for the vendor, but it hardly counts as a breach of confidence. Lee Krasner Pollock, the artist's widow, communicated with *The New York Times* (October 16, 1970) about this. "Whether Dr. Henderson has acted properly in disclosing Jackson's communications with him and making his personal psychoanalytic judgment public is a matter about which he must search his own conscience." It must be said that the catalogue is perfectly circumspect, staying well within public knowledge of Pollock's troubles. In a book by Bryan Robertson, countenanced by Mrs. Pollock, there are several references to Pollock's alcoholism, for example, including this sinister apologia: "when he was drunk and unhappy, and involved in trivial bar squabbles, weapons were sometimes thrust into his hand by avid onlookers."

The drawings originally were used to facilitate communication between Pollock and Henderson. Apparently by discussing the drawings with the doctor Pollock could reveal what he had trouble saying straight out. It is a serious shortcoming of the catalogue by C. L. Wysuph that, though he is introducing us to the drawings, he is, at the same time, screening us from their original interpretation. There is a tantalizing reference to "Joseph Henderson, M.D., 'Jackson Pollock: A Psychological Commentary.' Unpublished essay," but only Section II of Mr. Wysuph's essay goes into clinical detail, including five quotes, no more, from the doctor.

According to Wysuph, Henderson diagnosed schizophrenia and the drawings are said to indicate alternations of "violent agitation" and "withdrawal." He is quoted as interpreting a specific drawing (No. 57 in the show) as follows: "these pathetic upper limbs reaching upward toward an unfeeling, purely schematic, female torso, must denote a problem left unsolved and perhaps insoluble, a frustrated longing for the all-giving mother." This is hardly a reduction of Pollock's privacy; it is cliché, not revelation. Mr. Wysuph proposes that Pollock's move, in the late thirties, from an imagery influenced by Midwest and Mexican social art styles toward Surrealism shows that "he must have felt the need to express a more interior reality." However, it is more as if Pollock switched from one set of simple public symbols to another set, equally simple and no less public. Pollock seems to have been familiar with analytical psychology before he went to Henderson, so we have a self-sustaining rapport of Jungian doctor and a predisposed Jungian patient. Indeed, Dr. Henderson admits to a "counter-transference to the symbolic material."

I don't mean that analysis may not have been good for Pollock, but I

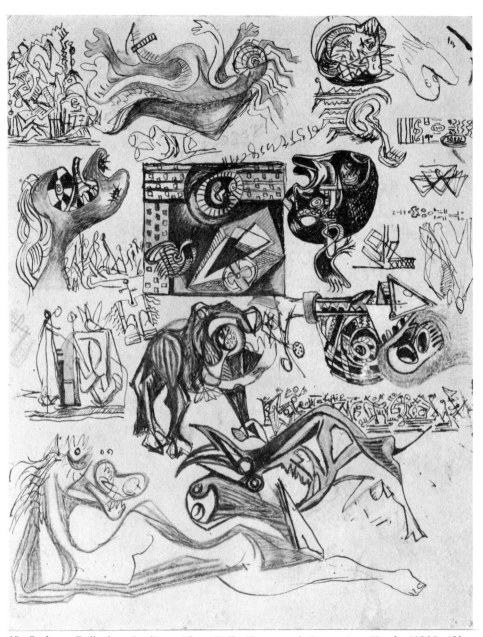

17. Jackson Pollock: *Studies with a Bull, Horse and Screaming Heads* (1939–40). Crayon, colored pencil, pencil, and pen and ink on gray cardboard, 14″×11″. Estate of the artist.

doubt that the drawings done for his analyst are in any sense more expressive, more authentic, than his other work. The weakness of the psychoanalysis of art is that its literature consists of a heap of unrelated and untestable guesses about artists in crisis. Art is assumed to be a source of secret knowledge, an idea related to the 19th-century view of art as self-expression. What Jungian psychology gave to Pollock was an iconography; not a mode of involuntary revelation but a set of mythical figures to use knowingly. Except for his best period, 1948–50, the figures and the animals always inhabit Pollock's paintings as public property of the analyzed generation.

The drawings themselves are interesting as they fill in the outline that was indicated by the previously known sketches of the period belonging to the Pollock estate. The main style is the Mexican version of Cubism, a ponderous meshing of mechanical, totemic and organic form sources, heavily contoured and greasily shaded in crayon. When a lighter scattering of images occurs, there are frequent shreds of Arp, Miró, Henry Moore and Picasso. The drawings are mostly heavy-handed and banal, the work of a man who did not get going as an artist until 1942, at the age of 30. He was, if not exactly a late starter, an awkward one, like other Americans of his generation working in the absence of the support systems now abundant in the art scene.

The future of the psychoanalysis of art seems to lie in work with artists who are nonpatients. Only then will the problem of how an artist views his own work, what his satisfactions are in working, be documented with any precision. Then the aberrant cases usually discussed will have a meaningful field of reference. An example of such work is the series of sessions of Robert Indiana and Dr. Arthur C. Carr, in which the artist provided his free associations to his own paintings. Indiana is an articulate artist and Dr. Carr is a collector (owning a good many early Indianas), as well as a psychiatrist. The match was exceptional and the results illuminating though, at the present time, unpublished. It is clear, however, that discussions of this kind, with nonpatient artists, will reveal more about art than the infatuation with breakdown ever did. In any case, it seems that Pollock, for one, made art that conformed to his doctor's requirements. This is the reason that makes one wish for a fuller use of Henderson's original material, not as news from Pollock's archaic past but as a guide to the artist's later conscious intentions.

WILLEM DE KOONING

It is a curious fact of the New York art world that artists in their 30s don't mind having retrospectives (Rauschenberg and Johns, for instance, at the Jewish Museum), but older artists are very sensitive about it. Exhibitions of artists in the 1903–13 age group, that is to say the men usually called "Abstract Expressionists," are subject to endless qualification. Museum shows of these artists, no matter how extensive, have to be presented as tentative and partial samples of the iceberg, to protect the artist from feelings of completion and exhaustion. The de Kooning exhibition at the Museum of Modern Art [March, 1969] lists 147 items in the catalogue and covers thirty years, but there is the standard warning not to take all this as a retrospective. It is, to quote the catalogue, just "a look at the artist in mid-career." Is "mid-career" honestly the right term for an artist who will be 65 next month?

De Kooning's presence at the Modern, whether one regards the show as a retrospective (which is my inclination) or a glimpse, is the welcome realization of a lengthy project. New York museums have been overusing guest directors for their exhibitions, inviting outside people to arrange shows well within the capacity of their curatorial staffs. However, inviting Thomas B. Hess, editor of *Art News,* to do the de Kooning show was absolutely correct; he not only knows more about the artist than anybody else; he is the only person likely to have persuaded the artist to go through with a big museum show (the Modern had been trying for years). Hess's modesty in the acknowledgements and introduction to his catalogue [*Willem de Kooning* (New York, 1968)] should not deceive anybody as to the centrality of his role.

The catalogue is rich in information about the artist, his work, his life style, his milieu. In a text that has space for the artist's relation with his dealers, however, I miss any discussion of de Kooning's immense influence on young artists in the 1950s. This was either a power play on his part, or a toleration of the role of king when it was pressed on him; whichever it was it calls for discussion. The other lacuna is that Hess is less precise about the flattening of de Kooning's forms in the

SOURCE: From *The Nation* (March 24, 1969), 380–381.

late fifties and early sixties than on any other matters pertaining to the man he regards as "the most important painter at work in the middle of our century."

My experience of the show was very different from my expectation. De Kooning's paintings and drawings, seen in different places, a few at a time, over years, had left me with an image of a painter who possessed a wide range for handling several subjects. Seeing all the work together has the effect of reducing somewhat the gritty particularity of individual paintings and periods. When the paintings are gathered only footsteps apart, not even the confused hanging that is normal at the Modern can blot out an emergent unity. The correspondences that become visible seem more binding than the differences between various periods, though Hess lists fifteen from 1934 to 1965: equivalences grow between black-and-white paintings and the ones in color, between the images of women and the abstractions. Early and late works become symbiotic instead of antagonistic siblings.

Consider the famous paintings of *Women,* 1950–54. I remembered them as plastically solid figures heroically dominating the maelstrom of paint through which they loomed. By comparison, the women painted after 1964 seemed like Fragonard, say, compared to Rubens. In the context of thirty years of work, however, the "Women" that struck one as so violent appear now pretty much in accord with the rest of the painter's work; they are part of a rococo empire. The all-over curve of the line, the scatter of color, are now seen to pulverize the central image, so that the plasticity of the Grand Manner, which once seemed brilliantly preserved, is virtually effaced. Thus the early *Women* are not so different from the soft, shallow paint ripples of the later paintings. In both periods the image is diffused into the picture surface, flattened and gesturized simultaneously. Top patterns of line and floating patches of color are constant.

Criticism of de Kooning has generally dwelt on his art as an open-ended process. To quote Hess: "Joining impossibles is a de Kooning method" and "to finish meant to settle for the possible." The artist is seen to be involved in an existentialist dilemma in which he successfully resists all those forces that reduce the complexity of life to the simplicity of a convention; that is, to art. Still, all de Kooning's revisions and abandonments do issue, ultimately, in paintings. That these bear the signs of sweat and contradiction is evident, but what does this mean in terms of the paintings? His anxiety, struggle, irresolution and abrupt conclusions converge in a style of improvised painterliness. There is no need, when speaking formally about de Kooning, to get involved in the simplistic dialogue between critics who think that painting must be flat and those who think it need not be. We do not have to think in terms

of either de Kooning or Morris Louis. It is not that de Kooning fails to paint flat enough; on the contrary, his forms are always sucked flat against the canvas, as by a powerful vacuum cleaner. His forms are monotonously stuck, squashed, multiplied, and disintegrated across the flat plane of the canvas. To change the metaphor, his flatness has an aggressive and defamatory character, as of insects glued to the windshield of a car.

De Kooning's art is glutted with potential meanings, what Hess describes as his receptivity to "all possibilities." In practice this shows in brush work that is sometimes the record of visual perception, sometimes haptic or mnemonic (as when he draws with his eyes closed), sometimes iconographic (alluding to Rubens' flesh painting or to a pin-up girl's breasts). The surface that results from these multileveled signs tends to be diffuse and disjunctive. The same level of probability is in all the paint marks and this becomes oppressive. Of course, de Kooning is not open to everything. The possibilities that get into his pictures are only the ones that he is aware of and thinking about. He is associational and permissive, which is an attitude, a structure. His art demonstrates a principle that can be compared to disjunctive syntax (poor *but* honest, this *or* that). Of a painting his critics can say: turn the landscape sideways and it's a woman; it's a woman, it's East Hampton, it's paint. De Kooning's color, except when monochromatic, has a similar interchangeability.

He is certainly right to act as if there were no universal system by which his art, or anybody else's, can be regulated. On the other hand, his refusal to accept an arbitrary form or system, however improbable, as a means by which to create art seems to have left him in the air. To be Robinson Crusoe on an island of his own creation from scratch repels him. He seems obsessed by the quest for an authentic self, but is far too sophisticated to embrace a belief that would confer a sense of authenticity on him. He is like a Nietzsche who has read Wittgenstein and had the bad fortune to believe him. Each of his paintings becomes, then, an example of complexity, a cluster of ways to go and of things that might have been, and why not? For all his vigor and wit, de Kooning's position has the effect of making his pictures, early and late, run together in a melee of suspended possibilities which, instead of celebrating freedom, perpetuates indecision.

THE SIXTIES, I
Hard Edge and Systems

Common to these articles on Abstract art after Abstract Expressionism is an idea of order that is in opposition to the assumption that the order in a work of art is the symbol of a larger, possibly universal, order. The decisions of the artist, without external sanction, are taken as the source of order. My intention was to resist the platonic elements that are so strong in early Abstract art theory. I derived the idea of arbitrary order, in part at least, from Norbert Wiener's formulation of order as an improbable form of structure [1] rather than an inherent pattern. By viewing order as personal and arbitrary I felt free to appreciate the internal syntax of art without being restricted to a form of art for art's sake. I viewed formal play as the projection of a particular set of human decisions without the support of absolute beliefs. Whether the unit of work to be examined is an individual painting or an artist's development, the formality discernible is evidence of humanity rather than detachment, of autobiography rather than impersonality.

1. Norbert Weiner, *The Human Use of Human Beings* (orig. ed., 1950; repr. New York, 1969).

LEON POLK SMITH

Leon Smith works in oil paint, unlike most artists interested in using large areas of even color who tend to use acrylic paint. Smith prizes the density of oil paint which he builds up solidly until it is "like a wall," as he says. Acrylic paint, though very neat when used flat, results in a dematerialised image of color. The technique of Smith's, on the contrary, is one that intensifies the weight and, as it were, massiveness of tonally unmodulated color. For the first coat he uses plenty of turpentine as a medium, so that he can work quickly with the liquid paint. From the beginning his decisions about color areas are pretty exact, leading continuously, without major changes, to the final image. The number of coats he lays in varies with the color: for yellows and cadmium reds, three is sometimes sufficient; for blues, somewhat lighter, five coats may be necessary. In these later coats Smith uses oil as the medium, so that the color is firmer and more solid. Successive coats are laid on in different directions, north-south followed by east-west, which has the effect of reducing the presence of the weave of the canvas. It is not effaced on principle so that the color may be pure and imperturbable, but neither is it retained to become, as in much acrylic painting, an integral part of the dye-like paint.

The oil paint in the later coats is sticky enough to retain tracks of Smith's brushwork. This is a point worth stressing because the appearance of brush strokes (the record of pressure and indicators of direction) is a part of Smith's intent. The obvious functions of visible brushwork in abstract art are seismic (feeling expressed *via* touch) and sensuous (a manipulative play with paste). Smith's brushwork, however, is neither expressive nor hedonistic in these senses. The marks, seen within large, even color areas, stress the physicality of the paint, its weight as a substance. This is a means of control for Smith, inasmuch as the perception of large unbroken color areas tends to induce afterimages in the spectator's eyes, and the protracted contact of the edge where the two bright colors meet may appear to oscillate. The brush

SOURCE: From *Leon Polk Smith* (San Francisco, 1968), pp. 3–9, the catalogue of an exhibition at the San Francisco Museum of Art.

marks serve to arrest any drift of these paintings towards a purely optical experience. Visual variation, though natural in such large color surfaces as Smith's, is subdued by the emphasis of the brush; changes in the paint work against changes in the eye. Smith gives the track of the hand a reticent but structural function. He has used oil paint all his working life as an artist and the technique now is so natural to him that he "doesn't have to think about it." He always uses Windsor and Newton oil colors and he takes them straight from the tube (violet and mauve alone have white mixed with them). This factual approach to materials corresponds to his attitude to color, which he keeps as direct as possible within the demands of an art of high-finish.

Smith uses ready-primed canvas, but he makes his own stretchers and he stretches his own canvases. He is an expert in this, including the construction of shaped canvases and the stretching of canvas on double-curved forms, as early as 1959, incidentally. Clearly he decides on the size before he starts to build a stretcher, and we should consider the carpentry as preparatory work, taking the place of the sketches that he does not make. Before the new canvas is touched with paint, Smith knows its dimensions physically and not just in terms of its measurements. He keeps the stretched canvas around for a time, no set period, before he starts to paint, getting used to the proportions of the dazzling white plane. "Sometimes I figure: Oh, should I do anything to it? A well-stretched canvas is very beautiful, just to sit and contemplate." [1] Then he draws on it the line that will be the junction, rather than the border, of the two color areas. The decision is usually an impulsive one, carried out fairly quickly, but based on the exercises of carpentry and contemplation he has already gone through, with the result that not much is changed afterwards. To the extent that the line does need adjustment it is usually done in the first state of the painting, while the paint is light and rather dappled in appearance. Shifts are in the direction of keeping the line animate and equal along its length, often six or seven feet. Without any interruptions of its continuity, accents, favoring one side or the other, are stressed to maintain the line's conciliatory ambiguity.

The fact that Smith takes his color as it comes may be a surprise to some of his admirers who think of color as something handsome in itself, so that a red that works well in a painting might be regarded as the source of its own quality. Actually, this is like admiring the moustache and forgetting the man. Smith does not consider colors one at a time; for him color results from "the relation of proportional amounts." "Any two colors will go together if the proportionate amounts are right." It is his brilliant sense of the relativity of color that is embodied in the

1. Leon Polk Smith and D'Arcy Hayman. "The Paintings of Leon Polk Smith." *Art and Literature,* autumn-winter, Paris, 1964. Quotations from the artist for which no sources are given are from a conversation with the author, March, 1968.

extraordinary two-color paintings on which he has worked since the late 50's. There is no sense of shortage of color in these works which clearly need no more than two to glow or flare. His paired colors never become dualistic; red and blue, black and yellow, green and orange do not contest the canvas. They are not in opposition, so that the spectator confronts an implicit drama of unlike forms and colors dragged into service as symbols. On the contrary, Smith shows that the precept, drawing is a line with two sides (and not, that is to say, merely an object's boundary), is applicable to color, too.

The unified, non-divisive operation of his colors can be related not only to the act of drawing (more like closing a zip-fastener than making an incision), but to other factors. In Smith's tondos of the mid-50's, for example, the circumference frequently generates the internal image, serving as the base for entering curves and converging planes. In *Sun and Moon,* in the present exhibition [1968], the curved stretcher not only provides the actual perimeter, it is the source of the ogee curve that spans the canvas to link top and bottom edges. The support and the surface are bound together as a whole image. In rectangular paintings, too, Smith was impressively early and resourceful in relating the real corners and the ninety degrees turned-over edges of the stretcher to the canvas plateau facing the spectator. His shaped canvases are the systematic end of a spectrum, at the other end of which are his later paintings, where the form is free, not based on the edge but on the field. Equivalences of unlike color areas, balanced by the artist's judgment, replace diagrammatic projections. A reason why Smith is unlikely to raise the number of colors in any one painting should be mentioned here: it would tend to subdivide the painting and return him to a colorist version of the geometric complexities of his early paintings. He does not want the canvas to be, as it is in the geometric art of the earlier 20th century, a container of discrete forms. He wants the painting to have no detachable bits, no movable elements, like the games-board or abacus which geometric paintings often resembled. The reduction to two colors allows greater space for each color and hence an expansion of scale in the painting without the artist being forced to mammoth canvases. More colors, on canvases of the size that he generally uses, would lead, as Smith himself observed, back to "the bunch of little rectangles" of his earlier work.

References to the earlier work of Smith raises a problem that bears not only on his work, but on that of other American painters. To what extent is his later work related to earlier geometric art which was, of course, European in origin? The focus of orthodox geometric art in New York was the American Abstract Artists, a group which Smith never joined, despite chances to do so. Nevertheless, his own early work does have a crucial contact with a pioneer of abstract art. Smith had been interested in Mondrian, whom he regards as "a great painter,"

since 1936 when he saw his work (and Arp's) in the Gallatin Collection. He took, as artists often do, another artist and converted his work into a problem for himself. What Smith aimed for was to "release Mondrian from the rectangle" but without giving up "Mondrian's discovery of the interchangeability of form and space." [2] The exchange of positive and negative space, which Smith learned from Mondrian, contributed, of course, to the later development of Op Art. The discovery of pictorial space as a variable (in which areas exchange dominance) lead in two directions in abstract painting. On the one hand, it produced an art that sought instability and spectator-impact; on the other, it contributed to an art of high economy and unity, in which colors relinquished dominance but did not flicker. Smith's colors are not, as a rule, optically animated. He has spoken of interchangeability (as in positive and negative space relations) in terms which make his position clear: "areas no longer behave as form, but become all space." To get from Mondrian's rectilinear art, based on black and white, to the free form and intense color of Smith's mature work, is a great distance to travel.

During what might be called the problem-solving phase of his development Smith produced a very interesting body of work. Most of the paintings of 1945–52 originated on a grid and in a series of straight-line paintings he replaced Mondrian's right-angled cross-overs of black lines by lines that ran in one direction, say, north-south. These lines, considerably shorter than the upright measurement of the canvas, never over-lapped. However, they touched at the corners; thus, a higher line's lower west corner would touch a lower line's upper east point. This, as Gerald Nordland observed to the artist, sets up implicit obliques that run through the almost open contact points of the forms in what, at first sight, looks like a strongly vertical painting. The meandering or plunging, precipitous or delayed obliques of the paintings in the present show are signalled here.

It was in 1954 that Smith hit on the "way of freeing Mondrian's concept of space so that it could be expressed with the use of the curved line as well as straight." [3] In a catalogue of athletic and sports equipment he chanced on the right stimuli: drawings of a baseball, football, tennis ball, and basketball. The flowing seams on the circular drawings lead to the resolution of his problem. He made various drawings [4] in which he worked out the basis for a continuous space which he then transferred to a series of tondos. After a group of large circular paintings he felt "able to carry this particular space concept, using two

2. Leon Polk Smith. *Statement* (*ca.* 1961). Typescript. Galerie Chalette, New York, 1968.
3. *Ibid.*
4. For a reproduction, see p. 13, Solomon R. Guggenheim Museum. *Systemic Painting.* Introduction. Lawrence Alloway. New York, 1966.

or three forms and two or three colors, over into the rectangle." [5] It is at this point that Smith solved his self-imposed problem; and it is at this point we can indicate an answer to the problem we set ourselves concerning his work's relation to earlier abstract art. (It is noteworthy that the free forms of Smith are not biomorphic; the curves are concrete and non-associative. They derive neither from Arp nor Matisse, who are two sources for large-scale, bright, and highly finished abstract art in New York in the 50's.)

Leon Smith's kind of painting, with a closed surface instead of an open one, an art of the end-state rather than the process-record, is often regarded as the successor to Abstract Expressionism. Clement Greenberg, writing about a group of artists in which Smith was not included, but to which he belonged, stated: "they have not inherited it (the hard edge) from Mondrian, the Bauhaus, Suprematism, or anything that came before." [6] All that he allows in the way of influence is a "hardness" that is to be won "from the softness of Painterly Abstraction." [7] The influence of Abstract Expressionism (or Painterly Abstraction) is present in dilation of scale and intensification of color, but this is not an exhaustive inventory of American abstract artists' backgrounds. What seems to have occurred is that artists interested in geometric art, as Smith was, have radically transformed their point of departure, which is not the same thing as having "inherited" nothing. Smith is, surely, accurate when he regards his art as an extension of earlier geometric art, rather than as a break with it. Perhaps Greenberg fears that Europeans are getting ready to claim as theirs any Americans who admit to European influences. In fact, the uniqueness, or waywardness, of most artists' developments protect them from irrelevant annexation. What could be more original, and less predictable, than Smith's transformation of Mondrian into paintings which have no resemblance to his art?

Smith's art developed out of European geometric art, then, in an entirely original way, and participated in the general expansion of scale of American art. His canvases average man-size when vertical and, by 1960, as in *Black Anthem* in this exhibition, can stretch to ten feet horizontally, a giant step from Mondrian. To have achieved this Smith must have been obsessively driven and, at the same time, critically aware of both European precedent and American experience. The statement by the artist that records his discovery of Mondrian concludes with this note on color: "I grew up in the Southwest where the colors in nature were pure and rampant and where my Indian neighbors and

5. *Op. cit.* Smith. *ca.* 1961.
6. Los Angeles County Museum *Post-Painterly Abstraction*. Text by Clement Greenberg. Los Angeles, 1964.
7. *Ibid.*

relatives used color to vibrate and shock." [8] By 1954, his drawings and
the paintings on circular canvases clearly show his sense of continuous
space. The artist described it as a "curved space which moves in every
direction and when at a particular point a line changes its course you
cannot tell whether it turns right or left, up or down, in or out." [9] This
image of space as a field was made possible by his two-sided drawing
and by the relativity of color in large areas. While he was still working
with geometric forms, he discovered the differences of perception that
exist between each spectator of a work of art. In a painting of repetitive
forms in different primary colors on a gray ground, the gray, though
uniform throughout, changed according to its neighboring color. On a
big scale, Smith uses this variability in his later paintings: the color of a
single blue changes according to the distance of any point from a red
area, and vice versa. The later work thus has its intimation in the
earlier period, though now amplified to coloristic splendor in the *Cor-
respondence* paintings of the last six years. The word "correspondence,"
which Smith uses to preface his titles (as in *Correspondence: White-
Orange*) states clearly the nature of his sense of color and space. While
it is true that he thinks that any two colors will do, they have to be
made to work, by the two-sided line and by judgment of quantity and
intensity of color. What is meant by "made to work" is clarified by that
word "correspondence": the colors have to sustain a subtle equivalence
that functions visually, even as it resists verbal accounting.

In the past four years Smith has found a way to revive intricacy in
his work, without any adulteration of his unified forms. Continuity of
space is maintained over the full surface of the canvas, but the canvases
are joined in groups of three to six. The sets were one-sided at first but
are now usually two-sided. The flow, the oneness, of each canvas is
retained, but they add up to a vigorous parade of his motives. The
tolerance of variables which Smith showed in his use of color is here
extended to include the chance relations caused by side-views. The
panels are hinged to make screens that fold and stand zig-zag on the
ground, as a result of which it is impossible for the spectator in motion
to avoid combinations of head-on and foreshortened views of the panels.
(Smith calls these *Involvements:* because each painting has its own
motive, there are different involvements in each unit.) The jump from
one canvas to the next, they touch at the edge, is abrupt but works
brilliantly to transfer to the group of panels as a whole the diversity of
incident that cannot be contained within one of them. The diversifica-
tion which he properly excludes from his paintings, given the color
usage and the space concept on which they are based, appears in another
way on some screens. One form spans the whole set of panels, such as

8. *Op. cit.* Smith. *ca.* 1961.
9. *Ibid.*

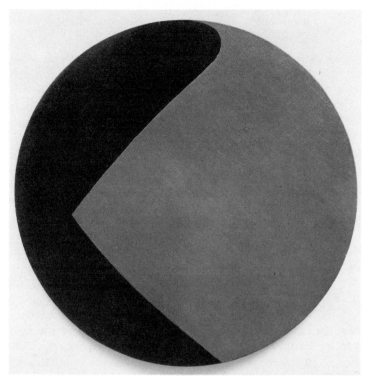

18. Leon Polk Smith: *Black-Gray* (1955). Oil on canvas, tondo, 24″ diameter.

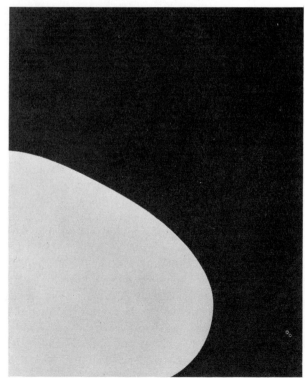

19. Leon Polk Smith: *Correspondence, Red-Black* (1962). Oil on canvas, 33″ × 27″.

a great yellow arc or a huge dark-red rectangle. The angles at which the screens must be placed if they are to stand ensure distortion and, moreover, a distortion recognisable to the viewer as such. Owing to the regularity of the forms, the kinks and gaps produced by hidden sections or sections in steep perspective, involve the spectator in variables, as does the play of light on differently angled surfaces.

Smith's sculpture began in 1961, largely, he thinks in retrospect, through a misunderstanding. In that year he showed a painting in automobile enamel on steel and it was mistaken for a wall sculpture. This led him to 3-dimensional sculpture, such as *Clouds A* and *B* in this exhibition. They are a demonstration of positive and negative exchange, literally; what Smith cut out of one sculpture he used in the other. The forms relate to the earlier tondos in their sense of the encroaching circumference. There is a sculptural potential in structuring the perimeter as there is in his use of metal paint, aluminium, gold, and copper in 1955–56. In the present show a later work *May 20, 1959*, shows his use of silver, and commemorates the artist's birthday, when he happened to finish the painting. That sculpture was not his main interest can be seen by reference to the screens' construction. Their spatial effect is different from that of paintings intended for the wall; standing on the floor, which is the same level at which the spectator is placed, they pull us into a physically participative space. Although the screens might seem to require another technique, Smith asserts that he is a painter, and that a painter can work in three-dimensions without becoming a sculptor. The screens, for all their spatial depth, consist of linked canvases on stretchers.

While he was still engaged in his struggle with Mondrian, Smith gave up certain technical means. He stopped modelling his forms tonally, because it competed with the flatness of the painting and isolated one form from another. In the way that he uses color now, he is still illusionist, but without intercepting the plane of the canvas by isolated forms. Next he reduced texture, not because he has any general objection to it, but because it was an interruption of the kind of space he wanted. Like other Americans of the period, he did not experience any sense of impoverishment at these reductions. On the contrary, he feels that any return to his earlier forms of complexity (subdivision, tonal gradation, multiple elements) would be oppressive. Content is complex when form is simple, for Smith now. This content is neither the color of the Southwest nor the Yin and Yang, to cite two proposals. The content cannot be pinned down by a reference to regional origins or by a philosophical analogy. Any pattern communicates and it is on this basis that we can best view rigorous and non-referential paintings. To confront such work is to be faced with something *new* that has been *made*. Of this we are sure. As such there is a human meaning in the work, as a project, as well as a formal meaning in the visual structure.

Art as human work and art as structure support each other, though they are too often treated separately. It is a particular value of retrospective shows, such as the present exhibition, that an artist's work is displayed in time, for ten years in this case. Thus, without leaving a visual context defined by the artist, we can observe the change of repeated motives and the unity of apparently disparate ones. Without translation into personal or evocative data, the pattern that emerges is highly communicative. To see this work is to see Leon Smith, not in the sense of self-expression, but in the sense that the artist's name is the symbol of a unique structure, achieved by the space of each painting and by his occupancy of history. I have tried to indicate characteristic features of his taut, holistic paintings and of the obstinate and unprecedented development which made them possible.

SYSTEMIC PAINTING

On the cover of the exhibition catalogue *Systemic Painting* was a defini-
tion of "systemic" taken from the *Oxford English Dictionary:* "3. *gen.*
Arranged or conducted according to a system, plan, or organised
method; involving or observing a system." And "system" was defined
in the same source as "a set or assemblage of things connected, associ-
ated, or interdependent so as to form a complex unity; a whole com-
posed of parts in orderly arrangement according to some scheme or
plan." Anatol Rapoport uses the word "systemic" in opposition to
"strategic" ["Systemic and Strategic Conflict," *Virginia Quarterly Re-
view,* XL/3 (1964)], the latter being characterised in Game Theory by
conflicts partly shaped by bluff and psychology, as defined by Von
Neumann. Joseph H. Greenberg [*Essays in Linguistics* (Chicago,
1963)] uses "systemic" to mean "having to do with the formulation and
discovery of rules" in "actually existing sign systems." That part of
linguistics, however, that calls on psychology and the social sciences he
refers to as "pragmatic." In line with these usages, my attempt here
is to provide a general theory, within objective limits, of the uses of
systems by recent abstract artists.

The painting that made American art famous, done mostly in New
York between 1947 and 1954, first appeared as a drama of creativity.
The improvisatory capacity of the artist was enlarged and the mate-
riality of media stressed. The process-record of the creative act domi-
nated all other possibilities of art and was boosted by Harold Rosen-
berg's term Action Painting. This phrase, though written with de
Kooning in mind, was not announced as such, and it got stretched to
cover new American abstract art in general. The other popular term,
Abstract Expressionism, shares with "action" a similar over-emphasis
on work-procedures, defining the work of art as a seismic record of the
artist's anxiety. However, within this period, there were painters who
never fitted the lore of violence that surrounded American art. The

SOURCE: From *Systemic Painting* (New York, 1966), pp. 11–20, the catalogue of
an exhibition at the Solomon R. Guggenheim Museum.

work of Clyfford Still, Barnett Newman, and Mark Rothko was clearly not offering revelatory brushwork with autobiographical implications. Not only that, but an artist like Pollock, who in his own time, seemed all audacious gesture, appears very differently now. His large drip paintings of 1950 have been, as it were, de-gesturized by a few years passing: what once looked like impulsive directional tracks have condensed into unitary fields of color. This all-over distribution of emphasis and the consequent pulverizing of hierarchic form relates Pollock to Still, Newman, and Rothko.

Meyer Schapiro compared the non-expressionistic, non-gestural painting of Rothko to "an all-pervading, as if internalized, sensation of dominant color." [1] Later H. H. Arnason proposed the term Abstract Imagist for those artists who were not expressionist.[2] This is a recognition of the fact that the unity of Action Painting and Abstract Expressionism was purely verbal, a product of generalization from incomplete data. (Obviously, any generalizations are subject to scepticism, revision, and reversal, but these two terms seem especially perfunctory.) It is the "sensational," the "Imagist," painters who have been ratified by the work of younger artists. Dissatisfaction with the expressionist bulk of New York painting was expressed by the number of young painters who turned away from gestural art or never entered it. Jasper Johns' targets from 1955, Noland's circles from late 1958, and Stella's symmetrical black paintings of 1958–59 are, it can now be seen, significant shifts from the directional brushwork and projected anxiety of the Expressionists. Rauschenberg's twin paintings, *Factum I* and *Factum II,* 1957, along with duplicated photographs, included almost identical paint splashes and trickles, an ironic and loaded image. A gestural mark was turned into a repeatable object. The changing situation can be well indicated by the opinions of William Rubin six years ago: he not only deplored "the poor quality of 'de Kooning style painting'," he also assumed the failure of de Kooning himself and praised Clement Greenberg's "prophetic insight" in foreseeing the expressionist cul-de-sac.[3] It is symptomatic that three years later Ben Heller stated, "the widespread interest in de Kooning's ideas has been more of a hindrance than a help to the younger artists." [4] In fact, it was now possible for Heller to refer to "the *post*-de Kooning world" (my italics). In the late 50's de Kooning's example was oppressively accepted and alternatives to it were only fragmentarily visible. There was (1) the work of the older

1. Meyer Schapiro. "The Younger American Painters of Today," *The Listener,* London, no. 1404, January 26, 1956, pp. 146–147.
2. The Solomon R. Guggenheim Museum, New York, 1961, *American Abstract Expressionists and Imagists.* Text by H. H. Arnason.
3. William Rubin. "Younger American Painters," *Art International,* Zurich, 4, 1, January 1960, pp. 24–31.
4. The Jewish Museum, New York, 1963, *Toward a New Abstraction.* Introduction by Ben Heller.

Field painters, (2) the development of stained as opposed to brushed techniques (Pollock 1951, Frankenthaler 1952, Louis 1954), and (3) the mounting interest in symmetrical as opposed to amorphous formats, clear color as opposed to dirty, hard edges as opposed to dragged ones.

Barnett Newman's paintings have had two different audiences: first the compact group of admirers of his exhibitions in New York in 1950 and 1951. Second, the larger audience of the later 50's, with the shift of sensibility away from gestural art. As with any artist who is called "ahead of his time" he has a complex relation with subsequent history. On the one hand he has created his own audience and influenced younger artists; on the other hand, his art was waited for. There was talk and speculation about Newman even among artists who had not seen his work. Newman asserted the wholistic character of painting with a rigour previously unknown; his paintings could not be seen or analyzed in terms of small parts. There are no subdivisions or placement problems; the total field is the unit of meaning. The expressionist element in Still (who signed himself Clyfford in emulation of the Vincent signature of Van Gogh) and the seductive air of Rothko, despite their sense of space as field, meant less to a new generation of artists than Newman's even but not polished, brushed but not ostentatious, paint surface. In addition, the narrow canvases he painted in 1951, a few inches wide and closely related in height to a man's size, prefigure the development of the shaped canvas ten years later. Greenberg, considering the structural principles of Newman's painting in the absence of internal divisions and the interplay of contrasted forms, suggested that his vertical bands are a "parody" of the frame. "Newman's picture becomes all frame in itself," because "the picture edge is repeated inside, and *makes* the picture instead of merely being *echoed*." [5] This idea was later blown up by Michael Fried into deductive structure [6] and applied to Frank Stella's paintings in which the stretcher, as a whole, not just the sides, sets the limits for the development of the surface.[7] Although this idea is not central to the paintings of Newman, it is indicative of his continuous presence on the scene in the 60's that a proposed esthetic should rest, at least partially, on his work.

Alternatives to Abstract Expressionism were not easily come by in the 50's and had to be formulated experimentally by artists on their own. Leon Smith, who had already suppressed modelling and textural varia-

5. Clement Greenberg. "American-Type Painting," *Art and Culture,* Boston, 1961, pp. 208–229.

6. Fogg Museum Art, Harvard University, Cambridge, Mass., 1965, *Three American Painters: Kenneth Noland, Jules Olitski, Frank Stella.* Text by Michael Fried.

7. Deductive structure is the verbal echo and opposite of what William Rubin called " 'inductive' or indirect painting" but the phrase, which meant painting without a brush, never caught on.

tion in his painting, studied in 1954, the stitching patterns on drawings of tennis balls, footballs, and basketballs. These images laid the foundations of his continuous, flowing space, both in tondos, close to the original balls, and transferred to rectangular canvases. In France, Ellsworth Kelly made a series of panel paintings, in which each panel carried a single solid color. There is an echo of Neo-plastic pinks and blues in his palette, but his rejection of visual variation or contrast was drastically fresh, at the time, 1952–53. Ad Reinhardt, after 1952 painted all red and all blue pictures on a strictly symmetrical lay-out, combining elements from early 20th-century geometric art and mid-century Field painting (saturated or close-valued color). These three artists demonstrate an unexpected reconciliation of geometric art, as structural precision, and recent American painting, as colorist intensity. They showed at Betty Parsons Gallery and her adjunct Section Eleven, 1958–61, along with Alexander Liberman, Agnes Martin, and Sidney Wolfson. It is to this phase of non-expressionistic New York painting that the term Hard Edge applies. "The phrase 'hard-edge' is an invention of the California critic, Jules Langsner, who suggested it at a gathering in Claremont in 1959 as a title for an exhibition of four non-figurative California painters," [8] records George Rickey. In fact, Langsner originally intended the term to refer to geometric abstract art in general, because of the ambiguity of the term "geometric," as he told me in conversation in 1958. Incidentally, the exhibition Rickey refers to was called eventually *Four Abstract Classicists*. The purpose of the term, as I used it 1959–60, was to refer to the new development which combined economy of form and neatness of surface with fullness of color, without continually raising memories of earlier geometric art. It was a way of stressing the wholistic properties of both the big asymmetrical shapes of Smith and Kelly and the symmetrical layouts of Liberman and Martin.

Hard Edge was defined in opposition to geometric art, in the following way. "The 'cone, cylinder, and sphere' of Cézanne-fame have persisted in much 20th-century painting. Even where these forms are not purely represented, abstract artists have tended toward a compilation of separable elements. Form has been treated as discrete entities," whereas "forms are few in hard-edge and the surface immaculate. . . . The whole picture becomes the unit; forms extend the length of the painting or are restricted to two or three tones. The result of this sparseness is that the spatial effect of figures on a field is avoided." [9] This wholistic organization is the difference that Field Painting had made to the

8. George Rickey. "The New Tendency (Nouvelle Tendence Recherche Continuelle)", *Art Journal*, New York, 13, 4, Summer 1964, p. 272.

9. See the author's "On The Edge," *Architectural Design*, London, 30, 4, April 1960, pp. 164–165.

formal resources of geometric art.[10] The fundamental article on this phase of the development of systemic painting is Sidney Tillim's early "What Happened to Geometry?", in which he formulated the situation in terms of geometric art "in the shadow of abstract expressionism." [11]

The emerging non-expressionist tendencies were often complimented as Timeless Form's latest embodiment, as in the West Coast group of Abstract Classicists. Jules Langsner defined Abstract Classicism as form that is "defined, explicit, ponderable, rather than ambiguous or fuzzily suggestive," and equated this description with the "enduring principles of Classicism." [12] It is a tribute to the prestige of the Expressionist Action cluster of ideas that it was assumed any artist who did not belong there must, of necessity, be a classicist. Langsner wrote in 1959 but, as late as 1964, E. C. Goossen could refer, when discussing symmetry, to its "underlying classical conventions." [13] Whereas Mondrian and Malevich, in the formative period of their ideas, believed in absolute formal standards, of the kind a definition of Classicism requires, American artists had more alternatives. The 1903–13 generation, by stressing the existential presence of the artist in his work, had sealed off the strategies of impersonality and timelessness by which earlier artists had defined and defended their work. Now, because of the intervening generation of exploratory artists, the systematic and the patient could be regarded as no less idiosyncratic and human than the gestural and cathartic. Only defenders of the idea of classicism in modern life resisted this idea of the arbitrariness of the systemic.

Alexander Liberman produced paintings in which the immaculate finish associated with international geometric art was taken up to a physical scale and fullness comparable to the work of the 1903–13 generation of Americans. The completeness of symmetry, in his paintings of 1950, the random activation of a field without gestural traces in 1953, are remarkably early. A symmetrical and immaculate painting of his was seen at the Guggenheim Museum in 1954, where its total absence of touch was remarked on by, among others, Johns and Rauschen-

10. The formal difference between wholistic and hierarchic form is often described as "relational" and "nonrelational." Relational refers to paintings like that of the earlier geometric artists, which are subdivided and balanced with a hierarchy of forms, large-medium-small. Nonrelational, on the contrary, refers to unmodulated monochromes, completely symmetrical layouts, or unaccented grids. In fact, of course, relationships (the mode in which one thing stands to another or two or more things to one another) persist, even when the relations are those of continuity and repetition rather than of contrast and interplay. (For more information on Hard Edge see John Coplans: "John McLaughlin, Hard Edge, and American Painting" *Artforum,* San Francisco, 2, 7, January 1964, pp. 28–31.)

11. Sidney Tillim. "What Happened to Geometry? An Inquiry into Geometrical Painting in America," *Arts,* 33, 9, June 1959, pp. 38–44.

12. The Los Angeles County Museum of Art, 1959, *Four Abstract Classicists.* Text by Jules Langsner.

13. E. C. Goossen. "Paul Feeley," *Art International,* Lugano, 8, 10, December 1964, pp. 31–33.

berg. Several of Liberman's paintings of this period were designed by him and executed by workmen, an anticipation of much later practice. Here is a real link with Malevich, incidentally, though not one likely to have occurred to Liberman at the time; in Malevich's book *The Non-Objective World,* his Suprematist compositions are rendered by pencil drawings, not by reproductions of paintings. The conceptual act of the artist, that is to say, not his physical engagement with a medium, is the central issue. Ad Reinhardt, after working as a traditional geometric artist, began his symmetrical, one-color paintings in 1953, which darkened progressively through the 50's, culminating in 1960 in the series of identical black squares. His numerous statements, dramatic but flamboyant, in catalogues or even in Action-Painting-oriented *Art News,* were well known. "No accidents or automatism"; "Everything, where to begin and where to end, should be worked out in the mind beforehand"; "No symbols, images, or signs" [14] are characteristic, and prophetic (the date is 1957).

It is not necessary to believe in the historical succession of styles, one irrevocably displacing its predecessor, to see that a shift of sensibility had occurred. In the most extreme view, this shift destroyed gestural painting; in a less radical view, it at least expanded artists' possible choices in mid-century New York, restoring multiplicity. Newman's celebrated exhibition at Bennington College in 1958 was repeated in New York the following year, and the echoes of his work were immense. In 1960 Noland's circles which had been somewhat gestural in handling, became more tight and, as a result, the dyed color became disembodied, without hints of modelling or textural variation. Stella's series of copper paintings in 1961 were far more elaborately shaped than the notched paintings of the preceding year; now the stretchers were like huge initial letters. In 1962 Poons painted his first paintings in which fields of color were inflected by small discs of color; Noland painted his first chevrons, in which the edges of the canvas, as well as the center, which had been stressed in the circles, became structurally important; and Downing, influenced he has said by Noland, painted his grids of two-color dots. In 1963 Stella produced his series of elaborately cut-out purple paintings and Neil Williams made his series of sawtooth-edged shaped canvases. Other examples could be cited, but enough is recorded to show the momentum and diversity of the new sensibility.

A series of museum exhibitions reveals an increasing self-awareness among the artists which made possible group appearances and public recognition of the changed sensibility. The first of these exhibitions was *Toward a New Abstraction* (The Jewish Museum, Summer 1963) in which Ben Heller proposed, as a central characteristic of the artists, "a

14. Ad Reinhardt. "Twelve Rules for a New Academy," *Art News,* New York, 56, 3, May 1957, pp. 37–38, 56.

conceptual approach to painting." [15] In the following year there was *Post Painterly Abstraction* (The Los Angeles County Museum of Art, Spring) in which Clement Greenberg proposed that the artists included in the show revealed a "move towards a physical openness of design, or towards linear clarity, or towards both." [16] Heller and Greenberg, the former no doubt affected by Greenberg's earlier writing, were anti-expressionist. In the fall of 1964 The Hudson River Museum put on a significant though at the time little noticed exhibition of *8 Young Artists,* among them Robert Barry and Robert Huot. E. C. Goossen described the group characteristics as follows: "none of them employs illusion, realism, or anything that could possibly be described as symbolism" and stressed the artists' "concern with conceptual order." [17] Noland occupied half the U.S. Pavillion at the Venice Biennale in 1964 and had a near retrospective at The Jewish Museum in the following year. In the summer of 1965 the Washington Gallery of Modern Art presented *The Washington Color Painters,* which included Noland, Downing and Mehring. Finally, in the spring, 1966 The Jewish Museum put on a sculpture exhibition, *Primary Structures.* This list of museum exhibitions shows that critical and public interest in the early 60's had left Abstract Expressionism, and the main area of abstract art on which it now concentrated can be identified with Clement Greenberg's esthetics.

Greenberg's *Post Painterly Abstraction* was notable as a consolidation of the null-expressionist tendencies so open in this critic's later work. He sought an historical logic for "clarity and openness" in painting by taking the cyclic theory of Wölfflin, according to which painterly and linear styles alternate in cycles. Translated into present requirements, Abstract Expressionism figures as painterly, now degenerated into mannerism, and more recent developments are equated with the linear. These criteria are so permissive as to absorb Frankenthaler's and Olitski's free-form improvisation and atmospheric color, on the one hand, and Feeley's and Stella's uninflected systemic painting as well. It is all Post Painterly Abstraction, a term certainly adapted from Roger Fry's Post-Impressionism, which similarly lumped together painters as antithetical as Van Gogh, Gauguin, Seurat, and Cézanne. The core of Post Painterly Abstraction is a technical procedure, the staining of canvas to obtain color uninterrupted by pressures of the hand or the operational limits of brush work. Poured paint exists purely as color, "freed" of drawing and modelling; hence the term Color Painting for

15. The Jewish Museum, *op. cit.*
16. The Los Angeles County Museum of Art, Los Angeles, 1964, *Post Painterly Abstraction.* Text by Clement Greenberg.
17. The Hudson River Museum, Yonkers, New York, 1964, *8 Young Artists.* Text by E. C. Goossen.

stain painting.[18] It is characteristic of criticism preoccupied with formal matters that it should give a movement a name derived from a technical constituent. The question arises: are other, less narrow, descriptions of post-expressionist art possible than that proposed by Greenberg? It is important to go into this because his influence is extensive, unlike that of Harold Rosenberg (associated with Action Painting), but there is a ceiling to Greenberg's esthetic which must be faced.

The basic text in Greenberg-influenced criticism is an article, written after the publication of *Art and Culture,* but on which the essays in his book rest, called "Modernist Painting." [19] Here he argues for self-criticism within each art, "through the procedures themselves of that which is being criticized." Thus "flatness, two-dimensionality, was the only condition shared with no other art, and so modernist painting oriented itself to flatness." This idea has been elaborated by Michael Fried as a concentration on "problems intrinsic to painting itself." [20] This idea of art's autonomy descends from 19th-century estheticism. "As the laws of their Art were revealed to them (artists), they saw, *in the development of their work,* that real beauty which, to them, was as much a matter of certainty and triumph as is to the astronomer the verification of the result, foreseen with the light given to him alone." [21] Here Whistler states clearly the idea of medium purity as operational self-criticism, on which American formalist art criticism still rests. Whistler typifies the first of three phases of art-for-art's-sake theory: first, the precious and, at the time, highly original estheticism of Walter Pater, Whistler, and Wilde; second, a classicizing of this view in the early 20th century, especially by Roger Fry, stressing form and plasticity with a new sobriety; and, third, Greenberg's zeal for flatness and color, with a corresponding neglect of non-physiognomic elements in art.

What is missing from the formalist approach to painting is a serious desire to study meanings beyond the purely visual configuration. Consider the following opinions, all of them formalist-based, which acknowledge or suppose the existence of meanings/feelings. Ben Heller writes that Noland "has created not only an optical but an expressive art" [22]

18. *Optical* has, at present, two meanings in art criticism. In Greenberg's esthetics color is optical if it creates a purely visual and nontactile space. It is one of the properties of "Color' 'Painting, the term Greenberg applied to Louis and Noland in 1960 (which has been widely used, including adaptions of it such as William Seitz's "Color Image"). It is curious, since color is mandatory for all painting, that one way of using it should be canonized. The other meaning of *optical,* and its best-known usage, is as the optical in Op Art, meaning art that shifts during the spectator's act of perception.

19. Clement Greenberg. "Modernist Painting," *Arts Yearbook,* 4, New York, 1961, pp. 101–108.

20. Fogg Art Museum, *op. cit.*

21. James A. McNeill Whistler. *Ten O'Clock,* Portland, Maine, Thomas Bird Mosher, 1925.

22. The Jewish Museum, *op. cit.*

and Michael Fried calls Noland's paintings "powerful emotional state-ments." [23] However, neither writer indicated what was expressed nor what emotions might be stated. Alan Soloman has written of Noland's circles, which earlier he had called "targets": [24] "some are buoyant and cheerful . . . others are sombre, brooding, tense, introspective," [25] but this "sometimes I'm happy, sometimes I'm blue" interpretation is less than one hopes for. It amounts to a reading of color and concentric density as symbols of emotional states, which takes us back to the early 20th-century belief in emotional transmission by color-coding.

According to Greenberg the Hard Edge artists in his *Post Painterly* exhibition "are included because they have won their 'hardness' from the softness of Painterly Abstraction." [26] It is certainly true that "a good part of the reaction against Abstract Expressionism is . . . a con-tinuation of it," but to say of the artists, "they have not inherited it (the hard edge) from Mondrian, the Bauhaus, Suprematism, or anything that came before," is exaggerating. Since Greenberg believes in evolu-tionary ideas, and his proposal that Hard Edge artists come out of gestural ones shows that he does, it is unreasonable to sever the later artists from the renewed contact with geometric abstract art which clearly exists. If we omit Greenberg's improvisatory painters, such as Francis, Frankenthaler, Louis, and Olitski, and attend to the more systemic artists, there are definite connections to earlier geometric art. Kelly, Smith, and Poons had roots in earlier geometric art, for example, and it is hard to isolate modular painting in New York from interna-tional abstract art. What seems relevant now is to define systems in art, free of classicism, which is to say free of the absolutes which were previously associated with ideas of order. Thus, the status of order as human proposals rather than as the echo of fundamental principles, is part of the legacy of the 1903–13 generation. Their emphasis on the artist as a human being at work, however much it led, in one direction, to autobiographical gestures, lessened the prestige of art as a mirror of the absolute. Malevich, Kandinsky, and Mondrian, in different ways, universalized their art by theory, but in New York there is little reliance on Platonic or Pythagorean mysteries. A system is as human as a splash of paint, more so when the splash gets routinized.

Definitions of art as an object, in relation to geometric art, have too often consolidated it within the web of formal relations. The internal structure, purified of all reference, became the essence of art. The object quality of art is stressed in shaped-canvas paintings, but without a corresponding appeal to idealism. When the traditional rectangle is

23. Fogg Art Museum, *op. cit.*
24. The Jewish Museum, *op. cit.*
25. *XXXII International Biennial Exhibition of Art,* United States Pavilion, Venice, 1964, pp. 275–276. Text by Alan R. Solomon.
26. The Los Angeles County Museum of Art, *op. cit.*

bitten into or thrust outwards, the spectator obviously has an increased consciousness of the ambience. The wall may appear at the center of the painting or intersect the painted surface. Despite the environmental space of the shaped canvas, however, it has also a great internal solidity, usually emphasized by thick stretchers (Stella, Williams). The bulk of the painting is physical and awkward, not a pure essence of art. On the contrary, the contoured edges are highly ambiguous: the balance of internal and outside space is kept in suspense so that there are connections with painting (color), sculpture (real volume and shaping), and craft (the basic carpentry). Shaped canvases tend to mix these possibilities. Another non-formal approach is indicated by Robert Smithson's reaction to Stella's "impure-purist surface," especially the purple, green, and silver series: "like Mallarmé's *Herodiade,* these surfaces disclose a 'cold scintillation'; they seem to 'love the horror of being virgin'." [27] Mallarmé is being quoted, not to take possession of the work in literary terms, but to indicate experiences beyond the eyeball. It is a reminder that shaped blocks of one color have the power of touching emotion and memory at the same time that they are being seen.

Stella's recent paintings (started in the fall of 1965 from drawings made in 1962) are asymmetrical and multi-colored, compared to the symmetrical and/or one-color paintings done since 1958. The change is not a move to a world full of possibilities from one that was constricted. Simplicity is as sustaining in art as elaboration. It is more probable that the new work is prompted aggressively, as a renewal of the problematic, for the style change came at a time when an esthetic for minimal, cool, or ABC art (to which his earlier work is central), was out in the open. The new paintings are a kind of two-level image, with the contoured stretcher providing one kind of definition and the painted forms, cued by the stretcher but not bound to it, making another. Color is bounded by painted bands or by the edge of the canvas, which has the effect of scrambling the spatial levels of the painting. This act of superposition disregards the idea of deductive structure which Michael Fried proposed as the present historical necessity of "modernist" painting in which the painted image is obedient to the shape of the perimeter. Each of Stella's new shaped canvases exists in four permutations, with alternate colors though with fixed boundaries.

Kenneth Noland painted a series of square canvases in 1964, a shape that is more in use now than at any other time in the 20th century. Presumably its non-directional character, with neither east-west nor north-south axes, accounts for its currency. However, Noland, who laid in bars of color parallel to the sides of his squares, was oppressed by the sense of the edge. For this reason he turned the squares 45°, making them diamonds; this led him to the long diamond format, of

27. Robert Smithson. "Entropy and the New Monuments," *Artforum,* Los Angeles, 4, 10, June 1966, pp. 26–31.

21. Frank Stella: *Wolfeboro, II* (1966). Fluorescent alkyd and epoxy paint on canvas, 136″ × 100″.

20. Frank Stella: *"Die Fahne hoch"* (1959). Enamel on canvas, 121½″ × 73″. Collection of Mr. and Mrs. Eugene M. Schwartz, New York.

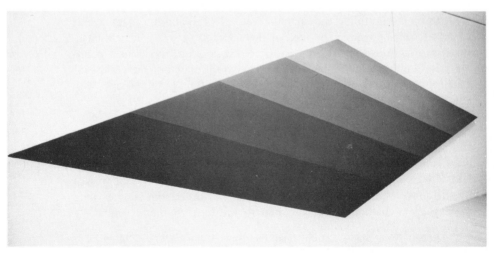

22. Kenneth Noland: *Brown Stretch* (1966). Acrylic on canvas, 84″ × 288″.

which one is in the present exhibition. The points of the diamond are the farthest points from the center, a format which frees Noland from his sense of confinement by the edge. The edge is reduced to a functional oblique, linking the most distant parts of the painting. Thus, the diamond format is not so much a shaped canvas, with consequent connections to the pictorial and to the object-like, but the discovery of a format highly suited to the "disembodied" color effects of staining.

The essentializing moves made by Newman to reduce the formal complexity of the elements in painting to large areas of a single color, have an extraordinary importance. The paintings are a saddle-point between art predicated on expression and art as an object. Newman's recently completed *Stations of the Cross* represent both levels: the theme is the Passion of Christ, but each Station is apparently non-iconographical, a strict minimal statement. Levels of reference and display, present in all art, are presented not in easy partnership but almost antagonistically. When we view art as an object we view it in opposition to the process of signification. Meaning follows from the presence of the work of art, not from its capacity to signify absent events or values (a landscape, the Passion, or whatever). This does not mean we are faced with an art of nothingness or boredom as has been said with boring frequency. On the contrary, it suggests that the experience of meaning has to be sought in other ways.

First is the fact that paintings, such as those in this exhibition are not, as has been often claimed, impersonal. The personal is not expunged by using a neat technique; anonymity is not a consequence of highly finishing a painting. The artist's conceptual order is just as personal as autographic tracks. Marcel Duchamp reduced the creative act to choice and we may consider this its irreducible personal requirement. Choice sets the limits of the system, regardless of how much or how little manual evidence is carried by the painting. Second is the fact that formal complexity is not an index of richness of content. "I am using the same basic composition over and over again," Howard Mehring has said, "I never seem to exhaust its possibilities." [28] A third related point is that most of the artists in this exhibition work in runs, groups, or periods. The work that constitutes such runs or periods is often less outwardly diverse than, say, the work of other artists' periods.

A possible term for the repeated use of a configuration is One Image art (noting that legible repetition requires a fairly simple form). Examples are Noland's chevrons, Downing's grids, Feeley's quatrefoils, and Reinhardt's crosses. The artist who uses a given form begins each painting further along, deeper into the process, than an expressionist, who is, in theory at least, lost in each beginning; all the One Image

28. Leslie Judd Ahlander. "An Artist Speaks: Howard Mehring," *Washington Post,* Washington, D.C., September 2, 1962, p. 67.

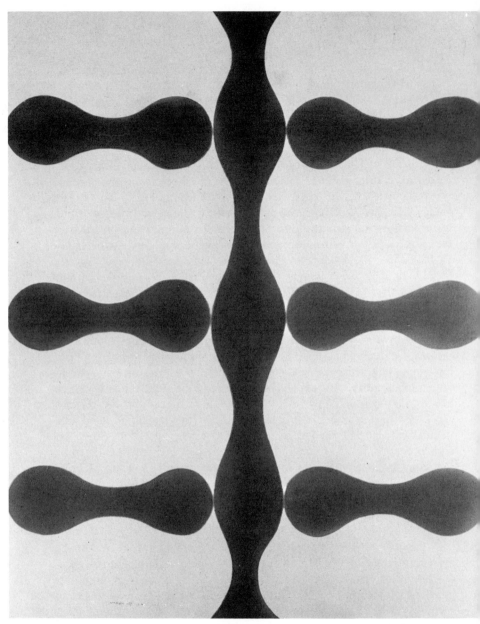

23. Paul Feeley, *Minoa* (1962). Acrylic on canvas, 48″ × 60″.

artist has to have done is to have painted his earlier work. One Image art abolishes the lingering notion of History Painting that invention is the test of the artist. Here form becomes meaningful, not because of ingenuity or surprise, but because of repetition and extension. The recurrent image is subject to continuous transformation, destruction and reconstruction; it requires to be read in time as well as in space. In style analysis we look for unity within variety; in One Image art we look for variety within conspicuous unity. The run of the image constitutes a system, with limits set up by the artist himself, which we learn empirically by seeing enough of the work. Thus the system is the means by which we approach the work of art. When a work of art is defined as an object we clearly stress its materiality and factualness, but its repetition, on this basis, returns meaning to the syntax. Possibly, therefore, the evasiveness about meaning in Noland already mentioned, may have to do with the expectation that a meaning is complete in each single painting rather than located over a run or a set.

The application of the term "systemic" to One Image painting is obvious, but, in fact, it is applied more widely here. It refers to paintings which consist of a single field of color, or to groups of such paintings. Paintings based on modules are included, with the grid either contained in a rectangle or expanding to take in parts of the surrounding space (Gourfain and Insley respectively). It refers to painters who work in a much freer manner, but who end up with either a wholistic area or a reduced number of colors (Held and Youngerman respectively). The field and the module (with its serial potential as an extendable grid) have in common a level of organization that precludes breaking the system. This organization does not function as the invisible servicing of the work of art, but is the visible skin. It is not, that is to say, an underlying composition, but a factual display. In all these works, the end-state of the painting is known prior to completion (unlike the theory of Abstract Expressionism). This does not exclude empirical modifications of a work in progress, but it does focus them within a system. A system is an organized whole, the parts of which demonstrate some regularities. A system is not antithetical to the values suggested by such art world word-clusters as humanist, organic, and process. On the contrary, while the artist is engaged with it, a system is a process; trial and error, instead of being incorporated into the painting, occur off the canvas. The predictive power of the artist, minimized by the prestige of gestural painting, is strongly operative, from ideas and early sketches, to the ordering of exactly scaled and shaped stretchers and help by assistants.

The spread of Pop Art in the 60's coincides with the development of systemic abstract painting and there are parallels. Frank Stella's paintings, with their bilateral symmetry, have as much in common with Johns' targets as with Reinhardt and, if this is so, his early work can

be compared to Yves Klein's monochromes, which were intentionally problematic. The question "what is art?" is raised more than the question, "is this a good example of art?" This skeptical undercurrent of Stella's art, in which logic and doubt cohabit, is analogous to those aspects of Pop Art which are concerned with problems of signification. Lichtenstein's pointillism and Warhol's repetitive imagery are more like systemic art in their lack of formal diversity than they are like other styles of 20th-century art. A lack of interest in gestural handling marks both this area of Pop Art and systemic abstract art. In addition, there are artists who have made a move to introduce pop references into the bare halls of abstract-art theory. One way to do this is by using color in such a way that it retains a residue of environmental echoes; commercial and industrial paint and finishes can be used in this way. For example, Al Brunelle has written of his painting in the present exhibition: "*Jayne* has a blue edge on the left, superimposed upon the underlying scheme. On this side she does not silhouette as brightly as on the right, nor do the edges on left 'track' as they do so nicely within the painting. The blue line does not remedy any of this. It has a function similar to eyeliner." [29] The reference to eyeliner, combined with the "cobra skin" finish, the crystals, and the pink plastic surfaces, raises an association of pop culture that is hard to shake.

Irving Sandler's term for systemic painting, both abstract and pop, is "Cool-Art," [30] as characterized by calculation, impersonality, and boredom. "An art as negative as Stella's cannot but convey utter futility and boredom;" he considers conceptual art as merely "mechanistic." What Sandler has done is to take the Abstract Classicist label and then attack it like a Romantic, or at least a supporter of Abstract Expressionist art, should. He is against "one-shot art" because of his requirement of good artists: "they have to grope." This quotation is from a catalogue of *Concrete Expressionism,* his term for a group of painters including Al Held. He argues that theirs is struggle painting, like expressionism, but that their forms are "disassociated," his term for nonrelational. Thus Sandler locates an energy and power in their work said to be missing from hollow and easy "Cool-Art." The difference between so-called Concrete Expressionist and Abstract Expressionist paintings, however, is significant; they are flatter and smoother. Al Held's pictures are thick and encrusted with reworkings, but he ends up with a relatively clear and hard surface. The shift of sensibility, which this exhibition records, is evident in his work, Held may regard his paintings as big forms, but when the background is only a notch at the picture's margin, he is virtually dealing with fields.

29. Al Brunelle. "The Envy Thing," in *A Pamphlet of Essays Occasioned by an Exhibition of Paintings at the Guggenheim Museum,* New York, 1966.

30. Loeb Student Center, New York University, New York, 1965, *Concrete Expressionism.* Text by Irving Sandler.

The pressing problem of art criticism now is to re-establish abstract art's connections with other experience without, of course, abandoning the now general sense of art's autonomy. One way is by the repetition of images, which without preassigned meanings become the record and monument of the artist. Another way is by the retention of known iconography, in however abbreviated or elliptical form. Priscilla Colt, referring to Ad Reinhardt's basic cross noted: "In earlier paintings it assumed the elongated proportions of the crucifix; in the black squares the pointedness of the reference is diminished, since the arms are equal, but it remains." Colt also notes the expressive connotations of Reinhardt's "pushing of the visible toward the brink of the invisible." [31] Noland's circles, whatever he may have intended, never effaced our knowledge, built-in and natural by now, of circular systems of various types. Circles have an iconography; images becomes motives with histories. The presence of covert or spontaneous iconographic images is basic to abstract art, rather than the purity and pictorial autonomy so often ascribed to it. The approach of formalist critics splits the work of art into separate elements, isolating the syntax from all its echoes and consequences. The exercise of formal analysis, at the expense of other properties of art, might be called formalistic positivism.[32] Formal analysis needs the iconographical and experiential aspects, too, which can no longer be dismissed as "literary" except on the basis of an archaic estheticism.

31. Priscilla Colt. "Notes on Ad Reinhardt," *Art International,* Lugano, 8, 8, October 1964, pp. 32–34.
32. Adapted from Leo Spitzer's "imagistic positivism," by which he deplored literary criticis' overemphasis on imagery at the expense of a poem as a whole.

SERIAL FORMS

The technique of sculpture lends itself to serial production, as the proliferation of casts by, say, Arp, Lipchitz and Moore makes clear. However, serial, in the context of this exhibition, means a great deal more than meeting a market bigger than the supply of unique works of art. Construction as a technique, the use of standard iron or wood elements, is one application. Unlike Russian Constructivism, which validated the declared use of additive structure, but retained ideals of visual differentiation, recent American sculpture has proposed an aesthetic radically unlike garrulously inventive Constructivism.

Bars, slats, boxes, are used in ways that oppose previous expectations of sculpture. Basically the medium has been regarded as the extension of uniquely invented form into three dimensions. Thus the sculptors have felt obliged to invent all-round entertainment for the prowling viewer and this is as true of David Smith as it is of Gabo and earlier sculptors. The use of standard units, in disciplined open arrays, shifts the emphasis away from incident, so that the work becomes a form visibly and continuously structured up and out from the basic unit. Modular-based sculptures, such as LeWitt's or forms in tension, like Snelson's, have this kind of structure in which the unit remains distinct within the aggregate. It should be pointed out, perhaps, that serial imagery in sculpture has nothing to do with a Purist-type homage to industrial production. The line on the wall or the procession on the floor of Judd's boxes have no more semantic cargo than they do formal nuance. They are firm examples of quantitatively rigorous structure.

Serial, then, can be used to refer to the internal parts of a work when they are seen in uninterrupted succession. This is stated almost as principle by Hamrol, whose sculptures consist of jointed identical bars, combinable in various permutations. Instead of creating a rigid structure, he maintains control by anticipating, and limiting, future movement of the parts; however the bars may be shifted they are still

SOURCE: From *American Sculpture of the 60s*, the catalogue of an exhibition at the Los Angeles County Museum (Los Angeles, 1967), pp. 14–15.

within Hamrol's system. One of the chief factors is the sameness of the units. Other artists who do not keep to repetitive identical forms in single works can be considered as serial in another respect. This is when one form is common to a series of distinct but related works; the cross-references are more numerous than those which usually exist in an artist's work of, say, a particular period, because of the reiterated image. (The idea was derived from the work of painters like Noland and Feeley, who preserve a continuous image through long runs of work; my application of it here to sculpture is due to the suggestion of Maurice Tuchman.)

Such image series are not the same as a theme and variations (with a clear major statement accompanied by subsequent elaboration, often becoming frivolous) but, on the contrary, are a succession of moves, all of equal value. Repetition of the non-thematic image or structure in time seems to replace the assumption that a high degree of un-predictable formal play is necessary for every work. In sculpture the luminescent cubes of Bell or the plank sculptures of McCracken are examples of a form perpetuated over a series of works, not because the forms have some Platonic virtue or authority, but because they are adequate to the artists' purposes. This being so, why should artists feel obliged to diversify their works simply in order to prove their command of invention?

McCracken's sculptures, incidentally, each one a smoothly colored fiberglass plank that leans on the wall, could be said to be a witty solution of the problem of space-occupancy in plinth-less sculpture, that is if one regards works of art as answers to questions posed by his-torical process. It is true that I am making assumptions about history as I write. The two senses of serial, as internal repetition and as suc-cessive whole images, are being used to characterize aspects of the artists' work in the exhibition in opposition to some other kinds of sculpture. Thus I am referring to common stylistic features that touch a Coast-to-Coast scatter of artists. My observations are statistical rather than categorical. McCracken, it seems to me, is making a sharp gesture at the center of this trend in current sculpture. The characteristics of legible and unaccented structure with less elaboration and contrast are shared even by those artists who preserve unique parts and views, such as Smith and Gerowitz.

The usages described as serial are part of the present tendency of sculptors, or some of them, towards highly legible forms and systems. Legibility of image and consistency of development are stated as rigor-ous aesthetic principle. Clearly, a many-angled, many-sided closed sculpture is no less visible than a simple, regular solid, but it is less legible, in the sense that it is less easily grasped conceptually as a com-plete form. There is now, often, a suspension of the planar and volumetric transitions within the work, or at least a reduction of the

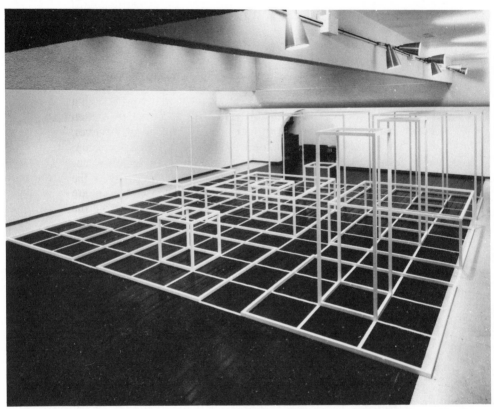

24. Sol LeWitt: *Sculpture Series "A"* (1967). Installation. Dwan Gallery, Los Angeles, California.

sense of transitional flow which characterizes earlier 20th-century sculpture. When a form is known, it can always be seen fairly clearly, no matter how it is viewed (e.g. Morris). Smith's polygons, for example, although not self-explanatory from any one view are not, as a rule, dramatically surprising from the other side.

To classify this kind of sculpture as minimal is perhaps off the mark, because there exists no agreed-upon point of formal and image complexity which is Enough. Because there is no consensus on what is Enough, or Too Much, one cannot accurately characterize these structures as minimal (except as a handy slang label referring to what a number of artists have in common). It is a weakness of "minimal" as a critical term that it assumes, or rather memorializes, a point in time when such work was less than expected. In fact, it must be remembered that forms of this kind sustain variables and complexities, too. LeWitt's lucid right-angled grids, beyond a certain size, take on a labyrinthine potential in our act of perception, if not in our grasp of the governing system. In viewing Smithson's solid stepped forms one hesitates (at least, I do) between sequence and progression, between the steps on each unit and the relation between the units as they change size along the row. The idea of boredom and monotony as the aesthetic experience induced by such works seems to postulate an absolute level of visual animation or entertainment. In fact, the combinatory steps of Andre, with the regular sections making a giant cube in this exhibition, is not boring to me, but a new Calder is. The recognition of frequent events is as appropriate to aesthetics as the shock of surprise, which is what the literature of 20th-century art has dwelt on so much.

To use repeatable forms as a constituent of one work or as a series, in preference to intricate unique forms, is not a recourse by artists to reduced elements. Nothing is simple. For one thing, our continuing contact as spectators with such work replaces blankness and the sense of zero with recognition of purpose. Without wishing to revive an expressionistic notion of art as the personal property of authorship, I want to stress that none of this legible and consistent sculpture is really impersonal. The individuality of the artist is recorded by the population of formal elements in his work and their distributional patterns (even when other people help to fabricate the work).

SOL LEWITT

Sol LeWitt's first reputation was based on the modular sculpture he did in 1965 and thereafter. These open grids of identical parts are logically easy to grasp, but viewed in perspective take on a visual intricacy and flicker from the overlapping of the slender, white-painted wooden or metal bars. As early as 1967 he referred to his kind of work as Conceptual art, meaning "that all of the planning and decisions are made beforehand and the execution is a perfunctory affair. The idea becomes a machine that makes the art." As LeWitt pursued this practice, he made an unprecedented move away from three dimensions into two—unprecedented because sculptors usually protect their notion of volume or physicality with great intensity. The mystique of physical plasticity, for instance, is common to sculptors as different in other respects as Tony Smith, Mark di Suvero and Richard Serra. LeWitt is free of this craftsmanly burden and it is pleasant, like meeting an actor without vanity.

Late in 1968 LeWitt turned to drawing. In a publication known as "The Xerox Book," he took sixteen squares made up of lines running in different directions and worked out twenty-four permutations, changing the pattern of vertical, horizontal and diagonal lines each time. It is a two-dimensional version of the equalized parts of the modular sculpture. In addition, LeWitt made his first two wall drawings, one at a gallery in New York, the other in Los Angeles. The one in New York LeWitt drew himself: two 4-foot squares put directly on the plaster; in Los Angeles, two tiers of twenty-four 4-foot squares were done by assistants, following LeWitt's verbal instructions. Since then most of his work has been in the field of expanded or delegated graphics and two galleries are showing the work at present: at the John Weber Gallery there are big wall drawings (until February 14, [1973]) and at the Rosa Esman Gallery, a selection of drawings, prints and wall drawings (until February 28, [1973]). In effect the wall drawings range from schematic echoes of architectural form, as at Weber, to a kind of wall mist, as at Esman.

SOURCE: From *The Nation* (February 19, 1973), 253–254.

At first, I think, many people had difficulty identifying the regular hatched and cross-hatched shading on the wall, drawn with a hard pencil, as works of art. To quote the artist: "The drawing is done rather lightly, using hard graphite so that lines become, as much as possible, a part of the wall surface, visually." The situation was similar to early exhibitions of the sculpture of Carl Andre: the walls were disconcertingly bare and when the metal plates on the floor were correctly identified, a problem arose about stepping on them or going around. Pale but systematic shading on the plaster wall lay at the threshold of legibility. However, "the conventions of art are altered by works of art," as LeWitt has observed, and now that we know the wall drawings exist they can be seen and estimated.

In art, the pencil is usually identified with preliminary works, sketches for painting and sculpture, or with finished drawings on a fairly small scale. LeWitt has dilated pencil marks to room scale. I presume an influence here of Agnes Martin, whose paintings are often a mixture of paint layers and pencil tracks, the pencil being used to create grids of absolute regularity, except for the tremble of variation that comes from drawing on canvas rather than paper. The sense of a thin, sensitized skin is similar in both artists. She is unique so far as I know for her use of direct pencil marks within full-bodied painting. The combination of the grid image and the promotion of the pencil to major usage suggest some link between Martin and LeWitt, though there is a fundamental difference in that she works on a delimited ground, that of the canvas, and LeWitt on variable fields without regular boundaries.

The wall drawings can be modular or free, but in either case the artist requires a consistent density of the elements, so that the surface of the wall is not dissolved by tonal gradients. The instructions for the wall drawings which LeWitt or other draftsmen follow read like this: "draw 10,000 straight lines three inches long;" or, "vertical lines, not straight, not touching." The simplicity of the program is essential to his intention, because "different draughtsmen produce lines darker or lighter and closer or farther apart. As long as they are consistent there is no preference." The procedure recalls old schoolbooks (I quote from *The Rational Elementary Arithmetic,* 1899): "Draw: A line one inch long. A line twice as long as the first line. A line three times as long as the first line. A line twice as long as the second line. A square with each of its sides the length of the first line." And so on. Some of the wall drawings progress as methodically as that; others, such as the group at the Guggenheim Museum in 1971, are more akin to the improvisation of all-over marks in a Jackson Pollock drip painting. Ironically, this correspondence cuts across the autographic uniqueness that was certainly a part of Pollock's original intention by verbalizing in advance the exact number of lines to be used. However, what

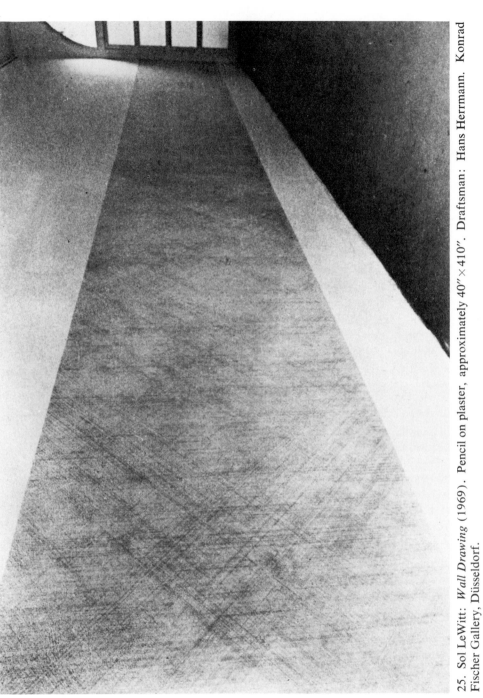

25. Sol LeWitt: *Wall Drawing* (1969). Pencil on plaster, approximately 40″ × 410″. Draftsman: Hans Herrmann. Konrad Fischer Gallery, Düsseldorf.

Pollock accomplished within the drip paintings, the interplay of similar variables, is achieved by LeWitt on the unbounded image fields of walls.

LeWitt emerged as a sculptor at a time when the objectness of sculpture was under much discussion. Donald Judd, the sculptor, wrote art criticism in the early 1960s which emphasized this theme dogmatically, as did an exhibition "The Art of the Real," at the Museum of Modern Art in 1968, in which what was real was the work of art as the sum of its material characteristics. LeWitt's wall drawings, however, subtly corrode the brute concreteness of Primary Structures and Minimal Art theory, not only in their low profile as objects and their ambiguous dilation but in another way. The drawings don't have to be done by LeWitt himself, since the idea is the "machine that makes the art." Thus, provided his ideas are capable of being transmitted and obeyed, he can dominate work done in his absence. In his hands, Conceptual art is executive control.

A characteristic of American postwar art, which has received less attention than it should, is its ostentatious physical presence. The elaboration of facture by the Abstract Expressionists, the stepping up of color by the next generation of Abstract painters, the stress on sculpture's objectness, show three generations of artists all accepting the mutually supportive goals of concreteness and handsomeness. One reason for the primacy of American art at present is quite simply its irresistible, competitive aura. LeWitt is one of the artists (Andre is another) who have withdrawn from this escalation of the object. Whether in his wall drawings or in his drawings on paper, LeWitt confirms the pleasures of the diagrammatic. A diagram is reserved in its physical presence, but it contains a maximum of information. LeWitt subverts the inertial notion of genius by the pertinent fact of consistency. A good example of his factual elaborations is his book *Arcs, Circles and Grids* (Kunsthalle Bern and Paul Bianchin; available from the Weber Gallery), in which these three forms occur in 195 hypnotic combinatory spectacles.

AGNES MARTIN
(with an Appendix)

Two quotations: "Agnes Martin's channels of nuance, stretched on a rack of linear tensions which 'destroy the rectangle' are the legendary examples of an unrepetitive use of a repetitive medium." [1] Thus Lucy Lippard. Robert Pincus-Witten: "Eva Hesse's drawing during 1966–68 emphasized modular and grid arrangements alluding, in this way, to the high regard in which Agnes Martin was held." [2] Martin's reputation is clearly stated here, both her status as legend and the interest of other artists. She ceased to paint in 1967 which did nothing to diminish her high if narrowly based reputation. An exhibition [1973] at the Institute of Contemporary Art, University of Pennsylvania, Philadelphia (which will travel, slightly augmented, to the Pasadena Art Museum), is the first opportunity to see Martin's work extensively, beyond the scale of one-man shows which are restricted in time as well as in size.

The developmental changes within the uniform fields set up by Martin's grids are clear as never before. The first grids, of 1959–62, are marked by a tough, laconic handling of lines and points, often on bare brown canvas. The paintings of 1963–65 reveal an enrichment of color and a smoothing of the surface, as in *Orange Grove* and *Falling Blue,* an extension of range, but with no diminution of Martin's initial rigor. In the paintings of 1966–67 the surface is harder and the grids sharper, coinciding with a move from oil to acrylic paint. This eight-year progress is approximately from rough to rich to systematic, though the systems are there from the beginning and the touch is direct to the end. There is avowed variation in the earlier pieces, different emphases on the dots and dashes, as in *Starlight,* 1962, for example. In later paintings, such as *The Cliff,* 1966, regularity is maintained more strictly,

SOURCE: From *Artforum,* IV/8 (April, 1973), 32–36; from "Letters," *Artforum,* XII/1 (September, 1973), 11.

1. Lucy R. Lippard, "Top To Bottom, Left To Right," *Grids,* Institute of Comtemporary Art, University of Pennsylvania, Philadelphia, 1972.

2. Robert Pincus-Witten, *Eva Hesse,* The Solomon R. Guggenheim Museum, New York, 1972, p. 5.

except in close-up, when the variations of ruled pencil lines on canvas, an uneven surface compared to paper, become evident. The outward variables of the early work become internalized, a part of the technical means of making the painting. The burr of graphite and the shifting placement of the lines are paced like natural irregularities, the currents in water or the wind on a field.

Another source of variation, though not one given autographically, occurs in viewing pictures carrying such sustained regular patterns. The bunching together of many straight lines, parallel or crosshatched, tends to induce larger momentary groupings in the spectator's vision. Thus *The Cliff* tends to display patches of texture when viewed from the side and *Falling Blue* resembles slightly worn corduroy. Suzanne Delehanty's choice of paintings and drawings, from 1957–67, is discriminating and exact. Her hanging, which included 15 of the 72″ × 72″ paintings in the larger gallery of the Institute, and six white paintings in a row in the smaller gallery, was an exemplary demonstration of the way in which hanging like paintings together leads to their individuation.

Martin's works thrive in the absence of opticality. Obviously they are visible, but they function without the rhetorical devices of the paintings that seem to resemble hers. Opticality is the property ascribed to Clement Greenberg-approved painters, the supposed special province of painting as opposed to sculpture or drawing. Opticality can be recognized as an artist's aim by a combination of such properties as intensity of color, the relation of one color to another (which includes acute edge control), and the absorption of positive and negative forms into a unified field. In early *Artforum* criticism these properties were signaled by such words as "modernist," "ambitious," and "advanced." The paintings that did not earn these prized adjectives were retrogressive, provincial, or easy. In Martin's first appearances in New York, at Betty Parsons' Section Eleven [3] in the late '50s, she was associated with Paul Feeley, Alexander Liberman (then Hard-edge), Ad Reinhardt, Leon Polk Smith, and Sidney Wolfson. It became clear later that Martin's place was not really with these painters, all of whom were concerned with painterly effects, either of high color or the fusion of color. The fact that Martin's layouts are symmetrical, however, is not sufficient to align her with the symmetry of early Liberman or with Albers. The "humbleness" and the physicality of her means differ fundamentally from the optical, painterly criteria of the painters with whom she shared a gallery or knew as friends in and around Coenties Slip (she had a studio on South Street from 1957).

3. Section Eleven was an adjunct to Betty Parsons Gallery from 1958 to 1960 (for two seasons, that is to say). Aside from other artists she showed a group of hard-edge painters who characterized the gallery more than contesting trends. Hard-edge meant, originally, the coloristic, post-Abstract Expressionist, extension of geometric painting that took place in the United States in the late '50s.

Judging from Martin's earlier work she did not reach the symmetrical format of her mature work via geometric art. Her early imagery, on the contrary, was soft, free-form, amorphous, and if linear, digressive and irregular. Her works were always attached to a concept of inwardness and even landscape references imply states of mind, psychic spaces. Thus, when in 1957 her imagery became symmetrical it must be presumed to be talismanic and tabletlike in character. Her paintings by this date, although not openly manifesting a grid form, rested on the definition of painting as a sequence of recurrent points or a holistic form with kinship to the form of the canvas itself.

Various precedents exist for her patiently repetitive paintings, such as the small *Islands No. 1,* 1960, or the large *Dark River,* 1961. These include Albers, but Martin avoids his smooth color transparencies, and Ellsworth Kelly, whose one-color panels, 1952–53, could have been seen in his New York studio, near her own. However, his de Stijl-like solid blues and pinks are very different from the roughly drawn marks and bare textures on fine brown canvas, that Martin used. These simple means conferred on her work a craft character which is given as both structure and image. The directness of its making is evident and connotes a kind of virtue; in addition, there are resemblances to sewn or stitched objects and to the sign systems used in crafts, such as the rows of triangles used in several works of 1959–61, which could be American Indian or Romanesque. The closest precedent I can think of is not American, although Albers, Kelly, and John McLaughlin could have directed her thoughts toward holistic rather than contrasting composition. However Mondrian's plus-and-minus drawings of 1915 combine a comparable degree of formalization in the signifiers without losing contact with a signified scene. In Mondrian's case it was the dunes and the sea; in Martin's case it appears to be aspects of landscape that can be schematized by the repetition of identical or similar units. Indicative titles include: *The Beach, Desert, Earth, Field, Garden, Happy Valley, Islands, Milk River, Night Sea, Orange Grove, Wheat, White Stone.* Although these titles are not openly descriptive, they are consistent and have a definite congruence to the visual imagery. The signifieds are all compatible with a notion of the world regarded in terms of synonymous forms and continuous surfaces (as opposed to contrasting forms and divided surfaces). The linear grid of *Song,* 1962, is like an architectural pattern, specifically a Romanesque blind arcade, which is a possible link to Mondrian's interests as well as to those pictures by Mark Tobey in which he takes the forest analogy of Gothic architecture literally as his subject. However, Martin's paintings are resolutely frontal.

The nonopticality of Martin's work withholds it from the canon of end-state color configurations general in the late '50s and '60s. One reason for her ability to resist the prevailing norms of finish and color may have to do with her age. She was born in 1912 and is thus asso-

ciated with the Abstract Expressionists in age, or with Ad Reinhardt, born in 1913, whose position is less with the Abstract Expressionists, with whom he had social ties, than with (earlier) geometric art and (later) Hard-edge. Martin, unlike Reinhardt, retains a manual candor in her work, characteristic of her generation, and, no less characteristic, a belief in the possibility of exalted subject matter. (On this matter Reinhardt was ambiguous: on the one hand, dim cruciform layouts and, on the other, *sec* statements that seem to refer more to the younger abstract painters of the '60s than to his own work.) Technically the surfaces of Martin's paintings are sparse, the marks drawn rather than painted, dabbed on, or ruled, as often in pencil as in paint.

With the establishment of the declared grid, rather than an implicit one as in various works since 1957, Martin achieves her mature style. At first, the grid is used to define an area just within the canvas, a few inches from the edges, with a potential for unitary form that Martin was early to realize in American art. As she draws it, the grid is halfway between a rectangular system of coordinates and a veil. It is put down in pencil, so that the network consists of marks far less clearly given than we are accustomed to in American painting, with its usual standard of impact and unrelieved clarity. Thus the grid, though tight, does not close the surface, but establishes an open plane, identified with the surface of the picture but accumulating sufficient differences to suggest, for all its regularity, a veil, a shadow, a bloom. These early grids are hung inside the canvas, away from the edges, but from about 1964 the area of the grids is extended to the edges of the canvas, making a single undifferentiated tremor of form, or a plateau of nonform, across the whole surface. By removing the internal boundaries of the grid, by which it was seen to stop and start, Martin emphasizes not the succession of the modular bits, but the wholeness of the module, its occupancy of space rather than its duration in time. Accepting the format of the painting (that is, the shape of the ground) as an absolute, as we must be prepared to do in interpreting painters' ideas of space, it is possible to say that Martin's seamless surface signifies, for all its linear precision, an image dissolving. The uninflected radiant fields are without the formal priorities of figure and field or hierarchic ranking of forms and the skinny grids are set in monochrome colors that make visible the shifting gradients of real light across the painting. The effect is of exactness and elusiveness at once.

Martin has pointed out that "my formats are square, but the grids never are absolutely square, they are rectangles a little bit off the square, making a sort of contradiction, a dissonance, though I didn't set out to do it that way. When I cover the square surface with rectangles, it lightens the weight of the square, destroys its power." [4] The grids vary in size, emphasis, and color from one painting to another: in *Park* the

4. Agnes Martin, "Homage to the Square," *Art in America,* July-August, 1967, p. 55.

rectangles are $\frac{5}{16}''$ wide by $1\frac{1}{8}''$ long and in *Desert* they are $\frac{3}{4}''$ wide and $\frac{1}{2}''$ long; the grid in *Park* is drawn in green pencil and that in *Desert* in lead pencil. Max Kozloff pointed out that "the micro-intervals of these works seem to contract upon examination. They hover on the verge of becoming tone, but never lose their porosity." [5] The grid is, of course, a network of uniform elements and Martin does not depart from the stimulus domain,[6] the set of rules by means of which each pattern is constructed, but the whole grid is characterized physically by her way of working. Her pencil lines on canvas, for all their modesty, have an inherent sensuous facture, an irreducible blur beyond the theoretical structure of the grid. A play of irregularizing refinements, which never become deviations from the prescribed system, is set up. The legibility of the system is held, the presence of the module never in doubt, though it supports not only a proposition concerning order but unpredictable physical variations as well.

Martin wrote that: "There's nobody living who couldn't stand all afternoon in front of a waterfall." [7] One of her paintings is called *Falling Blue,* but it is not necessary to assume that the words describe this painting or, conversely, that the painting illustrates these words. However, the experience Martin refers to includes factors of repetition and continuity (the changing water in a stable course) and of motion contracted into timelessness. The synonymic forms that she uses, then, may be analogous to geological strata, a handful of sand, the sun reflected on water, or the planting of a grove. "Nature is like parting a curtain, you go into it," [8] to quote Martin again, which is something that can be said about the quivering space of her own paintings.

There is some reason not to make too much of Martin's nature metaphors, despite her imagery's smoldering evocative power. To quote the artist: "my paintings have neither objects, nor space, nor time, not anything—no forms. They are light, lightness, about merging, about formlessness breaking down form." [9] She concludes the argument aphoristically: "You wouldn't think of form by the ocean." Allowing for the difference between a compact zone, like a painting, and a boundless field, the continuous space of the world, oceans do have form. And endlessness can be connoted by a contained work of art in one of two ways, either by an all-over field or by a grid with a sufficient number of repetitions. A collection of similar bits, beyond easy counting, implies infinity; that is why the internal area of a Martin painting can seem so highly expansive. It is clear that in her paintings the parts are submitted to the larger structure that the picture constitutes as a whole.

5. Max Kozloff, "Art," *The Nation,* November 14, 1966.
6. D. W. J. Corcoran, *Pattern Recognition,* Baltimore, 1971, p. 55.
7. Agnes Martin, quoted by Ann Wilson, "Linear Webs," *Art and Artists,* London, October, 1966, p. 48.
8. *Ibid.*
9. *Ibid.*

Thus the painting is an image of wholeness and this not merely a demonstration of formal completeness but a symbolic value as well. The unitary system of the picture becomes expressive of stability, fullness, and completeness as subject matter. The form of the painting itself becomes, to use E. H. Gombrich's phrase, "a visual metaphor of value." [10] To quote Martin again: "Walking seems to cover time and space but in reality we are always just where we started." [11] When one looks at a legible and sustained module, it can be said that one part predicts the other parts. This is true in the case of Martin, but the image of walking without progress is a clue to the reading of her grids in another way. One section of the grid or one row of it is locked into the others so that we get not an effect of succession (prediction and confirmation), but of an invariant pattern divulged all at once. The effect is not of simultaneity, which is too sharp a word, but of arrested movement revealed; the grid is still because the whole can be grasped by the eye and the mind at once.

Martin, in a manuscript note, writes: "Everyone recognizes the nature pattern of unequal and contesting parts. Classicism forsakes the nature pattern." [12] In another place she writes a poem:

> The underside of the leaf
> Cool in shadow
> Sublimely unemphatic
> Smiling of innocence
>
> The frailest stems
> Quivering in light
> Bend and break
> In silence

She comments on it: "This poem, like the paintings, is not really about nature. It is not what is seen. It is what is known forever in the mind." [13] This view is not incompatible with the nature imagery that I see in her work, because nature as "unequal and contesting" is one thing and landscape images cultivated by mental laws, which is the area of Martin's iconography, are something else. The value that she places on what is "known" rather than "seen" suggests innate ideas, which she sometimes calls "a memory of perfection." "Although I do not represent it well in my work, all seeing the work, being already familiar with the subject, are easily reminded of it." [14] Thus, the esthetic cri-

10. E. H. Gombrich, "Visual Metaphors of Value in Art," *Mediations on a Hobby Horse,* Greenwich, Connecticut, 1963, pp. 12–29.
11. Agnes Martin, unpublished notes, Institute of Contemporary Art, University of Pennsylvania, Philadelphia.
12. *Ibid.*
13. *Ibid.*
14. *Ibid.*

terion of wholeness has the function of confirming preexisting patterns in the mind. In another of her manuscript notes, one entitled "Response to Art," she has this to say of the relationship of artist and spectator:

The cause of the response is not traceable in the work. An artist cannot and does not prepare for a certain response. He does not consider the response but simply follows his inspiration.

Works of art are not purposely conceived. The response depends upon the conditions of the observer.[15]

Thus it is clear that Martin's belief in innate ideas, what she calls her classicism, does not lead her to simplify the function of art. She rejects the idea that a common pattern in both the artist's and the spectator's mind facilitates communication by a process of standardization, a common fault of idealist theory. She allows for the fact of diversity of spectator response and interpretation, despite her inclination toward classical fixity. Her invariant patterns do not take the form of a canon of absolute geometry, imposed inexorably on the painting, but constitute a sense of contact which occurs when the artist's and spectator's minds converge, despite their indifference to one another.

In the catalogue of the exhibition, Ann Wilson has collected oral and written statements by Martin, and Lizzie Borden prints another statement here. Recurrent themes wind through these brief, pointed sentences. Classicism is one: "Before it's represented on paper it exists in the mind." [16] Another topic is her separation from religion:

The idea is independence and solitude
Nothing religious in my retirement [17]

Earlier she wrote: "I paint out of certain experiences not mystical." [18]

. . . praise to most artists is a little embarrassing
They cannot take credit for inspiration [19]

In a big picture a blade of grass amounts to not very much
Worries fall off you when you can believe that pride is in abeyance when you
 think that [20]

There is in her statements, then, an idealistic belief in inspiration and innate ideas and, at the same time, a reluctance to be thought religious or mystical. She wishes to rid herself of pride and the small rectangles or lines of her pictures imply the humble in their modest scale and

15. *Ibid.*
16. Agnes Martin/Ann Wilson, "The Untroubled Mind," *Agnes Martin,* Institute of Contemporary Art, University of Pennsylvania, Philadelphia, 1973, p. 19.
17. *Ibid.,* p. 20.
18. Agnes Martin, "A Personal Statement," typescript (late '50s), Betty Parsons Gallery.
19. Agnes Martin, "Statement," transcribed and edited by Lizzie Borden.
20. Martin/Wilson, "The Untroubled Mind."

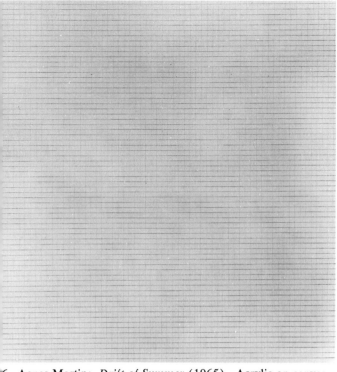

6. Agnes Martin: *Drift of Summer* (1965). Acrylic on canvas,
2″ × 72″.

27. Agnes Martin: *The Cliff*, detail (1966). Acrylic
and pencil on canvas, 72″ × 72″.

because they are simple means. "In graphic arts and all the arts technique is a hazard even as it is in living life." [21] This complex of ideas, involving noninstitutional revelation, personal modesty, links between the one and the many, the great and the small, seems distinctively American. Nature is both approached and transcended, respected and rejected. Without nostalgia there are puritan and folk elements in Martin's discourse, openly in the parables like the Willie Stories printed by Ann Wilson, but persistently in all her images.

Lucy Lippard points out that "perhaps by coincidence, perhaps not, many of the artists who have drawn a particularly unique interpretation from the grid's precise strains are women." [22] To the extent that women artists use grids Martin is a probable influence on their practice. That is to say, rather than taking grids as an inherent tendency of women's art, I consider their use to be learned and, in fact, the aura surrounding Martin and the influence of Lippard herself may be precisely the predisposing factors. It is notable that a number of the women artists who use grids, or synonymous forms, are associated with the Women's Ad Hoc Committee, of which Lippard was a cofounder. There may be a factor special to women and that is their recent willingness to use domestic techniques such as sewing and pleating in the construction of searching works of art. Martin implies this kind of repetitive technique by forms that resemble stitching and by occasional reminiscences of the motifs on American Indian textiles. On the other hand, there is the fact that her series of square canvases, starting in the late '50s, not only anticipate Reinhardt's series of black squares, 1960–66, but rival him in the pursuit of a subversive equilibrium. Here the comparison is simply between artists, not between women artists. Sol LeWitt's pencil drawings on the wall, which started in 1968, may be an extrapolation of Martin's incorporation of the pencil into painting. The combination of the grid image and the promotion of the pencil to major usage suggest such a link. Martin is, I think, unique for her use of direct pencil marks within full-bodied painting. The variable interpretation of LeWitt's instructions for his delegated drawings function in a way comparable to the varieties of manual pressure in Martin's work.

American postwar art is distinguished by its ostentatious physical presence. The elaboration of gesture by the Abstract Expressionists, the lateral expansion of color by the field painters, the stepping up of hue by the hard-edge painters, and the stress on the objectness of sculpture in Minimal Art are all cases of artists accepting the mutually supportive goals of concreteness and handsomeness. Comparatively few American artists withhold their art from this competitive mode but, as it happens, grids are conspicuous in the case of three artists who do. Martin's square canvases are reserved in appearance and unassuming in

21. Agnes Martin, unpublished notes.
22. Lippard, *Grids*.

their means; LeWitt's drawings, on walls or paper, are diagrammatic in form and undogmatic in their permutations; and Carl Andre's floor sculptures (except for the uncharacteristically showy *37 Pieces of Work* on the floor at the Guggenheim) occupy space firmly but without any drama of protuberance and void. In all three artists, the pleasure of synonymity and the discipline of restraint are essential to achieving a reserved art on a large scale. It should not be thought that this is a complaint about objects as such, only about their escalation. This is not an argument for "dematerialization," only for restraint. An artist like Martin can fill the house with a whisper.

<div align="center">APPENDIX</div>

My linking of Martin with the presumed influence of Lucy Lippard on women artists who used grids and were affiliated with the Ad Hoc Women's Committee elicited responses from five artists which indicate a situation of much greater complexity. Early uses of the grid, starting from diverse points, are clearly established by the following statements.

Loretta Dunkelman: The use of repetitive form or modules first appeared in my work sometime in 1964. I made a series of collages which consisted of rows of circles. I was interested in seeing how many times I could make the same picture by using a format and repeating it over and over again. I had seen Jasper Johns' numbers paintings and liked them a lot and Ad Reinhardt's writings and paintings were also sources. In looking through a sketchbook done in December, 1964, I found a drawing using a grid with circles placed in a scattered arrangement in relation to the lines. This drawing was directly influenced by having seen a Larry Poons painting in the Museum of Modern Art around this time.

Brenda Miller: My use of the grid as a basic structure or skeleton began around 1964–65 while I was still painting. . . . By 1967 the image consisted of three boxes connected to each other vertically with an object inside one of them. The boxes were always the same size. In 1967 I stopped painting and began to make constructions of boxes. One was a soft white box about 3' square which was made out of rug fabric. This consisted of uniform loops about ½ " in length. The fabric was itself a grid, merely a structural element. I was not conscious of the fact that I was working with a grid. Soon afterwards I began to work with string, yarn, latex, and paper without the tedious hooking. Once again the grid appeared as a structural necessity so that the object would physically hold together better. Since then I have consistently used a variety of grid forms, first in my ceiling pieces in which I spaced equal lengths of sisal 1" apart, then for wall pieces. One of these was a 20" × 30" grid in which a 3" length of sisal was placed in each intersection of the grid drawn on the wall in blue nonreproduci-

ble pencil. Since that time I have continued to use the grid in 1″ intervals as a basic structure for my work.

Mary Miss: I've made sculptures which suggest extendable networks both indoors and outdoors since 1966. My sources for this imagery (only once in the form of a true grid) have been from traces of human contact or manipulation of a space or situation. Five years after this direction was established I became involved with the political actions of the Ad Hoc Women's Committee.

Michelle Stuart: My employment as a topographical draughts-woman and cartographer in California influenced my use of map forms and the grid. I mapped the surface features of geographical areas for the Army Corps of Engineers. Since this was during the 50s it antedates any connection with the Ad Hoc Committee which I joined in the Winter/Spring 1971, or any awareness of Martin's work. In 1963 I began using simple unadorned boxes as containers for my sculpture and by 1965 some were used in modular units. In 1967 I used the grid as a ground for a series of detailed diagrammatic drawings that had to do with location, direction, and boundaries. . . . The grid was used as a framework or "scaffolding" for inner experiences that were imposed upon it. Gradually as the figuration was discarded and the work became more abstract, the grid remained with an all-over drawing topographical in nature all on the same plane. In some pieces, it was apparent in the structure of the piece itself, i.e., boxes placed in a grid form.

Paula Tavins: In 1967 I lived near Canal Street and used to go there frequently. The street, with its piles and accumulations of objects, was a constant demonstration of how repetition both enhances and destroys the identity of objects simultaneously, thus increasing their mystery. It was in trying to establish a visual vocabulary that made reference to repetition, molecular structure, and energy that I started using a grid to structure my work. The first painting I specifically recognised as using a grid was by Larry Poons in "The Art of the Real" show at the Museum of Modern Art in 1968. By the time the Ad Hoc Committee was formed in 1970 I had been using the grid structure for a year.

GESTURE INTO FORM
The Later Paintings of Norman Bluhm

The paintings of Norman Bluhm, done between February and November 1971, retain their characteristic appearance of velocity, enacted by giant brushstrokes and the splatter of paint and symbolized formally in twisting wave forms. There is both the image of liquidity and the evidence of it. The conspicuous paint relates to Bluhm's strongly gestural earlier paintings, but in fact the new works are different. His painterly means are now used in the construction of imagery, not in the release of motor power. Take a representative picture like *Arethusa* (he is using nymphs' names for titles at the moment; another time it was fabled swords). In scale it is close to his earlier pieces, 8 feet high, but the surface is more full and solid. The characteristic Bluhm brushstrokes, that start with a lunge in ripe paint and end in a dry skid, are present but the picture plane is strengthened.

Gesture has been solidified into form as can be seen by comparing the tapering forms in the upper half of *Arethusa* with the openly brushed handling of comparable forms in the earlier work. In the new painting the directional thrust of the brushwork has been reduced and the color expanded into the whole form. The image of a spiral, whether contracted to a central zone or orbited out towards the edges of the canvas, is constant in the new pictures. Its solid surface overlaps other forms to produce a layered, recessive space, though one in which most of the major planes are parallel to the picture plane.

Color in the new paintings is related to whole forms, not to parts of forms or to the picture plane conceived as an abstraction. Since each disc, loop, clover leaf, knot and helix is highly individuated there is a strong sense that these are colors *of* and not pure color. Without adopting a specific imagery Bluhm is producing a complex relation of form

SOURCE: From *Art News,* LXXII/2 (1972), 42–44.

and space by means of colors which hold the surface even as they imply chambers of red-violet, pale yellow or light purple. The radiance of the color prevents the complex space from being indeterminate. By color Bluhm blocks specific references and subdues the risk of what he calls "too much cartooning." His fusion of positive and negative volumes and his interleaving of containing and contained forms set up a purely pictorial space. These are not pictures between abstraction and figuration; they are abstract paintings with complex space in lieu of the flat or modular space of the '60s, and freshly invented forms in lieu of repetitive, neutral ones.

First Bluhm stretches his canvas and then, when about to work, takes it off the stretcher and pins it to the wall; the crease formed by the turned canvas sets the absolute limit of the image. It should be stressed that the development of structural complexity in his work is an extension of his earlier painting, not a break. For instance, his is still an adaptive work method as opposed to a conceptual one. That is to say, the painting develops by being painted, not by being planned. The artist's decisions are based on past experience, as present in the state of the picture, to which the artist can react without delay. The changing picture presents a series of incomplete displays to which the artist responds.

According to Bill Berkson, Bluhm comes "out of Pollock" and Barbara Rose puts it this way: Sam Francis "took his lead from Pollock's all-over drip paintings as did Friedel Dzubas, Norman Bluhm and others." The works referred to here are those in which he distributed patches of paint and liquid runnels in a hovering plane of paint marks of equal density. This style tapers off in the late '50s and by the end of the decade the repetition of small bits gives way to the irregular placement of a few large ones. In some of these (such as *The Anvil*, 1959, owned by the Whitney Museum) the runnels of paint are so insistent as to form themselves a kind of module more substantial than the initiating brushstrokes from which they leak. In that both the all-over and the rigid drip paintings depend for their structure on the constituent brush mark or paint trail, rather than on contrasting or hierarchic form, Bluhm may be said to come from Pollock.

However the bulk of his work, and certainly the work on which he would want to be judged, does not make much use of the microstructure of painting. This is Fritz Novotny's term for the use of constituent paint marks as prime structure in a painting as in Impressionism and in Pollock, though he did not extend its application into the 20th century. At least since 1959 Bluhm's paintings reveal compositions more diverse than those produced by the accretion of similar paint units. In 1963 Berkson referred to "a Mondrianesque 'equilibrium' " in Bluhm's work. This is certainly not the way to describe it, but the remark is a recognition of Bluhm's adoption of composition. In place of the gathering of

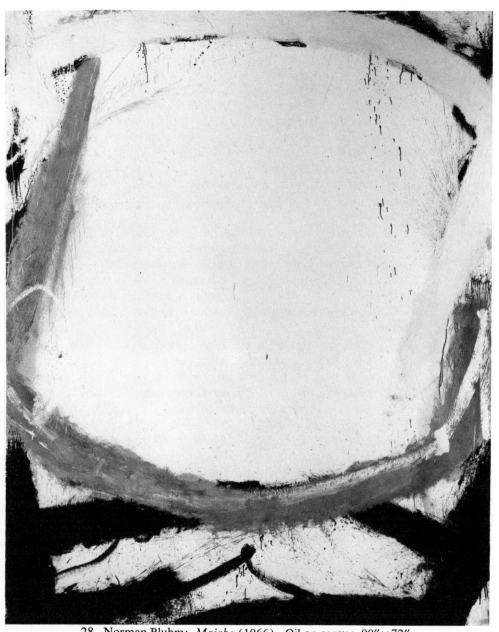

28. Norman Bluhm: *Mojabe* (1966). Oil on canvas, 90″×72″.

equal parts he is pursuing the diversification of parts and the contrast of form.

Just about everybody who has written on Bluhm has stressed the muscularity of his painting style, a word that refers to span of arm movement and to the pressure of the brush on the canvas. Pollock's art shows the reach of the arm but not the pressure of the hand; it is de Kooning that we associate with the surface produced by pressure. (Pollock's extraordinary achievement was, in part, to put the paint down without pressure and the kind of drawing that comes with it.) Bluhm's point of departure seems to be the landscape phase of de Kooning represented by *Bolton Landing, Park Rosenberg* and *February* of 1957 and *Suburb in Havana* of 1958. These big brush paintings, much concerned with the impact and spatter of paint, put down with what seems to be a countable number of gestures, coincided with Bluhm's own move towards a tougher, more abrupt structure in place of the continuous, uninflected field. (The tonal range of his early paintings are often wider than that of other all-over painters, with an emphasis on dark values, which suggest a discontent with fields of color as a prime means of painting.)

By 1962 he was combining big, solid L-forms clearly placed within the picture with a misty spatter of paint, contrasting the lunging brush track with lightly deposited showers. He was clearly at the point of technical command that he had posited in 1958 in the magazine *It Is* (Number 2): "Anyone can master anything, the drip, flood, smear, slash." His paintings of the early '60s are physically kin in size to the human scale in reach and height, as they have continued to be. The élan of these works, however, did not prevent Bluhm's development towards a form in which physical projection onto the canvas was diverted and reduced.

The crucial change perhaps was not the change from all-over pictures to ones composed on principles of hierarchy and variety; in both phases, what we see on the canvas is the record of process, a gestural diagram not merely of action performed but of decisions taken. By 1968 Bluhm made another step which was clearly demonstrated in his exhibition of the following year at the Corcoran Gallery. He retained the scale and the large forms of his later gestural pictures, but lessened their kinesthetic potential. The sense of the body traced in the pictures is abated and in its place are clearly shaped configurations. This process coincides with a renewed interest in drawing from the figure, but it would not describe these pictures accurately to call them abstractions of the human figure. All the same his rapidly done and copious drawings replenished his sense of forms with shapes beyond those produced naturally by a gestural attack on the canvas. Gesture is solidified into form, the autographic traces curbed enough to separate paint from compliance to body gesture.

Bluhm is what used to be called a "second generation Abstract Expressionist," part of the first group of painters, born in the 1920s, to emerge after the great generation. The trials and troubles of this group have been gone into pretty thoroughly, especially by their enemies. Nonetheless Bluhm's continuing vigor and coherence is not something that can be claimed for all of his generation. Among the painters that Bluhm knew in the '50s in Paris were Sam Francis, Paul Jenkins and Joan Mitchell; in New York the painters who shared some of Bluhm's interests were Milton Resnick (born earlier than the others—in 1917), Michael Goldberg, Al Leslie and Larry Rivers. Francis and Mitchell have thrived, but it seems clear to me that the others have not. Resnick and Goldberg have both turned into heavy-handed decorative painters. Jenkins reached an early point of dead skill and has not moved. In contrast Leslie has moved too much, switching styles expediently as the movements started by younger artists came along. Rivers has slid from facility to a bag of tricks. These are not failures of talent—all the painters were initially gifted—but a failure of development. None of them formulated projects that would sustain and expand their personal gifts or develop the tradition within which they found themselves.

The problems of this group were compounded, though not solely caused, by the influence of de Kooning, whose art turned out to be undevelopable for the most part. Bluhm, however, is an exception here, perhaps because he became interested in de Kooning later than the others when he had already mastered painting as an all-over sensitized surface. Therefore the wallop of de Kooning's big brush paintings was not athletically overwhelming but assimilable to a tautly controlled picture surface. Bluhm is able to use coagulated paint without choking the surface, and to swing forms over one another without spatial kinkiness. He has taken what were supposed to be the problems of 10th-Street style and, without simplification, incorporated them in a style that has grown, unimpeded, for ten years, to his present achievement.

THE SIXTIES, II
Pop Art

These articles represent different approaches to iconographical analysis. The notes on Marilyn Monroe concern a single motif, and the piece on Johns a single work. Both are attempts to substitute for the literary source of traditional iconography the known and accessible subject matter of general culture. "Rauschenberg's Graphics" was written without contact with the artist. There seemed to be ample published information lying around unused, so I took that as my source. On the other hand, "Roy Lichtenstein's Period Style" was based on conversation with the artist. The Art Deco revival was new when I wrote (not even named at the time), so that I depended on the artist for essential information. The notes on the changing sense of the term *Pop art* are a reminder of the mobility of art terms and represent an approach that could be extended to other group designations. "In Place" has not been published before.

POP ART
The Words

Pop Art is defined in the *Random House Dictionary* as follows: *'Fine Arts.* a style esp. of figurative painting, developed in the US and current in the early 1960s, characterized chiefly by magnified forms and images derived from such commercial art genres as comic strips and advertising posters.' In the ten years or so of its use the term has had more meanings than this and its shifts reveal the pressure of opposed ideas of culture. For this reason, its history is, perhaps, worth recording.

The term, originated in England by me, was meant as a description of mass communications, especially, but not exclusively, visual ones. By the winter of 1957–58 the term was in use, either as Pop Culture or Pop Art.[1] Its users were art-oriented, if not themselves artists, and interested both in extending esthetic attention to the mass media and in absorbing mass-media material within the context of fine art. It was an expansionist esthetics, aimed at relating art to the man-made environment of the 50's. Advertising, color photography and color reproduction, (big screen) films, (early English) TV, automobile styling were regarded on equal terms with the fine arts; not the same, but equally interesting. The group was criticized in the mid-50s, as being pro-American, because a majority of the admired films, ads, science fiction, and commercial photography was American, inasmuch as the United States was, and is, the most fully industrialized country. (Pop art, before it is American art is an art of Industrialism.) Pop Art was pro-urban and accepted the media's roots in mass production, at a time when traditional esthetics in England was mostly pastoral or universaliz-

SOURCE: From *Auction,* I/4 (February, 1962), 7–9.

1. The first published appearance of the terms that I know is: Lawrence Alloway. 'The Arts and the Mass Media.' *Architectural Design,* February, 1958. London. Ideas on Pop Art were discussed by Reyner Banham, Theo Crosby, Frank Cordell, Toni del Renzio, Richard Hamilton, Nigel Henderson, John McHale, Eduardo Paolozzi, Alison and Peter Smithson, William Turnbull, and myself.

ing. Pop Art, in its original form, was a polemic against elite views of art in which uniqueness is a metaphor of the aristocratic and contemplation the only proper response to art.

Pop Art/Phase 1 involved an open attitude in which art was scattered among all of man's artifacts, and could be situated anywhere. Hence the idea of a Fine Art/Pop Art continuum was necessary. In place of an hierarchic esthetics keyed to define greatness and universality and to separate High from Low art, a continuum was assumed which could accommodate all forms of art, permanent and expendable, personal and collective, autographic and anonymous. On the other hand, art was not regarded, owing to its environmental functions, as a social service. Rather it was put in a situation of complexity which demanded all kinds of attention and not assigned a set level in a pyramid of taste. At the time it was recognized that Pop Art/1 had an affinity to the definitions of culture by anthropologists, as all of a society, and not, as art writers and specialists prefer, as a treasury of privileged items.

From 1961 to 1964 Pop Art came to mean art that included a reference to mass-media sources (the meaning quoted from the *Dictionary*). This was the period of its maximum influence as an art movement: the compression of the term facilitated its rapid diffusion. By restricting its terms of reference to works of art with certain kinds of imagery, Pop Art/2 arrests the expansionist element in Pop Art/1. During this time Pop Art consolidated its formal properties: the explosive definition of culture as everything shrank to an iconography of signs and objects known from outside the field of art. This appeared to be such a drastic operation mainly because the articulate art world of that moment was habituated to the formalities of Abstract art. The productions of Pop Art/2 are dualistic, with unexpected structure conferred on existing subject matter or with structure following the display of unexpected subjects. The ambiguities of reference and speculation on the status of the work of art itself, basic in this period, are well within the iconographical limits of art from Futurism to Dada to Purism.

Pop artists of the second phase, by maximizing the presence of objects (Campbell's soup can or comic-strip image), while declaring their indifference to these subjects, propose, obviously, a third term between Abstract art and realism. Pop Art/2 could be called the iconographical period of Pop Art. Most of the artists began with some declaration of interest in their subject matter and, later, stressed the formal construction of their art as being the nitty-gritty. In fact, the double presence, the co-existence, the collision, of a reference and the artist's indifference to the reference, involves us, surely, in a complex iconographical art. Art of Pop Art/1 (early Rauschenberg, environmental displays, and the expressionistic-figurative work of the Reuben Gallery artists, 1959–61) is quite different from the art of Pop Art/2, with the dominance of easel painting and traditional sculptural forms.

During 1965–66 the meaning of Pop Art was again modified. In the

preceding four years the term had been applied to such a variety of objects and events that its limited use was corroded and dissolved. It had become more like slang than the name of an art movement. (Artists who had tolerated the term before, incidentally, cut down on its use now as it seeped everywhere.) The term was applied to fashion, films, interior decoration, toys, parties, and town planning. A typical use of it by an architect is Robert Venturi's 'Pop Art has demonstrated that these commonplace elements are often the main source of the occasional variety and vitality of our cities'. Here Pop Art is being used to defend the kind of lively man-made environment which had orginally contributed to the formation of the term in the first place. Pop Art/3 is the sloganized form of the original anthropological definition of urban culture, but now with nearly ten years of usage behind it. Some of the cross-overs between different arts, the connectivity between art and other experiences, have been precipitated by the term itself now.

Let us take one example of the many overlaps and connections between different points on the continuum: *Batman* provides a handy case. It was originally a comic strip, and nothing else. In the early 60s, Mel Ramos painted *Batman* subjects, in oils on canvas, which were shown in galleries and in 1963 at the Los Angeles County Museum. Bob Kane, creator of the strip, announced in 1966 that he had done a series of *Batman* paintings in oils, but seems not to have known about Ramos. (Kane's paintings have still not been shown, I think.) Then *Batman* hit TV and Bob Kane described the style of the series to me as 'Very Pop Art.' The comic continues, of course, and at present the readership is divided into a naturalistic group which prefers *Batman* as 'creature of the night, avenger of crime' and another group pledged to *Batman's* teen scene with Robin's campy expressions. The point is that experiences of art and entertainment are not necessarily antagonistic and unrelated, but can be linked into a ring of different tastes and purposes. And, to quote from a recent comic book: 'At the Gotham City Museum, Bruce Wayne, Millionaire Sportsman and Playboy [and Batman], and his young ward Dick Grayson [Robin], attend a sensational "Pop" Art Show. . . .'

This sketch of the term Pop Art's mobility reveals resistance, within the art world, to using a non-hierarchic definition of art. The first phase was a descriptive account of the whole field of communications, in which we live and of which art is a part. The third phase is an enactment of the idea of a continuous and non-exclusive culture. Pop Art/2, on the other hand, is an interruption of the anthropological view of art; though the mass media is iconographically present, the art is a consolidation of formal procedures that are largely traditional.

Future usage is hard to predict, but probably the references of the second phase will continue in use as the least demanding, but if so we will need a word for the wider field of general culture. I propose Pop Culture as the least troublesome supplement to Pop Art, if this term

is linked to a narrow definition. The anthropological definition of culture is likely to appear, under other titles. By it I mean to refer to the impulse towards open-ended as opposed to formal descriptions of events and to a speculative rather than to a contemplative esthetics, the main enemy of which at present in the United States is academic formal art criticism.

JIM DINE

Plato assigned art to the same category as shadows, images in mirrors, and reflections in water. Art was an untrustworthy form of knowledge, an imitation of higher reality. The tendency of esthetics ever since has been to save art by moving it out of this chancy and unstable realm by stressing its formality, which can be made a metaphor of ideal order. In this way, art, as it approached the ideal, could be made better than the world it imitated. For this reason discussion of figurative art still tends to discount the reality of subject-matter and to stress, instead, prestigeful formal elements. It used to be possible to look at a skull by Cézanne and see only a "spherical form," not an emblem of death. Faced with the subjects of Dine, we are not invited to discover their formal equivalents; nor are we tempted to see the subjects as symbols of vanity, or opulence, or whatever. What we get is the object presented as literally and emphatically as possible.

The question arises: what happens when an artist presents his subjects as literally and emphatically as Dine does? Does he remove his images from the world of imitation? He gives us images of neckties, the same size as life, only buried in paint; or, neckties, partly painted in gaudy facsimile, partly schematic, and partly left as vacant space. Similarly with *Beads,* a giant ring in which the beads run from three-dimensional orbs to flat unshaded circles. These images are incomplete but completely unambiguous. There is no uncertainty about what these signs refer to, but the provisional and arbitrary nature of the signs is ruthlessly celebrated.

Dine refers to hair by covering a canvas with paint tracks like greatly enlarged hairs and by writing in the word "hair" (it might have been "grass"). His *Pearls* unites the word with a mighty string of pearls (metal-painted halves of rubber balls). René Magritte has written words on paintings, but his words and his images are never congruent; by calling "A" "B," he aimed for poetic disorientation. Dine, on the contrary, presents his image with a maximum unmistakability combined with an absolutely accurate one-word description. Instead of feeling the

SOURCE: From *Jim Dine* (New York, 1961), unpaginated, the catalogue of an exhibition at the Martha Jackson Gallery. Reprinted by courtesy of the gallery.

redundancy of either the word or the image, one is faced with all the difference that exists between images and words, even when they are in apparent agreement. The image is there; the word describes it, but it is, after all, hard to hold the visual and the verbal together. Whereas the Surrealist sought mystery, Dine calmly shows it to be unavoidable. Max Ernst's chimneys made out of flowerpots, for instance, are like the crazy chimneys of Coketown in *Martin Chuzzlewit,* which Dickens describes "as though every house put out a sign of the kind of people who might be expected to be born in it." Dine's mysteries, however, are those inherent in simple objects, without the melodrama supplied by mood and emotion.

Dine has been known mainly in connection with the Happenings he has staged. However, his new work is very different from the earlier spectacles. For one thing, he is now highly painterly, and for another, he is no longer concerned with expendability. The city is still his theme, as it was in a Happening like *Car Crash,* but he has given up the use of perishable found objects taken from the city's waste. The objects he uses now are not scatological, but bought fresh, because then they are his from the beginning, like a tube of paint, and have no other history. The connection with the city remains, however, iconographically and presentationally. The giantism of popular art (the Camel ad in Times Square, The Biggest Pizza Pie in the World, etc.) underlies his imagery of enlarged common objects. *The Coat,* with its great buttons and high texture, makes us all orphans facing close up a detective's broad and unknown chest.

Dine's interest in the means of presentation underlies both his word-image combinations and his sequential runs of signs in different stages of completeness. There is an interplay of iconicity and arbitrariness (physical resemblance and difference), as the signs resemble their referents and yet, of course, fail to be exhaustive. Thus Dine's art is full of the problems, happily raised in his case, of art's connections with copying, conterfeiting, reflecting. This is the problematic realm of figurative art, which the esthetics of pure design has subdued and censored. The literalness and massiveness of Dine's objects is itself the source of strangeness. He cuts out any reference to the fetishistic or social functions of objects. (His *Fred Astaire and Ginger Rogers* pictures, with their nostalgic graffiti, are probably transitional between the Happenings and the clarity and impact of his new work.) His objects (suspenders, beads, hats, neckties, palettes) have the mysteriousness of detailed description. It is not an accuracy, like that of the Surrealists' works, in which old master conventions were parodied. On the contrary, Dine's is a style of physical directness and immediacy. He makes a comedy of *thereness,* of signs as solidly made as possible, for objects as familiar as possible, whose mystery lies in their desire to simulate the actual presence of objects.

RAUSCHENBERG'S GRAPHICS

Rauschenberg's prints belong in the main course of his development and are in no sense peripheral. In 1962, the year of his first lithographs, he also made his first silkscreened paintings and the two techniques need to be seen together. Fortunately it happens that at this time Rauschenberg was the subject of a detailed article by Gene Swenson.[1] Early in the year Rauschenberg had completed a large five-panel abstract painting called *Ace* in which a minimum of physical attachments intersected the flow of paint. He had begun work on a new combine-painting, but Swenson records that progress was desultory. After nearly eight years of assemblage, Rauschenberg was bored with the compilation of objects.

According to Swenson Rauschenberg accepted "a commission by a large hotel firm for a lithograph: he had not worked in this medium before and had to solve a number of technical problems. He did several other drawings and finished a number of lithographs during the summer, including one collaboration with James Dine and Jean Tinguely. These were, in fact, the only works he both began and finished during the later Spring and Summer."[2] Also he made the first group of black-and-white paintings, the images of which were printed from silkscreens onto the canvas. Rauschenberg's explanation for the printed paintings is given by Swenson: "I had been working so extensively on sculpture that I was ready to try substituting the image—by means of the photographic silkscreen—for objects."[3] Or, as Rauschenberg put it later, in the verbal statement that occupies the central panel of the billboard-size lithograph *Visual Autobiogarphy:* "began silk-

SOURCE: From *Rauschenberg—Graphic Art* (Philadelphia, 1970), pp. 5–9, the catalogue of an exhibition at the Institute of Contemporary Art, University of Pennsylvania.

1. G. R. Swenson, "Rauschenberg Paints a Picture," *Art News,* 62, 2, 1963, pp. 44-47, 65-67.
2. *Ibid.,* pp. 65-66.
3. *Ibid.,* p. 67.

screen paintings to escape familiarity of objects and collage." And, from the same source: "started lithography . . . big influence on painting."

Three years earlier, as part of his interest in an environmental and compound sensory work, Rauschenberg had installed three radios in a painting, *Broadcast.* He records his dissatisfaction with it on the grounds "that one had to be standing so close to the picture [to reach the controls] that the sound didn't seem to be using the space the way the images were reacting to one another." [4] Out of this sense of spatial and acoustic incongruity Rauschenberg seems to have developed a renewed appreciation of the potential of the flat surface.

The earliest works relevant to the theme of the printed image are a series of blueprints made around 1950, only one of which is known to survive. Here is Calvin Tomkins' account of the process: Rauschenberg used "blueprint paper, placing various objects on sheets of it and exposing them to sunlight, in much the same way that Man Ray had made his early 'rayograms' on photographic paper." [5] The imprinted image was usually a female body, occasionally with strewn flowers and shells, like an Ophelia's traces. This image, the size of life, naturally, anticipates later images of the artist, such as his silhouette on the right panel of *Wager,* 1957–59, and the X-ray of his skeleton in *Visual Autobiography.* The *Nude Blueprint* in the present exhibition is a complex image in which the actual print of the body lying flat on the paper produces an image made somewhat transparent and phantasmal by differences of pressure and light leakage. That is to say, the direct body-print leaves behind a dematerialized trace, an effect increased by the surrounding aura. (A photograph of this image, incidentally, is included among the collage elements of *Odalisk,* 1955–58, along with a pair of girl nudists.) Another case of Rauschenberg's curiosity about the direct imprint is a tire track, the making of which has been described by the artist: "I did a twenty-foot print and John Cage was involved in this because he was the only person with a car who would be willing to do this. I glued together fifty [sic] sheets of paper—the largest I had—and stretched it out on the street. He drove his A-Model Ford through the paint and onto the paper. The only directions he had were to try to stay on the paper. He did a beautiful job and I consider it my print." [6] Though a monoprint, not a multiple original like a lithograph, this work asserts polemically Rauschenberg's preoccupation with images as a direct trace.

The other phase of the early work which prefigures the copious

4. Dorothy Gees Seckler, "The Artist Speaks: Robert Rauschenberg," *Art in America,* 54, 3, 1966, p. 84.

5. Calvin Tomkins, *The Bride and the Bachelors* (New York, 1965), pp. 200-201.

6. Seckler, *op. cit.,* p. 81.

graphics of the '60s is, of course, the series of illustrations for Dante's *Inferno,* 1959–60. Rauschenberg developed a mixed technique of rubbing and drawing by means of which he transferred images from printed sources directly onto the paper. By wetting drawing paper with lighter fluid and placing photographic reproductions face down, and rubbing over them, with pencil or ball-point pen, he could peel the images off onto the plane of the paper. The deposited image had not only the verisimilitude of the photographic source, it was also characterized by the pressure and direction of rubbing, which bestowed a modulated field of tints and tones to unify the separate images. The images were suspended between the hand-done mark and reproduction and had elements of both.

The source of the raw material was magazines like *Time, Life, Newsweek, Sports Illustrated,* with their veristic inventory of events. That is to say, the sources of the *Inferno* drawings are an intensification of the kind of material used in the combine-paintings, where, along with the paint and the appended three-dimensional objects, there was a steady level of collage. In function it was partly material, partly referential. Newspaper comic strips in color were frequent also in the combines, but that is not all the printed material annexed. In *Charlene,* 1954, there are fine art reproductions (Van Gogh, Goya, Pieter de Hooch, Degas), in *Rebus,* 1955, Botticelli's *Primavera,* and *Odalisk* includes a nude from Giorgione's *Fête Champêtre,* along with the *Nude Blueprint* and the nudists. It is clear that the transfer drawings, like the later silk-screened paintings and the lithographs packed with contemporary source material, are an extension of the collage level of the combine-paintings. As found sources were incorporated with the continuous surface of canvas or paper Rauschenberg set up a web of internal correspondences between the parts to take the place of the ambiguous threshold between image and object proposed by the combines. As Bitite Vinklers has pointed out, Rauschenberg maintains a pretty firm differentiation in the combine-paintings, between the flat plane and the projective elements,[7] so that his concentration on the single surface is compatible with what he had been doing immediately before.

The two artists who have used silk screens for paintings are Andy Warhol and Rauschenberg. In 1963, close in time to the origins of their work, Henry Geldzahler put the matter thus: "Rauschenberg had been talking and thinking about the possibility of translating photographic material directly onto canvas for some time. In 1961 Andy Warhol began using the silk screen to reproduce the popular image exactly on canvas. This technical possibility, indicated by Warhol, made it clear to Rauschenberg that he could translate the specificities and ambiguities of the [*Inferno*] drawings onto canvas."[8] Warhol developed the poten-

7. Bitite Vinklers "Why Not Dante?" *Art International,* 12, 6, 1968, p. 99.
8. Henry Geldzahler, "Robert Rauschenberg," *Art International,* 7, 7, 1963, p. 65.

tial of the silkscreened image for repetition within each work as a metaphor of mass production, whereas Rauschenberg repeated his screens from one work to another, as a metaphor, perhaps, of recurrence. As a rule Rauschenberg does not repeat an image within a single work, but he has consistently used repetition in terms of pairs. In *Factum I* and *II,* 1957, paired photographs occur in almost identical paintings, a theme picked up later in, for example, *Tracer,* 1964 (a sumptuously colored silkscreened painting), in which the head and reflection of Rubens' Venus is echoed by two birds (next to her hidden buttocks) and the birds are echoed by the doubled image of a US Army helicopter. In *Landmark,* a lithograph of 1968, Rauschenberg picks up the theme with four pairs of photographs, each differently inked and contrastingly paired, in a game of likeness and unlikeness.

The first lithograph was called *Merger,* referring, in a characteristically Rauschenberg tone, to the collaboration with Dine and Tinguely; his contribution, according to Douglas Davis, is the dominant image of the Coca Cola bottle.[9] This is supported by the fact that Rauschenberg had already used Coke bottles in his combines, one of which had attained a certain notoriety as an example of Junk Culture's incorporation of waste, the *Coca-Cola Plan* of 1958, in which three bottles were awarded wings. Finding himself in an unfamiliar technical situation, it is likely that Rauschenberg would assert himself with a known image of this kind. His first solo print is *Urban,* followed, naturally, by *Suburban.* Without hesitation he established in *Urban* the basic format of his later lithographs; instead of the single object-dominated *Merger,* there is a swarm of partially seen photographic images, bound together in a cloudy tonal field. The focal points of the cluster include images impressed on the lithographic stone from printer's plates, that is to say, from the plates, or blocks, on which the original photographs were engraved. In other early lithographs there are transfer images, revealed as such by the fact that letters or numbers are backwards. The failure to reverse images for printing (once a sign of error, impatience, or unsupervised studio work in graphics) is part of the immediacy of the process to Rauschenberg. This engagement with process culminated in *Accident,* 1963, the stone of which split during printing, so that the widening crack sunders successive pulls from the stone.

The collage material in the combine-paintings is usually presented straight, so that its origin outside the work of art is clearly declared. The images may be dirty, but they are usually intact and, as pieces of pasted paper, they are seen frontally, no matter what the photograph or other image may depict. Rauschenberg finds the image and puts it into his work as a pre-finished and complete form. Similarly in the printing of images in his graphic works and paintings, he controls the emphasis of the print by hand pressures, but the image goes down all-in-one. The

9. Douglas M. Davis, "Rauschenberg's Recent Graphics," *Art in America,* 57, 4, 1969, p. 91.

directness of presentation in the combine-paintings is analogous to homemade shrines or locker-room pinups, both examples of what can be called the bulletin-board principle of tacking up transient, vivid images. Rauschenberg has exploited brilliantly popular culture's image-store. Instead of building up his works by successive stages of drawing and painting, he used the following method to obtain the whole form as quickly as possible. The imagery is the result of process-abbreviation, cutting down the technical operations to selecting photographs, having them either silkscreened or transferred to the lithographic stone, then printing them individually himself. These points of data are then absorbed by a fast and elegant process of fusion, as he makes a unified zone by the flicks, swipes, drags, and pressures that move ambient color over the stone (or canvas).

Rauschenberg's iconography has constants which a partial inventory of the subjects of his photographic sources indicates. There are recurrent sport subjects, with action photographs of players in motion, especially baseball, pole vaulting, and horse racing. There are endless technological images, from helicopters to construction sites, from radar bowls to control panels, from an occupied life raft to a racing car being serviced in the pit (technology *and* sport). There are architectural and environmental images, including the grid of a sports field, a store front with displayed fruit, the Sistine Chapel, a cloverleaf traffic intersection, and water tanks on the New York skyline. There are figures, male, JFK and LBJ, who both appear in the *Dante Series* of lithographs, done in 1964 at the time of the publication of the *Inferno* drawings, and female, usually from the old masters, such as Velásquez's *Venus and Cupid* (National Gallery, London) and Rubens' *Venus at Her Toilet* (Lichtenstein Gallery, Vienna). The common themes of some of these images, though not of all of them at once, have to do with adaptive mechanisms, so far as the hardware goes, and occupational gestures and stances, so far as the figures are concerned. The tools by which man boosts his 1.5 horsepower include the baseball bat and the helicopter. The relations of man and machine underlie many of the chosen images and it is relevant to note that in his theatrical pieces Rauschenberg has appeared on stilts (in *Spring Training*) and on roller skates (in *Pelican*). The man-machine interaction reaches a climax in the *Stoned Moon* series where Rauschenberg is out in the open as an artist of the urban-industrial-mythological complex.

The coalescing bulletin-board imagery, fully stated in *Stunt Man I–III* of 1962, is amplified and explored in later prints but not fundamentally changed. It is characteristic of Rauschenberg that as he diversifies his work—and his lithographs are concurrent with various sculptures, mechanisms, and theatrical performances—each branch of activity stays relatively separate, partly because improvisation works best within a familiar canon. His lithographs constitute a logically continuous ten-

year series. Mounting confidence and expertise combine irresistibly, as in the 1967 *Test Stone Series* (which are known, incorrectly, as *Booster Studies*), the large scale and emphatic drawing of which anticipate the *Stoned Moon* series. The later '60s is a period of commissions and extensions, though attempts to extend the lithographic image into three dimensions failed to equal the flat images. *Shades,* 1964, is a sculpture with movable transparent planes on which lithographed images are printed, but the real depth only obscures the spatial openness of the fading tonal sequences on each print viewed singly. The *Revolvers* of 1967 are a kinetic version of *Shades* and suffer from the same dilution of an open surface into real space. In 1965 Rauschenberg produced *A Modern Inferno* on commission,[10] in which his vernacular elements were drastically simplified. He replaced the evocative scatter of his own freely chosen imagery by a programmatic choice of public-affairs imagery (the Bomb, mass graves, refugees, racism). It is well knit but the images have an easily exhaustible level of reference, a limitation shared with *Reels* $(B+C)$, which was commissioned for a *Time* cover in 1968. Writing about Öyvind Fahlstrom, Rauschenberg defined the artist as "part of the density of an uncensored continuum that neither begins nor ends with any decision or action of his." [11] The initiating and concluding points of the modern *Inferno* and of *Reels* are too evident, however, so that the dive into the continuum turns out to be only a jump in the shallow end.

What is it about photographs that makes them so useful to Rauschenberg? One thing that he likes is their uninvented look; he is at pains to avoid bizarre photographs and picks consistently straight, familiar pictures. Thus the material, though not seen before in the particular constellation he sets up, preserves some of our expectation of factual records. The photograph, as the least personally meditated of all forms of image-making, is associated in our minds with the actual; it is affiliated with real events in time and space. Thus a photograph, especially of a familiar type, is a channel to something real; it is an iconic sign (a sign with a maximum of one-to-one references to the original). Thus when Rauschenberg puts the Statue of Liberty upside down as in the lithographs *Breakthrough I, II* or the silkscreened painting *Round Sun,* he may violate iconicity but not to the point at which the sign becomes illegible. There is a basic gritty specificity of reference in the transferred and printed photographs, the sum of which makes a continuum of textures that we recognize as the veristic space of mechanical reproduction.

Another property of the photographs, as used in the lithographs, is

10. Robert Rauschenberg, "A Modern Inferno," *Life,* December 17, 1965 (foldout, starting p. 45).

11. Robert Rauschenberg, exhibition catalogue, *Öyvind Fahlstrom,* Daniel Cordier Gallery, Paris, 1962 (also in *Art and Literature,* 3, 1964, p. 219).

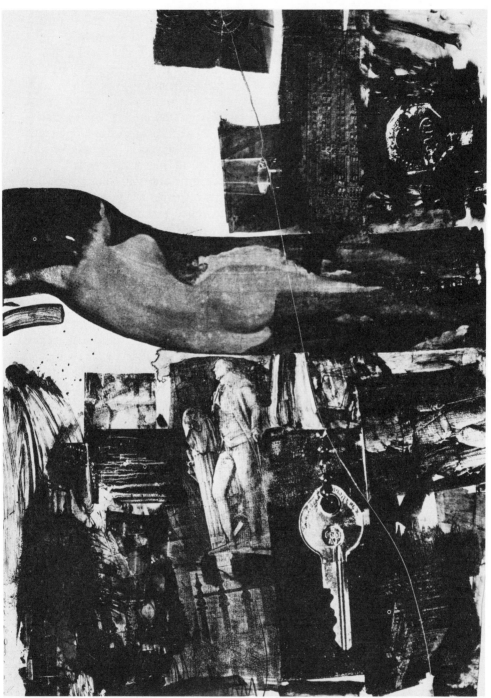

29. Robert Rauschenberg: *Breakthrough I* (1964). Lithograph, 41½″ × 29¼″.

this: they can be reproduced at the same size as the originals. Throughout his work, Rauschenberg has been concerned with images at the size of life or objects that are the same as life. It is a way of cutting down the distance of the process of abstraction from life to art. In the lithographs the photographic images are not at the scale of the original events, but they are, often, at the scale of the original source material and hence real in terms of their channel. It is appropriate to quote here John Cage on the effect of the *Inferno* drawings: "It seems like many television sets working simultaneously all tuned differently." [12] The swarm of coincident images is a basic structural principle of Rauschenberg's work and the kind of meaning it nourishes needs to be considered.

Rauschenberg has written: "with sound scale and insistency trucks mobilize words and broadside our culture by a combination of law and local motivation which produces an extremely complex random order that cannot be described as accidental." [13] The example he gives, involving the sight and sound of trucks may suggest the three-dimensionality of the combine-paintings, but this is not solely the case. In the same text he makes this observation: "Air volume can be compressed and flattened to the extent that a brushload of paint can hold it to a picture surface." [14] He is clearly thinking in terms of pictorial illusionism in which the brush mark opens up space by an atmospheric abatement of the flat plane. The oxymoron "random order" is very appropriate to describe the unstoppable connectivity of his non-denotative imagery: Perhaps the best way to amplify this kind of organization, which is not merely an absence of order, is by the following quotation from Raymond B. Cattoll: "the principle of 'simple structure' . . . assumes that in an experiment involving a broad and well-sampled set of variables, it is improbable that any single influence will affect all of them. In other words, it is more 'simple' to expect that any one variable will be accounted for by less than the full complexity of all the factors acting together." [15] If we apply this principle to Rauschenberg's work, we can say that it is more "simple" to expect that no single image be accounted for in terms of all the other images. It is improbable that any single meaning will be supported by all the images. Thus instead of an iconography in which each part is tightly related, we have an iconography of divergent episodes and simultaneous events, though, as already indicated, within certain parameters. The subject, as Cage has put it, is "a situation involving multiplicity" [16] and the multiplicity, not its reduction, is the subject of definition.

12. John Cage, *Silence* (Middletown, Connecticut, 1961), p. 105.

13. Robert Rauschenberg, "Random Order," *Location 1,* 1, 1963, pp. 27–31.

14. *Ibid.* (Note: the text is illustrated by photographs and silkscreened paintings.)

15. Raymond B. Cattoll, "The Nature and Measurement of Anxiety," *Scientific American,* 208, 3, 1963, p. 96.

16. Cage, *op. cit.,* p. 101.

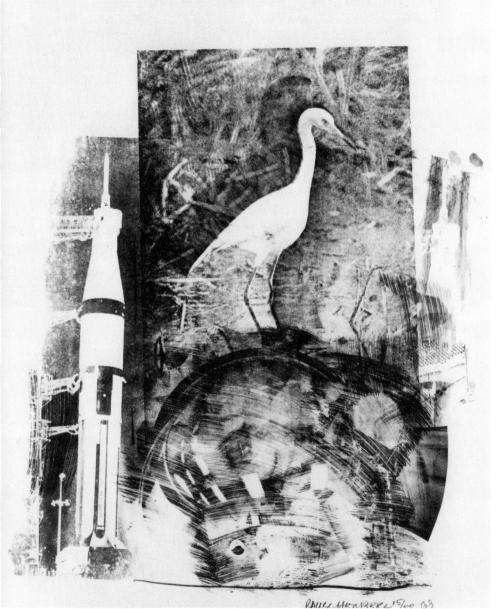

30. Robert Rauschenberg: *Horn* (1969). Lithograph, 41¼″ × 34″.

The transfer drawings, lithographs, and silkscreened paintings are rarely centered on monolithic objects but characteristically dilate with an animated all-over surface. There is an atmospheric envelope similar in visual effect to Rauschenberg's observation about color on the streets: "all you saw was a general no-color, in which the tone stood out." [17] There is color in many of his works but it is usually pulverized, as in the silkscreened paintings, or soft, as in the *Inferno* drawings. The distribution of images in clusters, based on half-hidden modules, holds a resemblance to Cézanne. There is a comparable sharpening and relaxing as objects come into focus or slip away; the points of detail always dissolve partially into an atmospheric flow. Rauschenberg's surface is defined by an image-based version of the later Cézanne's ellipsis. It is not the geometrics of middle-period Cézanne, emphasized by earlier 20th-century artists, but the perceptual delicacies of his later work that seem to be Rauschenberg's starting point. It is as if Rauschenberg were looking at the vertical racks of magazines on a newsstand while staying mindful of the quarry walls at Bibemus.

In 1969 Rauschenberg was invited by NASA to attend the launching of Apollo 11 at the Kennedy Space Center, which resulted in the eloquent *Stoned Moon* series. It is like a technological equivalent of Ruben's Medici cycle, now in the Louvre, in its pomp, wit, and fidelity. Just as Rubens' allegories are closely and aptly phased to events in Marie de Medici's court, so Rauschenberg's images stay close to the facts of the occasion. A new declarative and, so to say, non-random order is sustained through the thirty prints, in different sizes and different numbers of colors. In *Sky Garden* there is a central white diagram of a rocket with explanatory notes ("Helium Storage Sphere," "Main Tunnel," "Aft Dome" and so on), the flat outline superimposed on a low-angle photograph of the rocket leaving the ground balanced on top of its fireball. Around are glimpses of technicians and landscapes, including a view of the rocket with Mobile Service Towers seen through palm trees. *Trust Zone* combines a map of the Space Center with a diagram of a life-support system, *Tracks* features huge liquid nitrogen tanks, and *White Walk* shows hovering space-suited figures in heroic grouping. The rocket is called a "bird" in communication jargon, and Rauschenberg has used that in *Hybrid,* among other prints, which has a white bird present with the rocket, thus referring both to technology and to the local birds of Florida. In *Bait* he has added to his other images of flight an image from a print of a baroque male flying with the aid of a frail contraption. This persistent aptness of reference reinforces one's impression of the series as Early Space Age commemorative art.

17. Tomkins, *op. cit.,* p. 215.

In a text based on his experiences as a "NASA artist" [18] Rauschenberg records vividly the sight of "Apollo 11, covered and shimmering in ice." Takeoff is evoked as "the bird's nest bloomed with fire and clouds." He notes: "V.A.B. Man's largest construction. . . . Only possible to think how big it is. Can't feel it. Enter. Inside larger than all outsides." This reaction to the Vehicle Assembly Building catches exactly Rauschenberg's characteristic blend of alertness to the technological, to the man-made, and his laconic, lyrical way of referring to it. In the same text he notes: "Launching control aware of 2 ideologies man and technology responsive responsible control and counter-control." That the Launch Control Center should produce this kind of moralistic reflection confirms Rauschenberg's withdrawal from the principle of random order. He still improvises with high resourcefulness, but the range of images is no longer centrifugal but bunched tightly around the determined theme. Probability has replaced random order.

18. This and subsequent quotations from: Robert Rauschenberg, "Notes on Stoned Moon," *Studio International*, 178, 917, 1969, pp. 246–247.

JASPER JOHNS' MAP

For the U.S. Pavilion at Expo, in Montreal in 1967, Jasper Johns painted a work called "Map (based on Buckminster Fuller's *Dymaxion Airocean World*)." It is an elaborate statement of themes developed in the last seventeen years by an artist whose work is neither realistic nor abstract. Johns' subject is pre-existing signs and systems of signs and this holds true for his paintings of targets, the Stars and Stripes, numbers, words and maps.

In the early 1960s he painted four maps, of which Max Kozloff observed that in them Johns was "playing with the notion of measurement, in which the locked-in diagrammatic 'in scale' dimensions of map images are contrasted with the virtually gratuitous dimensions of painterly gestures." The first map is a tiny picture belonging to Robert Rauschenberg, the second is a flurry of red, yellow and blue, the third is monochrome, and the fourth is a combination of both color schemes. The second disregards the state lines freely, but the third follows the arbitrary boundaries conscientiously. These maps are all of the United States, but the new one at the Modern is a world map and correspondingly larger. It measures 15 feet high and 30 feet long and is painted in triangular sections derived from Fuller.

The map's central point of reference is the North Pole, and the world is arranged around it in accordance with Fuller's definition of the Arctic as the shortest route between the 12 per cent of the world's population in the Americas and the 88 per cent who "dwell in the Asia-Europe-Africa quadrangle." Johns's version of it is densely painted in a mix of encaustic, pastel, charcoal and collage. Within an overall gunmetal-gray base color are place names stenciled in color (mainly, but not consistently, they radiate from the Pole) and bits of collage. These include a winter scene from a comic strip with "BRRRRR" in a speech balloon, an allusion not only to climate but to a 1960 painting by Andy Warhol.

In appearance the painting is ungainly, splayed jaggedly on the wall, taking its form from Fuller's triangulation. This is not, I think, a failure on Johns's part; on the contrary, it is a part of his move away from

SOURCE: From *The Nation* (November 22, 1971), 541–542.

the elegant paradoxes of his early work to a brute style, of which this unruly painting is a climax. The map is usually hung flat, but the work has a potential for three-dimensional presentation that has not been used. The original version was hinged so that it could be folded to project forward. It would be an awkward object to manipulate, but Johns's provision of this option seems to be part of his insistence on exceeding the canon of wit and subtle painting with which he started.

Johns stayed close to Fuller's map in the form of its projection and in color, which was coded according to climate. It has now been repainted and, Johns says, "I applied colors purely arbitrarily." The map as given by Fuller is both followed and opposed. The divisions of Fuller's system are translated by Johns into separate sections, so that shaped canvases give bulky form to a purely linear projection, a paradox typical of Johns. In fact the picture seems to pun on the word projection, in the cartographic sense of the word, as systematic representation on a plane surface is turned into its physical sense of protruding or extending. The repainted version stresses the distinctness of each section rather than its modular seriality by means of discontinuities of color between sections.

Despite his fidelity to the form of the *Dymaxion Airocean World* map, Johns makes systematic departures from it. A map is analogous to something in the world and the painting is analogous both to the map and to something else in the world. He jettisoned, as mentioned, the color coding of climate, but it returns in another form. Johns's map is a representation of things seen as well as measured. Maps have been used in painting before this, of course, notably in Dutch genre painting of the 17th century, where they usually belong in one of two complexes of meaning. Either the meaning is mercantile, in which case the map, taken in conjunction with imported objects, links the room to the world via Dutch trade routes; or it is emotional, in which case the map, taken in conjunction with letter writing or reading by solitary female figures, implies separation. But Johns's is the first painting I can think of in which a map is accommodated to landscape. The varied paint textures, dominant stretches of indeterminate mineral color, with shreds and flashes of color and detail, evoke a voluminous space. Thus the theoretical form of a map is partially dissolved into the optical values of a landscape.

Johns has exploded the measured space of the map to present a physical configuration of the planet. The glimpses of continents with superposed place names and the turbulent paint skin resembling storm systems add up to the world view from an orbiting satellite. The successive aerial views, transmitted or collected by satellites, are pieced together by NASA or the meteorological bureau in mosaic patterns

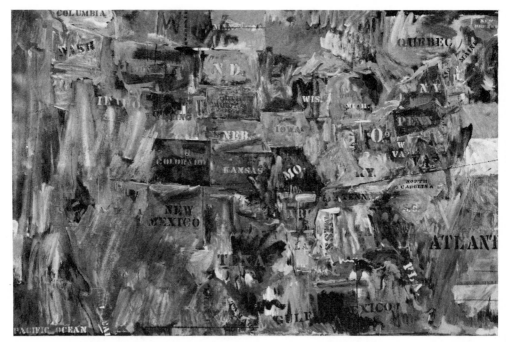

31. Jasper Johns: *Map* (1963). Oil on canvas, 60″×93″. Collection of Ben Heller, New York.

32. Jasper Johns: *Map* (1967–71). Encaustic, pastel, charcoal, and collage on canvas, 186″×396″.

similar to Johns's matching but jumpy sections. This penetration of sign systems, the projected and the photographic, is reminiscent of fragment 648 in Wittgenstein's *Zittel:* "One language-game analogous to a fragment of another. One space projected into a limited extent of another. A 'gappy' space." And gappy space is an apt term for Johns's tough, restless later paintings.

MARILYN AS
SUBJECT MATTER

The iconography of Marilyn Monroe divides into two phases. The first is numerically the smallest but, possibly, the most serious; these are the works made while Marilyn was alive. The earliest are by de Kooning and Cornell; neither is tied in tightly to the supposed subject and the Cornell box, from the mid-'fifties, is rather well described by its title *Custodian (silent dedication to MM)*. The de Kooning, from 1954, is a typical *Woman* painting of the period, that is to say, from the artist's best time. The painting is really a kind of 'eternal feminine' image, with all the gutter power that beat-up paint can carry. The star's name is attached to it as a tribute to popular culture's current sex symbol; if de Kooning's taste had been different it could have been called Jackie Dougan, or if it had been painted earlier Theda Bara, or if painted in Latin America Isabell Sarli. There is also a light painting, dated 1957, by Marcel Cavella (a West Coast autodidact) derived from the publicity for *The Seven Year Itch* (MM holding her skirt down in an updraft).

The early works most attentive to Marilyn as an image are by English painters. Richard Smiths' *MM,* 1959, is abstract, but closely derived from a *Paris Match* cover in which she smiles radiantly. (Smith did a *Kim* soon after, which was silvery and cool compared to the sunny *MM;* in 1958 William Green did a *Patricia Owens*—remember Patricia Owens?) Smith's friend Peter Blake included Marilyn in his *Love Wall,* 1961, a construction derived from a sensitivity alert to the relations between the separated items on a bulletin board. He situates the mass-produced, colored pin-ups with high finesse. Derived equally from the pin-up, but organized as a dense painting, is Peter Phillips' *For Men Only Starring MM and BB,* 1961. These English painters, Smith, Blake, Phillips, base themselves on the pin-ups and they do so in terms that celebrate the body. The film critic Pauline Kael put down Brigitte

SOURCE: From *Arts Magazine,* XLII/3 (September–October, 1967), 27–30.

Bardot and someone called "Monroe' (like a prefect in a girls' dormitory) "for their histrionic achievement in playing themselves." It was precisely for themselves that one went to their movies, as one now goes to see whomever one has elected as their replacements.

Joseph Cornell wrote of Hedy Lamarr in 1942: "Who has not observed in her magnified visage qualities of a gracious humility and spirituality that with circumstance of costume, scene or plot conspire to identify her with realms of wonder. . . . Her least successful roles will reveal something unique and intriguing—a disarming candor, a naïveté, an innocence, a desire to please, touching in its sincerity." [1] It is Hedy Lamarr, not her interpretation of roles and characters, that is the point; and so it is with MM. It is her physical and carnal image, intimate *and* conventionalized, that is the subject of artists in this first phase.

With her death all this changed and she was lifted out of the calendar-girl, sexy star context into a liberal drama of comedienne as victim. Critics praised her gift for comedy more often than they talked about what everybody in the audience was watching. And, with her early death, she became a pitiful creature trapped in the mass media, loss of privacy's sacrifice, Hollywood's throwaway. I would guess that paintings dated 1962 with MM as subject were done between August and December (August was when she died). This includes a Nakian relief of Leda dedicated "To Marilyn," a Rosenquist in which her face is fragmented, two touching Cornell keepsakes, and Warhol's silk-screen paintings. James Gill and Rotella, though their works are dated 1963, also belong to this phase of elegies for the tortured heroine. Gill shows the protest view most obviously in paintings which have an oddly Italian look. This is to say, Bacon's males are transformed into chicks (as some Milanese followers of Bacon used to do). Gill's MM image always has to do with screaming mouth, lots of knee, tapering arms, a vulgarization of both his source and his subject. Rotella's torn poster, given its date, has a strong potential to be read in terms of the destruction of a head, Marilyn's, like Rosenquist's painting.

One exception to the dropped level of post-1962 MM pictures is Richard Hamilton's *My Marilyn,* in which the scored marks on the photographs of the star function ambiguously, both as photographer's check mark and as a defacement of the image. The ambiguity is stressed by the fact that Marilyn is being used as a metaphor in a personal reference of the artist's. The other exception, which works in a different way, is Andy Warhol's MM paintings, which were executed after her death. As a result, they were somewhat affiliated with the opportunistic elegies of the second phase, but now, after a few years, they are seen to belong much more to the receptive, enthusiastic and celebrative phase

1. Incidentally, I am quoting from a collage, *The Enchanted Wanderer and Plan Now,* 1962, by R. B. Kitaj, which incorporates the Cornell text from *View* magazine.

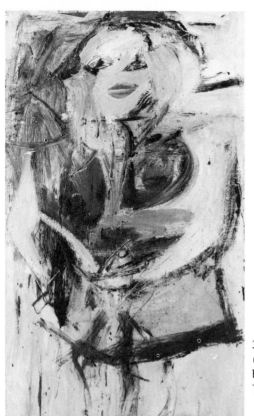

33. Willem de Kooning: *Marilyn Monroe* (1954). Oil on canvas, 50″×30″. Newberger Museum, State University of New York at Purchase.

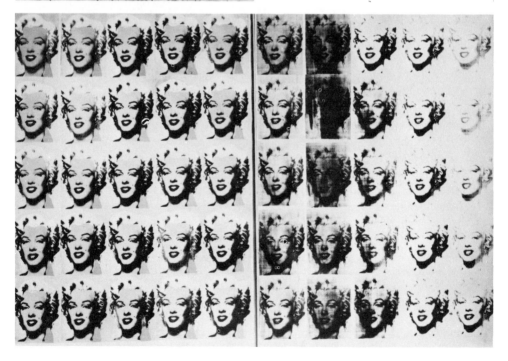

34. Andy Warhol: *Marilyn Monroe Diptych* (1962). Acrylic on canvas, 82″×114″. Collection of Mr. and Mrs. Burton Tremaine, Meridan, Connecticut.

35. James Rosenquist: *Marilyn Monroe, I* (1962). Oil and spray enamel on canvas, 93″ × 72¼″. Sidney and Harriet Janis Collection. Gift to The Museum of Modern Art, New York.

of the early paintings done when Marilyn shone and smiled and swung.

The Sidney Janis Gallery, in putting on a *Homage to Marilyn Monroe* has achieved a first; so far as I know, it is the first time a New York gallery has based an exhibition on a story in *Life* magazine. In the January 25, 1963, issue of *Life* there was an article on "The Growing Cult of Marilyn," illustrated by Gill, Rosenquist, a man called Marlowe, and Pauline Boty. Why Boty's *The Only Blonde in the World* is not in the show I don't know; and, given the theme of the show, why is Edward Weiss' *To Marilyn with Love,* 1963, not exhibited?

Most of the rest of the show consists of new works done for the show, or, at least, titled for it. They mostly look like standard jobs despite having been custom-built for Mr. Janis. Gandy Brodie's picture manages to make Marilyn look like Thelma Ritter. Lindner's two paintings are called *Marilyn Was Here,* but from the old Berlin eroticism he must mean Marilyn Dietrich. Indiana has labored in *The Metamorphosis of Norma Jean Mortenson* (her pre-Show Biz name) to combine his bands of letters and numbers with his recent figure paintings; the figure in the center is Marilyn's best-known calendar pose, but awkwardly painted. Segal has a plaster man confronting a poster girl: it is clay dreaming of flesh and fire, as in a late 19th-century genre scene. Oldenburg's pieces, especially the *String Wardrobe,* are good, but with no homage to MM. Chamberlain has crumpled some galvanized steel and called it *Norma Jean Rising;* painted, he could use it in the next theme show that comes along.

ROY LICHTENSTEIN'S
PERIOD STYLE

Through the period in which Roy Lichtenstein simulated comic books in his painting, 1961–65, other possibilities showed up sporadically and were not let go. There were, for instance, the whole objects, viewed dead on, one at a time, scattered through 1961–63, and there were the references to other artists: Earl Loran's Cézanne compositional schema, 1962, Picasso in 1963–64, Mondrian in 1964. By the last year of the comics period Lichtenstein had considerably systematized his method of working, and instead of ranging freely, as in the earlier 'sixties, testing out the perimeters of his area, he began to paint in runs. The girls' heads of 1964–65, for instance, are all in close-up and all are elegant. The explosions, the sunsets, the seascapes, the brushstrokes (all invented), are done as sets between 1964–66. One can describe the work either as being more concentrated thematically or as being conceived in groups or sets, in which case the effect is of diffusion among individual works. The latter description is probably truer, because thinking and working in terms of a period is to be in an extended situation, as opposed to trying to squeeze everything into one knock-them-dead picture. The prints, banners and multiples of Lichtenstein also point to an idea of diffusion, this time by stepped-up distribution.

Lichtenstein has revealed an increasing interest in three-dimensional form recently, at first mainly as a paradoxical accompaniment to pictorial elements. His ceramic sculptures of stacked cups in the same medium as the original objects (a sculptural first?) were colored in a thick handcraft way, and his heads of girls carried two-dimensional symbols for shadow and volume overlaid on real masses, so that the representational signs became decorative devices. Similarly, the explosions are ironic monuments, combining solid slices with pictorial images of flame and smoke. Referring to the 'solidification' of sunsets and explosions, Lichtenstein observed, "Cartoonists have developed explo-

SOURCE: From *Arts Magazine*, XLII/1 (September–October, 1967), 24–29.

sions into specific forms. That's why I like to do them in three dimensions in enamel on steel. It makes something ephemeral completely concrete." [1] It is a VARRROOM forever. However, his new *Modern Sculptures,* though they have their double takes, do not depend on incongruities of graphic and plastic convention. The new sculptures are autonomous, but still charged with complex references, this time to the formal vocabulary, to the *style,* of another period, the thirties. His combinations of brass or copper with tinted glass, or of green and black veined marble with shiny metal, carry a period reference, as do the forms themselves, such as gleaming parallel bars, rounded corners, stepped forms, arcs partially buried in other forms. These are the same forms that he uses in his paintings, but hard and clear in a way that the earlier sculptures, stretched between allusive image and physical fact, were not.

It makes no difference whether Lichtestein invented or copied particular comic-book images (he worked both ways), because a reference to the general style of the comics is legible. (This is not something that will, as it were, dry out of the painting, leaving a pure formal structure for the ages to contemplate: popular references are easily accessible in medieval art, in Brueghel, in Hogarth, in Seurat, in the Expressionists, and are part of the meaning of the art.) The 'thirties function in Lichtenstein's new work, not as references to major monuments like Radio City Music Hall or the Chrysler Building, but as a style, the overall characteristics of which Lichtenstein uses on the terms of his own art. (The Picasso and Mondrian paintings are in the background here.) His pleasure in reference and annexation, in allusion and parody, goes back at least to his free paraphrases of 19th-century Western paintings which he did in the early 'fifties.

Today, the forms of the 'thirties have a particular meaning, both in terms of familiarity and of irony. The 'thirties have been, as Lichtenstein calls them, "a discredited area, like the comics"; on the other hand, they have become visible, even conspicuous, again. Lichtenstein observed wryly of the period: "I think they felt they were much more modern than we feel we are now." Sustaining ideas of the 'thirties were the machine aesthetic and technocracy, which assumed a happy future as the gift of the Machine. A kind of Platonism of the production line promoted machine-made forms to the status of Pure Form. Although there were puritanical and exuberant versions of the machine aesthetic (Alfred Barr, for instance, stuffily deplored the 'modernistic'), both extremes shared basic assumptions. The geometrics of the 'thirties, lean or splendid, are charged with idealism, but even the timeless dates. Thus the forms of the 'thirties are symbols of an antique period with a naïve ideal of a modernity discontinuous with our own.

1. *Roy Lichtenstein.* Interview with John Coplans. Pasadena Art Museum, 1967.

The two attitudes to industrial design, one apparently rational, one apparently commercial and indulgent, are merging now, as can be seen by referring to a typical document of the period (for instance, the Museum of Modern Art's *Machine Art, 1934*). Sections of wire rope are displayed like flower patterns and outboard propellers shine like Brancusi. Black glass cylindrical vases, chromium pretzel bowls, black-face electric clocks without numerals, cantilivered desk lamps, are now not the logical form of good design but the record of somebody else's aesthetics, as much nostalgic as functional. These objects are merely the classy end of a spectrum which includes Horn and Hardart automats. The forms, therefore, that used to symbolize the machine and its benefits, have changed their meaning to symbolize the taste of the period that produced them. The symbolic content has shifted from the original referent to the channel itself, where it has been located by Lichtenstein's serious ironies.

There are links between the 'sixties and the 'thirties as well as an irrevocable difference, and Lichteinstein's new 'period' depends on the double focus. For one thing, we live among its monuments and its detritus, from the dazzling Chrysler Building to a thousand run-down 'swank' façades (Lichtenstein's phrase) stuck onto delis and bars all over the U.S. It is as a public style, perhaps (ball rooms in luxury liners, Hollywood homes, sets for musicals), and as threshold architecture (bar fronts, shop windows, hotel and movie theater foyers) that the 'thirties form sense received its most luxuriant embodiment. Especially the foyers of movie theaters are orgies of invention and inflection. The machine aesthetic was anti-handcraft and anti-nature, values which are, broadly, associated with Pop art. Hence, the industrial content of Pop art has a precursor, all ironies aside, in the 'thirties. The revival of interest in old movies (as movie history became public property owing to late-night TV and, maybe, Film Societies, too) amplifies the Pop Culture of new movies. It is probably relevant to note that Lichtenstein's first full-scale play with 'thirties forms is his poster for the 4th New York Film Festival (designed, Summer 1966). Prior to this, however, he had made an unintentional 'thirties work, *This Must Be the Place,* 1965, a lithograph of the New York World's Fair treated in 'a Buck Rogers way' in which he inadvertently 'invented' various 'thirties clichés.

'Thirties architectural ornament and industrial design, which are the sources of Lichtenstein's new densely packed abstractions, are diagrammatic, in their distinctness and repetition of bands, darts, arcs, fanned triangles, bisected dics, stepped forms, rounded corners, scooped planes, and zigzags. Details of these paintings have ironic parallels to minimal art, but, in addition to this correspondence, there is a battery of elaborate inflections. Forms are expanded, echoed, shifted, and bent before your eyes. It is the interlocking and crowded plane of these inflected

forms that give Lichtenstein's *Modern Paintings* their peculiar claus-
trophobic bounce, their stocky *élan*.

Lichtenstein has commented appreciatively on the 'cartoonish' quality
of much 'thirties decoration, and if one thinks of cartooning as some-
thing like 'vivid reduction' the link to the rest of his art becomes clear.
Miró and Picasso are relatable, he observed to 'cartooning' which he
defined as "highly-charged subject-matter carried out in standard,
obvious, and removed techniques." [2] He has recorded his liking for the
'diagrammatic' property of Picasso and Mondrian. The cartoon (and
caricature) is a route to the simplified, the strongly formed, and there is
a comparable principle in Lichtenstein's reduction of color to four
(blue, yellow, red, and a sparingly used green). "Anything slightly red
becomes red, anything slightly yellow becomes yellow [with] color
adjustment achieved through . . . size, shape, and juxtaposition." [3]
This binary system for judgment of color intensity, with its semblance
of programming, is supported by his even and unaccented drawing,
which purports to be impersonal. He has even deceived people into
thinking it is.

Lichtenstein's point of departure is usually a specific detail in a
French, German, or American book or magazine of the period (either
editorial or ads in the latter). Here are the prototypes of the linked
and embedded forms, the stylization and the counterchange, of his
original paintings. These derivations are as active a process of organiza-
tion by which to make art as any other. Among the material he has
collected, which functions somewhere between reference library and
sketchbook, is one that hits the mood of the 'thirties with particular
aplomb, a promotional book, *52 Ways to Modernize Main Street with
Glass*. Here are variant designs for curved plate-glass store windows,
endless combinatory possibilities for Vitrolite, an opaque structural
glass, which gives many 'thirties buildings their shine (the range includes
'gleaming ivory' and 'tropical green'). It was much used to clad lus-
trously the squat, blind, sign-bearing towers that push above drugstores,
gas stations, and cinemas, in sluggish celebration.

The specific origin of many Lichtenstein works does not give them
the status of covert commentary on hermetic origins or closed-circuit
jokes. He is engaged in a total critical response to the 'thirties as sub-
ject, as artifact, that is not, in any sense, camp. It is more like doing the
archaeology of one's own life and place. Lichtenstein's choice of source,
and the 'size, shape, and juxtaposition' of the forms in his works are
accessible formally and iconographically. The formal features he uses
are representative of the form-sense that permeates the whole period.
Solid glass, multi-layered ash-trays, for instance, are often like models
of a Ziegfeld or Arthur Freed set for, respectively, stately or animated

2. *Ibid.*
3. *Ibid.*

36. Roy Lichtenstein: *Modern Painting, 1* (1966). Oil and magna on canvas, 80″ × 68″.
Collection of Ilena Sonnabend.

chorus girls. In a film still of *Broadway Melody,* in Lichtenstein's possession, the *mise en scène* is an inventory of swank type-faces and the smooth shading reveals the love of continuous graded planes that occurs in much 'thirties design and architecture. The positive/negative pattern of the girls' costumes echoes much jewelry and textile design of the period, and extends into their hair (dark on one side, light on the other). It is a handy example of the way people resemble their designs, a subject that Lichtenstein is about to develop in paintings of the human image in neo-classic streamline.

THE
REUBEN GALLERY
A Chronology

The Reuben Gallery (at both its addresses, 61 4th Avenue and 44 East 3rd Street) was one of a number of downtown galleries, important in New York in the 50s, for showing new, experimental, or unfashionable work. This is not the place for a history of them, but reference to a few helps define the position of the Reuben Gallery. Allan Kaprow and George Segal came from the Hansa Gallery (the word compounded from Hans Hofmann's Christian name and the Hanseatic League), a cooperative gallery that ran from 1952 until the close of the 1958–59 season. Red Grooms used successive studios as a gallery: first the City Gallery (1958–59 season), then the Delancey Street Museum (1959–60 season), which coincided with the Reuben's first season. The Judson Gallery, including Dine and Oldenburg, paralleled the opening of the Reuben Gallery, and then, subsequently, joined it. There was, as these examples show, an easy contact between artist and gallery, an affinity between the act of production and the act of presentation, which was very different from the regular marketing or promotional activities of art dealers.

Pop art, used as a comprehensive term, includes most of the Reuben Gallery artists. However, their early work and personal developments are entirely different from other artists called Pop, such as Andy Warhol or Roy Lichtenstein. There was, for instance, a strong expressionistic undercurrent to much of the work shown there. They are different again, despite a connection with John Cage in Kaprow's case, from Jasper Johns or from Robert Rauschenberg. To the extent that there is a Reuben Gallery style, it existed momentarily and was unevenly manifested in different artists. However, there was a shared quality which is

SOURCE: From *Eleven from the Rueben Gallery* (New York, 1965), unpaginated, the catalogue of the exhibition at the Solomon R. Guggenheim Museum.

anti-ceremonious, anti-formal, untidy, and highly physical (but not highly permanent). Shared, also, was an interest in stretching and violating the borders of art, which was done, not by repetition or quotation, not by riddles or the incorporation of solid found objects, but by the assumption of an organic continuum, expressionistically taken possession of and shaped.

Anita Reuben, in retrospect, regards her gallery as an outpost for human image art in a sea of Abstract Expressionism, which describes an aspect of the iconography common to the gallery artists. This was certainly an aspect of art downtown. Important at the Hansa Gallery, for example, was Jan Muller, with his influence in the direction of a symbolically weighted figure painting. Lester Johnson (Red Grooms was his student) was also influential with his dark human contour paintings, like shadows with volume and juice. Oldenburg's streets, Dine's heads, Drexler's resolutely human lumps, Samaras' plaster rags twisted into reclining figures, Grooms' toy-like effigies may be related to this curiosity about "the uses of the human figure" (to quote a 1959 symposium title). However, this imagery is inseparable from a particular use of materials, in opposition to the intact surface or the compact rectangle by which art is habitually separated from nature and random events. The city and its inhabitants was not only the *subject* of much of this art, it was also, literally, the *substance,* providing the texture and bulk of the material itself. The works are like condensations of city products and waste, identified by the mark and edge put on it by the artist. The material is anonymous, throwaway, and theoretically infinite; like plaster, cloth, cardboard, or paper. Where found objects are used, they are embedded in this continuum of intimate common material. The homogeneous, undifferentiated materials thus echo experiences of the environment beyond the gallery or museum in which individual objects, made out of its substance, are shown.

The first season of the Reuben Gallery was a series of extraordinary exhibitions and happenings, packed with artists whose futures were beginning. The second season was devoted to further happenings, in which the dispersive and throwaway properties of the sculpture, paintings, and drawings were expanded. Both Allan Kaprow and George Brecht have argued for a line of descent for happenings out of Jackson Pollock owing to his use of "chance processes used with such primacy, consistency, and integrity" (Brecht) and owing to the environmental "sprawling" of his big pictures (Kaprow). Whether or not this is Pollock's main legacy (and it is true that few painters have found ways to continue his work), it has been fertile in an area of art's extension into the environment. Ideally, in a happening, the boundaries and duration of acts and the area of the scene are problematic. Renée Miller and Martha Edelheit call their works with elaborate pointed projections, like steam-rollered bouquets, extension painting. It is

generally true of the Reuben Gallery artists that extension into the environment or absorption of the environment into the work of art happens. Whether the work is amorphous or concise, discursive or perfunctory, the work of this time is remarkable both for its physicality and its speculativeness.

Exhibitions at the Reuben Gallery

1959 Oct. 16–Nov. 5: George Brecht, one-man show

Nov. 6–26: Roughly 18 Oils and 60 Pastels by Lucas Damianou Samaras

Nov. 27–Dec. 17: Robert Whitman, one-man show

Dec. 18–Jan. 5: Below Zero—Group exhibition: Yvonne Anderson, George Brecht, Jim Dine, Martha Edelheit, Jean Follette, Red Grooms, Bruce Gilchrist, Al Hansen, Ray Johnson, Allan Kaprow, Renée Miller, Claes Oldenburg, Robert Rauschenberg, George Segal, Richard Stankiewicz, James Waring, Robert Whitman

1960 Jan. 9–28: Red Grooms, one-man show (paintings, collage, constructions, and part of the set of *Fireman's Dream*)

Jan. 29–Feb. 18: Paintings: Herb Brown, Jim Dine, Red Grooms, Al Jensen, Lester Johnson, Allan Kaprow, Nicholas Krushenick, Claes Oldenburg, Patricia Passloff, Renée Rubin [Miller], Lucas Samaras, George Segal, Robert Whitman

Feb. 19–March 10: Rosalyn Drexler, sculpture

March 11–31: Herb Brown, one-man show

April 1–14: Jim Dine, one-man show

April 15–May 5: Renée Miller, one-man show

May 6–19: Claes Oldenburg, sculptures and drawings

May 20–June 9: Martha Edelheit, one-man show

Happenings at the Reuben Gallery

1959 Oct. 4, 6–10: Allan Kaprow, *18 Happenings in 6 Parts*

1960 Jan. 8–11: Red Grooms, *Fireman's Dream* [changed to *The Magic Trainride*]
Allan Kaprow, *The Big Laugh*
Robert Whitman, *Small Cannon*

June 11: An Evening of: Sound—Theatre—Happenings
Jim Dine, *Vaudeville Act*
Allan Kaprow, Intermission Piece
Richard Maxfield, Electronic Music
Robert Whitman, *E.G.,* a new opera
George Brecht, *Gossoon,* a chamber-event

	Nov. 1–6:	Jim Dine, *Car Crash*
	Nov. 29–Dec. 4:	Robert Whitman, *The American Moon*
	Dec. 16–18:	Varieties—Happenings at the Reuben Gallery
		Jim Dine, *A Shining Bed*
		Simone Morris, *See Saw*
		Claes Oldenburg, *Chimneyfire* and *Erasers*
1961	Feb. 21–26:	Claes Oldenburg, *Ironworks* and *Foto-Death*
	March 22–27:	Allan Kaprow, *Spring Happening*
	April 18–23:	Robert Whitman, *Mouth*

IN PLACE

The Pop artists certainly opposed the image of the artist as it had been projected by the generation of Abstract Expressionists. Several attitudes intertwined and the emphasis varied from artist to artist, but there was a shared sense of the artist's singularity that showed itself as a detachment from daily life and commonplace imagery. Their artistic values placed them in opposition to the quotidian. The Pop artists, on the other hand, accepted daily life as subject matter and its objects were quoted in or appropriated to their work.[1] However, aspects of the Abstract Expressionist example persisted, despite the changes in motifs and motivation. The Pop artists were not simply celebrators of commercial products, as used to be suspected, but they were also a long way from the sublime aesthetic of the field painters. There can be no doubt of cross-generational connections. Kozloff has proposed a link between Guston's brushwork and Johns's,[2] and presumably Johns' all-blue *Tango* (1955) or his all-gray flag of 1957 benefitted from the commanding monochromes of Newman and the near-monochromes of Rothko. In Johns's works a known image is presented frontally—that is to say, flat—so that the picture plane is homologous to the object represented. From this, a work like Jim Dine's *The Telephone* (1961) is a natural extension: the canvas, seven feet tall, simulates a section of wall on which a wall phone is centered. Thus the canvas simulates a section of space by treating the area as an object. The compound of mute device and participatory zone is typical of Pop art's complex thresholds between art and life. Dine certainly influenced Joe Goode in his paintings of 1962 in which a painterly monochrome canvas is turned into the image of a place by means of a milk bottle placed at its foot, the bottle painted the same pink or blue as the canvas. Goode turns the canvas into a wall section, as Dine continued to do in bathroom wall paintings of 1962, in which hardware and paint interact to feign the picture as an area of use. Thus the Field paintings of Abstract Expressionism were transformed into images of real and familiar

1. See Lawrence Alloway, *American Pop Art* (New York, 1974).
2. Max Kozloff, *Jasper Johns* (New York, n.d.), p. 16.

places. Their flat color and advancing space-effects were used literally. The display of objects on a shelf within the picture occupies an area that had previously been optically animated. The early works of Tom Wesselmann reveal such cargo, but his objects are not intended to be assimilated into a space derived from Abstract painting.

This surprising realignment of a crucial feature of Abstract Expressionism was possible for two reason. One is that the Pop artists accepted the formal strength of the older artists' work and did not want to produce art of less density themselves. The other reason derives from a topic of wide interest at the time which I can perhaps indicate by a contemporaneous quotation. In 1962 I wrote:

"Environment" is very big in art criticism just now and it has two main meanings. (1) The expansion of works of art until they are big enough to surround and envelop the spectator; attention to such works is discussed in terms of drama and encounter. Spectator participation has displaced disinterested contemplation. (2) The incorporation in works of art of objects and signs from the man-made environment or the simulation of the untidy world within the work of art itself.[3]

The concept of environment, therefore, involved a direct address to the spectator and/or a complex threshold between the subject of the painting and objects in the world. On this basis connections between Abstract painting and the sign systems in Pop art were possible. Hence, also, the contemporaneous emergence of Happenings and Pop art and their overlap in such artists as Dine and Oldenburg. Lichtenstein was asked in 1963: "Did the work of Johns or Rauschenberg provide you with any insights at that time?" Even though he himself was so strict a painter, he answered: "Although I recognize their great influence now, I wasn't as aware at that time. I was more aware of the Happenings of Oldenburg, Dine, Whitman, and Kaprow. I knew Kaprow well; we were colleagues at Rutgers. I didn't see many Happenings, but they seemed concerned with the American industrial scene. They also brought up in my mind the whole question of the object and merchandizing."[4] The elaboration of the interface between art and the environment provided a method of working that permitted all kinds of opening out of the work of art as it included or simulated the environment. Rauschenberg's *Interview,* with its allusion to a confessional, or his *Bed,* both 1955, are certainly part of this omnivorous aesthetic. And Oldenburg has systematized his own development in terms of the Street, the Store, and the Home.

Returning to the theme of the literalization of Abstract painting in

3. Lawrence Alloway, "Venezorama," *Art International,* VI/8 (1962), 35.

4. John Coplans, "An Interview with Roy Lichtenstein, in *Roy Lichtenstein,* ed. John Coplans (New York, 1972), p. 5 (originally printed in *Artforum,* II/4 [October, 1963]).

37. Jim Dine: *Four Rooms* (1962). Oil, metal, rubber, and upholstered chair, 72″ × 180″.

38. Robert Rauschenberg: *Pilgrim* (1960). Combine painting, 80″ × 54″. Collection of the artist.

39. Jim Dine: *My Long Island Studio* (1963). Collage, oil, and wood on canvas, 96″×192″. Collection of John G. Powers, Aspen, Colorado.

40. Jasper Johns: *According to What* (1964). Oil on canvas with objects, 88″×192″. Collection of Mr. Edwin Janss.

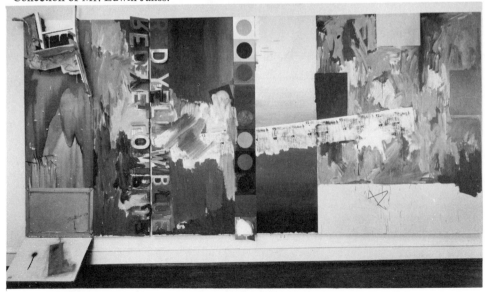

Pop art, Jim Dine's work of 1962 is important. In *Four Rooms,* for example, which is fifteen feet long, differently colored and textured canvases become metaphors of living space. There is an armchair in front of the picture, facing out, and a shower-curtain rod and head attached to one of the panels. It is on the scale of a room as well as being an image of a room or rooms with the participatory invitation to sit down, thus becoming a part of the work but losing sight of it (as in Rauschenberg's *Pilgrim,* 1960, in which a chair is also offered to the spectator). The sense of place is also seen, in a different, ironic form, in Johns's *Maps* (1962–63), which are large and in which the boundaries of cartography dissolve into the space of landscape. In 1963 Dine painted a group of large studio-referring works: *In My Long Island Studio* (*Large Color Chart*), *Long Island Landscape,* and *Studio Landscape.* Johns's large horizontal paintings pick up the theme of the studio: in *According to What* (1964), the self-reference takes the forms of allusions to his own early work, somewhat in the manner of Marcel Duchamp's *Tu M'* (1918), an inventory of the traces of prior works. In the Johns there are sharp-edged rectangles of solid color set against freely brushed colors, a reminiscence of Hans Hofmann. If this is so we are faced again with the Abstract Expressionist/environmental image link. In the same year Johns painted *Studio 1* in which it can be seen that the flat extensive surface of the painting supports an environmental reading; and in *Studio, II* (1966), there is a horizontal parade of forms like screen doors. The studio is the subject, both as a workplace (stressed by Dine's fondness for tools) and as a place haunted by earlier acts of creation (Johns's memories of early work). The studio, as both the source and tomb of art, is a motif that persists in Johns's later works, perhaps as a kind of return of the sublimity that the Pop artists did not at first take from the Abstract Expressionists, despite their use of the older artists' scale and color.

41. Jasper Johns: *Studio, II* (1966). Oil on canvas, 70″×125″. Collection of Mr. and Mrs. Victor Gamz, New York.

THE SIXTIES, III
Problems of
Representation

In the fifties, when I lived in England, I was instrumental in distributing information about Hard-Edge Abstract painting, both in its American form and English variants of it. In New York in the sixties, I was associated with Pop art more than anything else. It seems to me, however, that the modernity of the twentieth century does not consist of any one movement or tendency being more "correct" or more "relevant" than anything else, which is the usual norm of modernity. It is the irreducible profusion of styles, their equality as historical imperatives, that counts as a specifically new factor. The range of pieces I have written, therefore, including in this section both Realism and Photo-Realism, represents a view of twentieth-century culture, not a lack of commitment to a style. In fact, the re-emergence of Realism is a sign to me of the fact that criteria of progress and obsolescence are out of place in the arts.

HI-WAY CULTURE
(*with Notes on Alan D'Arcangelo*)

HI-WAY CULTURE: THEORY

Highway culture is the hardware and sociology generated by automotive transport and the road system. In a sense, highwaymen who held up English stagecoaches were symptoms of such a sub-culture, and so were the inns where long-distance coaches stopped, as in *The Pickwick Papers*. However, it is not the early forms that I mean by the term which is more usefully reserved for the later specialization and proliferation on and off the road. We can now speak of a specific culture of the highway, compounded of traffic laws and speed, adaptive commerce and technology.

Highway culture is invisible because it's taken for granted, except by those who don't like it. Present campaigns against accidents on the roads, automobile-made smog, and roadside advertising have coalesced into a single anti-highway package. (Accident and smog reduction are, clearly, legitimate targets, but advertising is not a problem in the same sense.) Led by the President's wife, who jumped on an already moving wagon of anti-billboard Woman's Club opinion, with Robert Osborne as official artist, it is the embodiment of pastoral nostalgia and suburban reformism. Some of the ways in which highway culture *is* in sight are folkloric, which presents a difficulty in defining it. Folklore is usually regarded as a body of archaic inherited lore (such as when it's O.K. for a pregnant woman to pick radishes by the full moon); but there is another folklore which is a constellation of topical attitudes and ideas, responsive to current, rather than rustic, situations. For the present we could call it urban folklore (as a continually updated snowball of styles, images, facts) compared to rural folklore (essentially a static repository).

The highways are, as nearly as anything built for human use, new

SOURCE: From *Arts Magazine*, XLI/4 (February, 1967), 28–33.

and not particularly datable (except to people who remember how great it was before a particular thruway went through). They are one of the most conspicuous of the completely new environments that, every now and again, we find ourselves in. When it happens, we get an immersive encounter with the new, without the inertial styles and the overlapping time-perspectives in which we usually live and move. It can happen, briefly, in hotels, motels, airports, on the road, in planes. It is not a common experience because any environment usually carries a scatter of survivals and mementos (for instance, the Control Tower of London Airport is built of warm-colored brick, like a seventeenth-century Dutch house). Antonioni's London in *Blow-Up* is sharp on the co-existence of all periods everywhere. *Alphaville* and *The 10th Victim* created a future mise en scène by photographing current anonymous architecture and by editing out the stylistic diversity of the twentieth-century city.

HI-WAY CULTURE: NOTES

1. The Baroque phase of Detroit car design having faded (historically parallel to Hollywood's big screen movies), and compacts not really taking over, the "American Sports Car" (the words mean that it is a symbol for a sports car) is still waiting for its matching movies. In support of the idea that American Sports Cars are symbolic of intimacy with the road, speed, and kicks, here's a wild sentence from this year's [1967] ad for the Plymouth Barracuda: "These are the sporty new 'Cudas that generate the excitement of a European road race but carry prices as American as Saturday afternoon football." Note: "sporty" means "not sports."

2. A science-fiction novel by Rick Raphael *Code Three* deals with policing future high-speed, trans-continental highways, sealed off from slow-speed road systems. The police cars are giant vehicles, manned by crews of three, on week-long tours of duty (extrapolated from Motor Torpedo Boats). Prowl cars in some cities can already get rapid computer checks on license plate numbers. Raphael extends this notion of computer servicing so that the future prowl car is physically autonomous but plugged in to a continent's stored data.

3. Urban, as opposed to rural, folklore, with its topical and adaptive basis, steady within the hyperbole: "Mom let me go for the Fairlane 390 Cld V4 with 4-in-the-floor, duals, and all the other goodies! I had the heavy duty shocks, springs, and stabilizer bar on it" ("Duel Drag" in a comic book *Teenage Hotrodders*).

4. In drag-strip and hotrod comics the most used onomatopoeic words for car sounds are voom, vroom (especially), v-rooomm, and (engine trouble) vroom-blat; also, brakkk, krassh, scree, screech, whump.

5. Since highways are directional, new ones cut into, across, through centrally grown communities. Hence those terrific sequences out of the side windows of cars, of court house, slum, ball park, apartment houses, sliced open, fanned out, visible only to on-going drivers. A city becomes an instant structure, like flipping the station control on TV.

6. On the roads that are small enough to stop on, stalls flourish like ivy in universities. They are (family) points of sale, with eats for motorists (nobody else can get there), from domestic lemonade to country produce (grown just back of the road) to brand-name ice cream. It's where the farmer's daughter is. A painter who has responded to these islands of luxurious democracy (folk produce at gourmet prices) is Thiebaud. He, more than any other artist discussed here, is a realist, inasmuch as he models forms in space. However, his paint quality does something quirky to the sense of scale, with the result that his wayside stall is like a retirement gift, patiently built in sugar icing, for a wayside vendor, memorialising his occupation. The fancy cake at the side of the road.

7. Through the windshield: Alamo Plaza, Leaning Tower of Pizza, Pizza Palace, Tiki Room, Holiday Inn, Flamingo, Glamour Cottage, The French Room, Crab Orchard Motel, Gulf, Giant City Lodge, Heritage Motel, University Drugs, The Moo and Cackle, Hub Cafe, Don's Body Shop, Elroy 'Butch' Grob, Pirate's Cove Inc., House of Fabrics, Air Conditional Chapel, Serv-U Mobile Homes, The Parasol. The signs, lifted on pylons, cantilevered out as dizzily as old Flash Gordon super-cities, softly buzzing with new neon colors, are the baroque progeny of old merchant signs (keys, candypole, gilt horse's head) and Burma Shave signs (memos in the grass). A fascia like a girl with her name written on her eye shadow.

8. Garages getting more mirage-like as consumer temptations swamp once-lonely pump islands.

9. The highway and the second half of the twentieth-century: Howard Johnson with flat roofs, same color, but the Disneyesque Colonial profile wiped out.

HI-WAY CULTURE AS SUBJECT MATTER

The highway is not only geared for speed and momentary cessations, as signs convince drivers to eat, sleep, spend, it is also an arena of timeless projects. It is the place where designers who dream of fixed international symbols, a platonic esperanto understood by all, work out their ideals. (I mean the kind of designers who go to conferences, like Aspen, and tell each other how better codes more neatly presented would provide an alternative to the 'throes,' 'tentacles,' or 'sprawl' of urban and highway chaos.) In fact, perfectly transmitting symbols don't

exist, but traffic signs, as opposed to ads, hanker after universality. Indiana has taken the street sign as a normative structure for paintings, either highway commands or austere commercial notices, such as 'Eat.' It must be pointed out that though Indiana enjoys the strict formats derived from public signs, he subverts their clarity by personal allusions and ambiguity. Signs in his, and in Gaul's, art are a source of formal immobility; D'Arcangelo, on the other hand, never uses the sign for control. His street signs provide no governing structure, but act as an emblem within a summary scenic space. In his serial paintings, for instance, the sign grows larger in the night landscape; we read its expansion as succession, as approaching, as speed, but each view is uniform in finish and unblurred.

Artists have used subjects taken from highway culture as part of the post-war expansion of iconography to take in the familiar man-made environment. At first artists emphasized the referential nature of the material but later many of the same artists played it down. The second option was probably motivated by two factors: old habits (the twentieth-century emphasis on formality first) and bad critics (writers so amazed to see hardware as the subject matter of art that they noticed almost nothing else). References to the environment are clearly present in, say, Bengston (motorcycles, his own), Ruscha (gas stations), Oldenburg, and Wesselmann (automobiles), in ways that separate their work from abstract art. Obviously. Equally clearly it is not a revival, or a new form, of realism that is responsible for the new art/environment connectivity. It is an art of signs, not street signs simply but of signs in the sense of conventional forms, unlike the evocation of bodies and space to which realism as a style is committed.

The use of signs permitted the familiar (unexpected in art a few years ago) and the unknown (which was expected in principle) to be related freshly, as when Oldenburg converts a brand-name car (again, a sign) into non-Detroit substances. Trova's *Carman* depends on the figure being schematic, a sign for a man, non-iconic, non-incarnational; then it can have wheels put on it and look logical (as well as fantastic). If the figure were not a conventional sign, we would be unable to avoid reflections on the fate of a human being as chariot, which would not be far from lamp shades of human skin. Wesselmann made five works on the automobile image (he calls them *Landscapes*), which are combinations of painted and cut-out forms. The first, and best, of the group is a low view of a VW, most of the surface taken up by the surface of the highway (plus taped sound). The second and fifth *Landscapes* show parked VW's, head-on and sideways respectively; the third was never finished and the fourth was of another car (a Ford Falcon). Although Wesselmann's VW is same-size as life, billboards are interposed between the car as hardware and the car as

subject matter. That is to say, a level of (real) signs is evoked by Wesselmann, even while simulating original size and sound.

Ruscha, in addition to painting gas stations and drawing triptychs of words or trademarks which swivel from front view to steep angles (like a sign from a moving car, like the view from three places at a drive-in), is a photographer/bookmaker. The first of these is *Twenty-Six Gas Stations* (count them, 26), a collection of photographs of Southern California sites, without sociological or compositional undercurrents, and his third book is *Sunset Strip*. This is a foldout which records all the buildings on both sides of the Strip, one side of the street at the top of the page, the other at the bottom. The result is a head-on panoramic view: it is Hi-Way culture's longest spread. (On the West Coast, incidentally, a cult figure, big in the rumors of artists, used to be Von Dutch Holland, a professional decorator of custom cars, but now even Irving Blum can't find him.)

NOTES ON D'ARCANGELO

Alan D'Arcangelo's work once included a good deal of social comment (sour and ironic conjunctions of spaceman and pin-up, of Eagle and trade mark). This discursive, montage-type space was concentrated in the highway paintings of big heads at the roadside (girls smoking) and road signs with symbolism (like Route 69). This hardened still further into D'Arcangelo's full style, the tough centralized imagery, with a view point out in the lanes on the highway, implicitly that of the man at the wheel. Since hitting his style he has continually varied the spatial layout of his work: oblique vistas, symmetrical vistas, highways with roadsigns, highways with overpasses, fragmented highways (collages with postcards), repetitive views within one work, and, lately, elaborate framing and subdividing sections. D'Arcangelo is attracted both by emphatic horizons and by one-point rigid perspective, in the full knowledge that the horizon is supposed to have been escaped from (for us all) by, say, Monet and Pollock and that vistas are incompatible with current flat surface aesthetics. In his work there is a collision of space as speed and paint as surface. Recessive space in painting begins as soon as you start to mark a canvas at all. D'Arcangelo accepts the dissolution of literal flatness as a perceptual fact of painting, but, at the same time, checks illusionism by a deadpan surface (making the kind of door that Tom, in Tom and Jerry cartoons, used to get flattened by).

D'Arcangelo's highway paintings are always hard, new and clean. The paint surface itself has a kind of blankness, a finish that involves the spectator nether in admiring high finish nor in awareness of a

42. Alan D'Arcangelo: *Safety Zone* (1962). Acrylic on canvas, 48″×57″.

43. Tom Wesselmann: *Landscape #2* (1964). 75½″×94″×3″.

44. George Segal: *The Gas Station* (1964). Plaster, metal, glass, stone, and rubber, 90″×288″×60″.

45. Wayne Thiebaud: *Riverboat* (1966). Oil on canvas, 28″×20″.

sensuous surface. It is, maybe, the analogue of the unnoticed but pervasive newness of highway engineering, of smooth surfaces (and U.S. road surfaces are smooth compared to, say, the autobahn) and clear enameled signs. The plunge of the perspective back to a mandatory vanishing point is the minimal way of establishing recession (every child draws converging railroad tracks). However, D'Arcangelo does not supplement linear thrust with atmospheric perspective. In fact, he simultaneously prunes both near and remote detail and keeps the horizon as hard as the foreground's nearest mark. The effect is somewhere between a streamlined tunnel, pulling us in, and a flat wall, the painting of which is as much an obstacle to entrance as the actual barriers painted or built across some of the paintings. His vista is as unelaborated, and unsupported by auxiliary spatial cues, as a rudimentary perception diagram. His perspective is like the raw material for perceptual judgment.

To relate this artist to highway culture rather than to landscape painting is deliberate. It is not because I regard him as an annalist of automotive transportation, or something of that sort. In fact, his use of the highway is the means to an unzoned, hard-hitting unity. There are no foreground through background or ground plane to sky shifts and contrasts of emotional emphasis. There is neither transition from one emotion to another (dark foreground, radiant mountain, say) nor exploration within one emotional complex (degrees of fertility, phases of wildness, steps of calm). His schematic vista induces no drama of entrance, unlike landscape paintings and unlike the deep space of Surrealist paintings in which recession was equated with regression and temporal distance. Except for his collages, in which he places postcards in inoperable spatial grids, sometimes with map sections, D'Arcangelo's art is savagely one-phased and unmodulated.

ART AS LIKENESS
(*with a Note on Post-Pop Art*)

<center>I</center>

In art a likeness is an arrangement of forms that corresponds to some aspects(s) of its subject. The subject may be known only to the artist, but the spectator must at least know the coordinates of the subject if he can have a meaningful relation to the work of art. The knowledge the spectator needs is (1) specific, such as the recognition of representative human or landscape forms, and (2) conventional, a recognition that the work of art presents only a part of the external subject of which it is a likeness. (That hypothetical Martian in his first contact with earth people could not read such art.) Discussing this article beforehand, the problem of how to write about art as likeness mounted; almost everything is still to be done. Was the problem how to describe the range of figurative styles in the U.S.? Or, was the problem a definition of realist-oriented paintings developing out of Pop art? The naturalistic time of Warhol's movies seems Post-Pop art (see below), while the play of signs in his paintings is more like Pop art. Should figure painting be included along with place painting and object painting, in view of the inadequacy of so-called revivals of the figure? The last problem was the easiest to settle: rather than return to a version of the ranked genres of past art (figures first, still life last), it seemed more exact to set figurative painting as a whole against abstract art, rather than to revive past classificatory systems.

The success or, better, successes of abstract art have put figurative painting under various pressures. It is not that figurative art has ceased to be produced; on the contrary it is a statistical part of the multi-style abundance of this century's art. (It is this abundance, this quantity, of artists and styles which is *modern* about modern art, and not one particular slice of the cake, not one privileged corner. Simple choices

SOURCE: From *Arts Magazine,* XLI/7 (May, 1967), 34–39.

of one main line, one way, are nostalgic simplifications of present experience which is nothing if not copious.) In the early twentieth-century polemics of realism versus abstraction, all the vigor, all the subsequent influence, was with abstract artists, but there is no reason that texts, written by artists in defence of their own early work, should continue as limiting cases. To Malevich, realism belonged to the under-developed centuries or to the country; to Mondrian it was an adulteration of pure visual structure (eggs, not heads); and to Kandinsky the specificity of a realist work destroyed art's universality and spiritual élan. Thus, modernity, concentration, and spirituality came to be reserved for abstract art and critics have, on the whole, accepted, either as cultural reflex, or in sophisticated reworkings, these primitive views, which of course are no longer adequate to abstract art.

Much of the art criticism devoted to figurative art has been based on a tacit acceptance of the domination of abstract art. Hence those short-lived and embarrassing slogans about a return to the figure or about a New Figuration or Other Figuration. The first claim delegates realism to be merely the revival of an interrupted tradition and the second term tries to claim the rhetoric of abstraction for figurative art. The so-called Monster School of Chicago was presented some years ago as if it were a return (that word again) to deep feelings and real passion after an interim of merely ornamental abstract art. Such crude efforts to turn the tables came to nothing as group promotion, but individual artists in the group have prospered (and others have not). Bay Area Figurative painting is probably the best-known and longest-lived figurative group, parallel in certain respects to the East Hampton painters who have existed as an enclave within Abstract Expressionism for years. The common point of the two groups is a rediscovery of Manet and the substitution of him for Cézanne, the previously mandatory model of art and ethics. The adoption of Manet led to a more sensually unified style than was reachable from other points of departure while retaining legible imagery.

The East Hampton realists expanded Manetesque handling into an assertion of the autonomy of paint; it is as if they were enacting for their friends the abstract painters, the Ortega y Gasset–André Malraux view of Manet as the first modern painter (more paint than people). Alex Katz is the tough and adaptive artist to come out of this Long Island–Downtown New York group. In his figures (both the billboard-scale heads and the off-life size, but otherwise illusionistic cutouts), the post-Manet style is persuaded into an art of deceptive blandness which, actually, is rooted in accurate notation and expansive painterliness. His recent series of big flowers, some derived from seed catalogues, some from stuffed vases, have the diffuseness of wallpaper, but with intricacy and modulation, not repetition, discovered within

the spread (the reverse, that is to say, of Warhol's flowers). Katz exemplifies the graces and the double-takes of likenesses in art.

Apropos the position of the East Hampton painters, except for Katz, Fairfield Porter is absolutely their emblem: what is needed are less gestures of special tolerance towards "realists we like," than a recognition of present stylistic diversity. Only a pluralistic aesthetic is adequate for the first move towards seeing figurative painters straight and not as marginal courtiers or saboteurs around the thrones of abstract artists.

We have a fair vocabulary for defining our theories and experiences of art as an object, as an autonomous thing different from other classes of things in the world. We do not have, however, a comparable vocabulary to describe an aesthetics of figurative art. (Oddly, only the fantastic aspects of figuration have received particular attention, as in André Breton's writings.) Although art critics have been undiligent, art historians have addressed themselves to the problems of legibility and likeness. It is because of their work that there may be some possibility of improving simultaneously our power to see and to describe figurative art. Erwin Panofsky's iconographical studies and E. H. Gombrich's *Art and Illusion* are well enough known by now, but there are other relevant studies: Richard Bernheimer's *The Nature of Representation* (New York University Press, 1961) is a systematic study of designation, and Sven Sandstrom's *Levels of Unreality* (University of Uppsala, 1963) is a survey of real and illusory space in murals of the Italian Renaissance. The methodology of the former book and the scrupulous analyses of the latter are relevant to the present problem, more so than any art criticism devoted to individual figurative artists.

One of the hangovers from abstract art theory of the first quarter of the twentieth century still present in this, the third quarter, is the separation of art into visual display, on the one hand, and literary content or description on the other. This view reduces the referential elements of a work to dead weight that slows down the real thing, formal structure. In fact, iconography is as visual and as active as color. For example, Thiebaud's *Riverboat* is a centered, near-symmetrical image; the placidity of the water permits the reflection to be, apart from color modifications, almost an inverted facsimile. Other recent Thiebauds have pursued reflections also, as well as repeated tree forms in groves, and lines of trees with individually distinct matching shadows. Apparently he is extending into the natural landscape the repetitiveness that he got before from identical or similar mass-produced objects. This doubling up and repeating of forms is not only a visual device, it is also an expressive one; the group of paintings and pastels referred to, then, marks a change in both Thiebaud's composition and in his iconography.

When I look at a painting that is like a scene or object known or presumed to exist apart from the image in the work, I experience a complex recognition. It is true that the figurative painting "stands in a relation of dependence upon another entity," to quote Bernheimer. In one sense, the absent entity is the real, the original, item; in another sense, the form of its representation is what is real, embodied in the painting, fixed on the canvas, spread on the paper. All figurative artists are engaged in translation; the work of art is *of* something, but the representation occurs in another medium. The object is recognized, but absent; it is present, but in translation. Thus what appear to be levels of reality in figurative art are, at the same time, to use Sandstrom's phrase, levels of unreality. Sylvia Sleigh's *Bob's Greenhouse* is a slice of deep space, but it only opens partially; the verdant interior returns us to the surface. Rosalyn Drexler's paintings of men and machines have a dual function, evoking and blocking a psychological drama. The still point of a painting at which figurative imagery becomes mute, where action is suspended, is not a result of the triumph of form over content, but of our awareness of the interaction of representation with medium, the coalescence of presence and absence.

In figurative painting all events occur in a perpetual present; even the past is only another present, like a flashback in the movies. The threshold between a painting and real space is a spatial, not a temporal experience (although symbols for time can be presented spatially). Costume does not separate us from historical paintings; the position of the frame, as a cut-off point, determines the intimacy or the distance of the scene in relation to the spectator. Marti Edelheit's anthologies of nudes appear to the spectator as one all-englobing tumult, with bodies pouring to the framing edge, echoing the scale of our own bodies. There is a kind of double focus, of present representation and absent model, of a translated world dominated by painting, in figurative art. Mirror-held-up-to-nature and loving-transcription-of-incredible-event theories are static constructs, quite inadequate to present experience. An art that deals in likeness deals with problems, double-takes, illusions. Roy Schnackenberg's *Lincoln Park,* in which painted areas and modeled forms penetrate and enwrap one another, is a clear statement of the ambiguous threshold of figurative art, as the grass-colored platform thrusts forward carrying figures and litter, out in front of the painted landscape.

II

William Seitz was quoted by Grace Glueck (*The New York Times,* March 19, 1967) on his selection of works for the U.S. section of the São Paulo Biennial as follows. Edward Hopper, who gets a big exhibi-

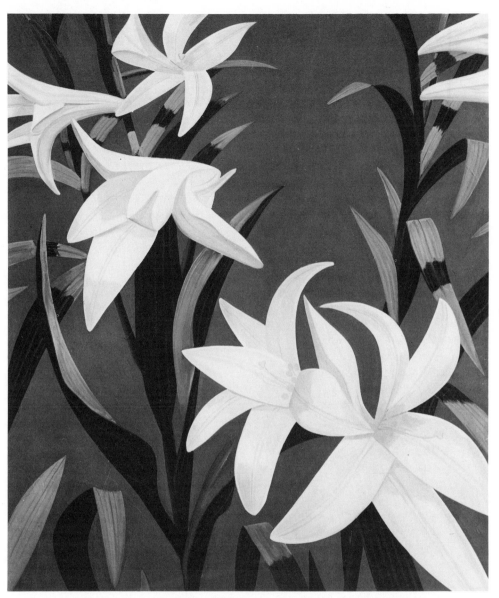

46. Alex Katz: *White Lilies* (1966). Oil on canvas, 94″×76½″.

47. Ed Ruscha: *Apartment House* (1965). 23⅜″×14″. Collection of Mr. and Mrs. Bagley Wright, Seattle, Washington.

48. Sylvia Sleigh: *Bob's Greenhouse* (1966). Aquatec on paper, 16″×20″. Collection of Mr. and Mrs. Keith Irvine, New York.

tion, is represented as "a bridge" between the Ash Can school and Pop art. Then there is to be a group of twenty-one younger artists (and who isn't younger than Hopper) who "responded, as Hopper did, to their environment, but also to a new climate of ideas." This seems to mean that the unity of the star and the gang is mainly demographic, except that Hopper emerges as obscurely honored. Seitz has put Indiana, Johns, Lichtenstein, Oldenburg, Rauschenberg, Rosenquist, Segal, Warhol and Wesselmann with Morley, Raffaele, Ruscha and Thiebaud. Of these artists one seems to have some real kinship with Hopper: Segal's *Gas Station,* for instance, has that mood of human isolation increased by architectural barriers that characterizes a Hopper, such as *Nighthawks.* Another painter who does not have the moral atmosphere of Hopper or Segal but whose paintings are really influenced by him is John Button, not in Seitz's choice. He does not paint out of a feeling of Dickensian pessimism, as Hopper does, but he goes over some of the same ground with innocence, cheerfully.

What Seitz appears to have done is to mix up Pop art and what we might as well call Post-Pop art. Admittedly both groups refer to the urban environment, as a scene or as a source of objects, but with differences. The environmental references of the artists called Pop are either literal (the incorporation of hardware into the work of art) or highly conventional (in the sense of trademarks and flattened signs, including lettering). In both cases, the object or the sign retains evidence of its environmental source; even a bent can was clearly Campbell's as well as Warhol's. The result is a great syntactical complexity in Pop art, and in this respect a number of artists who disavow the term can be related with other artists whom it doesn't seem to bother. The play of signs, the collision of mass-produced object and hand-made art context, led to a situation in which the environmental references and the formality of the work of art were simultaneously maximized. The referential material, whether Johns' coat-hanger or Dine's coat-hanger with Nancy's dress hanging on it in front of a picture, exist in terms that stress the ambiguity, the openness, of their union. Whereas figurative art depends on the complexity of function between one class of signs and their referents, Pop art emphasized the internal diversity of sign-levels and their external connectivity.

Post-Pop art is technically and syntactically less elaborate and less heterogeneous, though sharing many of the same reference sources as Pop art. Photographic sources have been used by both kinds of artists, but the differences in the use of subject matter and reproduction are significant. When Warhol and Rauschenberg use photographs, they are printed from silk screens, which can be used again, in the same work by Warhol, in different works by Rauschenberg. The silk screen, like the use of objects, abbreviates the technical procedures of painting and sculpture to a point of gestural suddenness. Post-Pop artists, how-

ever, use techniques that are closer to forms of realist painting. Artschwager uses photographs to work from, but he transfers them by hand, in dogged detail, figuring out subtle tonal correspondences. His subject is both the photograph and, say, the apartment house recorded in it; though both references persist he does not juggle sign-levels within the work and the original photograph is identified completely with the area of the board on which he works.

The paintings of Joe Raffaele are derived from photographs in magazines but they are of unique and/or anonymous situations (as opposed to the pre-known forms and signs of Pop art), set in clusters of detail. His earlier works are of images that generated connections between one another by their proximity on one canvas; the later ones tend to identify one image with each canvas. The delicate and brutal imagery, which hits the white canvas like a violation, has a resolute plasticity which forces the spectator to hesitate. The choice is between acceptance of the work as a literal compilation of specifics and taking the details as cues for closure, linking abdomen and canyon, man and beast. In fact, neither possibility can be given up: the detected themes of pains and sex coalesce tentatively, like the mirage of an oasis superimposed on Grauman's Chinese Theater.

Compare a nude by Wesselmann with nudes by Mel Ramos and Peter Holbrook. Wesselmann's girl will be a contour with signals for lips, nipples, and hair, one sign in an array of signs. Ramos, of course, makes references to Pop culture, but the form of his nudes is that of plausible three-dimensional solids located in an atmospherically lit space. The nudes (which developed out of his costume heroines from pre-Code comic books) have physical bulk; it is as if Wonder Woman, when turning back into Captain Diana Prince and becoming real, were to pop her costume and hide in the life room. Holbrook divides his paintings into grids, each equal square of which carries details of girls and their underwear. His earlier works were derived mostly from girlie books, the later ones from photographs taken by himself. Thus, the environmental reference (to *The Body Shop* or whatever) is reduced and personal control introduced from the beginning. The fragments of bodies are modeled with bulging plasticity; they are realistic details, not signs. A comparable tightening of the photographic source and the mimetic painting occurred in Morley's work, also. His earlier views of ocean liners had an ambiguous presence, caused by the fidelity of his brushwork to both object and photograph (it's a ship, it's a photo, it's Morley, man). His paintings of cabins, however, have a less paradoxical status, though also derived from photographs; the spatial recession is countered and oppressed by the color and texture of the paint (derived by the artist from devising paint translations for printed originals). Ambiguity comes from being close up to one translation channel rather than in simulating channel switches.

The term Pop art began as a comprehensive term designed to admit the mass media into the narrowly defined field of the fine arts. Then the term shrank to refer to the art produced by artists quoting the mass media or mass-produced sources. In the last two years it has opened out again and there is perpetual feedback between Pop art and mass culture. Bob Kane told me, before the Batman TV series started, that it would not be like his *old* comic book; on TV it would be 'Pop art Camp.' Thus, not only are artists quoting from the media, the media is responsive to Pop art, with the result being that any sense of cohesion some of the artists might have felt is weakened, either by sheer diffuseness or by artists withdrawing more emphatically from the term and scene it covered. (Roy Lichtenstein's solution is to rely increasingly on the traditional formal infra-structure of his art and, also, to make fine art instead of mass-art references, brushstrokes instead of comic books.) The environment as a source of intimate (because known) events and objects continues to occupy artists, but on a shifted basis. On one hand, there are artists who have developed towards aspects of realism, away from signs, and, on the other, there is a group of artists who retain much of the sign quality of Pop art, but without the syntactical ambiguity. The result: the art of the Chicago group called The Hairy Who.

The artists in the group have some shared interests which are the point here, not their individual profiles. Like Pop artists they use comic books as a source, but with them it is to help create a snow-balling discourse in an urban vernacular. There are no covert or imperious problems of signification, such as usually confound the apparently easy access of Pop art. Hairy Who art takes in tattooing, graffiti, and comic books as sources, especially perhaps *Mad, Help, Humbug,* and the college cartoons (Wonder Wart-Hog, for instance, started out at the University of Texas). Parody and caricature have no sense of self-reference, of self-explication, in Hairy Who art; parody and caricature are the direct embodiments of the human comedy, the authentic projection of organic life driving through awkwardness and city style. To trace an historical line for such art, one might go back through the Kelly Freas Baroque of the 'fifties Science Fiction magazines to Heinrich Kley. Jim Nutt's figures have bits of environment sticking to them like souvenirs attached by other people's chewing gum; Gladys Nilsson's crowds, to quote Bernheimer on something else, celebrate the "wild growth of imperfect individual specimens"; and Suellen Rocca's paintings have the profusion, simultaneity and directness of gossip. Karl Wirsum works without the others' sense of the urban crowd, but his fixed stare at balloons and French Letters in 1966 produced fascinating paintings in which the object struggles for its identity against its arbitrary handling.

A loose commentary, such as this article, is based on a couple of

49. Jim Nutt: *G. G.* (1966).
Acrylic on canvas, 30″ × 24″.

50. George Segal: *Woman Shaving Her Legs* (1963). Plaster, porcelain, and metal, 63″ × 65″ × 30″. Estate of Robert Meyer, Winnetka, Illinois.

assumptions that may be worth spelling out. First is the fact that discussion of figurative art is so far behind criticism of abstract art that some kind of general survey seemed appropriate. Second is the fact that much art criticism, when it hardens into opinion, becomes traditional two-valued, good/bad, in/out classification. However, trigger-happy value judgments made in advance of a descriptive and intentional account of all the work make the world too simple (which is how most people like it). This is the time for topographical work on a diverse art scene rather than for autobiographical preferences masquerading as ultimate judgment.

GEORGE SEGAL

The sculptures of George Segal are not cast from life in the usual sense that the material takes the direct impression of head or body. On the other hand, these sculptures do depend on the real bodily presence of the sitters, whom Segal wraps in bandages soaked in wet plaster. The sitters are protected by a layer of burlap or plastic as the chill dead weight of the impregnated material presses on them, absorbing the contours and posture of the enwrapped figures. Each separate section is cut off when it has hardened and joined ultimately with others to form the lunar crust of Segal's plasters.

What you see when you look at a Segal, then, is not a life cast but a skin, bearing on its buried interior surface the negative impression from which a conventional life cast would have been made. The exterior surface flows continuously in a way that recalls his origins as a painter; the plaster is, so to say, like a curving, folded painting, with comparatively little opening up or penetrating of the solid volumes. Spatial drama, where it occurs, is achieved by the sudden lifting of the whole figure, on a scaffolding or a ladder, or dropping it to the floor, in sleep or stupor.

The work process, as it blunts specific detail and muffles individual personality, performs an essentializing function, converting the documentary human traces into resonant images of humanity. Segal is one of the few figurative artists of this time who can generalize without becoming sentimental or gross. His figures have an expressive clumsiness, a kind of dumb concreteness that is stressed by their build—thick rather than athletic—as well as by their Frankenstein's monster feet. (The monster, as defined in early movies, was touching in its approximation to human bearing.)

In the catalogue of the exhibition at the Sidney Janis Gallery in April [1970], a work called *The Artist in his Loft* is described as consisting of "plaster, wood, glass, porcelain, metal." A plaster figure is shaving before a circular mirror framed by washbasin, cupboards, shelves and heater, simulating the corner of a room. There is a distinction here that

SOURCE: From *The Nation* (June 8, 1970), 702 ff.

the mere listing of constituent elements does not show. Segal makes and models plaster, but assembles the hardware with far less processing; the objects are found, fitted together. Handmade plasters are corporeal presences in an ambiance defined by ready-made objects.

The generalized humanity of Segal's figures is based, I think, partly on the bulky figures' aspiration to action and partly on Segal's ability to take hold of human gesture at its most representative moment in typical situations. His figures constitute, in a way, an anthology of ergonomic gesture. (Ergonomics is the study of the relationship between men and machines, but *machines* must be understood to include furniture, work space and all territories of human use.) Segal's early sculptures were of figures at table, a bus driver behind the wheel, a man on a bicycle, a man leaning on a pinball machine—all situations in which figures and hardware are joined. The plaster figures in real chairs and beds or on the stairs and in doorways show clearly Segal's care for the way people occupy a space shared with objects. Space, here, is not the abstraction of 1950s art criticism, but the area of human reach. Segal's eye for stance and gesture enable him to reconnoiter the "infinity of gestures and attitudes" that men make, to quote the artist, and to locate those with a typical significance. He has a shrewd sense of occupational poses (how to drive, how to climb a ladder) and of the typical kinds of rapport between the body and objects in walking, standing, sitting, lying.

When he is dealing with more than single objects, such as a chair, a ladder, a mirror, there is a risk that the objects will become a scenic setting for Expressionistic waxworks. Segal defends himself from this by a severely schematic use of real objects. Since 1965, the year of *The Butcher Shop* and *Old Woman at a Window,* his décor has been as artificial in its reality as the *mise en scène* of a late Godard movie. Segal has said, "My pieces often don't end at their physical boundaries." An example in the recent show is "Girl Looking into Mirror"; she stands on the floor, on the same plane as the spectator, and the mirror, on the real wall of the gallery, includes oneself as well as the girl's white reflection. *The Store Window* (a girl in a doorway is the depicted situation) is lit by two bright fluorescent tubes; the light source is contained within the sculpture, but radiates to illumine the spectator's space as well. Segal's ability to combine this expansive environmental space with the definition of compact figures is extraordinary. Body image and environmental space are convincingly united.

In the ten years he has been working in this style, Segal has been dealing with whole forms, the same size as life (plus an inch or two), uninterrupted by the demands of composition. Formal control is in terms of the location of figures among objects and their distance from the spectator. Beautiful works in this mode in the recent show were *Girl Looking into Mirror, Man on a Ladder* and *The Store Window.*

Parallel to the sculpture, however, Segal has made many pastels in which anatomies are cut and cropped with a doctrinaire post-Degas abruptness. Unexpectedly, he has transferred this tight fragmentation to sculpture in a group of shallow boxes, all 5 feet high and 2 feet wide, into which he has forced a bit of a red table, a bit of a blue chair, and slices of figures in relief. This sudden move into ostentatious tension and dense composition results in very awkward works whose experimental status was made even more obvious by their hanging in the gallery at a slanting angle off the wall.

PHOTO-REALISM

The discovery of the usefulness of photographs to a special form of realist painting began ten years ago. Richard Artschwager made a series of monochromes in which washes of liquitex, spread across a porous board, built up grainy images of buildings and other subjects, the veracity of which was a cross between newsprint and Daguerre. Malcolm Morley did several naval subjects in a similar monochrome before beginning in 1965 his fully polychromatic paintings of ocean liners, followed by cabin interiors. Artschwager has continued his monochromatic images, staying close to his initial style, but the work in this exhibition is concentrated on the simulation of color photography rather than black-and-white. The choice of work presumes an equivocal correlation between the status of painting and the photographic source, which means that Morley's later works, photographically derived but translated in terms of an unruly dark-keyed painterliness are excluded. What is presented here are the painters of a bright sunlit world or, at least, of bright sunlit photographs.

A few names have been proposed for this kind of painting, none of which questions its status as a form of realism. There is new realism, which overlaps too many old new realisms, to be useful. There is radical realism which has the disadvantage of originating with a dealer, thus mixing the functions of promotion and criticism. The same qualification must be attached to sharp-focus realism, a term which, whatever its origin, has been compromised by dealer use. Or there is photo-realism, adopted for this exhibition, which uses a contraction meaning photographic. I shall spell it out here as photographic realism and mean by it paintings that pertain to photography and are "suggestive of a photograph" (*Random House Dictionary,* unabridged).

In England the use of photographs by artists is not new: there is Sickert's well-known portrait of King George V and there is the extensive use of momentary poses and blurred forms in Francis Bacon's work.

source: From the catalogue of the exhibition *Photo-Realism: Paintings, Sculpture and Prints from the Ludwig Collection and Others,* arranged by the Arts Council of Great Britain and shown at the Serpentine Gallery, 1973.

Peter Blake derived figure paintings from magazine pin-ups at an early date, too. However, the thorough simulation of photographs or photographic reproductions by hand-done paintings is less familiar and it is this practice that has developed in the United States in the last ten years. There is no doubt Pop art was influential here, whether as a model of admitting casual contemporary subject matter or of imitating in painting images characterized by other means of communication. Warhol's use of repetitive photographs and Rauschenberg's use of a proliferation of photographs in their silk-screened paintings show, within the terms of Pop art, an interest both in annexing ready-made imagery and in simulating other channels.

The first exhibitions of photographic realism combined Artschwager and Morley with Rauschenberg and Warhol on the basis of their common photographic sources. Though distinctions emerged later, the origin of photographic realism close to Pop art is significant for it enables us to define one aspect of the tendency with some confidence. What happens when an artist quotes a photograph, not simply as an *aide memoire* as Delacroix and Courbet did, but in such a way that the photographic quality as well as the depicted object are readable in the painting? To answer this we can define a photograph as a system of co-incident "points between the photograph and pre-existing points of physical reality." [1] For this reason, as William M. Ivins, Jr., has pointed out, "a photograph is today accepted as proof of the existence of things and shapes that never would have been believed on the evidence of a hand-made picture." [2] In this sense, the photographic realist can count on the evidential content of photographs, reliable to him as a source of visual data and trusted by the spectators who share his belief in the medium. The photographic sources can be found or newly made: found sources include Morley's travel-poster Ektachromes and McLean's ads in ranch and stable magazines; newly made sources include Bechtle's, Goings', and Parrish's own photographs, taken with a view to being painted later. There is not all that difference between them, because personal photographs easily take on the standard gloss of CinemaScope movies, color ads in weekly magazines, and display effects in automobile or kitchen-appliance literature.

One of the reasons for the believability of photographic reproduction is the fact that, to quote Ivins again, "the lines of the process . . . could be below the threshold of normal human vision." [3] Hence it was "a way of making visual reports that had no interfering symbolic linear syntax of their own." [4] Compared to the engravings (Ivins'

1. Max Bense. "Esthetics and Photography." *Camera,* 4, 1958. (English summary.)

2. William M. Ivins, Jr. *Prints and Visual Communications.* London, 1953, p. 94.

3. *Ibid.,* pp. 176–177.

4. *Ibid.*

"linear syntax") that preceded photography as a method of reproducing objects, this is quite true but, in addition, there have been consumers and producers of photography for generations now. Thus along with the credibility of photographs is the fact that we have developed an expertise that makes us aware of the limits of the process itself. Cropping, focus, and omitted material are a part of photographic convention as well as the iconicity of the image. Thus photography has acquired its syntax, too, its specific channel characteristics. As a result, when we look at a photographic realist painting there is a double image: we see both a painting and an image clearly derived from a photograph. The painting carries a reference to another channel of communication as well as to the depicted scene or object. The reality of photographs, however, is not the reality of slow, hand-done paintings, so that the realism of the subject matter is definitely called in doubt. It is as if the subject matter of, say, Eddy's picture is not a Volkswagen but a photograph of a Volkswagen. The photograph corresponds to the car as we know it, but the painting corresponds as much to the photograph as to the car: it is, perhaps, the photograph that functions as the primary reference. To the extent that this is so the terms photographic and realism can be viewed centrifugally, as tearing themselves apart by the interplay of channel and iconography.[5]

The artists are of course all concerned with the illusionism that accompanies high finish in the rendering of stable objects and scenes. The style does not, for the most part, refer to things in use, but to things on display, for sale it seems. By taking the lustrous surfaces of Hollywood photography and Detroit styling as norms, the artists have cultivated a deceptive realism. There is a sustained sense of newness, of a world of highlights that is stylistically akin to the ravishing reflections and gradations in, say, brochures for new cars or company reports on new products. This means that the realism of those artists is diverted from its expected target, turned away from the notion of use in the world and the occupancy of real space and affiliated with the sphere of symbolic use, of advertising. The rhetoric of consumer persuasion is attached to the finish of these pictures, a point made not in criticism but descriptively. It is by adopting the impact of the imagery of commercial art that the photographic realists present their imagery so forcefully. It is their irony, and one cultivated by the artists to judge from their evasive remarks on iconography quoted below, that the technique does not enshrine the object so much as define its periphery of symbolic uses in the media.

5. It is this aspect of photographic realism, its conversion of channel to subject matter, that leads to its being called post Pop art [see the author's "Art as Likeness," pp. 171–181 in this volume]. Note that Roy Lichtenstein's comic-strip imagery simulates another channel of information as well as an appropriated image.

Consider some representative statements [6] concerning iconography and the artists' attitudes towards it. Bechtle: "I am certainly aware of the social implications of my subjects, but I try to preserve a kind of neutrality." Cottingham: "I'm just using the subject as the stepping-off points to compose the subject." Eddy: "I think the subject matter is dictated to me by the kind of painting problems I'm interested in." McLean: "I think neutrality is extremely important" and Morley has always equivocated about his engagement in the iconography of his paintings. None of the artists expresses, as a realist would, his commitment to objects or a situation in the world. On the contrary, they stress either stances of detachment or formal convenience.

It was the intention of the organisers of Documenta 5, the exhibition held at Kassel [in 1972], to compare American photographic realism with Soviet social realism.[7] In the event, only the American contingent was shown but the project was clearly based on an iconographical reading of the works involved. What is characteristic of the photographic realists, but the topography of the interfaces and points-of-sale of American life? Leisure subjects include ocean liners and prize horses, beach scenes and movie stars' homes. There are street scenes with the web of reflections that was unknown to urban life before the 20th century (the Futurists and Léger were the first to notice the effect of the use of glass in the city) and fascias signalling wares and services. Cars are present in a complete cycle from show room to parking lot, from street parking to wrecking yard. Highway culture is present from gleaming capacious trailer to gleaming customized motor cycle. Thus there is a subject matter of great accessibility, not only to Americans who recognise the details of the hardware but to Europeans who recognise the process of industrialization that makes all this possible and who know their equivalents. Compared to Soviet realism, which is closely related to genre and history painting, American photographic realism derives from its source a sense of chance configurations at arrested moments. Russian realism aims to mold images that are historically significant whereas the American artists aim at the statistically familiar. There is in this kind of painting a discrepancy that produces a formal tension between the high finish of the paintings as objects and the typical, randomly chosen, subjects that they depict.

There is no built-in restriction in the subject matter of photographic realism obviously, but Morley is one of the few to have dealt with the past in his château and castle pictures (begun on the basis of a postcard that David Hockney sent him). However, it is significant that the

6. *Art in America,* 60, 6, November–December, 1972. "Photo Realism. 12 Interviews," pp. 73–89. Quotations from pp. 74, 78, 81, and 83.
7. For a list of the projected Soviet representation, see the author's " 'Reality': Ideology at D5." *Artforum,* 11, October, 1972, p. 36.

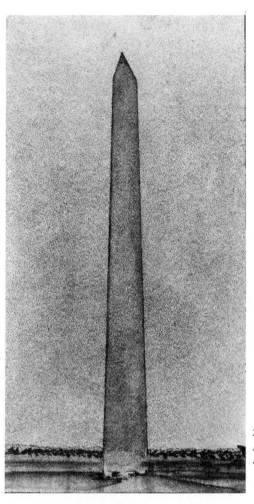

51. Richard Artschwager: *Washington Monument* (1964). Liquitex on celotex, 47″×26″.

52. Malcolm Morley: *Cristoforo Colombo* (1966). Liquitex on canvas, 47″×26″.

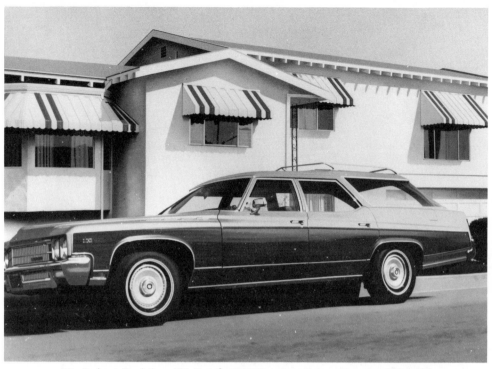

53. Robert Bechtle: *'71 Buick* (1972). Acrylic on canvas, 48″×68″.

54. Ralph Goings: *Jeep 40809B* (1969). Acrylic on canvas, 45″×63″. Collection of Mr. and Mrs. Richard Thompson.

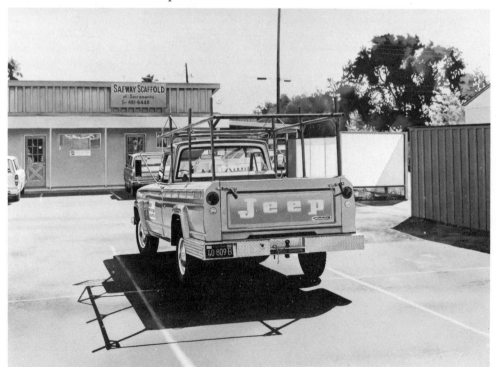

iconography of these painters includes a minimum of historical references; what they seem engaged with is the typicality of the present, the conjunctions of objects that are normal in our society, not its precious monuments.[8] A great many of the scenes and objects that they represent, such as Goings' *Air Stream* or Salt's *Cars* are meaningful to us by their commonness. This is no less true of Close's portraits than of the other artists' objects, inasmuch as they are selected from the artists' friends and are representative of the art world in terms of social style and type. This use of a fund of common images and signs is related to Pop art. McLean is alone with his "Sure, I owe a big debt to Pop." However the other painters have recorded various degrees of affection or obligation.[9] Goings is especially interesting in this context, when he says: "I believe in a kind of random order in the way reality puts itself together."[10] The oxymoron random order was coined by Rauschenberg who used it, as Goings does, to describe the chance conjunctions of daily life.[11]

What we have therefore in photographic realism is an art of high visual impact, but with complexities held in suspense within it. There is no single and direct route from the signifier to the signified. It is true that this iconography is derived from everyday life. To quote Henri Lefebvre: "the quotidian is what is humble and solid, what is taken for granted and that of which all the parts follow each other in such a regular succession that those concerned have no call to question their sequence."[12] However, as we have seen, the quotidian is not directly expressed in these paintings. It is mediated by borrowed images, by the quotation of sources known, at least in type, to the spectators as well as to the artist. Thus there is an intricate relation of the painting as one kind of sign to other signs of an absent object, but a sign which, owing to the technique of presentation, appears as a powerful presence. To borrowed images and mediated references we must add the emotional disengagement of the artists, for which we have

8. Aside from Morley, Audrey Flack, with her paintings of Macarenza Esperanza (a 17th-century statue), Notre Dame, and Michelangelo's *David,* has dealt with the image of historic monuments filtered by modern slide technology.

9. See *Art in America, op. cit.* Bechtle: "Pop was the catalyst" (p. 74). Close: "Certainly we have to be aware of the fact that Pop happened" (p. 76). Cottingham: "Pop showed us that there was a lot more subject matter around than we were paying attention to" (p. 78). Eddy: "Without Pop I don't think this would have happened" (p. 81). Estes: "I always liked Pop" (p. 79). Parrish: "I like the freedom of Pop" (p. 88). Salt: "I like some of the Pop artists, sure, but it's a long way away" (p. 88).

10. *Ibid.,* p. 88.

11. Robert Rauschenberg. "Random Order." *Location,* 1, 1, 1963, pp. 27–31.

12. Henri Lefebvre. *Everyday Life in the Modern World.* Trans. Sacha Rabinovitch. New York, 1971, p. 24.

their own word. This complex situation, an interplay of illusion and convention in deceptive intimacies, the "disinvolvement from passion," [13] is as reminiscent of Mannerism as of realism. Such a view seems to accord with the fascinating mixture of daily subjects oddly distanced from us, of complex references rather than substantial presences, that characterise photographic realism.

13. John Shearman. *Mannerism.* Harmondsworth, 1967, p. 61.

ART AND INTERFACE

There are two completely opposed approaches to art: one that aims to distill and purify (an activity at present identified with formalist criticism) and one that studies the expansion and connectivity of art. One form of this is ambiguity in the interface between the work of art and the spectator. This takes various forms, such as the interpenetration of different arts (as in Happenings), the equivalence of documents to art works (as in Conceptual Art), and the proposal of new ways to use the landscape (Earthworks). In all these activities works of art are expanded or contracted or displaced from their customary legibility in pure media arts. Hence the use of the term *interface* to indicate the problematic boundaries of art's zone and our space as well as our understanding. (*Interface:* 1. a surface forming a common boundary of two bodies or two spaces; 2. the changeover from one system of communication to another.)

ALLAN KAPROW,
TWO VIEWS

Allan Kaprow's book *Assemblages, Environments and Happenings* was designed by the artist and the first section has a sequence of lively photographs, captioned by Kaprow in awkward, tough, hand-printed letters. A run of these words and phrases, printed like a poem (one line per double page spread), catches the evocative potential of Happenings and display the lyrical side of the author:

> Specters from refuse
> Obsession
> Enchantment
> Out of gutters and garbage cans
> People inside
> Statues inside
> Fragile geometries
> Science fictions
> And immaterial spaces
> Objects hung on panel
> Days to be moved
> Panels to rearrange
> Caves
> Chrysalis
> Animals
> The animal, nods, sings, jigs
> Endless. . . .

Kaprow records in the Preface that his book was written in 1959–60, revised in 1961, and revised again later. More has happened to

SOURCE: A composite of two pieces: (1) "Art in Escalation," *Arts Magazine,* XLI/3 (December, 1966–January, 1967), 40–43; (2) from *The Nation* (October 20, 1969), 419–421.

Happenings in this period than can easily be handled in a 20,000-word essay stashed away between masses of *Paris Match*-type illustrations bound into something that looks and weighs like the family Bible. One problem of the long writing period is revealed by alterations that Kaprow has made to earlier texts embedded in the book. In the original description of a model Happening, for example, he began with "everybody crowded into a downtown loft," but in the book "everybody is at a train station." The Happening has also been expanded to include summer and winter, though other items and occurrences are unchanged. When he first wrote, lofts (or galleries) were the places for Happenings, but he has changed his mind about this because a room is "a frame or format, too." He concluded that the loft situation, despite some crowding and surrounding of the audience, failed to block theatrical residues in the spectacle-spectator relationship. Audience elimination is now mandatory; only participation remains.

Loft and gallery are too geometric for Kaprow now; open country, a secondary theme in some early writing, is now the scene. Redrawing the lines of demarcation between different art media is no longer enough; not only have these media lost their "traditional identities," but Kaprow proposes "moving and changing locales" and "variables and discontinuous" time as well. To the continuity of one art with another, he has added fluidity of architecture with art and nature in one big loop.

Despite his new emphasis on country settings and on the diffuseness of the work, beyond any form of compactness, Kaprow preserves some of his earlier arguments. He has not changed his escalation ladder for more or less unprocessed readymade material from Collage to Environments to Happenings. It is true that the early, Junk Culture phase of Environments and Happenings can be viewed in such a sequence, indeed grows out of it, but not the later developments, such as Kaprow's own work or the events of Brecht and Watts, reticent and, to many, imperceptible. The spread of Happenings as structure, more duration, more area, raises undiscussed problems about the limits of attention and recognition as well as of the artist's remote control. If there is a discontinuity between Kaprow's present theory of Happenings, cogently derived from his own work, and the historical origin of Happenings in general, he does not go into it. The urban quality of his early work (shared with Oldenburg and Dine, for instance) once led him to record his pleasure in "the vastness of 42nd Street" and to propose that "a walk down 14th Street is more amazing than any masterpiece of art." These (unreprinted) words of a few years back have been replaced by mythic patterns and, to quote the self-aware Kaprow, an increased stress on "organicist principles."

In the Hansa Gallery catalogue for a 1958 Environment, Kaprow

wrote: "This idea of a total art has paradoxically grown from attempts to extend the possibilities of one of the forms of painting, collage, but unknowingly this led to the rejection of 'painting' in any form, without however eliminating the use of paint." Given the formalist bias of U.S. art criticism, it was undoubtedly to the point to affirm Cubism not as a maximal pictorial structure, but as an art form geared to incorporate literal quotation in the form of newspapers, wallpaper, and wine-labels. It was, for one thing, in opposition to the one-medium aesthetic which was and is so strong in New York painting. However, Happenings are now clearly established and evidently a mixed-media art exists now as a public and available alternative to one-medium art. Even the Mayor's office is tuned in: "A 'Happening' is a favorite term of this city's [New York] Park Department, whose staffers say that if you can define it, it's not a true Happening," wrote the *Wall Street Journal* (November 14, 1966). What is needed now is not so much arguments to defend mixed-media art from one-medium-art theories, but an attempt to differentiate Happenings from one another and from other compound media arts.

The term total art is not one that Kaprow has returned to, but it is significant for his subject, the expanding art work. The theory of total art comes from Wagnerian opera in which the individual arts were submerged for a greater unity. What are the differences, not between Happenings and Morris Louis or Chardin, but between Happenings and Opera? It is not enough to dismiss any connections as theatrical holdovers; the point is the melting of the media. The spatial flow of Baroque art unified each bit of separate medium in terms of spectator participation in a unified space; the stylistic continuity of Art Nouveau stretched to cover unique High art and mass-produced objects. The phased time-sequences of picturesque landscape gardening included spectator time, natural objects like trees, and surprise as an aesthetic category; the building of ornamental ruins assumes time as a medium; and the complex tradition of *Ut Pictura Poesis* depends on the connections between two art forms, visual and verbal. Some of these matters might have been more usefully discussed today than the profile of painting as picture-making (the caves, the Middle Ages, pure painting) which is what Kaprow gives us history-wise. The purpose of such a discussion would not be to show that Happenings really have their roots in past activity, but by using the past as a control group we might define more clearly what is happening now. What are the terms for an aesthetics of temporal succession rather than of instantaneous spatial display? How to set up an aesthetics to cover multiple heterogeneous objects, instead of the usual homogeneous single unit? Kaprow's work, his Happenings and his writings, were seminal and stay central, even if he has not resolved the divided claims of early work and later ideas in his book.

55. Allan Kaprow: *Record II* (*for Roger Shattuck*) (1968). Happening. University of Texas.

II

Happenings, of all art forms, are dependent on a photographic record, if the fugitive actions are not to be confined to the participants' memories. Claes Oldenburg's season of Happenings, 1961–62, the last of the classic first wave, was filmed by Raymond Saroff. The filmic record is essential to supplement Oldenburg's scenarios (published by the Something Else Press). Peter Moore has photographed with remarkable patience almost everything in the way of Happenings, events, and environments through the sixties; as a result, his archives are crucial to a study of the occasional aspects of recent American art. A shift in the forms of visual art, toward the ephemeral and the diffuse, has created a storage problem. Paintings and sculptures persist as objects, but an art of performance and problematic thresholds leaves no original body and can be preserved only in record form. Warehouses and libraries supplement galleries.

Allan Kaprow's *Days Off, A Calendar of Happenings* [1969] is a case in point of the uses of documentation. The calendar consists of inscriptions and photographs (including some by Peter Moore) of ten Happenings, all but one of them enacted last year (the exception, "Moving," dates from 1967). When a new Happening is scheduled there is an announcement like: "Those interested in participating should attend a talk by Mr. Kaprow at the Campus Center Cafeteria, the State University of New York at Albany," or wherever it may be. The kind of Happening that Kaprow produces now is totally unlike Oldenburg's more or less theatrical form. Kaprow says he "selects and combines situations to be participated in, rather than watched." The experience of the participants and their memories are the aesthetic constituents of what Kaprow calls "the Activity Happening." The calendar perpetuates such occasions, though a calendar is, in function, expendable and the cheap paper here looks it.

Kaprow describes the publication thus: "This is a calendar of past events. The days on it are the days of the Happenings. They were days off. People played." The kinds of activity are mostly physical and nonreflective; it is not that the action cannot be thought about but that this phase is postponed until the act, for example, of unrolling a mile of tar paper, has been performed. Here are the complete instructions for *Shape:* "Shoes, bodies on streets, sidewalks, fields. Spray painting their silhouettes. Reports and photos in newspapers." One Happening called *Transfer* is dedicated to Christo, presumably because the activity here consists of rearranging and re-siting metal barrels, objects which Christo used as material for art in Paris in 1961.

Documentation cannot transmit the zeal of the agents, but it brings out an aspect of Happenings which is often lost sight of, or is not known, by the original participants (except for Kaprow). Taking part in a Happening must include individual boredom, facetiousness and uncer-

tainty, but the visual trace, the documentation, has another value. The activities in Kaprow's recent pieces have to do with labor (diverting water, moving furniture), monument building ("triumphal" stacks of barrels, walls of ice), the imprinting of human tracks, as in "Shape," and memorializing the gesture of sitting, for instance, with chairs carried around outdoors and instant Polaroid snapshots of each stop left *in situ*. Kaprow's early Happenings were overtly mythological; now the games concern the body in action and its occupancy of space, a kind of playful human engineering. The calendar, memorializing one of Kaprow's most brilliant periods as a Happenings master, is itself an object of tough grace, with a profusion of grainy, factual and enigmatic photographs. It is obtainable for $2.37 including postage from the Museum of Modern Art (it was commissioned by the Junior Council) and the original collages of photographs, laconic scenarios and dates are on view through October at John Gibson Commissions.

The expanded role of documentation has become an essential element in the definition of art. It is an extension of the area of artistic control, and it brings new information to an old argument about the relation of originals to reproductions. Works of art consist of both unique and translatable elements. Some things resist reproduction (the interplay of scale and facture in a painting, the collective *élan* of a Happening crowd) and can be experienced only in the presence of the work itself; but other information can be transmitted by reproductions. Many iconographic, formal, and intentional aspects of art survive in reproduction. Norbert Wiener in *The Human Use of Human Beings* (the book that should be read in place of its cheap derivative, Marshall McLuhan's *Understanding Media*) has this to say on the subject: "Cultivated taste may be built up by a man who has never seen an original of a great work and . . . by far the greater part of the aesthetic appeal of an artistic creation is transmitted in . . . reproductions."

The only reservation one might have is that reproductions are read best by those who know *some* originals, though not necessarily the ones being reproduced. Wiener's slight overstatement, however, is preferable to the exclusive praise of the uniqueness of originals at the expense of all translations. The unreproducible parts of a work are frequently secondary refinements. It is certain that Brueghel communicates to people who have not been to the Kunsthistorisches Museum in Vienna. Kaprow's calendar could convey more to a reader than some participants could be expected to derive from a performance. The expertise everyone has developed in reading modern reproductive processes impinges at this point on what Walter Benjamin called the "aura" of the original. In fact, documentary reproduction can be the only route of access for some art. Current uses of reproduction as a constituent of art make creative play out of everybody's familiarity with mass communications.

ARTISTS
AND PHOTOGRAPHS

At least since Delacroix, when the camera provided a modern technique for getting direct images of the world (*Journal,* May 21, 1853), photographs have been in the hands of artists. They were, as Delacroix saw, images of the world unmediated by the conventions of painting; these were followed, later in the 19th century, by the wide distribution of works of art by photographic reproductions. This was defined by Walter Benjamin in Marxist terms in the 20s and celebrated later by André Malraux in terms of the camera's autonomous pictorial values. In the 20s, collages and photo-montage, new works of art produced by photography, were abundant.

The present exhibition/catalogue clarifies with a new intensity the uses of photography, in a spectrum that ranges from documentation to newly minted works. Some photographs are the evidence of absent works of art, other photographs constitute themselves works of art, and still others serve as documents of documents. This last area was the subject of an exhibition at the Kunsthalle, Bern, last year, *Plans and projects as art,* a survey of diagrams, proposals, propositions, programs, and signs of signs. Bernar Venet's book which is a profile of his "exploited" documents since 1966 demonstrates this possibility. The different usages are immense: for example, Douglas Huebler documents place not duration, whereas Dennis Oppenheim's piece is sequential, a chart of time-changes. One thing everybody has in common should be noted: there is an anti-expertise, anti-glamourous quality about all the photographs here. Their factual appearance is maintained through even the most problematic relationships.

One of the uses of photography is to provide the coordinates of absent works of art. Earthworks, for example, such as Robert Smithson's, can sometimes be experienced on the spot, but not for long and

SOURCE: From *Artists and Photographs* (New York, 1970), pp. 3–6, the catalogue of an exhibition at Multiples, Inc., New York.

not by many people. Documentation distributes and makes consultable the work of art that is inaccessible, in a desert, say, or ephemeral, made of flowers. The photographic record is evidential, but it is not a reproduction in the sense that a compact painting or a solid object can be reproduced as a legible unit. The documentary photograph is grounds for believing that something happened.

Photographs used as coordinates, or as echoes, soundings that enable us to deduce distant or past events and objects, are not the same as works of art in their operation. Max Bense has divided art and photography like this: "the esthetic process in painting is directed towards creation: the esthetic process of photography has to do with transmission." "Painting reveals itself more strongly as a 'source' art, and photography more strongly as a 'channel' art." [1] Dennis Oppenheim classifies photographic documentation as a "secondary statement . . . after the fact," [2] the fact being, of course, the work out in the field. He feels restricted because "the photograph gives constant reference to the rectangle. This forces any idea into the confines of pictorial illusionism." However, the distinction between source art and channel art enables us to disregard the four edges as a design factor; the area of the photograph is simply the size of the sample of information transmitted, a glimpse. Common to both the absent original and to the photographic record is phototopic or day vision, with light as the medium of perception on the site and in the record. The works are, after all, photographable.

There is the possibility that documents, as accumulating at present, may acquire the preciousness that we associate with, say, limited-edition graphics. The development of Earthworks or Street Events is resistant to the possession of art as usually understood and photography resists becoming personal property by its potentially endless reproduction. The fact that photographs are multiple originals, not unique originals, as well as one's sense of them as evidence rather than as source objects, should protect their authenticity ultimately. In the present instance, in *Artists & Photographs,* the contents of the catalogue are variants of the items in the exhibition, not reproductions. Both the exhibited "object" and the catalogue "entry" are permutations made possible by the repeatability of the photographic process.

Michael Heizer has discussed the role of photography in relation to his own work. Of a work in Nevada he writes: "it is being photographed throughout its disintegration." [3] The run of photographs records the return of probability to his initial interruption of the landscape. He points out that photographs are like drawings, as the basic graphic form of his big works in the landscape is recovered in aerial

1. *Camera,* 4, 1958.
2. Letter to Multiples, 1969.
3. *Artforum,* December, 1969.

56. Douglas Huebler: *Variable Piece, 107* (1972).

photography which shows the earth's surface as an inscribed plane. Related to the concise graphism of photographs is the camera's effectiveness as an image-maker. Heizer's own bleak landscapes, like excavation sites, Smithson's photographing of mirrors in a pattern in landscapes to make a compound play of reference levels, and Richard Long's walks in the country with regular stops for documentation with a camera (of the view, not of the walker) presupposes a photographic step in the work process. As Oppenheim has said: "communication outside the system of the work will take the form of photographic documentation. . . ."[4]

Other artists in this exhibition/catalogue use the camera as a tool with which to initiate ideas rather than to amplify or record them. Edward Ruscha is represented by *Baby Cakes*, one of the factual series of photographs which began as early as 1962 with his book *Twenty-six Gasoline Stations*. This book, like his later ones, is neither sociological (the sample of subjects is arbitrary) nor formalistic (the imagery is casual), but it is a concordance of decisions, unmistakably esthetic, for all their deadpan candour, in the absence of other purposes. Similarly Bruce Nauman's photographs of the air (sky?) over Los Angeles solidifies the channel functions of photography into a source art. In such works the photographs are themselves an object, an original structure projected by the artist. The information that Nauman's photographs carry cannot be decoded as news of weather or pollution or as a lack of unidentified flying objects. (The information that Nauman's *LA AIR* does not carry, though it looks as if it might, is different from Marcel Duchamp's *Air de Paris*, 1919. That sample of the atmosphere is contained in a sealed glass ampule, of which one would have to say, this is *not* a piece of laboratory equipment, etc. The artists in both cases work against the reduction of the photograph or the object to a channel function.)

Michael Kirby takes "clarity as the only conscious standard" in both shooting and developing his photographs, but the result is not record but source. In *Pont Neuf* he uses six photographs, taken from one point, to provide views of the surrounding space: the work can, as it were, be inferred backwards to the converging point. Jan Dibbets' work is inconceivable without monocular vision (that is, a camera); his "perspective corrections," whether constructions built in a field or areas ploughed on a beach, demand one absolute viewpoint to be effective. Only from that one point can his inversion of distance give the appearance of flat squares and posts of identical size. "Misunderstandings," an anthology of quotations found by Mel Bochner (his contribution to the catalogue), includes this: "Photography cannot record abstract ideas," but his piece in the exhibition ironically and defiantly is concerned with measurement (i.e. a form of abstraction).

4. *Land Art,* Fernsehgalerie, Berlin, 1969.

The artistic ideas and operations that need photographic documentation are especially those that are modified in time. Time, in fact, is central to photography. In the case of Christo there is data on the wrapping of a tower, some of it prospective (diagramatic or simulated) and some of it memorial; the work process is arrested at different points in time. Sol LeWitt's *Muybridge III* takes a classic image of motion (successive views of a walking nude) and encloses it to be viewed directionally. Dan Graham's work alludes to Muybridge's measured walking images, but here it is the walkers who take relational photographs of one another. The slides are then projected quickly on two screens, compressing the original time sequence. Robert Morris' piece is a record of a "continuous project (altered daily)." Only by photography can the temporal route of a work of art be recorded in terms homologous to the original events. It should be stressed that it is not a question of memorializing a favorite state, catching the work's best profile, but of following the process.

These artists occupy various points in a zone that includes Conceptual art, Earthworks, Happenings. Conceptual art, to the extent that it is to be thought about, or repeated, or enacted by others, insists on documentation systems *originated by the artist himself*. This is no less true of performance arts, such as Happenings or Events, which survive verbally as scenarios or schedules and visually as photographs. The record of one of Allan Kaprow's Happenings is a form of completion. It is necessary to differentiate these uses of photographs by artists from other approaches. The present title *Artists & Photographs* has a verbal echo of, for instance, *The Painter and the Photograph* (University of New Mexico, 1964) which is a study of photography as a transmitter of information for the use of figurative painters.[5] *The Photographic Image* (Solomon R. Guggenheim Museum, 1966) was divided between artists who imprinted photographs in paintings (see below) or who copied photographs, less as an aid to illusion than as a play with the channel characteristics of the medium. (In the work of Richard Artschwager, Malcolm Morley, and Joseph Raffaele the subject is frequently the photograph itself rather than what the photograph depicts.) *Paintings from the Photo* (Riverside Museum, 1969–70) combined both realist and post-Pop usages.

A NOTE ON PROCESS ABBREVIATION

Abstract painting has many ways of achieving the 20th-century dream of an instant, unrevised, all-at-once art form. There has been a steady sequence of process abbreviation, compressing and reducing in number the stages that go to make up a work of art. Staining and high-speed

5. The catalogue includes a history of artists using photos by Van Deren Coke.

calligraphy, for instance, have a directness to which figurative art has little access. One of the few ways is in the use of photographic images printed on silkscreens; not only is there an immediate delivery of a grainy, convincing image to the canvas, as the screen is pressed down and painted on the back, but the screen can be used again. Both technique and image are immediate. If "a print is the widow of the stone," to quote Robert Rauschenberg,[6] then a photograph is the twin of an event. Andy Warhol's method is the repetition of the single image within each work, varying it by nonchalant registering and impatient inking; Rauschenberg's way is to cluster different screens in each work, repeating them only in other works.

6. *Studio International,* December, 1969. Rauschenberg is referring to lithography, but in terms of assimilating photographic impressions the medium resembles silkscreen printing.

THE EXPANDING
AND DISAPPEARING
WORK OF ART

The minimum requirement of esthetic identity in a work of art has been legibility as an object, a degree of compactness (so that the object is united, composed, stable). In the 'sixties, a number of non-compact art forms (diffuse or nearly imperceptible) have proliferated. It is the expansion or diminution of art as a solid structure that I want to describe. The interface (cross-over point, junction) of art and other things has blurred. (This tendency has been discussed as "The *Dematerialization* of Art." [1]) New control methods devised by artists lead to recognition-problems for spectators.

I propose a cluster of seven items: (1) the function of the cliché, (2) the mode of intimacy, (3) permissive configurations, (4) exteriority, (5) occupancy of places, (6) conceptualization, and (7) diffuse systems.

1. Clichés.

 The use of the cliché in context of art connects public signs with personal systems. Clichés dissolve formal boundaries (as in Roy Lichtenstein). Alain Robbe-Grillet: "The integration in a plastic work of, on the one hand, the objects belonging to an acquisitive society and, on the other, the comic strips." [2]

2. The mode of intimacy.

2.1. Claes Oldenburg: "I am for an art that unfolds like a map, that you can squeeze, like your Sweety's arm, or kiss, like a pet dog. Which

SOURCE: From *Auction,* III/2 (October, 1969), 34–37.

 1. Lucy Lippard and John Chandler, "The Dematerialization of Art," *Art International,* 12, 2, 1968.
 2. Alain Robbe-Grillet, "Anti-humanism in Art," *Studio International,* 175, 899, 1968.

expands and squeaks like an accordion, which you spill dinner on, like an old table cloth." "I am for an art that grows up not knowing it is art at all, an art given the chance of having a starting point of zero." "If I could only forget the notion of art entirely, I really don't think you can." "I have got my sentiment for the world all mixed up with art." [3]

2.2. Oldenburg's Ray Gun Manufacturing Co. (his studio used like a store) became the Ray Gun Theatre: crowded audience and performers. Partial views and ambiguous duration.

2.3. George Brecht's, Robert Watts' Events known only incompletely to those taking part. Allan Kaprow: "The Activity Happening selects and combines situations to be participated in, rather than watched or just thought about." [4]

3. Permissive configurations.

3.1. Soft sculpture and scatter. Robert Morris on the opposition to "preconceived enduring forms and orders for things." "Object-type art," rigid, predicated on right-angled relationships. "Oldenburg was one of the first to use . . . materials other than rigid industrial ones." [5] Alan Saret's galvanized wire, 1967–68; Barry Le Va's "distributions," 1966–68; Bruce Nauman. An imagery of harnesses, straitjackets, ragtrade leftovers, fallen fences. Use of felt.

3.2. Carl Andre: "Random piling, loose stacking, hanging, give passing form to the material. Chance is accepted and indeterminancy is implied since replacing will result in another configuration." Andre, referring to his brick piece in the Jewish Museum, 1965: "naturally occurring particles which I simply display in a natural unmodified manner." [6]

4. Reflecting and transparent materials.

4.1. Formerly celebrated as symbols of modernity ("new materials of new world") but, as visual fact, plastics and polished metal are incessantly renewed by light-changes. The spectator as witness of unexpected disintegrations and shifts of the object.

4.2. Work of art as "an instrument for seeing rather than merely an object" (Michael Kirby's expression). "Years of practice in ignoring the surrounding environment" [7] reflected in the glass in front of pictures (used as a trap by Francis Bacon). Exteriorated works,[8] as Michael Heizer calls them, tolerate environmental changes, are larger than their physical dimension as parts of the outside are incorporated. Limits not set by the work's outer face. "Awareness must clearly include the real space" (Kirby) around the work, including light sources and movements. Sculpture as "instruments" that are stimuli to perception. (Samaras' mirror rooms.)

3. Claes Oldenburg, *Store Days,* edited by Emmett Williams, New York, 1967.

4. Allan Kaprow, "Pinpointing Happenings," *Art News,* 66, 6, 1967.

5. Robert Morris, "Anti Form," *Artforum,* 6, 8, 1968.

6. Quoted, Howard Junker, "Getting Down to the Nitty Gritty," *Saturday Evening Post,* November 2, 1968.

7. Michael Kirby, "Sculpture as a Visual Instrument," *Art International,* 12, 8, 1968 (reprinted in Kirby, *The Art of Time,* New York, 1969).

8. Quoted, *Options,* exhibition catalogue, Milwaukee Art Center, 1968.

57. Carl Andre: *Joint* (1968). Uncovered common baled hay, 183 units, 14″×18″× 36″ each. Windham College, Putney, Vermont.

58. Dennis Oppenheim: *Time Line,* detail (1968). Frozen St. John River, 3 miles. Boundary between the United States and Canada.

59. Robert Morris: *Drawing for Los Angeles Project* (1969).

5. Earthworks (title of science-fiction novel by Brian Aldiss, 1965); also land art.

5.1. "Remote places such as the Pine Barrens of New Jersey and the frozen wastes of the North and South poles could be coordinated by art forms that would use actual land as a medium." [9] Smithson's proposal makes the scale of Heinz Mack's (ideal) Sahara project feasible. Area as place (site) mapped and sampled (non-site). Smithson's New Jersey rockpile as specimens in trays. Dennis Oppenheim: Decompositions, in which the matter used is an ingredient of the place (in a gallery it could be gypsum, for instance); place reduced to constituent matter. Removal in progressive steps as a "decomposition" of the place's substance. In both Smithson and Oppenheim the material is (a) brute sample and (b) metaphor of state.

5.2. Pressure of outdoor scale defeats monumental art, which is never big enough. (David Smith, Barnett Newman's *Broken Obelisk*). Nature not a receptive medium for big objects to be thrust on, but one term in a relationship. Hence the term Ecologic Art. Michael Heizer's "negative objects" in deserts in Nevada or California: "indeterminate" and "inaccessible." [10] Systems that are alternatives to monumentality.

5.3. Smithson's "Monuments of Passaic" substitute Passaic, New Jersey for Rome, Italy.[11] Retitling as art-conferral act: sandbox as "The Desert," sewage outlet as "the Fountain Monument, etc."

6. Conceptual art as part of a reaction against art as process-record (history of the creative act as facture) towards art as end-state (signs of manufacture and production minimized). Increase in forms of conceptualization from premonitory gestures in the 'fifties to present activity.

6.1. Sol LeWitt: "In conceptual art the idea or concept is the most important aspect of the work." "In other forms of art the concept may be changed in the process of execution." Idea/end-state compatibility, even symmetry.

6.2. Art in a framework of language. Verbal substitution and translatability. "Some ideas are logical in conception and illogical perceptually." (LeWitt) "The function of conception and perception are contradictory (one pre- the other post-fact)." "Ideas may also be stated with number, photographs or works or any way the artist chooses, the form being unimportant." [12] Propositional art. Art separated from perceptual hardware.

6.3. Douglas Huebler: The existence of the work of art is certified by its documentation in the "form of photographs, maps and descriptive language." [13] Sites on maps indicated by markers; 14 towns along 42nd

9. Robert Smithson, "Towards the Development of an Air Terminal Site," *Artforum*, 5, 10, 1967.

10. Junker, *op. cit.*

11. Robert Smithson, "The Monuments of Passaic" (original title: "Guide to the Monuments of Passaic"), *Artforum*, 6, 4, 1967.

12. Sol LeWitt, "Paragraphs on Conceptual Art," *Artforum*, 5, 10, 1967.

13. Douglas Huebler, exhibition catalogue, New York, 1968.

parallel marked by the "exchange of certified postal receipts." Matching areas in Boston and New York as "exchange shapes."

6.4. Where process may appear is after the completion of the work. Exhibition announcement: "Dennis Oppenheim's Sculpture is Alive and Growing at John Gibson's." Compare Robert Rauschenberg's (accidental) dirt paintings of c. 1953 with grass and moss.

7. Art and distribution.

7.1. Art as a communication system: Ray Johnson's New York Correspondance (*sic*) School. Collages, verbal and/or visual, and straight found material mailed to various people, sometimes to send on, sometimes to hoard. Content: somewhere between gossip and oracle, joke and enigma. Envelope as well as the enclosures significant.

7.2. The Andy Warhol continuum. Silk-screened photographs in paintings, interviews in magazines or on TV, films, rock 'n' roll group, *A,* all points of a unified sensibility using the technologies of home movies and tape recordering. Warhol thrives on disintegrating thresholds, unlike Rauschenberg who is hung up on hardware and concrete things.

My point was to argue for a rehabilitation of the relation of environment to works of art. And to assume an expansionist rather than a reductive esthetics. Conceptual art has its clerks as Abstract Expressionism has its truckdrivers, but no movement is tested by its failures. The animation of the spectator, by signs, by scale, by substitutions, by deceptive familiarity, by durational change, by wide focus, is part of the argument.

STOLEN

(*with Arakawa: An Interview*)

This is the record of a theft of art. A group of five young artists removed from an exhibition at the Dwan Gallery a painting by Arakawa inscribed: "IF POSSIBLE STEAL ANY ONE OF THESE DRAWINGS INCLUDING THIS SENTENCE." So they did and their action has esthetic ramifications which should be indicated here. In one sense, the group's intervention is in a tradition concerning the annexation of art by artists. Marcel Duchamp is a precedent, with his addition of a beard and moustache to a reproduction of the *Mona Lisa* in 1919 and, also, in this note for a readymade: [1]

Use a
Rembrandt as an
ironing board.

Yoko Ono's "instruction paintings (meant for others to do)" [2] include the following:

Borrow the Mona Lisa from the gallery.
Make a kite out of it and fly (it).
Fly it high enough so the Mona Lisa smile disappears. (a)
Fly it high enough so the Mona Lisa face disappears. (b)
Fly it high enough so it becomes a dot. (c)

These examples, two from various precedents, are not a direct influence on the group but a part of the line of thought to which their act

SOURCE: The first part is the Introduction to *Stolen* by Kathe Gregory, Marilyn Landis, Russell F. Lewis, David Crane, Scott R. Kahn (Colorcraft Lithographers, Dwan Gallery, Multiples, Inc., New York, 1970). The interview is from *Arts Magazine*, XLIV/4 (February, 1970), 46–47, where it appeared as "Arakawa Annexed."

1. Marcel Duchamp. *Notes and Projects for the Large Glass.* Ed. Arturo Schwarz. New York, n.d. [1970], p. 100.
2. Yoko Ono. *Grapefruit.* New York, 1970, unpaginated.

belongs. Nor should any of these acts or proposals be assessed as merely destructive. They are part of a larger pattern of annexation, transposition, and collaboration dealing with problems of authorship and meaning.

The action came out of an ongoing conversation about Happenings and Conceptual art and the problems these raise about control and interpretation; there was a series of speculations on art as ideas and actions rather than as an object. The group's act was a participatory one, an amplification of attention into physical terms. A crucial factor is that the idea of collaboration was started inadvertently from the artist's inscription. Arakawa's pseudo-command was intended to put the spectator in an impasse; he received an instruction, but without any expectation of carrying it out. When, suddenly, the command was obeyed, in fact, the artist was disconcerted at the impact of an unexpected feedback. Arakawa's sentence is part of a recurrent theme of his art, the ambiguous threshold of visual images and verbal statements. The group violated the esthetic stasis of the two sign-systems by moving into the realm of illegal action. Arakawa has pointed out that they did not follow his instruction exactly. They took the painting, not "any one of these drawings." The misunderstanding, however, is well within the margin of error that is one of Arakawa's working assumptions. We might consider the group's action as an heuristic interception of the routine set up by the artist in his work. The initiative was removed from the artist and located in the cooperative group.

That the group was involved in an esthetic act is shown by the wording of the telegram by which they recorded the theft: "work complete." In addition to the polemical form of collaboration by annexation, the collaboration between the members of the group is very important. They came to the idea simultaneously and devised a scenario for it; an early plan called for the painting to be deposited in the racks of the Art Students' League, but was rejected. Then the scenario was executed with a speed and crispness which suggests the pleasures of group reinforcement, as one member supported another, as might occur within a successful Happening. (The group is, incidentally, sympathetically aware of Allan Kaprow's ideas.) Thus the two forms, of group collaboration and of malicious-philosophical collaboration, run parallel through the whole enterprise.

Arakawa regained the initiative when he sent his telegram, including the line "it has been a great surprise to collaborate with you," proposing the painting be donated to a museum. Thus the group that had taken the painting from the artist were put in the position of donors. The collaboration had entered a second stage and the ironies implicit in their relation to the artist now became ironies in their relation to institutions, as the later correspondence reveals. This is the point at which their action becomes a comedy of communications, including the theft

of the painting from the thieves (an unserious act, compared to the motives of the group). The collaboration started as a purposeful sequence of decisions and acts, a solid relationship of agreed-on roles around a participatory center. Then the personal collaboration escalated from the compact operations of a group to the message-system of urban society. The documents of the events, assembled by the participants, is now their work of art.

ARAKAWA: AN INTERVIEW

ALLOWAY: Did you think that the Art Workers' Coalition stole it?

ARAKAWA: No. My first reaction was very surprised. Then I felt angry at the situation. Then minutes later I was strangely excited. I talked to the secretary at the gallery explaining the painting. It was as if I was explaining it to myself. Then I felt very good about it.

ALLOWAY: When you had that first telegram from the thieves it said: "Drawing safe. Work completed." This means that they were collaborating with you?

ARAKAWA: I like the collaboration idea, but they are not *exactly* collaborating because they were wrong. I mean by that, they made a meaning without me. Their act has almost nothing to do with me. They are creating in a different way.

ALLOWAY: You mean that they stole the painting itself, not just one of these drawings including the sentence?"

ARAKAWA: Exactly. We need other words than collaboration to describe what happened. It is very difficult.

ALLOWAY: Could we think of the thieves as a variable factor introduced into the history of the painting?

ARAKAWA: That's quite close. Perhaps we can think of the thieves as accidental collaborators.

MADELEINE GINS: When I think of the painting now, I go through the history of all that's happened to it. It's very thick. It curls your vision.

ALLOWAY: Can we consider the thieves' action as a random triggering device that brought out unexpected meanings?

ARAKAWA: I forget the subject nearly. I only remember the situation now. Every subject in art is tiny or funny, but the situation that the thieves made is a tremendous discovery.

MADELEINE GINS: Did Arakawa tell you how the painting evolved?

ARAKAWA: I wrote the sentence, I had that for months, but I had to wait for the image. Then I saw *Pickpocket,* you know, the Bresson movie, and I was fascinated by the act of stealing.

ALLOWAY: How did it feel when you met the thieves?

ARAKAWA: When I met them I was very shy. They didn't seem so shy. Meeting is like stealing in a way. I felt I must get the "painting" back

IF POSSIBLE STEAL ANY ONE
OF THESE DRAWINGS INCLUDING
THIS SENTE

60. Arakawa: Untitled (1969). Oil and pencil on canvas, 72″×49″. The Wadsworth Atheneum, Hartford, Connecticut.

somehow, because they made another subject of it. But, of course, all the time the original is there, secretly, even though the words have been used. It is extra-ambiguous.

ALLOWAY: Are there any other versions of this painting?

ARAKAWA: Yes. I am going to show the same subject almost, in a museum in Germany. I hope people will steal with extreme caution.

RADIO CITY
MUSIC HALL

Radio City Music Hall contains indisputable pieces of art, such as Stuart Davis' mural in the men's room, *For Men Only,* but recently the building itself has been raised to the status of art. The highly elaborate interior design has been recognized and is being cherished on its own terms. At present its standing is that of a putative monument threatened by divisive miniaturization. There is a plan to insert an art theatre (or theatres?) within the protracted threshold that winds between street and auditorium. There is plenty of space, but to make the change would destroy one of leisure architecture's fanciest transition zones between the life outside and the spectacle in the dark inside.

In addition to its aesthetic rehabilitation, the Music Hall has become the subject matter of art. Roy Lichtenstein's "Modern Paintings," which he began in 1966, take 1930s' design motifs, from such places as cinema foyers, ocean-liner ballrooms, cocktail lounges, and maybe a few magically preserved diners. Whether or not he used the Music Hall specifically, his choice of period forms as the subject matter of paintings and sculptures shifted his use of "a discredited area" of taste (the artist's phrase) from the quotation of comic books to the evocation of a period style. When he started there was no generally agreed-on term for the style, but by the end of the 1960s usage had settled on Art Deco.

Last month [April, 1972] at the Sonnabend Gallery there was an exhibition by Brigid Polk entitled "Radio City Music Hall." She presented a slide show that stayed away from architecture and films and focused on the Rockettes. She used two slide projectors to throw images of the stage show on the wall of the gallery. The slides were taken from out front: some were detailed, some blurred images of pre-Crazy Horse stately chorus girls; some photographs were about the dazzle of light, others about its shortage. A tape of thunderous tap-dancing accompanied the successive dissolving images.

SOURCE: From *The Nation* (June 19, 1972), 797–798.

There seems to be a pretty clear derivation from another artist in this exhibition. The Rockettes provide the subject of the cover photograph of Ira Joel Haber's *Radio City Music Hall,* a mimeographed pamphlet published in 1969. Although it is in an edition limited to forty copies, Haber last year presented a version of it as a performance piece, with tape, slides and film. It is hard to exclude Brigid Polk from the group that is cognizant of performance and Conceptual Art work of even limited circulation. (Her earlier work, incidentally, derived from Andy Warhol's use of the Polaroid with an emphasis on skin.) Because performance and Conceptual Art pieces are new phenomena, it does not mean that a situation of breathless simultaneity exists in which all is freshness and experiment. On the contrary, the priorities and rip-offs that are the standard subject of art history occur constantly. One of the functions of an art critic should be to provide a short-term art history. Since an art critic sees more *new* art than most people, he is in a position to register the sequence in which work is actually done, something which is often hard to sort out later.

Let me describe Haber's *Radio City Music Hall:* on the cover is a grainy photograph of the Rockettes; the frontispiece shows the corner site on 50th Street and 6th Avenue, with its lunging Art Deco geometry; this is followed by maps, with blocky modernistic lettering, of the Fire Exits from the orchestra, first, second and third mezzanines. Then Haber lists the films shown at the theatre from 1933, when it opened with *The Bitter Tea of General Yen,* through to 1969 and *The Christmas Tree* (a soap opera with William Holden that bombed). He includes contemporary ads for *Words and Music* ("based on the lives and music of Richard Rodgers and Lorenz Hart"), a colored postcard of the exterior, a Xerox of the program for the "week beginning Thursday, December 5, 1946" when the stage show consisted of *The Nativity* and *The Good Ship Holiday* and the movie was *Till the Clouds Roll By,* with Robert Walker as Jerome Kern. Ads for Anthony Mann's 1961 remake of *Cimarron* and Delmer Daves' *A Summer Place,* one of the best soap operas from 1959 (that was a good time for the genre), are included. The book concludes with a panoramic view of the auditorium, empty, with the lights on, the great fan of seats curving across the floor (room for 6,200) and the enormous fluted roof with concealed lights arching overhead.

Various themes are implicit in the book but without becoming its subject. Haber is aware of and appreciates the style of the building, but he is too objective to be suspected of nostalgia; and he is certainly devoted to movies. The thirty-six-year list of films offers a graph of popular taste, both in subject changes and in length of booking (forty-seven films in 1933, eight in 1969). However, he does not comment on this, though it is revealed by his way of ordering the data. Possibly greater emphasis is to be put on the fact that the titles of movies are,

for many of us, shorthand cues for values and moments in time, in the way that classical allusions used to be. On that basis, the listing means a great deal to a media-trained audience, but the material is presented as a deadpan array of specifics. Haber is using publicly available and partially familiar information, without departing from, to quote the artist, "acknowledged sequences of facts."

Haber's *Radio City Music Hall* (and two other books, *Films No. 1* and *Films No. 2,* both of them based on variant listings of movies, at once systematic and arbitrary) belongs with what is called Conceptual Art. It is a very broad category that often has nothing to do with the "pure play of thought" or with the "dematerialization" of the art object. Its form is frequently documentary, as here. It is a climax of the penetration of art by quotidian information, the taking of facts in a literal form into art. The source material is neither ideal nor bizarre, but fundamentally familiar, though the system by which it is organized introduces fresh configurations. It is in this area that Haber's work seems important and vivid, and that of Brigid Polk derivative and secondary.

ROBERT SMITHSON'S DEVELOPMENT

Smithson's sculpture of 1964–68 is regarded as belonging with Minimal art, but this view needs qualification, partly because of the way in which his later development throws retroactive light on earlier pieces. The reason for linking him with Minimal art is not hard to find: he made the connection himself. In an article of 1966, for example, he writes particularly about Flavin, Judd, LeWitt, and Morris [1] and in 1968 discusses the writings of Andre, Flavin, Judd, LeWitt, Morris, and Ad Reinhardt.[2] These names do not exhaust his references, but they amount to a primary emphasis. Aside from the evidence of his interests and associates, what about the style of his work in relation to the requirements of Minimal art? The canon certainly required a sculpture of neutral units, either modular or monolithic. Another expectation was inertness, a denial of visual animation and contrast. A third factor, proposed by Lucy Lippard, was the desire of the artists to "compete visually with their non-art surroundings" by means of "projects that would in fact create a new landscape made of sculpture rather than decorated by sculpture." [3] Whether this environmental impulse belongs properly to Minimal art can be contested if, as Lippard suggests, it begins with "Tony Smith's long visualized 'artificial landscapes without cultural precedent.' " [4] Actually Smith makes big sculptures, sometimes at architectural scale, but their solid fabrication separates them fundamentally from the concept of a "landscape made of sculpture." Lippard's extrapolation of Minimal art to Earthworks is problematic in

SOURCE: From *Artforum,* XI/3 (November, 1973), 52–61.

1. Robert Smithson, "Entropy and the New Monuments," *Artforum,* June, 1966, pp. 26–31.
2. Robert Smithson, "A Museum of Language in the Vicinity of Art," *Art International,* March, 1968, pp. 21–27.
3. Lucy Lippard, "10 Structurists in 20 Paragraphs," *Minimal Art,* Haags Gemeentemuseum, 1968, p. 30.
4. *Ibid.*

another way, inasmuch as she assumes Minimal art to be a fundamental stylistic entity. It is true that artists who were called Minimal produced Earthworks in and after 1968, but this does not make the later work dependent on Minimalism. What happened with Minimal art is that the very general reductive impulses of a period were consolidated and appropriated for a few artists. At any rate, what is clear on rereading contemporary criticism is that Smithson presented a problem to the critics who supported Minimal art as a movement. Typically in Lippard's text quoted above, the main reference to Smithson concerns his article "Entropy and the New Monuments" and not his sculpture.

What aspect of Smithson's sculpture relates most closely to Minimal art? Obviously it is the use of modules to control repetitive arrays of forms. Though some of Smithson's pieces employ an extendable module of fixed dimension, like LeWitt's or Judd's, the direction of his development is toward progressions with expanding sequences. The morphological difference between seriality and progression is considerable. The steps of these sequences are systematic but their complexity is in excess of the tolerances of Minimal art. Consider Smithson's long steplike sculptures, such as *Plunge,* 1966: the intricacy of the units, ten of them expanding along the row at the rate of half an inch each time, deliberately opposes the notion of all-at-once graspability typical of the Minimalist application of Gestalt theory. It is true that LeWitt's grids, as the parts become numerous, propose a visual display of overlapping partial and oblique views different from the given module in effect. The divergence of recipe and object is of course intentional, but can this be linked to Smithson's interests? LeWitt's precisely defined and repeatable ambiguities are easily learnable and, as such, have a kinship with Renaissance rational perspective platforms. Smithson, on the contrary, has a sense of collapsing systems which has far-reaching implications for his art. A clue to his attitude is contained in the title *Alogon 1,* 1966. This is a Pythagorean term for mathematical incommensurables, meaning "the unnamable" or "unutterable"; these were unaccountable imperfections in the numerical fabric of the universe, not mysteries, which is why they were not to be named or discussed.[5] Jo Baer (who studied Greek) prepared a lexical note for Smithson on alogon: its senses include inexpressive, irrational, and unexpected as well as incommensurable. *Alogon 1* has regular forms but the interplay of actual diminishment and the perspectival effect of tapering in the side views produce a sense of dislocated systems. Its cantilevered bulk resembles a massive corbel table, but with nothing to support, and the black matte paint, by reducing perceptible light changes, can be said to "slow" the light. The formality of the sculpture, therefore, confirms the title's

5. Tobias Dantzig, *Number: the Language of Science,* New York, 1954, p. 103. (All books cited here are in Smithson's possession.)

pessimistic reference to the limits of knowledge or to a system's weak points.

Smithson's intricacy and suspension of definite closure seem to me decisive separations from what Minimal art was supposed to be. In 1967–1968 the tendency to complexity reached a climax in Smithson's sculpture. One example is the project for the Dallas–Fort Worth Regional Airport, a large spiral constructed of triangular concrete segments, flat on the ground, viewable as a whole form only from airborne planes. The spiral motif is developed three-dimensionally in *Gyrostasis* in which twelve joined blocks, triangular in section, rise from the largest step which is also the base of the sculpture and diminish to form a suspended half-circle at the top. Here the tapering progression is not simply stretched in one direction, as in *Plunge* and *Alogon 1,* but made into a complex freestanding object: each straightedged step is clearly articulated and each is an episode along the flow of the spiral. The source of the spiral is in crystallography, as Smithson's early sculpture *Enantiomorphic Chambers,* 1964, proves. An enantiotropic system is one for which "changes are completely reversible," [6] as in "a substance [which] when heated changes from form A to form B, the reverse change taking place on cooling." [7] In the sculpture two identical but reversed chambers are placed side by side with internal mirrors to double up the symmetry. The translation of a concept from crystallography to the structure of a work of art is typical of Smithson's interest in the relationships of art and the world as opposed to an art isolated by its internal relationships. In this case he applies the reversible forms and the mirrors to a refutation of "the illusionistic plane of focus sometimes called the 'picture plane.' " [8]

Coincident with his sculpture Smithson began a series of trips into the country in December, 1966, which he documented photographically. The first was to Great Notch Quarry, near Paterson; the visual record is of a desolate New Jersey landscape. Smithson has commented on his fondness for "sites that had been in some way disrupted or pulverized." [9] This means, as his practice from this time on confirms, that he is attending to landscape not only in terms of natural process but in terms of human intervention as well. Since the 19th century, man has shared in landscape formation at a scale comparable to that of geological process. The development of cities and industries with their attendant pollution has produced changes of the same order of magnitude as nature's. Indeed it is no longer possible to separate man from nature and New

6. Ajit Ram Verma and P. Krishna, *Polymorphism and Polytypism in Crystals,* New York, 1966, pp. 20–21.
7. *Ibid.,* p. 10.
8. Robert Smithson, "Pointless Vanishing Points," Typescript, 1967.
9. "Discussions with Heizer, Oppenheim, Smithson," *Avalanche,* Fall, 1970, pp. 48–71.

Jersey, the California of the East, is one of the places where the geological network of faults and the human network of waste penetrate one another to form a unitary landscape. On an earlier trip to the quarry with Donald Judd, based on their "mutual interest in geology and mineralogy," he wrote of its walls: "fragmentation, corrosion, decomposition, disintegration, rock creep, debris slides, mud flow, avalanche were everywhere in evidence." [10] The fullness with which Smithson describes these traces of change is typical of his relish of collapsing systems. In fact, what he sees *out there* is related to the interpreting brain which, Smithson stresses, governs perception: "slump, debris slides, avalanches all take place within the cracking limits of the brain." [11] He does not tolerate ideas of man and nature in separation; his interest is in systems that contain both.

In April, 1966, he made a "site selection trip" to the Pine Barren Plains with Robert Morris, Carl Andre, Nancy Holt, and Virginia Dwan which culminated in the first nonsite. They subsequently tried to buy some land for an Earthwork exhibition there. In May, 1968, he wrote: "If one travels to southern New Jersey in order to see the origin of the nonsite, one may look around and say 'Is this all there is?' The Pine Barrens Plains are not much to look at. And the hexagonal map with its 30 subdivisions surrounding a hexagonal airfield may leave the participator wondering." [12] It is no accident that the cut for this first non-site was an airfield. Since July, 1966, Smithson had been an artist-consultant to Tippets-Abbett-McCarthy-Stratton (engineers and architects) on their projected Dallas–Fort Worth Regional Airport. To quote from his report: "The straight lines of landing fields and runways bring into existence a perception of 'perspective' that evades all our conceptions of nature." [13] "The landscape begins to look more like a three-dimensional map rather than a rustic garden." [14] Thus there is a reference to a real but artificial object at the center of the hexagonal map. It is not only a question of real site and artificial nonsite; we must take into account the artificiality of the signified site as well as the concreteness of the soil samples in the Minimal art containers.

Nonsite, 1 was originally described as *A Nonsite (indoor earthwork)*. Smithson was interested in the scale change, as between a signifier and the signified. A stubborn sculptural sense has always kept him aware of the mass and volume of absent signifieds; it is a sculpture of absence. The contraction of the world into more or less arbitrary designations led him to the concept of the "indoor earthwork" but his immediate re-

10. Robert Smithson, "The Crystal Land," *Harper's Bazaar,* May, 1966.
11. Robert Smithson, "A Sedimentation of the Mind: Earth Projects," *Artforum,* September, 1968, pp. 44-50.
12. Robert Smithson, "Participation Degree Zero," Typescript, 1968.
13. Robert Smithson, "Aerial Art," *Studio International,* April, 1969, pp. 180–181. (Smithson invited the collaboration of Andre, LeWitt and Morris.)
14. *Ibid.*

vision of this paradox to a dialectic strengthened his position immensely. He equalized the ambiguities of both site and nonsite, nature and its analogue, presuming a common spectrum of artifice and abstraction. Site and nonsite constitute a collection of relationships among variables. The site is identified by information supplied by the artist in the form of maps, photographs, analogical objects (bins and trays cued by the original lie of the land), rock samples, and verbal captions. The nonsite, by this accumulation of references, acts as the signifier of the absent site. What has happened is that the modules of Smithson's abstract sculpture have been turned into maps. The coordinates of cartographical grids have replaced the ideal geometry of modular sculpture. This can be put another way, inasmuch as Smithson rejects Wilhelm Worringer's dualistic system of abstraction and empathy. "Geometry strikes me as a 'rendering' of inanimate matter. What are the lattices and grids of pure abstraction, if not renderings and representations of a reduced order of nature?" [15] Thus the significative role of the grid in the nonsites can be taken as a linguistic extension of the modules of Minimal art. Smithson defines the relation of site and nonsite as dialectical, affirming its basis in "a changing reality with a material basis" (*Random unabridged*). Here is the artist's list of the two terms:

Site	*Nonsite*
1. Open limits	Closed limits
2. A series of points	An array of matter
3. Outer coordinates	Inner coordinates
4. Subtraction	Addition
5. Indeterminate certainty	Determinate uncertainty
6. Scattered information	Contained information
7. Reflection	Mirror
8. Edge	Center
9. Some place (physical)	No place (abstract)
10. Many	One [16]

The names of several of the sites are evocatively "entropic," to use a word that Smithson brought into the literature of art. *Pine Barrens, Line of Wreckage, Edgewater, Mono Lake.* This is in line with his sceptical view of the optimistic technology of 20th-century modernists, such as David Smith; Smithson proposes rust as "the fundamental property of steel." [17] This is an acknowledgement of the inevitability of decay and of change; the sites/nonsites are a meditation on the con-

15. Robert Smithson, "Nature and Abstraction," Typescript, 1971. Cf. "Language to be looked at and/or things to be read," press release, Dwan Gallery, New York, 1967. (Pseudonym for Smithson: Eton Corrasable.)

16. Robert Smithson, "Dialectic of Site and Nonsite," in Gerry Schum, *Land Art*, Berlin, 1969, n.p.

17. Robert Smithson, "A Sedimentation of the Mind: Earth Projects," p. 46.

61. Robert Smithson: *A Nonsite, Franklin, New Jersey*, detail (1968). Wooden bins with rock samples, 16½″ × 82″ × 110″.

62. Robert Smithson: *Partially Buried Woodshed* (1970). Kent State University, Ohio.

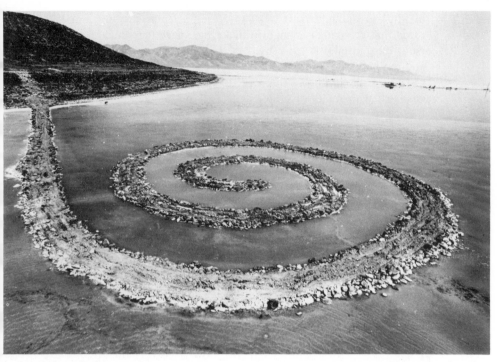

63. Robert Smithson: *The Spiral Jetty* (1970). Coil approximately 1,500′ long. North shore, Great Salt Lake, Utah.

nection of these states to everything in the world. *Site/Nonsite: Bayonne, Line of Wreckage,* 1968, refers to a crumbling shore line in New Jersey which was being stabilized by clean fill. Smithson subtracted some of the broken concrete being used for this for the nonsite. It was characteristically a desolate place to be "redefined in terms of art," to quote the artist. The Jersey swamps are here, masses of reeds that grow high enough to make the space they enclose indeterminate; the turnpike is close by, but it is hard to enter if you are off it; and the buildings are, Smithson observes, "essentially anonymous." On a later visit Smithson discovered that the landscape had radically changed, with factories built out to the line of the recently completed fill. A part of what he likes about New Jersey is the fact that it is a "landscape in transition." As the sites change, his nonsites take on increasingly the character of memorials to dead cities (or hypothetical continents). The nonsite system of references always has the possibility of canceling itself out.

The original location of *Site/Nonsite: Edgewater, the Palisades,* 1968, was discovered in a book on the geology of New York City by Christopher J. Schuberth. He discusses layers of sandstone, "the oldest exposed strata of the Newark series," and basalt in the cliff face of the Palisades and describes "the right of way of the old trolley that connected the amusement park with the Edgewater–125th Street ferry until August 5, 1938." [18] The trolley bed climbs the cliff, through choking vegetation; it has become the corroded track of an occasional stream, littered with junk that has come down from adult discards to children's playthings. There is a "large open clearing . . . where the trolley made a hairpin turn," to quote Schuberth, now a clearing for nothing except a spectacular view over the suburban roofs of Edgewater across the Hudson River, to Manhattan. The site is a coalition of indeterminate time rates. There is a piece of 19th-century engineering almost effaced; by comparison the ancient and complex geology is intact. The prehistoric asserts its newness against old technology, for it is old compared to the 20th-century buildings in view across the river, and from which we come. Smithson's photographs of the site record objects and spaces in trajectories of change.

The contrast of sense perception, on site, and abstraction, at the nonsite, is stretched further in *Six Stops on a Section,* 1968. To quote Smithson: "the section line is a 142-degree angle on an 1874 map of northern New Jersey, showing iron and limestone districts. Covering about sixty-three miles." Along this line he selected the following sites, each characterized geologically: (1) Bergen Hill (gravel); (2) Second Mountain (stones); (3) Morris Plains (stones and sand); (4) Mount

18. Christopher J. Schuberth, *The Geology of New York City and Environs,* Natural History Press, 1968, pp. 232–236.

Hope (rocks and stones); (5) Lafayette (gravel); and (6) Dingman's Ferry (slate). The first stop, also known as Laurel Hill, is a high outcrop of ancient trap rock, which is being quarried on one side for gravel. It sticks up rawly from the flat swamps; from the top is a view of the Newark skyline and a sight of the second stop. The quarrying operations have a long way to go before the outcrop is consumed, but the machines are munching away steadily. In *Passaic Trip 1,* 1967, Smithson made 24 photographs of a construction site along the river (published with six photographs in *Artforum* as "The Monuments of Passaic"). [19] The "monuments" have not survived to 1972, except for the bridge and *The Sand-Box Monument* (also called *The Desert*) in Taras Shevchenko Park, which has been newly painted blue, orange, and gray. The sites/nonsites are not a dualistic system, such as nature and art, true and false. On the contrary the same unstoppable rate of change and threat of entropy permeates both terms: "it is the back-and-forth thing," as Smithson has observed.[20] Neither site nor nonsite is a reliable source of fixed value, neither completely elucidates the other.

"On Saturday, September 30, 1967, I went to the Port Authority Building on 41st Street and 8th Avenue. I brought a copy of the *New York Times* and a Signet paperback called *Earthworks* by Brian W. Aldiss." [21] Then he took the bus to New Jersey on the excursion described in "The Monuments of Passaic." In the proposals to Tippets-Abbett-McCarthy-Stratton, Smithson had already used the term: "on the boundaries of the taxiways, runways, and approach 'clear zones' we might construct 'earthworks' or grid-type frameworks close to the ground level." [22] In fall, 1968, a group exhibition at the Dwan Gallery was called "Earthworks" and it was clear that a new tendency had been named. It was the large spaces around the airport that forced Smithson's attention to a new scale of operation, eliciting the idea of an art of expanding thresholds. Returning to the bus: from the *New York Times* Smithson quotes a series of inanities about works of art, including the headline "Moving a 1000 Pound Sculpture Can Be a Fine Work of Art, Too." From this it is a logical step to interpret the construction site as a series of monuments, such as *Monuments with Pontoons: The Pumping Derrick,* and *The Fountain Monument.* This monumentalizing of the quotidian relates to a basic turn of Smithson's mind. He is not taking the Dada tradition of the found object and applying it to the newspaper and the construction site equally, but it is an anticipation of Conceptual art's play with naming. It has more to do with the

19. Robert Smithson, "The Monuments of Passaic," *Artforum,* December, 1967, pp. 48–51.

20. *Earth Art,* Andrew Dickson White Museum of Art, Cornell University, exhibition catalogue 1970, Robert Smithson et al., "Symposium," n.p.

21. Robert Smithson, "The Monuments of Passaic," p. 48.

22. Robert Smithson, "Aerial Art."

overlap of systems that, in one way or another, recurs through his work. The article is a documented inventory but Smithson imposes a convention on the data that we do not anticipate. It is, to use the original title, a "Guide to the Monuments of Passaic" and follows the perambulatory form of a guide book, including meditations on time and monuments. "Has Passaic replaced Rome as the Eternal City? If certain cities of the world were placed end to end in a straight line according to size, starting with Rome, where would Passaic be in that impossible progression?" [23] This is *Six Stops on a Section* translated into the city-mobility and contracted time of science fiction. The guide is a fictionalized documentary, with a nitty-gritty iconography amplified into the grandeur of monumentality and ancient cities. The fluctuations and intersections of the two conventions seem closer to the way one handles the input of the world than any single-valued interpretation of data would be.

Smithson is a brilliant writer with a vocabulary that includes knotty technical terms, adjectival largesse, broad references, and serpentine arguments. It is I think indicative that his spell of maximum writing, 1966–1969, coincides with the period when he was moving from sculpture to Earthworks, from an art of autonomous objects to an art penetrating the world and penetrated by sign systems. However, as pointed out earlier, his sculpture was prone to demonstrate complexity and artificiality, rather than summary wholeness and supposed inevitability (an illusory quality, in fact). Thus he seems always to have resisted the reductive and essentializing moves begun in the '50s, and continued through the '60s. He wrote mainly for two editors, Phil Leider of *Artforum,* five articles, and Sam Edwards of *Arts* and *Art Voices,* four articles. The central subject is his art or at least the ideas that inhabit and direct his art. He wrote about the Hayden Planetarium and science fiction, Art Deco and New Jersey, the writings of his fellow artists and art as a linguistic system, geology and Mexican mythology. To indicate both the specificity of his data and its discursive routes, I shall quote from the "Cretaceous" section of "Strata":

Globigerina ooze and the blueish muds. *Creta* the Latin word for chalk (the chalk age). An article called *Grottoes, Geology and the Gothic Revival. Philosophic Romances.* Greensands accumulated over wide areas in shallow water. Upraised plateaux in Australia. Sediment samples. Conifers. Remains of a flightless bird discovered in a chalk pit. Causes of extinction unknown. The fabulous sea serpent. The classical attitude toward mountains is gloomy.[24]

By means of the sites/nonsites Smithson established a dialectic between outdoor and indoor locations. He was able to use the gallery not

23. Robert Smithson, "The Monuments of Passaic," p. 51.
24. Robert Smithson, "Strata: A Geophotographic Fiction," *Aspen,* 8, 1967.

simply as a container for preexisting objects but brought it into a complex allusive relation to the absent site. Earthworks depended for their financing and for the distribution of information concerning them on the traditional resources of art dealers, but only Smithson figured out a way to use the support system as part of the meaning of the work. By comparison Michael Heizer, when he shows blown-up or small photographs in galleries, is settling for the simple situation of signaling an absent original by means of confirmatory documents. His photographs, as it were, say, yes there is a hill or a cut out there in a positivistic sense, whereas Smithson's nonsite is epistemological. The mirror displacements, begun in the salt mine at Cayuga Lake, New York, 1969, climaxed later that year in the Yucatan series; here the problematics of the nonsite are carried into the site itself. A dozen mirrors, each 12 inches square, were arranged in various places, such as a field of ashes ("The people in this region clear land by burning it out"),[25] a quarry, the seashore, the jungle. The manufactured 20th-century artifacts are not only set *against* the landscape, the images in the mirrors are of the environments, but displaced by reflections. The reflections bring in the theme of duplication, a kind of mapping, but the reflections of light are endless and unpredictable; to quote the artist, they "evade measure." The scattering of modular plates in the organic environment also has the effect of mixing the ordered and the unexpected. The mirrors act like the elements of the nonsite in their allusive signification.

Entropy is a loaded term in Smithson's vocabulary. (It customarily means decreasing organization and, along with that, loss of distinctiveness.) Here are some examples from his writings which, since they come from the same source as his art, may be considered to provide information about the art. Referring to the construction site in Passaic, he observed: "That zero panorama seemed to contain *ruins in reverse,* that is—all the new construction that would eventually be built." [26] In his original article on entropy he stated "falseness, as an ultimate, is inextricably a part of entropy, and this falseness is devoid of moral implications." [27] Thus all systems of communication, to the extent that they are not one-to-one, have a false and indistinct aspect. Smithson applies the idea to time, as in his characterization of "the obsolete future of H. G. Wells' *The Shape of Things to Come* (1938)." [28] "The Jersey Swamps—a good location for a movie about life on Mars." [29] Basically Smithson's idea of entropy concerns not only the deterioration of order,

25. Robert Smithson, "Incidents of Mirror Travel in the Yucatan," *Artforum,* September, 1969, pp. 28–33. The title of course is a paraphrase of the brilliant travel book, *Incidents of Travel in Yucatan,* by John L. Stephens.
26. Robert Smithson, "The Monuments of Passaic," p. 50.
27. Smithson, "Entropy and the New Monuments," p. 29.
28. Robert Smithson, "Ultra-Moderne," *Arts,* September–October, 1967, pp. 31–33.
29. Robert Smithson, "The Crystal Land."

though he observes it attentively, "but rather the clash of uncoordinated orders," to quote a formulation of Rudolph Arnheim's.[30]

There is a shift in Smithson's work to outdoor sites solely, large in scale, freed of significative bonds, which is marked by his *Partially Buried Woodshed,* 1970, at Kent State University, Ohio. The measurements of the shed are $45' \times 18.6' \times 10.2'$ high, but these figures do not describe the limits of Smithson's work, only what was given. His original intention was to subject an existing hill to the pressure of a mud flow, but sub-zero temperatures defeated the plan. He had already used a truck in *Asphalt Rundown* the year before and now he used a backhoe on a tractor to pile dirt onto the shed until the central beam cracked. (In Smithson's mind, among other things, as he set up this piece, were those science-fiction movies in which amorphous beings inundate known structures and incorporate people, such as *The Blob.*) The man-made (in terms of structure and right-angles) and the inchoate (masses of soil) were brought together to create a stress situation: the work was finished when the beam broke, so that the timing of collapse is, in a sense, the work's subject. Hence Smithson's instructions when he donated the work to the university: "everything in the shed is part of the art and should not be removed. The entire work of art is subject to weathering and should be considered part of the work." [31]

The Spiral Jetty, 1970, built on the north shore of the Great Salt Lake, is an expansion to literal scale of the capacious sign systems that Smithson had been dealing with since 1968. It's a move into logistic complexity and an expanded technology. It can be described as a "post-studio" system of operation. After he had located the site Smithson took specifications for the job to a number of contractors, none of whom were willing to run the risk of moving heavy earth-moving equipment out into the shallows of the lake. Finally Parsons Asphalt Inc., Ogden, took the job, because of the personal interest of Robert Phillips in the problems it presented; the company had worked in the lake before, building straight and square dikes, but this was the first time they had had to construct curved embankments into the water. The working procedure on what was called Job No. 73 was as follows. Front-end loaders (Michigan Model 175) were used to burrow rocks out and to collect sand on the shore. Ten-wheeler dump trucks carried the load to the lake, backed out along the coil, and tipped it off the end. Here truck loaders (Catepillar Model 955) placed the dumped rocks and tamped them down within the narrow limits set up by guide lines placed by Smithson. The technical difficulties were considerable and called on all the skills of the drivers, including the operational hunch that tells when the ground is too soft and likely to subside. The drivers, far from being ironic about a nonutilitarian project, appreciated the task as a

30. Rudolph Arnheim, *Entropy and Art,* University of California, 1971, p. 15.
31. Robert Smithson, Typescript, 1970.

challenge and would bring their families out to the site for picnics at which they could demonstrate their virtuosity. The machines tipped and jostled their way along the spiral as the new embankments grew. A crucial figure in the work was the foreman, Grant Boosenbarck, who responded to the problems of the unprecedented structure with canny skill and maintained the concentration of the workmen by his leadership.

The dimensions of Smithson's work had been increasing since *Asphalt Rundown,* 1969, in which he tipped asphalt down the side of a quarry near Rome, Italy. The use of this sluggish material picks up an earlier theme, stated in the *Tar Pool Project,* 1966, and expanded conceptually in 1969 as *Earth Map of Sulphur and Tar* (*Cambrian Period*), a proposal for a model of the earth with (yellow) sulphur continents and (black) tar oceans to be constructed on a long axis of 400 feet. The viscous mud-asphalt theme is also present in *Texas Overflow,* a project of 1970, in which a plateau paved in asphalt is ringed by broken chunks of sulphur. When he came to operate in enlarged dimensions, the conditions of Smithson's work changed drastically. He found himself out of the studio and no longer dependent on middle agents for the handling of his work. With the earth as his medium he had to deal directly with contractors, engineers, realtors, executives, and civic officials. This was true for both *The Spiral Jetty* and the *Spiral Hill* and *Broken Circle* at Emmen, Holland, and for a group of pending projects. For the Salton Sea, California, he has a proposal he has been discussing with city authorities for a work called *Coastal Crescents,* to measure 750 feet across. For the Egypt Valley, Ohio, there is a proposal under discussion with the Hanna Coal Company for reclamation of a 1,000-acre tract of strip-mined country. The work is a jetty that combines elements of both spiral (a hornlike curve of beach) and circle (an arm of earth carried out into a lake). It is an expansion of ideas given in *Broken Circle* and *Spiral Hill.* Smithson wrote recently: "Across the country there are many mining areas, disused quarries, and polluted lakes and rivers. One practical solution for the utilization of such devasted places would be land and water re-cycling in terms of 'Earth Art'. . . . Economics, when abstracted from the world, is blind to natural processes." [32] Thus, as his works have expanded, as the contacts that make them possible have diversified, he has come to a situation in which he can manipulate directly the large-scale natural and man-made forces of which he has always been aware. Accompanying this expansion of operations the view he takes of galleries and museums has hardened, from the subtle accommodations of the site-nonsite relationship to what Smithson has described nicely as "a more succinct disclosure of limits." In "Cultural Confinement" he emphasizes the limits of architectural display in term of privations rather than conventions.[33]

32. Robert Smithson, Typescript, 1972.
33. Robert Smithson, "Cultural Confinement," *Artforum,* October, 1972, p. 39.

To return to the *Spiral Jetty*. Approaching it from the land you crest a low ridge and there, in front of and below you, is the spiral, spun out into the flat reddish water. It is securely locked to the shore, both materially and morphologically. It is 1,500 feet from the top of the ridge out to the tip of the coil which measures about 15 feet across, just enough to support the trucks. The fill is made up of 3,500 cubic yards of boulders and earth; each cubic yard weighs 3,800 pounds, which means that a total of 6,650 tons was moved to constitute the embankment. These statistics, which should be read as the equivalent of a technical description, such as oil on canvas or watercolor on paper, indicate scale. Walking along the spiral lifts one out into the water into a breathless experience of horizontality. The lake stretches away until finally there is a ripple of distant mountains and close around one the shore crumbles down into the water, echoing the mountains. From this point of view the spiral is a low trail of stones and rocks, resting on the water like a leaf on a stream. It is a moist and earthy causeway with salt caking on the rocks and on the visitor. The landscape is openly geologic, evoking past time with placid insistence.

Concurrently with the Earthwork Smithson made a film which shows its construction and, after completion, its vertiginous relation to water and sun. The film is both a record and a representative work by Smithson as well. The sculpture and the film are related like site and nonsite, though with a new amplitude of resources and references. "The sites in films are not to be located or trusted," Smithson has observed.[34] In the film he declines to use the horizontal expanse of the site. As in his still photography he likes low-profile imagery. The typical camera angle is, so to say, slightly stooped, with little sky visible, or close up. The machines are mostly shot in close-up, looming on the screen, biting earth, emitting rocks: they are compared to prehistoric animals in a technological-prehistorical analogy. In various ways the theme of time runs through the film. The present acts of construction (earth-moving) are compared to earth's past. The ancient geological formations constitute a time-bound present and the sequence in the Hall of the Late Dinosaurs in the Museum of Natural History implies futurity. The sequence was shot with a red filter to suggest an entropic equalization of energy. "Nothing has ever changed since I have been here," says Smithson on the soundtrack, matching the drained images to Samuel Beckett's *The Unnamable* (Alogon). Thus the photographic record of present activity, the building of the jetty, is set into a context of great duration. The long final sequence, photographed from a helicopter, abolishes the low-keyed style that the film maintains until this point. The climactic sequence fuses water and sun as the camera picks up the sun's reflections in the lake and in the channels of water that

34. Robert Smithson, "A Cinematic Atopia," *Artforum,* September, 1971, pp. 53–55.

infiltrate the spiral to its center. Here the reflected solar imagery, an enormous "displacement," produces an exhilarating world picture. The sound track at this point includes a quotation from *The Time Stream* by John Taine referring to "a vast spiral nebula of innumerable suns." [35] The quotation is apt but it is typical of Smithson's double takes, his sense of perpetual reservation, that the story should be old-fashioned science fiction, published originally in 1932. In an early sequence, establishing the ubiquity of spirals and "introducing" the sun, the sound track records the wheezes of the bag of a respirator machine. It is as if to say the sun is burning up, but it is still alive. At the close of the film, after the solar and water spectacular (a planetary amplification of Smithson's original Dallas–Fort Worth Airport ideas), Smithson himself appears running into the spiral, pursued by the helicopter though only for the purpose of photographing him. When he gets to the center he pauses, then starts to walk back, a factual, deflationary detail, typical of Smithson's laconic but undeviating anti-idealism.

What is remarkable about Smithson's work in the past ten years is both the distance of ground covered in his move from sculpture to Earthworks without any break in the continuity of his generating ideas. He has a built-in sense of permeability, possibly parallel to his interest in geology, the subject of which is matter in perpetual stress, overlapping, and penetration. The ways in which modules turned into mapping and mapping into sites are examples of the course of one idea into and through another. To this can be added the diffusion of his early experiences in New Jersey, where he was born and raised, into his later investigations of the same landscape. The Pines Barrens, for instance, was an area he had frequented long before he brought it into the area of art. "Since I was a kid," Smithson remembers, he had been interested in crystals after an uncle, who worked for the Hammond Map Company, gave him a quartz crystal. The point is that the landscape and its systems of ordering have been familiar to Smithson most of his life and their presence can be felt on every level of his art and thinking. He is not building barriers around fragments of personality or stylistic innovation, as happened with a good deal of art in the '60s. He does not attempt to fix reality in a permanent form by means of art, but demonstrates a sustained and interlocked view of a permeant reality.

MAJOR NONSITES, 1968

Nonsite 1, Pine Barrens, New Jersey.
Sand.

35. John Taine, *Three Science Fiction Novels* (including *The Time Stream*), 1964.

Nonsite 2, Franklin Mineral Dumps, New Jersey.

Limestone.

Nonsite 3, Bayonne, New Jersey: Line of Wreckage.

Broken concrete.

Nonsite 4, Edgewater, The Palisades, New Jersey.

Trap rock.

Source: Christopher J. Schuberth, *The Geology of New York City and Environs,* pp. 232–236.

Nonsite 5, Mono Lake, California.

Cinders.

Nonsite 6, Oberhausen, Germany.

Slag.

Bernard Becher acted as guide through the Ruhr District.

Nonsite 7, site uncertain.

Coal.

Based on a hypothetical map of the Carboniferous Period, somewhere in the midwestern United States.

Double Nonsite.

Baker-Kelso, California. Lava.

Source: Mary Francis Strong, *Desert Gem Trails,* p. 61.

Mineral County, Nevada. Obsidian.

Source: Cora B. Houghtaling, *Rock Hounding Out of Bishop,* p. 11.

Six Stops on a Section.

(1) Bergen Hill (gravel); (2) Second Mountain (stones); (3) Morris Plains (stones and sand); (4) Mount Hope (rocks and stones); (5) Lafayette (gravel); (6) Dingman's Ferry (slate).

ART CRITICISM
AND SOCIETY

"Notes on Op Art" is a record of the ways in which art, or rather information about art, can be distributed outside the traditional channels through which the art world is accustomed to communicate. It deals with art without art criticism. "The Public Sculpture Problem" is related inasmuch as it deals with a difficulty of artists in working effectively outside the privileged context of the art world. "The Uses and Limits of Art Criticism," not previously published, is an attempt to view the profession in its social context.

NOTES ON OP ART

Op art has a history and, in the mid-1960's, was a fashion. The two kinds of time, the historical past converging on the present to give it continuity and echoes, and the present as a wonderful party, never met. An explanation of this double focus, of the effect of two simultaneous worlds inaccessible to one another owing to different time rates, involves a problem of mid-century culture. William Seitz, whose exhibition "The Responsive Eye" at the Museum of Modern Art popularized Op Art, postponed an historical study to a later date and submitted, without much apparent pleasure, to what he called "the demands of the present." [1] Not only was he oppressed by the number of artists stylistically eligible, but also by the public interest: "It is a question whether any new movement, tendency, or style can withstand the public onslaught for long." [2] As this was written in a "preview" of his exhibition in *Vogue,* it can hardly be said that Mr. Seitz did much to cool it. What happened is that an inhabitant of one time-stream had become distractingly aware of the other and deplored the overlap.

The currency of the term Op Art, first printed in *Time,*[3] was extraordinary. Through 1965 it was in common use in art, fashion, and humor magazines, and in the newspapers. For example, paintings with zigzags or concentric circles appeared in a New York store's ads as appropriate furniture for the young life. *Harper's Bazaar,*[4] under the heading of "Op Scene," had dress descriptions like: "Black and brown dots getting the bends on white pique (it's all in the way you look at it)." *Vogue* returned to Op Art with a cover girl's head overprinted with a moiré pattern: "Pow! Op goes the Art. Op goes the fashion." [5]

SOURCE: Based on a lecture given by the author at The Solomon R. Guggenheim Museum, April 11, 1965; first published in Gregory Battcock, ed., *The New Art* (New York, 1966), pp. 83–91.

1. *The Responsive Eye.* Text by William C. Seitz. Museum of Modern Art, New York, 1965.
2. William C. Seitz, "The New Perceptual Art." *Vogue,* Vol. 145, No. 4, New York, 1965.
3. *Time,* October 23, 1964.
4. *Harper's Bazaar,* No. 3041, New York, 1965.
5. *Vogue,* Vol. 145, No. 10, New York, 1965.

Op Art did not stay with the slick magazines but appeared promptly in teen magazines. Here are quotations from two British journals: "Here's how the In Birds will play the Pop Art Game *gearwise* . . . crazy circles, ill-assorted diamonds, zany zigzags" and "Remember— Black and White is THE colour." [6] A little more detail on gear: "Cotton Op Art bag with lots of room" and "Op Art bag from Top Gear boutique." [7] The linking of Pop Art and Op Art, incidentally, was widespread: *Scientific American* observed that "Op (for optical) has topped Pop (for popular) as the fashionable gallery art of 1965." [8] The most elaborate of the references to Op Art in the humor comic books was on a cover of *Sick* in which narrow bars of jumping color cut up a character like an egg slicer; it was described as an "Op-tickle Ill-usion issue." [9]

Bridget Riley, one of the artists called Op, became celebrated but, like Mr. Seitz, was embarrassed at the unexpected interpretations and unanticipated usage to which her work was subjected. Shortly after her success she wrote that "my work has been . . . vulgarized in the rag trade" (she sued the man who did it) and went on that real "qualities were obscured by an explosion of commercialism, bandwagoning and hysterical sensationalism." "Virtually nobody in the whole of New York was capable of the state of receptive participation which is essential to the experience of looking at paintings." [10] This reaction reveals the violation of a desire for the humanist tradition of an intelligent, sensitive, numerically small audience on whom an artist can count for understanding. In one way or another Miss Riley's complaint echoes the complaints of American art critics, most of whom disliked the show (including her work), but they shared her assumption of a small congenial audience. On this basis they resented the large-scale public attention given to the artists in "The Responsive Eye."

Thomas B. Hess echoed the fashion, teen, and humor magazines by equating Pop Art and Op Art: "the content of both . . . is advertising" (or, to put it another way, the content of neither is Action Painting). Real painting, Hess announced, is "difficult, serious, remote, aristocratic." [11] Thus, Op Art is to be segregated from the real thing because it is popular. "The Responsive Eye" was dismissed as a "smash survey of the mode *à la mode*" and he noted that "the Establishment has reacted . . . warmly to these images." (The editor of a glossy and

6. *Music Parade,* No. 5, London, 1965.

7. *Rave,* No. 19, London, 1965.

8. Martin Gardiner, "Mathematical Games." *Scientific American,* Vol. 213, No. 1, New York, 1965.

9. *Sick,* No. 39, New York, 1965.

10. Bridget Riley, "Perception Is the Medium." *Art News,* Vol. 64, No. 6, New York, 1965.

11. Thomas B. Hess, "You Can Hang It in the Hall." *Art News,* Vol. 64, No. 2, New York, 1965.

long-lived art magazine might himself be considered to be a member of "the Establishment," if this British term is applicable in the United States, which is doubtful; however, the Establishment, like hell, is "the others.") Dore Ashton decided that "these objects on the whole cannot qualify as works of art"; [12] she missed "that margin within which the imagination is free to wander." Barbara Rose dismissed Op Art as "mindless" because there is no "expressive content." [13] All three reviewers, it is interesting to note, not only recognize instantly that Op Art is not art, but they are also in possession of knowledge of what art is. For Miss Rose, Op Art was not performing "the real task before painting in our time." She spelled out what is implicit in the Hess-Ashton-Rose position: "Our affluence, leisure, and rising literacy will call for more and more art of this kind, which should be colorful, decorative, and easily experienced." This is merely the revival of an archaic definition of the masses and their *kitsch,* but it makes possible a flattering drama of the one versus the many, the cultivated elite against the brute (if more affluent) crowd.

What happened with Op Art is that it was made famous by all the magazines except the art journals. It was precipitated into the public realm in the United States without the customary procedure of filtering and preparation in the specialized journals which has accompanied earlier twentieth-century art movements. Pop Art, for example, though the art magazines were slow to take it up, underwent a traditional sorting out process within an elite framework of judgment and inside knowledge. However, in the case of Op Art the only position left for art critics was to act as checks on supposed abuses originated by others, and to put down the new movement. The only American art critic to write about "The Responsive Eye" as if it actually contained art, and to assume that it could be approached by the use of literary sources, visual experience, and personal ideas was Sidney Tillim. [14] The initiating move by a museum and the hair-trigger topicality of the popular press left the art magazines (with their residue of minority humanism) nothing to do but castigate and ironize. The public entertainment that accompanied Op Art forced into the open the caution and restricted interests which are becoming characteristic of the art critic as a professional. It is perhaps time to state that the art world would be a dull and rarefied place without fashion. It is fashion that welcomes and celebrates new artists and new tendencies, whereas established critics and editors evoke standards as a barrier to curiosity and generosity.

12. Dore Ashton, "La Peinture Optique à New York." *XX^e Siècle,* Vol. XXV, Paris, 1965.
13. Barbara Rose, "Beyond Vertigo: Optical Art at the Modern." *Artforum,* Vol. III, No. 7, New York, 1965.
14. Sidney Tillim, "Optical Art: Pending or Ending?" *Arts,* Vol. 39, No. 4, New York, 1965. This is essentially a footnote to an earlier article called "What Happened to Geometry?" in *Arts,* Vol. 33, New York, 1959.

Barnett Newman was named, in a premature press release from the Museum of Modern Art, as an Op artist, but was not represented in the exhibition. The reasons why his flat one-color paintings are not Op Art may clarify what Op Art is. His surfaces, though monochrome, are characterized by manual traces (though these are restrained); not only that, his work is imbued with an esthetic of the Sublime, as the artist himself has named it. If one compares a Newman painting with an Yves Klein (not in "The Responsive Eye" oddly) one can see immediately how nuanced a work by the American painter is, how qualified in color and tense in phasing. A Klein monochrome, on the other hand, lives by being a solid chunk of blue, as if a bit of Mallarmé's Azure had fallen on Chicken Little. His work is modulated by an all-over texture, which makes it receptive to light changes and shifts in the spectator's attention, whereas Newman creates effects of light within the painting. Klein's monochromes were painted with rollers to get an "impersonal" finish, and a part of their importance lies in their inertness as objects. Once a painting is sufficiently undiversified in its surface, variables of handling are replaced by variables in perception. In a Newman, the marks of the artist create a stable structure (despite some perceptual shifts), whereas a Klein is simple enough for the spectator to recognize his own perception in operation.

Mr. Seitz presented his exhibition in terms of an affective theory (of spectator participation) rather than a genetic theory (of the artist's creative experience); of consumption rather than of production. In this he is certainly correct, so far as it separates Op Art from the autobiographical and existentialist process-records of Abstract Expressionism and Action Painting. It is true that the spectator of checker-board inversions, moiré patterns, and after-images is made aware of the experience of perception and its corollary, that stimuli are shifting and ambiguous.[15] However, there are surely no still works of art and no passive spectators. Audience research on a movie, *Home of the Brave,* for instance, led to the conclusion that "interpretation was consistent with the degree of prejudice of the interpreters. . . . Because perception is selective and because content, considered as stimulus material, is more or less ambiguous . . . distortion always occurs."[16] Any meaning or pattern is unstable and polyvalent, an experience not peculiar to Op Art.

Mr. Seitz linked Op Art with kinetic art on the basis of identifying apparent (optical) with real (physical) movement, thus linking it with the machine aesthetic and Constructivism. However, the pro-technology attitude of many European artists was not stressed in his exhibition,

15. The best account of the effects is Gerald Osters' "Optical Art." *Applied Optics,* Vol. 4, No. II, New York, 1965.
16. Wilbur Schramm, *Mass Media and Education.* Chicago, University of Chicago Press, 1954.

where emphasis was on individual authorship and formal compactness. This meant that collective manifestations, such as the Groupe de Recherche d'Art Visuel, Gruppo N, and Equippo 57, were inadequately represented. The study of possibilities of collaboration and anonymity, with the team operating instead of the individual artists, was not pursued. To consider Op Art fully it must be viewed in relation to pro-technology attitudes and authorship problems. Standardized forms and agreed-on systems make possible an art that is not necessarily equated with individual activity. Memory cues are blocked as far as possible by regular forms and the values of inspiration and uniqueness (so strong in post-war painting) are critically reduced. Basically, Op Art is part of a general use of more systematic forms than have previously engaged artists. Viewed like this, Op Art as such is not a style but a technique, one of the means of achieving certain effects. Isolating the optical elements, at the expense of other factors, is like discussing landscape paintings as Vanishing-Point Perspective art.

Sidney Tillim has suggested that grids are a sign of European art's "traditional geometric orientation." [17] but when a grid has become a field of points, an all-over display of equal emphasis, it ceases to be readable as geometric in his sense. Geometric art requires, obviously, diversified figures; when these are, as it were, pulverized, as in a dense compilation of small units, we see something else. There is a visual texture [18] which, though it can contain cluster intensifications, is homogenous, not differentiated. Control is achieved by clusters, density, flow, grain, and nets, that is to say, factors which affect equally the whole painting as a single system, rather than by balances of separate forms. In fact, the crucial element is, perhaps, not the grid but the point, the dot, the regular and repetitive unit. Starting with Georges Seurat, there is a history of the dot in painting. He reduced the structural unit of painting to the point; previously the skin of a painting was un-analyzable, either because of the motor variety of the visible strokes (too complex for description), or because the individual strokes were subsumed into one skin (hidden). Seurat, however, destroyed both the intricate and the continuous paint surface to make painting as systematic a process as engraving. Engravers who worked for reproduction possessed a syntax by which they could translate forms and space, originally painted, into graphic equivalents. They worked with set elements which could be varied and combined without loss of individual solidity. News of pointillism (which, in this context, is a better term than Neo-Impressionism and Divisionism) was distributed rapidly. The principle went to Seurat's personal contacts (for example, Paul Signac), then to *their* contacts (for example, Van Gogh), and so on to a legion of French,

17. Tillim, *op. cit.*
18. Cesar Jannello, "Texture as a Visual Phenomenon." *Architectural Design,* Vol. 33, No. 8, London, 1963.

Italian, and American artists. On a longer term, his influence is traceable to Decorative Cubism and to the Bauhaus (Klee particularly was taken with systematic color, both as dots and as all-over grids of small squares). At the Bauhaus the dot was also identified as a basic design unit, an atom, in Kandinsky's point-line-plane sequence. However, such a theory gives the unit only an initiating role, soon lost; we are faced in Op Art, however, with the point (without the line and the plane) repeated.

Information Theory is certainly present in recent uses of the small repeated unit in painting, either intentionally or inhaled with the twentieth century. Vasarely, for one, is conscious of a likeness between his ranks of regular forms and the binary code of digital computers in which there are two states—on/off, yes/no. Though large forms may lurk in some of his paintings, a systematic binary code is never far from his later work. One reason for his delay in developing a full color range was that its complexity made it intractable to binary coding; its random luxury overwhelmed the system. Instead of the Froebelesque solids which haunted early geometric art, the reference, in a lyrical or offhand way, is to the point, the dot, as in punched cards and tapes. Instead of the former comparison of abstract art with music there is an evocation of Information Theory. However, it must be stressed that the analogy, though vivid, is partial, because art and Information Theory constitute different systems. Writers on art who desire, fear, or scorn the marriage of art and science should not be misled by the images to assume a one-to-one relation of art and mathematics. At the Hochschule für Gestaltung in Ulm, Information Theory, not architecture, is the Mother of the Arts,[19] and it is on some such basis that the references to science should be understood. It is unifying theory, not a formula for work. It is to systematic art what the Unconscious was to effusive art.

19. Almir Mavignier typifies Ulm ideas in this direction.

THE PUBLIC
SCULPTURE PROBLEM

Most twentieth-century art is produced privately (initiated solely by the artist himself) and becomes public information later. Once the art object exists and gets circulated beyond an intimate audience that the artist can control, it enters the domain of public knowledge. Some artists accept, others resist, this diffusion; resistance obligates them to a programme of curatorship to reduce the proliferation of unanticipated readings. Oldenburg is an example of an artist who considers variable interpretations inevitable and Stella, who has displayed a development that claims evolutionary coherence at each step, is an example of the effort to exclude free readings by closing his work as he goes. In this sense the problem of 'going public' faces every artist, but the term public sculpture means something more specific. It refers to art that is *intentionally* public from the outset, designed to occupy an unregulated site (by which I mean a place outside gallery, museum, or park limits).

The nineteenth century closed the tradition of public sculpture and the twentieth has not established one. A part of the success of nineteenth-century monuments came from the artists' capacity to draw on extra-artistic fields of knowledge. They could represent a hero, a personification (of a virtue or a city), memorialize an individual or a battle, without any scarcity of legible signs. The choice of classical robes, ceremonial dress, or modern clothes, for example, all held iconographical meanings that were easily available in non-esoteric literary sources as well as in baroque or classical prototypes. In addition to an accessible iconography the public sculpture of the last century usually maintains a sense of scale that makes it visually distinct even in cluttered sites. Hence the clarity of iconography was equalled by a clarity of human contour and gesture. In earlier *Documentas* when the park was used for sculpture the eighteenth-century figures along the ruined wall of the Orangerie were always more coherent and readable against the sky than the Moores and Picassos and the rest of the hardware below.

SOURCE: From *Studio International*, 184 (October, 1972), 123–124.

245

It is clear that the resources of the tradition that made nineteenth-century sculpture legible cannot be revived as if nothing had happened. What we have now is a cluster of public arts that are not in the hands of sculptors or painters at all. Obviously television, the movies, advertising, packaging, ceremonies, peer-group games constitute a set of public arts, though characterized by continuous flow and replacement rather than by monumentality. Popular culture has created an inventory of signs and themes, but it is an unstoppable flow of variants rather than a succession of classic points. Hence it does not help a sculptor working for a public site: Mickey Mouse in concrete or fibreglass is no more a solution to the problem of public sculpture than the White Rabbit in marble at Llandudno, North Wales. If an artist takes a sign from an existing store and displaces it by transformation we are entitled to ask what the gain is. Max Bense has pointed out that the path of a sign, through different uses, is the path of its alteration [1] and not every phase is of equal interest. For example, at what point in its path is Nicholas Munro's *King Kong?* The congenial beast is clearly now merely part of a hypothetical group of play sculptures, which is OK but not much. To the exhaustion of classical iconography, then, we must add the unavailability for direct quotation of the now-autonomous popular arts.

A great deal of current sculpture acquires its meaning in one of two ways: either in terms of style as subject or of history as content. The forms of an artist's work, insofar as they are learnable, constitute a pattern of information that is essentially iconographic. As the constraints and repetitions of form are perceived a subject emerges, the artist himself, not in an expressionistic sense but as the source of this set of decisions as opposed to other possible sets. The artist's style as subject is a perfectly adequate source of meaning in galleries and museums but it is not necessarily sustaining to the larger public for the sculptures called public. The same objection holds against sculpture in which the referent is the tradition to which it belongs. Here a work of art is an abbreviation standing for a tradition and its position in a form-series is its meaning. This kind of content presupposes a deterministic view of (art) history in which full information about the present is assumed to be available to the artist. Formality, therefore, summarizes the artist's historical awareness and the work's position in time becomes its content.

It seems to me that the production of public sculpture is not compatible with this narrow base, in which the artist retains for himself the role of exclusive donor of meaning. What is needed, maybe, is a sculpture that has to do with the formation of idioms. An idiom can be both the "style of speaking peculiar to a people" and "an expression whose meaning is not predictable from the usual meanings of its constituent

1. Aloisio Magalhaes. *Der Weg Eines Zeichens.* Nachwort Max Bense. Edition Rot no. 39, Stuttgart, 1969.

elements" (*Random House Dictionary,* unabridged). For my purpose the first sense suggests the need for a broad-based sculpture and the second sense suggests a sculpture that creates an image beyond that of its constituent material parts. Image-making has to supplement form-giving in public sculptures; examples are the *Statue of Liberty* in New York Bay and *Eros* in Piccadilly, both of them legible and learnable as images. (Albert Gilbert has recently been claimed for art history, but this is a second reputation, additional to his ability to coin, in the *Eros,* a long-term image.) New sculptures would probably be less reminiscent than Gilbert's pagan image, but that is the problem. What body of preparatory doctrine, outside the realm of art itself, can sculptors refer to?

This is not an easy question to answer: it is neither a matter of overt political engagement, with a readymade stock of slogans and images, nor of aesthetic detachment, adding a few more self-referring works to the environment. Both positions seem more simple than the situation can tolerate. A point of reference can be located in Tatlin's *Monument to the Third Republic,* 1919–1920. It was built, and duplicated twice recently, as a model for a building, but its possible relevance is sculptural rather than architectural now. As a summarizing social structure it was like, and influenced by, the Eiffel Tower, but remained unbuilt. Its ascending spiral and triple zones of occupancy are insistently symbolic but not banal. The Vesnin Brothers' *Pravda* Building project, 1921, which incorporated signs, ads, and loudspeakers in its open structure, is part of the Tower's heritage. These and other works constitute a distinguished public art on paper. It is the Piranesi syndrome but with reference to a projected future rather than to a classical past. In the absence of a support system the monuments remained unbuilt, but to ignore them in favour of routine formalist objects is to withdraw from one of the challenges of twentieth-century art. Constructivism, in the light of recent exhibitions, reveals a new usability in its compound of formal sophistication and symbolic accessibility.

It was noticeable that many of the contributors to the Peter Stuyvesant Foundation's City Sculpture Project in England seemed uninterested in public sculpture. To William Turnbull "the problem of public sculpture is largely with the public—not with sculpture." [2] According to William Tucker, "the idea of designing a sculpture for a particular site, even if chosen oneself, seems to me a gross limitation on the sculptor's freedom of action." Turnbull would just pass on to the public a slight increase in the demand for art appreciation and Tucker would hold sculpture to a sum of internal decisions locked away from the environment.

John Pantine states that "I didn't really consider the nature of the

2. *Studio International.* July-August, 1972. Turnbull, p. 23; subsequent quotations from artists, pp. 25, 27, 26.

opportunity as being other than a chance to extend my own experience of sculpture." The Foundation's funds seem to have been regarded as just another handout by artists who regarded themselves as too smart to be taken in by the optimistic programme. Liliane Lijn's statement is a classic of the derealization of sculptors' sensibility. After her work was installed, "the result was that the environment itself seemed to lose its concrete reality, the sculpture remaining what it was envisioned." Well, congratulations, Miss Lijn, and good-bye world out there. In all these statements very simple views of the autonomy of the artist and the work are maintained which, so far as public sculpture is concerned, is like talking Welsh on prime time.

The general attitude towards vandalism is in accord with the nostalgic defence of "artistic licence" in these quoted statements. It is usually described in terms that derive from the nineteenth-century concept of philistinism (hostile crowd versus sensitive individual), so that a sculptor whose work gets manhandled knows the pang of good old-fashioned alienation. My own feeling is that the artists are responsible for what impulses to *graffiti* and damage their works trigger off in passers-by. I propose here Alloway's laws of public sculpture. (1) If a work can be reached it will be defaced. (2) If the subsequent changes reduce the level of information of the work, it was not a public work to start with. The requirements of public sculpture, therefore, are not the same as for gallery- or museum-bound pieces. A public sculpture should be invulnerable or inaccessible. It should have the material strength to resist attack or be easily cleanable, but it also needs a formal structure that is not wrecked by alterations. One defence of public sculpture could be a high level of redundancy which would incorporate frivolous additions and sprayed slogans and all that into the structure.[3]

Public works of art can be classified as successes only if they incorporate or resist unsolicited additions and subtractions. Newman's *Broken Obelisk* collected "God is love" and other messages when it was on the plaza of the Seagram Building in 1967. These had to be sandblasted off the corten surface. When the sculpture was installed in Houston, Texas, it was placed in the centre of an ornamental pool. It is safe from *graffiti* presumably, but at some cost: the connection of the pyramid with the earth has been sacrificed by the cutback underwater support which gives an effect of suspension that exaggerates the lower lip of the sculpture. Conclusion: despite its vivid manipulation of the forms of public sculpture (the pyramid, an *inverted* obelisk), it is not suitable for an unregulated place. Since no work of art can be expected to be protected by its "sacredness," it is up to the artists to figure out

3. Another solution to the problem of public sculpture is expendability: however, I am deferring here to the convention of solid materials and longish duration as the proper state of sculpture. Nonetheless, loose, scattered, changeable, growing pieces, with anticipated temporal limits, should not be left out of account.

systems to deflect or absorb post-terminal traces (i.e. activity following completion by the artist). Bernard Rosenthal's *Alamo* in Astor Place (originally part of the *Sculpture in Environment* exhibition in 1967) is successful in this respect: although the artist is unhappy at the posters and slogans on it, they do no harm; students lounge under it, and kids rotate the cube, balanced on one point. It has become a part of the pattern of leisure there.

Karl Deutsch has commented that "autonomy involves . . . the feeding back of a stream of data recalled from memory upon a stream of data regarding current behaviour. The points at which these two kinds of communication channels meet are strategic points in the decision system." [4] Memory, for the formalist sculptor, consists of recall of a definite group of precedents and models, the prestige of which overrides the input from current behaviour. Current behaviour includes the area of public sculpture inasmuch as the audience is an unknown present factor untouched by the usual conditioning and reinforcement that the sub-group for art receives and which the artist counts on. To the extent that a sculptor dismisses this audience he is rejecting public art in relation to current behaviour. It takes more than an outdoor site to make sculpture public. The target of public art is the achievement of a focusing point for an undifferentiated audience. The problem is to mobilize ideas and values by means of imagery in the way that biblical and classical allusion functioned until the end of the nineteenth century.

It is my impression that the importation of existing sculptures into public spots is inconsequential in effect. The *Sculpture in Environment* show in New York neither inspired the citizens nor impeded the flow of traffic. *City Sculpture,* to judge from the literature, was subject to a mixture of optimistic organizers and participants declining to be drafted. The result was an uneasy interface between what each artist does anyway and an expanded range of sites. This year the Venice Biennale had a section, out of the gardens, devoted to *Scultura nella Città* which brought into the open the fallacies lurking in the other exhibitions. A scatter of modern sculpture was put around the city; the pieces looked stranded and isolated, desolate and affected in an environment already self-sufficient in terms of art and urban design. The ideal of public service in the absence of a public iconography or public interest cannot give public sculpture relevance. It is in this context that a recent project of the Public Arts Council is significant; it proposes nothing less than a realignment of the art/public relationship.

Usually a sculpture is inserted readymade into an available space and its unveiling is the first contact we have with a work supposedly intended

4. Karl W. Deutsch. "Self-Referent Symbols and Self-Referent Communication Patterns," in *Symbols and Values: An Initial Study,* eds. Lyman Bryson, *et al.* The Conference on Science, Philosophy, and Religion. Distributed by Harper and Brothers, New York and London, 1954, p. 624.

for the public. The Public Arts Council, which is part of the Municipal Art Society, a non-profit civic organization in New York with a private membership, has conceived a way to break this pattern. The Council initiated an Environmental Sculpture Programme, which took the form of a competition among artists for sculpture on public sites in the uptown West Side of New York City, the Washington Heights-Inwood-Marble Hill area. The list of possible sites, which was announced to the artists, had been prepared by the communities themselves on the assumption that residency is better preparation for siting public work than abstract design principles. The project was sponsored not only by the Municipal Art Society, but by the New York City Department of Cultural Affairs and the Mayor's Neighbourhood Action Programme (NAP). Thus neighbourhood involvement began with the project rather than being solicited later.

Twelve of the 60 proposals were selected by a joint committee of community representatives and art-world professionals, a mixture aimed to secure decisions based on local expertise and disinterested aesthetic judgment. The selected proposals were circulated in the recipient neighbourhoods in the form of models and visualizations where residents voted on them in order of preference. Thus community participation was continuous from initial site selection, to the filtering of the send-in, and final decisions about which works would be realized. The first five choices of the community were Eduardo Ramirez, Inverna Lockpez, Clement Meadmore, Richard Hamner and Terry Fugate-Wilcox. The Art Commission, a city agency charged with overseeing urban design from park benches to monumental sculpture, objected to Lockpez's and Hamner's environmental pieces, but later withdrew its objection. In this incident the artists involved were supported by the community against the city agency, which suggests that the approach is soundly based. This social shifting of the basis of public sculpture, so that the community is brought in as a client, may be the way in which the absence of a shared iconography can be overcome in terms of shared projects.

THE USES AND LIMITS
OF ART CRITICISM

BACKGROUND

An art critic's function is the description, interpretation, and evaluation of new, or at least recent, art. Though critics enjoy the art of the past, their publications on it are less likely to be decisive than those of art historians. Critics can rethink or refeel the art of the past in fresh ways, but art historians do this too, effected as we all are by the changing assumptions of our time. An art critic with a retroactive focus would be one who was not facing what I take to be the critic's special area— the present, defined as a complex of paths whose nodes are to be sought and guessed at. Thus critics are closely dependent on the art being produced in their own time, both for subject matter and for their own set of values. Art criticism is as much a topographical as a memorializing mode, the latter being the province of art historians. However, as Max Kozloff has observed, description can be an act of "laconic interpretation," so the mapping procedures that I advocate are by no means passive.

Art criticism in many ways is a condensation of the observations scattered through earlier guidebooks, technical manuals, and aesthetic treatises, but it was founded as a separate mode of writing by Denis Diderot. He reviewed the annual *Salons* from 1759 to 1781 in pieces that varied from a few harassed pages to book-length texts, but always in a basically discursive form. It is clear that his working method was to visit the Salon with a catalogue and react to the works with a mind well stocked with prior ideas, some of them habitual, some of them fresh. This walking-thinking-writing form was, of course, the model for Baudelaire's *Salons* and the method is one that continues to our own

Expanded from three lectures given at the Art Students League, New York, in 1973. (The section on Kenneth Noland appeared originally in *The Nation* [March 19, 1973], 381–382.)

period (for instance, in John Perreault's criticism in *The Village Voice,* 1967–1974).

To appreciate Diderot's contribution we need to consider the nature of the Salon. Founded in 1737 it was the first of numerous exhibiting institutions founded in the eighteenth century to enable artists to present their new works directly to a large audience. The subsequent deterioration of such institutions should not distort the fact that they were originally an expression of the artist's escape from total dependence on patronage. Freely conceived and personally painted works went straight from the studio to the Salon. Even if these works were often commissioned, the fact that they received a public showing in addiion to the patron's private reception was a significant step in the democratization of the artist's work. This is the situation that Diderot was attuned to in his rambling, associative pieces, open to almost random stimuli. As is well known, the painters of history pictures, intellectually programmed figure compositions, dominated other forms of painting, but by the early nineteenth century water-color painters had founded an exhibiting society of their own in London, one of a number of proliferating artist-controlled outlets. As art, by means of biannual and, later, annual exhibitions became available to a growing audience, the need for commentary arose. The regular appearance of a thousand or so works, painted largely on the artists' initiative, was an experience of plenty where previously there had been privation. In this situation the commentary of specialists was needed, and Diderot appeared in response to the new demand. That it was a modernist like Diderot who performed this act is logical, for a constant theme of his *Salons* is freedom. This ranges from appreciation of free handling of the brush and a defense of the sketch to the artist's evolving freedom from patrons. In one usage, painting is released from rules; in the other it is liberated from social constraint. It should be remembered that royal patronage of the Salon, or of the slightly later Royal Academy in London, was not oppressive; on the contrary, it defended the artists from the inertial constraints of the guild system.

Overproduction began to be a problem for artists in Holland in the seventeenth century, where there were competitive outdoor art markets on one hand and artists with additional occupations on the other (customs inspector, tavern keeper, tulip grower). The crowding did not lessen in the eighteenth century, and it has not in our own time. When the guild system broke down, more people were free to adopt the now unregulated profession of artist. The expanding middle class produced both more artists and more patrons. In the nineteenth century improved education lead to a further increase in the number of artists, so that the experience of abundance at the early Salons turns out to have been merely premonitory. As both the production and consumption of art increased there was a corresponding expansion of aesthetic boundaries,

which Baudelaire expressed in a remarkable passage in his Diderotesque text on the Universal Exposition, Paris, 1855, one of those great nine-teenth-century assemblies of commercial products and art into one ideal department store, to use Walter Benjamin's image. In his open-ing reflections on "critical method," Baudelaire invites the reader to "imagine a modern Winckelmann (we are full of them; the nation over-flows with them; they are the idols of the lazy). What would he say, if faced with a product of China—something weird, strange, distorted in form, intense in color, and sometimes delicate to the point of evanes-cence? And yet such a thing is a specimen of universal beauty; but in order for it to be understood, it is necessary for the critic, for the spec-tator, to work a transformation in himself which partakes of the nature of a mystery—it is necessary for him, by means of a phenomenon of the will acting upon the imagination, to learn of himself to participate in the surroundings which have given birth to this singular flowering." [1] Against the classical canon, authoritatively defined by Winckelmann, Baudelaire sets something "distorted in form" and perhaps fleeting. The anticlassicism of this passage is more than an inversion of accepted values; it is an enlargement of aesthetics to include global culture. The culture of the world as it was opened up by the communications sys-tem of the nineteenth century, following exploration in the preceding centuries, is presumed to be simultaneously present with and equal to classical art. Porcelain and marble are equalized. It follows, of course, that the barriers between modern art and primitive, as well as classical art and exotic, are lowered. This situation of postclassical abundance, recognized at an early point by Baudelaire, is not what his commenta-tors have picked up, all being obsessed by Delacroix, late Romanticism, General Aupick, or Baudelaire's dreams, but it is a pivotal insight.

The multiplicity of styles is obviously a given factor in later nine-teenth- and twentieth-century art, acknowledged by the competition of different art movements and by the coexistence of antithetical galleries and magazines. However, the bulk of art criticism has resisted coping with this plenty except by ever more strict gestures of exclusion. The multiplicity of styles can be linked to the ubiquity of art as an industrial society interacts with historical culture. The resistance of critics to the seepage of high art into mass culture can be typified by Roger Fry. In 1912 or thereabouts, he sat down in "a railway refreshment-room" and looked around.

The space my eye travels over is a small one, but I am appalled at the amount of "art" that it harbors. The window toward which I look is filled in its lower part by stained glass; within a highly elaborate border, designed by some one who knew the conventions of 13th-century glass, is a pattern of yellow and purple vine leaves with bunches of grapes, and flitting about

1. Charles Baudelaire, "The Exposition Universelle, 1855," in *The Mirror of Art,* translated Jonathan Mayne (Garden City, N.Y., 1956), p. 193.

among them many small birds. In front is a lace curtain with patterns taken from at least four centuries and as many countries. On the walls, up to a height of four feet, is a covering of lincrusta walton stamped with a complicated pattern in two colors, with sham silver medallions.[2]

(*Note:* lincrusta is a form of heavy, embossed wallpaper.) All that Fry could see was anachronism and adulteration. He wishes to isolate art from other aspects of life and because of this he forgets that very few interiors are of all one date or style. Few occupied rooms represent the crystallization of a single moment of time; there is always overlapping style and changing usage in a room. That railroad refreshment room is a playful analogue of the temporal and stylistic density of culture that Fry, like many art critics, opopse in the name of higher ideals.

Fry preserved the preciousness of aestheticism. In this respect it is significant that he translated Mallarmé's poems; but he also edited Sir Joshua Reynolds's *Discourses*. Reynolds's art theory is, in many ways, rationalistic and moderate, but it is a classicizing theory, based on the necessity of the artist to generalize and on the assumption of a binding tradition. The result is that Fry's own aesthetic is a form of art for art's sake that relies on the sanction of geometry. This shows clearly in his study of Cézanne: "One divines in fact that the forms are held together by some strict harmonic principles almost like that of the canon in Greek architecture."[3] And, significantly: "I had to admit to myself how much nearer Cézanne was to Poussin than to the Salon d'Automne."[4] Fry classicized the detachment, autonomy and exquisiteness of aestheticism, applying it to Florentine structure and French composure. Referring to Post-Impressionism (the generational name that he coined), Fry wrote: "the artist of the new movement is moving into a sphere more and more remote from that of the ordinary man. In proportion as art becomes purer the number of people to whom it appeals get less."[5] One more quotation: "Pictures in which representation subserves poetical and dramatic ends are not simple works of art, but are in fact cases of the mixture of two distinct and separate arts . . . the arts of illustration and the art of plastic volumes."[6] He would seem to be embracing Abstract art here, but this is not so; his writing remained devoted to art in which poetic and dramatic figuration is present, but not attended to. He did not write about Abstract art, but he suppressed iconography and references in figurative art, so as to display his superiority amid art that others misunderstood. Fry had

2. Roger Fry, "Art and Socialism" (1912), in *Vision and Design* (New York, 1957), pp. 67–68.
3. Roger Fry, *Paul Cézanne* (London, 1927), p. 48.
4. *Ibid.,* p. 2.
5. Roger Fry, "Art and Life" (1917), in *Vision and Design, op. cit.,* p. 15.
6. Roger Fry, "Some Questions in Esthetics," in *Transformations* (Garden City, N.Y., 1956), p. 35.

a good eye, but his dandyish absolutism is not the ground for a sound art criticism, because it is nostalgic and exclusionist.

The criticism of Apollinaire shows up the shortcomings of Fry's approach. It should be noted that Apollinaire does not write out of his poetic resources as a rule, except for a few set pieces on Picasso. He is not contributing to that French literary genre in which writers apotheosize a chosen artist. Distinguished cases of this are Baudelaire on Delacroix, Sartre on Giacometti, Malraux on Goya, and Ponge on Braque. Apollinaire wrote from straight journalistic motives, describing a complex art scene. The fact that he was a participant, Marie Laurencin's lover, and a friend of artists, improved his access and extended his subject matter but did not tempt him to elaborate acts of interpretation. He quoted favorably these words: "the critic was to be as accurate as posterity; he must speak in the present the words of the future." [7] His own predictive power was excellent, as is shown by his prompt and ardent backing of Picasso and by his singling out early paintings by Giorgio de Chirico at the Salon d'Automne in 1913.

However, Apollinaire's criticism has another value. Reviewing the Salon des Indépendants in 1910 in several episodes, he commences the third part: "Let us continue our tour of these miles and miles of paintings." [8] At an exhibition of the Aquarellistes françaises in the following year he writes: "What happens to all the paintings one sees exhibited? I think that they probably melt away. *Mais ou sont les neiges d'antan?*" [9] His criticism is unique for this awareness of the population problem: as artists increased in number, the channels for the distribution of art increased in number and became more efficient, both in terms of volume and speed of transit. Apollinaire registered this numerical change as no other critic of the early twentieth century seems to have done; his intuition of the demographic problems of a crowded art world resume, in a different form, Diderot's original inclusive form of discussion. Reviewing the Salon de la Nationale in 1910, he reflected: "In painting . . . there are no longer any masters, since there are no longer any pupils. There are only artists without certitude who submit themselves to uncertain influences. That is why in the absence of mastery one must sometimes praise the virtuosity and even the consumate art of pastiche in the paintings of the Nationale." [10] This insight into the position of artists who must choose their styles out of an abundance of possibilities rather than rely on historical imperatives or even the master-pupil relationship can be applied to the densely populated and highly educated art world of New York today no less than to early twentieth-

7. Guillaume Apollinaire, *Apollinaire on Art,* ed. Leroy C. Breunig, trans. Susan Suleiman (New York, 1972), p. 420. Apollinaire is quoting Ernest Hello.
8. *Ibid.* p. 72.
9. *Ibid.* p. 136.
10. *Ibid.* p. 82.

century Paris. Abstract painting at present shows a surfeit of skills accompanied by incertitude.

Apollinaire's wide-ranging art criticism, therefore, defines the period 1902–1918 in its complexity rather than in terms of easily learned patterns. By comparison to the dense mosaic of Apollinaire's criticism, our usual view of his period is brutally streamlined by historical method into a small pantheon of great artists, agreed-on masterpieces, and dominant movements in causal sequence. This is what a critic like Roger Fry tries to do to his contemporaries, reducing multiple choice to premature neatness. It is also the error of Clement Greenberg and his followers, who hypostasize a single subgroup of artists as the sole source of artistic value. A bizarre example of this kind of exaggeration in Kenworth Moffett's claim that "Olitski is, at least for the moment, saving the easel painting itself as a viable modernist idiom." [11]

Michael Fried made it his task to rationalize the brief, suggestive essays of Greenberg. There is no need to summarize Greenberg again here, nor to detail the difficulties revealed by Fried's attempt to put a large edifice on small foundations. This was admirably done by Kozloff, Calas, and Steinberg [12] in the sixties. However, it might be worth comparing one aspect of formalist rhetoric with another account of the same topic. Fried, for example, congratulates Noland for "an exemplary act of radical criticism of his own best prior work and . . . the attainment . . . of a wholly new dimension of formal and expressive freedom for his art." [13] Just as Fried sees a chain of common problem-solving and its advancement running from Pollock to Louis to Olitski, so he sees Noland the artist grappling with Noland as tradition (i.e., his own earlier work). Noland is praised for his "refusal to regard a particular formal 'solution,' no matter how successful and inspired, as definitive." [14] This process is called admiringly "the act of radical self-criticism." [15] Using other terms, let us compare Fried's view with a brief description of Noland's development. After the circles (1958–1961) Noland worked with chevrons, first in the square canvases that had contained the circles, but more successfully in broad colored *V*s that spanned horizontal canvases (1963–1964). Later, in a group of very wide canvases (1967–1969), he deposited sequences of narrow stripes of color that crossed the picture from side to side, parallel to though not touching the top and bottom of the picture, but hitting the sides as a succession of points.

11. Kenworth Moffett, *Jules Olitski* (Boston, 1973), p. 23.
12. Max Kozloff, Letter to the editor, *Art International*, VII/6 (June, 1963), pp. 88–92; Nicolas Calas, "The Enterprise of Criticism," in *Art in the Age of Risk* (New York, 1968), pp. 139–142; Leo Steinberg, *Other Criteria* (New York, 1972), pp. 55–91.
13. Michael Fried, *Three American Painters* (Cambridge, Mass., 1965), p. 25.
14. *Ibid.*
15. *Ibid.*

Common to these phases were (1) an avoidance of overlapping forms; (2) a reliance on big stretches of bare canvas; and (3) a preference for central images. For example, the circles expanded from a central point toward the edges and the chevrons joined the central axis of the picture directly to the perimeter. These formal devices were occasionally relaxed, as in the diamonds of 1966–1967 when the entire canvas was paint-covered, and in a group of late chevrons in which the *V*s are twisted sideways to make an asymmetrical image. These are moderate extensions of his system, however, not its collapse, which the paintings of 1971 revealed.

In the later paintings the stripes of color overlap; the canvas is entirely covered with solid or mottled color; and the centrality of the image (which is not given, but is also not denied, in the horizontal stripe paintings) effaced by restless off-center compositions. (Indeed it is a departure from Noland's earlier criterion of unity that it is possible to talk at all about his composition, in the sense of the arrangement of unlike parts.) Thus the all-at-once effect, essential to the earlier paintings, was lost and the holistic, or indivisible, image, constituted by such legible forms as circles, *V*s, or horizontal stripes, was compromised. The 1971 paintings depart from Noland's usual circumspect formality as, on one hand, he affirms flatness and rectangularity and, on the other hand, evokes spatial illusion, either by overlapping stripes or by the separation of colored stripes from colored backgrounds.

The paintings of 1972 refine these unruly works, and that is logical, inasmuch as Noland's idea of development is the consecutive extension of his work, like a series of memos. Lines still overlap, but the intersections are now restricted to the corners, because the lines are all held to within a few inches of the edges of the canvas. Thus the tartan-plaid effect, which jarred the 1971 paintings, is blocked. These lines are obtained by putting down rows of masking tape and painting in the channels left between them. The result is that the lines are neat yet disembodied, because in the absence of drawing, produced by the changing pressures of the hand, the color is weightless. Noland intends this effect but it is not necessarily the best thing for the pictures, now that he has moved into intricately differentiated composition.

The weightless color lines, timidly close to the perimeter of the canvas, never veering away from pure north-south, east-west directions, are placid; even the little wrench where lines cross one another at the corners, avoids the awkwardness of the plaids but at the expense of all energy or tension. The central area, the bulk of the canvas, is filled by soft washes. These are pale, high-keyed, pretty, all rosy-fingered dawn and September morn in their sentimental nuances. Noland's intention may be to dissolve the picture plane by tremulous washes and then to close it again by taut edges and snappy corners, but the feeble prettiness of the washes and weightless stripes achieves only a vacant lyricism.

What has happened to Noland is something as follows. He had a viable style, derived from the field painters among the Abstract Expressionists—that is to say, from those artists concerned with color on a big scale, such as Newman and Rothko. Both those artists were preoccupied with the problem of content and expended great effort to make their expanses of color symbolic. Noland is of the generation that picked up their formal structure but not their concern with, in Newman's case, the sublime, and, in Rothko's case, the tragic. What remained was the objectness of the painting, purged of humanistic reminiscence and the myth of depth, as Robbe-Grillet has called it. This was incisive and salutary at first, as in Stella's early paintings, the factual and unevocative black, aluminum, and copper series (1959–1961), but repetition has not improved the stance.

Through the 1960s Noland, like Stella, was highly productive, but of what? He painted shrewd and inventive elaborations of visual emblems from which the function of signification had been drained. Or, rather, what was signified was the evolution of Noland's painting itself; the position of each painting in the series became its meaning. This led to a loss of physical presence which conflicts oddly with the declared concreteness of such work. No decisions are really binding in Serial paintings and thus they can be done, in sets or runs. It is enough for the artist to think of the configuration and direct the project in accordance with the logic of his development and a few formal customs concerning flatness and color without drawing. Thus the new paintings of Noland are not visual discoveries, but permutations of an easy idea about painting.

The tendentious nature of the "modernist" vocabulary becomes clear. Without the mystique of art's self-reference and the artist's ethical bond to it, Noland's development can be seen for what it is—a narrow progression, prudently limited, rather than what Fried regards as a series of hard-won renewals.

CRISIS

In the sixties, writing about art was in the hands of many people besides art critics. The mass media accepted art as a legitimate part of leisure and hence as a sustained subject of attention. However, this expansion had little effect on art critics, unless it led them to close ranks a little against unqualified outside commentary (see my article on Op art, pp. 239–244). In line with the interest of the media it is significant that the quantity and availability of art criticism itself increased in the decade.[16] The magazines *Art in America, Art News, Arts,* and, after

16. Although I stress the importance of topicality I do not value art criticism written on a daily basis. There seems to be too brief a lead time between seeing

1967, *Artforum* were all published in New York City. *Art International,* though published in Switzerland, contained copious American coverage, written by such critics as Barbara Rose. Lucy Lippard, and Carter Ratcliff and more recently Phyllis Derfner and April Kingsley. Not only that, but collections of essays appeared consistently, starting with Greenberg's *Art and Culture* in 1961. This was followed by Dore Ashton's *The Unknown Shore* in 1962, Harold Rosenberg's *The Anxious Object* in 1964, Michael Kirby's *Happenings* in 1965, Nicolas Calas's *Art in the Age of Risk* and Kozloff's *Renderings* in 1968, and another Rosenberg book in 1969, *Artworks and Packages.* In 1971 there were Lippard's *Changing,* Nicolas and Elena Calas's *Icons and Images of the Sixties,* and Jill Johnston's *Marmalade Me.* These books by art critics were not reviewed by each other, but this does not reduce their significance. For the first time a substantial body of occasional art writings by individuals was available, as opposed to their scattered appearances in the multiauthor format of art journals.

Most of this criticism, though it can be short-winded or cliquish, carries a good deal of hard data on the art and artists of the period, much more than earlier reviewers provide. Kozloff has neatly compared the criticism of the sixties with that of the preceding decade: "Just as *Art News* developed a florid style to treat Abstract Expressionism, a style that now seems too gullible, we are in danger of cultivating a pedantic style in handling current art that can seem quite as credulous." [17] The influence of art history on art criticism in the sixties is not only a change from drama to bookkeeping. The fact is that art critics are not bound, with the same conviction as historians of art, to a procedural methodology. A more descriptive form of writing became more frequent in the sixties, but this does not necessarily signify a sudden increase of objectivity in the writers. On the contrary, acts of description can be agressive (imputing sentimentality to anybody who attempts more) or self-expressive (implying humble rationality as a superior mode of thought to anything more ambitious). It is characteristic of American art critics, particularly those with an art-historical education, to accept the necessity of specialism. Thus they tend to bestow an intense and concentrated support on small segments, subgroups, of the art world. Examples of this are seen in the early writing of Barbara Rose as it stressed the abstract art around Frank Stella, in Lippard's work on behalf of Minimal Art and Conceptual Art, and in Fried's formalism geared to the glorification of Louis, Noland, Olitski,

and writing. I must agree with Hilton Kramer's judgment in 1965 of the *New York Times:* "the criticism published in this paper, criticism designed to educate, satisfy, guide, lead, and entertain . . . grows dimmer and dimmer." (Kramer in *The Critic and the Visual Arts* [American Federation of Arts, 1965], p. 57. This piece is not reprinted in his *The Age of the Avant-Garde* [New York, 1973].)

17. Max Kozloff, "Psychological Dynamics in Art Criticism of the 60s," in *Renderings* (New York, 1968), p. 319.

and Stella. Thus academic specialism was transferred to movement consolidation in the contemporary area. These special interests lead to a certain isolation of each writer from the others, which is increased by the casualness of footnoting in such writing. Without the acknowledgments that footnotes provide, the origins of writers' ideas can be passed over, debts and parallels to others obscured, and a deceptive independence made to emanate from each personality. However, there has been an increase in the factual content of art criticism, as is evident if one compares American writing with, say, European impressionistic criticism, which veers uneasily between uplift and commerce.

The events of May, 1968, in Paris, when students fought the police and felt a momentary affiliation with the workers, had no American equivalent. The intersection of political and aesthetic action lacked a focus until the early summer of 1970. The invasion of Cambodia and the shootings at Kent State University, Ohio, precipitated a unified chain of protest. Two art critics responded specifically to the domestic and external violence—Max Kozloff and Barbara Rose. At a conference on art criticism and art education, Kozloff said:

I prepared this talk during the opening weeks of the Cambodian invasion, and one of the latter's off-hand consequences was to make this business-as-usual symposium *look* of a distant, naïve, and privileged past. None of the concerns to which I've spoken are of course intrinsically ignoble but their present socio-political context would taint with them the onus of a classy tipping for investors, a form of exalted PR work for a superannuated establishment.[18]

Rose declared:

the beginning of the liquidation of art criticism. A number of choices are open to the critic who would renounce the false authority of a judgmental opinion. He may: (1) report neutrally and inclusively for the media; (2) retire to the academy and try to mend fences with art history, applying critical methods to historical study; (3) study the history of art criticism as a discipline; (4) become an artist; (5) use sociological analysis of the present relationship between culture and society in the service of an economic, political, social, and cultural revolution. The one thing that no critic in good conscience can do is to influence the market. There is no way to avoid the consequence that making judgments in print results in market manipulation.[19]

Of these options the first is the one that she adopted, writing for mass-media journals rather than art magazines, though it could be disputed how "inclusive" Baudelaire would have considered her choice of subjects. Kozloff, who had been working a few years earlier on the third option,

18. Max Kozloff, in *New York University Conference on Art Criticism and Art Education* (New York, 1970), p. 68.
19. Barbara Rose, *ibid.*, p. 18.

a study (unpublished) of art criticism, opted for a position closer to the fifth.

Both critics had prepared themselves, in a sense, for this crisis. In 1967 Kozloff, considering art criticism from an ethical point of view, examined possible sacrifices. "One, for instance, might be that enormous knowledge and sophistication which contaminate, even as they inform, every response." [20] Thus the events of 1970 confirmed existing doubts concerning the validity of the critic's unique instruments. At the same time, Rose expressed severe criticism of the way in which "criticism is dominated by an element of the disenchanted American left, led by Rosenberg and Greenberg, which has managed to achieve a rapprochement with the society it once rejected." [21] She argued that the lack of political action lead to frustration which was being displaced into aesthetics. It was her acuteness to link both "Action Painting" and "Modernism," the term by which Greenberg's special notion of art draws surreptitious semantic support from the very word *modern*. Thus instead of the two critics representing antithetical points of view, as they are usually assumed to, both existentialism and aestheticism are taken as ideologically flawed by their easy accommodation to the status quo in the art world. Clearly, critics with opinions taking the direction of Kozloff's and Rose's would not react to Cambodia and Kent State in silence. Indeed, it is possible that there was an element of relief in Rose's case at the sudden simplification of the critic's task that the impact of outside events seemed to offer.

Their politicization of art criticism had analogies elsewhere in the art world. The Art Workers Coalition planned, with the support of sympathetic dealers, a general strike "in memoriam to those slain in Orangeburg, S.C., Kent State, Jackson State, and Augusta and as an expression of shame and outrage at the government's policies." [22] This became the New York Artists' Strike against Racism, Sexism, Repression, and War, which was staged on May 22, 1970. Some galleries and a few museums closed for the day, but the main outcome was the grandly titled Emergency Cultural Government, with Robert Morris and Poppy Johnson as co-chairpersons, Max Kozloff, and Irving Petlin. The ECG succeeded in undermining an exhibition planned as the American representation for the pavilion of the Venice Biennale: either spontaneously or after pressure, many artists in a scheduled group show of prints withdrew. Incidentally, protesting artists had successfully fragmented the intended American contribution to the São Paulo Biennial in 1969, on the basis of criticism of the Brazilian regime. It was announced that ECG would

20. Kozloff, in *Renderings, op. cit.,* p. 315.
21. Barbara Rose, "Problems of Criticism: The Politics of Art, I," *Artforum,* VI/6 (February, 1968), p. 32.
22. Ephemeral literature.

act as "the American Artists agency for supporting, encouraging, and organizing American participation in international art events formerly sponsored by the U.S. Government." In the event it has done nothing, and its one attempt to arrange an exhibition in New York, a kind of anti-Biennale, was aborted by black and women artists who considered it to be a male-dominated show. Such a comedy can now be seen to have had a firmer base in the unfolding of contemporary art than more cautious writers realized at the time, though the efficacy of public gestures of this sort has not been settled one way or the other.

A loss of confidence in art criticism can be found in Lucy Lippard's writing. As she put it: "I am supporting a system that I abhor by writing criticism." [23] In 1971 she published *Changing,* a collection of art criticism from the sixties. (The title presumably derives from Merce Cuningham's *Changes,* and hence an allusion to art beyond art, but most of the collection is straight art criticism.) In the same year, she wrote an article on the realist painter Alex Katz in a style very different from her previous brisk, explanatory mode. "He smiles a nice quick smile, an innocent smile, a sweet shy smile that gives away the whole game, Maltese Falcon or no Maltese Falcon. He likes to dress up. The people he paints are often beautiful but not quite beautiful, or maybe more beautiful because they aren't exactly beautiful. Like Ada. Or else they aren't at all beautiful, but they look so damn nice." [24] Here, the style is that of "creative writing" as a literary exercise. In 1973 Lippard edited *Six Years: The Dematerialization of the Art Object from 1966 to 1972,* in which Conceptual Art, Earthworks, and performance pieces are documented in a literal chronological order that resists retrieval or summary. The low usability of the book seems designed to compensate for a personal disappointment. Her "hopes that 'conceptual art' would be able to avoid the general commercialization . . . of modernism were for the most part unfounded." [25] Thus she, Rose, and Kozloff have in common a recoil from the merchandizing of art. Kozloff came in 1973 to believe that the art that criticism, his own and others, had supported was ideologically flawed. "As Pop art spoke best to the entrepreneurial collector, so expensive-looking color-field abstraction blazoned the walls of banks and board-rooms." [26] Kozloff, picking up a melodramatic phrase of Norman Mailer's, wrote: "Without so intending American abstraction of the 60s strikes us as the visual anagram of these 'lusts for

23. Lucy R. Lippard, "Freelancing the Dragon," *Art-Rite,* 5 (Spring, 1974), p. 19.
24. Lucy R. Lippard, "Alex Katz Is Painting a Poet," in *Alex Katz,* ed. Irving Sandler and Bill Berkson (New York, 1971), p. 5.
25. Lucy R. Lippard, ed., *Six Years: The Dematerialization of the Art Object from 1966 to 1972* (New York, 1973), p. 263.
26. Max Kozloff, "American Painting during the Cold War," in *Twenty-five Years of American Painting, 1948–1973* (Des Moines, 1973), p. 16.

new order.' " [27] This ideological interpretation of sixties style is strikingly anticipated by Nicolas Calas: "According to Coplans, Serial imagery evokes 'the underlying control systems central to an advanced society.' This is alarming for it implies that Serial imagery serves to reinforce the system of control that managerial order wishes to impose on both our actions and the expression of our ideas and emotions." [28]

The compound of American foreign policy and violence at home with a revival of ideology forced these critics, all in their thirties, into crises that effected their work. All recoiled from capitalism in the way that Juvenal had from Rome:

> Wealth springs from crime:
> Landscape-gardens, palaces, furniture, antique silver—
> These cups embossed with prancing gods—all, all are tainted.[29]

Were there no stabilizing factors within art criticism to which they might have appealed? If we consider older critics as models, the only candidates are Rosenberg and Greenberg. Both are ex-Marxists, a fact perpetuated by Greenberg's deterministic view of history and by Rosenberg's typology of imagined representative figures. This heritage might seem to equip them for consultation by a younger generation of writers under political stress, but this was not the case. Rosenberg's *The Anxious Object,* his first book of art criticism,[30] appeared in 1964, but it was too essayistic in form to satisfy the restlessness of the newly politicized. Rosenberg had been the art critic of the *New Yorker* and his urbane dissatisfaction was too poised on earlier precedent to be congenial to a generation shocked by a new experience of violence.

The disappointment with Greenberg was more complex. In 1961 he published *Art and Culture,* following it with two essays—"Modernist Painting," which appeared in 1961 right after the publication of the book, and "After Abstract Expressionism," which was published the following year.[31] From this point on his art criticism has been administered by younger writers—William Rubin, Eugene Goossen, Michael Fried, Rosalind Krauss, Kenworth Moffett—but his own writings are desultory. (All of these writers separate themselves in terms of ideas, in one way or another, from Greenberg, but their common point of origin remains.) Greenberg's aesthetics, and hence his admired artists,

27. *Ibid.*
28. Nicolas and Elena Calas, *Icons and Images of the Sixties* (New York, 1971), p. 221.
29. Juvenal, The Sixteen Satires, 1 (trans. Peter Green). Baltimore, 1967 p. 67.
30. Rosenberg's more influential first book, *The Tradition of the New,* 1959, contained only four essays on art.
31. Clement Greenberg, "Modernist Painting," *Arts Yearbook,* 4 (1961), pp. 101–108; Clement Greenberg, "After Abstract Expressionism," *Art International,* VI/8 (1962), pp. 24–32.

have prospered in a subset of magazines, galleries, collections, and museums. This acquiescence of writers in a pattern of promotion is probably a major factor in the recoil by other writers from the commercial potential of art writing. It is not only the desire of younger writers to avoid the narrow formalistic bias of Greenberg-oriented writers that has cut back his influence, but their skeptical relation to the art market, an area that Greenberg has never questioned. A typical concern is that of Kenworth Moffett who defends the Abstract painting that he likes, by arguing that "the leading Pop artists have sold at prices many times those achieved by the best living abstract painters," [32] thus conferring comparative alienation on Olitski and Noland.

Lucy Lippard, Max Kozloff, and Barbara Rose all have in common their training as art historians—Lippard and Kozloff at New York University, Rose at Columbia. This academic training shows differently in each writer: it is clear in the systematic detailing of Rose's monograph on Claes Oldenburg, in Lippard's early bibliographies (usually for other people's museum catalogues), and in Kozloff's humanistic resonance. What does an art historian's training do for somebody who is writing about modern art? In this capacity one applies the techniques of "historical method and . . . meticulous documentation" to the unruly present, a procedure that started, according to Erwin Panofsky, with Alfred H. Barr, Jr., and Henry-Russell Hitchcock.[33] A trained art historian can expect to receive a firm orientation toward the primary object and be equipped to handle the secondary data around works of art. However, Lippard has not maintained a regard for art as a humanistic object, and Rose does not give her journalism a strong factual base of widely surveyed data. It seems, therefore, that the lessons of education shatter at the input of new information rather than absorb it. As presently taught, the discipline seems to develop neither a sense of connections between art and society nor a sense of the historical diversity of art.

Hence the three critics discussed here typify a cultural crisis which can be formulated on these lines. How to continue to write about art when the ideological framework in which you were trained, and which you began by accepting, appears corrupt? One aspect of the problem is the failure of graduate departments to provide any serious motive, beyond the criterion of clerklike industry, to their students. In particular, the pressure of public accountability, as it has developed all over the country, has placed the arts under unaccustomed stress. What is the public benefit with which the art critic's work, less confirmed by institutional sanction than the historian's, can be collated? The art critic, unlike the historian, has no mystique of the discipline to which he can appeal, and the critic is, in any case, more exposed to the impact of cur-

32. Kenworth Moffett, "Pop Art," *Art News*, LXXIII/5 (May, 1974), p. 31.
33. Erwin Panofsky, "Art History in the United States," in *Meaning in the Visual Arts* (Garden City, N.Y., 1955), p. 328.

rent problems and changes of taste. Neither clerical diligence nor humanistic continuity, as taught at present, seem sustaining when three of the system's most productive graduates responded as they did to crisis. Other questions that can be added to the stress situation are these: What to put in the place of stylistic criticism and its assumptions, sometimes explicit, but always assumed, of the objective existence of norms of quality? How to advance the recognition of the art of newly enfranchised social groups, which is part of the pressure of postclassical abundance? This derives from the problem of quantity and the difficulty of critics in devising a system adequate to contain it.

THE ONGOING PRESENT

The problems that art critics have to cope with, the shifting social matrix within which their ideas of the continuity of art are tested, are undergoing changes that, in an arbitrary way, can be identified with the seventies. One aspect of this situation is the politicization of art criticism in the form discussed above, but the reactions of individual conscience are not the only indications of stress. The concept of a revolutionary art has been altered by an unexpected confluence of events. In the early twentieth century there was an historical connection between art and revolution. In addition to the general leftish *esprit* of the intellectuals as a class, a specific case, that of Russian constructivism, seemed promising. If you were on the side of "modernity," like Apollinairé, Léger, or Mondrian, a future socialist state seemed desirable and close to realization, merely delayed momentarily by the forces of reaction. It turned out that the USSR had no place for the artists who thought that a new form of society would suit a new form of art. However, the notion of the artist as a radical was retained even when the political connections on which the idea has been based collapsed in the 1940s. The artist was still revolutionary, but only in terms that were an unearned extension of what he was doing anyway.

In this phase of undemanding revolution, it was enough for the artist to (1) expand our perception of the world, or to (2) seem to prophesy coming events. The artist's image of the world more often, in fact, followed what was already current (as with Bauhaus versions of technocracy), and the prophecies did not have to be verifiable. If the audience would only attend closely to the artist it would emerge with a new sensibility, one attuned to what "the age demanded." Thus the artist continued in his operational routines, but through a mystique of communication his work was supposed to infuse the spectator with contemporary awareness. Somehow, we were supposed to be able to change the world, or be predisposed toward the right kind of change, by the sight of primary colors, right angles, flashing lights, or whatever.

Abstract artists benefited particularly from this notion of education for the future because they had the satisfaction of doing what they wanted to do—painting without reference to the world, while being congratulated on the significance of their geometry, viewed as paradigms of order, or their gestures, viewed as organismic wholes. It is one of the ironies of twentieth-century culture that every little internal shift of Abstract art styles—or of Surrealism, for that matter—has been equated with revolutionary shifts in social meaning. In retrospect, it is hard to see any connection between stylistic and social innovation. If anything, innovative art has been supported less by the agents of political change than by the proponents of the status quo.

Roger Fry, writing in 1917, noted accurately that "the revolution in art seems to be out of all proportion to any corresponding change in life as a whole." [34] This state of affairs satisfied Fry, of course. However, the separation of revolution into unrelated zones, one of social action and one of sensibility, is unsatisfactory and suggests that the term *revolution* is being stretched inordinately. The art styles called experimental have accommodated themselves perfectly to the process of widespread distribution and reproduction. The artists, with their supposedly implicit revolutionary message, have enjoyed the support of those least interested in social change. We are presented, therefore, with the paradox of a conformist revolutionary style or perhaps a false revolutionary style.

Against this situation are some artists whose claims on society are revolutionary but whose works cannot be affiliated with the former stylists of revolution. There are now a great many artists, some of them women, some of them black, who are putting a revolutionary pressure on society by revising the role of the artist, but without following the models of ambiguous style change. The fact that they are producing art and forcing its recognition is socially of prime importance, and it makes the often-recited inventory of formal breakthroughs—that is, the procession of stylistic revolution without sociological impact—seem remote and idle. To take one example, Marcel Duchamp lived within the system no less than the Duke of Windsor and Cole Porter, and in fact the three had a fair amount in common. The stance that seems interesting now is that of artists who propose social as well as aesthetic revisions.

The separation of the concept of social change (which is the least that revolution is) from stylistic change is overdue. It is, I think, central to a new condition in the art world that the content of art can be a group's awareness of its identity over and above stylistic differences in the works themselves. What the artists have in common as an active group rather than the definition of their work according to formal criteria is what provides a revolutionary potential. This is all part of a

34. Fry, *Vision and Design*, p. 15.

wider interest among artists and critics in the social consequences of art. It is a move into what C. W. Morris called pragmatics [35]—that is to say, the study of the relationship between signs and their users. We have reached a point of self-awareness in which political action can no longer be claimed as a subliminal source of prestige for art that is not in fact politically oriented.

Greenberg called his essays *Art and Culture,* though the traces of culture in his book are slim. The definition of culture has expanded at a considerable rate since he tried to restrict the term to a handful of precious objects of only one kind. In different ways both Pop Art and Happenings forced an expansion of the spectator's attention into a variety of environmental spaces and objects. In 1970 a group calling itself the New Art Association was formed within the College Art Association, and one of its first acts was to attack the Frick Symposium. Every year at the Frick Museum, graduate students present papers, usually exercises in the established procedures of attribution, style definition, and iconographical decoding. The narrow definition of culture implicit in such work leads to the neglect of "social, political, and psychological contexts," to quote a newsletter of the NAA. The association has called for the formulation of a broader-based study of "visual culture" than art-historical expertise usually condones. (An example of this restrictiveness, taken from undergraduate education, would be the suppression of the vivid, nonverbal culture that high-school students possess before they go to college. Once there, they discover that their peer and mass culture is discontinuous with the curriculum, whereas it would seem more logical for the university to attempt to connect with what the students bring with them.)

The expansion of the definition of culture and hence of art, rather than the narrow definition of art and the closure of culture as an inclusive term, can be seen elsewhere. There has been an unanticipated upsurge from "outside" or "below" the narrowly defined professional art world which has raised doubts about the absoluteness of the identification of art with the educated. Such an identification can be taken to be an ideological weapon against black and Puerto Rican artists, for example. Thus traditional curriculums and exhibition programs, in universities and museums respectively, are under pressure for excluding art that does not conform to racial ideas that were once, legitimately, aesthetic ideas. It is necessary also to consider the status of the work of lay artists. By lay art I mean work that exists beyond the accustomed professional limits of twentieth-century art. It is different from Sunday painting or so-called "primitive" painting, in which naïveté was expressed in a definite stylistic form. From Camille Bombois to Grandma Moses there is a common enumerative style and pastoral content that

35. C. W. Morris, *Signs, Language and Behavior* (New York, 1946).

speaks of a peripheral social position. Lay art is not to be defined in stylistic terms. For generations art has been taught as something easy to do: first, there was expression theory (paint as you feel); later, automatic procedures; most recently, Duchampian decisions function as art. The result is that there is a great deal of work, expressionistic, decorative, Abstract, and figurative (including much assemblage) that short-circuits the expectations learned from prior art traditions. A good deal of black and Puerto Rican art is of this kind, existing, at present, beyond the vocabulary of art criticism.

Another nonstylistic grouping of artists, who take their unity from a social and sexual rather than an aesthetic center, is that of women artists. They did not represent a problem for critics in the sixties, when Louise Nevelson and Helen Frankenthaler could be discussed in good conscience as artists, not as women, thus showing the presumption of equality. This is no longer so neatly the case, as the connections between art and society have gone on multiplying in the last few years. On the occasion of the Georgia O'Keeffe retrospective at the Whitney Museum in 1970, the sex of the artist was not much discussed, but a year or two later she had become not only a model of feminine independence but a test case of feminine iconography. Women artists, as women, have brought new demands and values into the established art world. The revolutionary factor, therefore, is not a style, but the identity, cultural and individual, of the artists themselves. The speed with which women artists have entered the art world is worth recording, for the schedule is a signal of both the energy of the artists and the aptness of the cause. I shall deal here only with exhibitions in New York State, but other factors would need to be discussed in a fuller survey.

In 1970 an exhibition entitled "X^{12}" at Museum (so-called) brought together a hectic group of artists, some of them members of Women Artists in Revolution (WAR), an offshoot of the Art Workers Coalition. For the most part the show consisted of lay art, symbolizing simplistic protest. The exhibition was arranged by the participating artists, but in the following year Lucy Lippard selected a group of "Twenty-six Contemporary Women Artists" (Larry Aldrych Museum of Contemporary Art). This exhibition turned out to be a model for a sequence of subsequent shows. In 1972 "Thirteen Women Artists" was staged at 117–119 Prince Street, a co-operative show in which the artists got together for the purpose of a single showing. A sequel was held later in the year at the State University of New York at Albany as "New York Women Artists," and another college in the state system, Potsdam, showed "Women in Art." A European acknowledgment of the movement came with the "American Woman Artist Show," arranged by the Gemeinschaft der Kunstlerinnen und Kunstfreunde at the Kunsthaus, Hamburg. The A.I.R. Gallery (Artist-in-Residence), a women's co-operative gallery, opened in the fall and began a series of brilliant

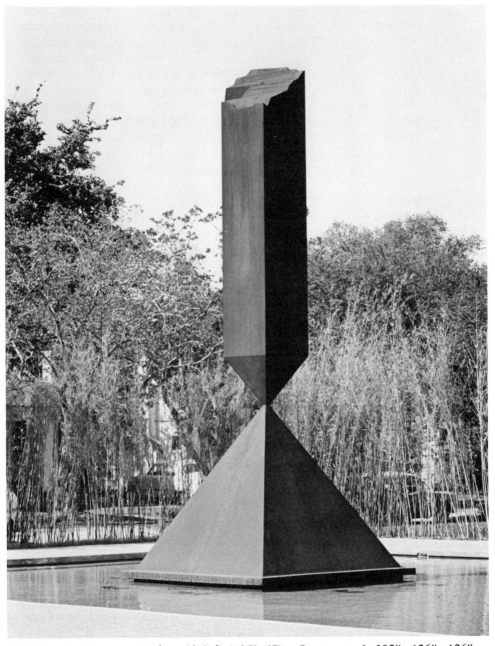

64. Barnett Newman: *Broken Obelisk* (1963–67). Cor-ten steel, 305″×126″×126″.

exhibitions by its members. In the season 1972–1973 there was a three-part survey called "Unmanly Art," arranged by June Blum at the Suffolk Museum, Stony Brook, and "Ten Artists (Who Also Happen to Be Women)" was arranged by Joan Miller at the Kenan Center, Lockport, and the Michael C. Rockefeller Arts Center Gallery, Fredonia. These shows began to make possible a detailed exploration of women's art, initiating an inquiry into the possibilities of inherent sexual characteristics in art. Though these shows were not reviewed much, catalogues were published and a literature began to crystallize.[36] In January, 1973, the group Women in the Arts organized a large exhibition at the New York Cultural Center, and it is notable that it was selected by the artists themselves. In that year another co-operative gallery opened, Soho 20, and Joan Miller did a sequel to her earlier show, "New York Eleven," at the C. W. Post Center Art Gallery. This brief chronology reveals the rate at which the topics critics are supposed to deal with can move.

The problem is a fundamental one. At the start of the seventies one assumed that women's art had no specific feminine properties and that to attribute them was a discriminatory act. Now, however, intrinsic feminine characteristics are being sought by the women themselves, for the purpose of self-definition. The matter is not yet settled for it is only in this decade that enough work by women has been available for study and comparison. It is too early to see where the present speculation will lead, but there are several paths. There are formal and technical nominations: the use of grids, centralized compositions, or craft techniques. There are subject-matter nominations too: realism of a practical cast, self-imagery, or male nudes. These problems, for future resolution, remind one of the way in which the critic is hounded by topicality.

36. In addition to the catalogues of exhibitions mentioned here, see the various issues of *The Feminist Art Journal* (Brooklyn, N.Y.) since 1972.

INDEX